Arequipa, Peru / Astacinga, Mexico / Autlán, Mexico / Azogues, Ec[uador,]

Thailand / Bangsar, Malaysia / Barretos, Brazil / Basra, Iraq / Beirut, Leb[anon,]

a / Brantford, Canada / Bridgetown, Barbados / Buenos Aires, Argentina / Calgary,

hihuahua, Mexico / Chişinău, Moldova / Chongqing, China / Chungju, South Korea / Ciudad

Bangladesh / Dingras, The Philippines / Don Yay Village, Laos / Dublin, Ireland / Edmonton,

nd Prairie, Canada / Guadalupe De Trujillo, Mexico / Guanajuato, Mexico / Guatemala

Cuba / Hounslow, United Kingdom / Hudiksvall, Sweden / Istanbul, Türkiye / Iztapalapa,

Kanpur, India / Karachi, Pakistan / Karbala, Iraq / Karen State, Myanmar / Karlsruhe,

c of the Congo / Kitchener, Canada / Krefeld, Germany / Kuala Lumpur, Malaysia / Kuwait

Labartoov, Poland / Lahore, Pakistan / Lampang, Thailand / Las Flores, Mexico / Leeds,

on, United Kingdom / Lopburi, Thailand / Lupron, Dominican Republic / Luuq, Gedo Region,

s, Cuba / Medellin, Colombia / Mexico City, Mexico / Michoacán, Mexico / Middlesbrough,

nada / Moscow, Russia / Murewa, Zimbabwe / Murree, Pakistan / Nagpur, India / Nairobi,

Novokuznetsk, Russia / Nuku'alofa, Tonga / Nyaruguru District, Rwanda / Oaxaca,

ernik, Bulgaria / Petaling Jaya, Malaysia / Phanat Nikhom Refugee Camp, Thailand

Pristina, Kosovo / Puerto Vallarta, Mexico / Quevedo, Ecuador / Quito, Ecuador / Recife,

Mexico / San Andres Tzirondaro, Mexico / San José de la Montana, Colombia / San Luis

ngo, Dominican Republic / São Paulo, Brazil / Secunderabad, India / Shuri, Bhutan / Sinuni,

ulgaria / Stafford, United Kingdom / Strasbourg, France / Subang Jaya, Malaysia / Surat,

o, Chile / Tepic, Mexico / Thimphu, Bhutan / Thma Koul, Cambodia / Titiribí, Colombia / Tizi

ra Dornei, România / Vellberg, Germany / Vientiane, Laos / Voinjama, Liberia / Winnipeg,

ynthos, Greece / Zenica, Bosnia and Herzegovina / Zimte, Myanmar / Zitácuaro, Mexico

# FINDING
## AMERICAN

# FINDING AMERICAN

## STORIES OF IMMIGRATION FROM ALL 50 STATES

**COLIN BOYD SHAFER**        FOREWORD BY ALI NOORANI

**Figure.1**
*Vancouver / Toronto / Berkeley*

To my mother, Vivien Boyd,
the first photographer—and immigrant—
I ever met.

IN MEMORY OF

Nusrat Brown (1948–2019)

William Jerry Barnett (1941–2020)

Ernie Simon (1929–2020)

Patrick Wood (1964–2020)

Yvonne Brown (1977–2021)

Feridun (Phil) F. Gencay (1924–2021)

Ruth Olsen (1936–2021)

Manjit Kaur Reddick (1940–2022)

Bruno Santos Perez (1950–2023)

THANK YOU FOR THE GENEROUS SUPPORT

Madina Institute of Arkansas

Arizona Dream Act Coalition

Metropolitan Family Services

The Interfaith Center of Arkansas

Amy Nave

Layla Khamoushian, Esq.

Margaret Knight, Esq.

Tahmina Watson, Esq.

Victoria Susanne Taylor

Ernest Simon, in memoriam, on behalf of his wife,
Eve, and daughters Carol, Lori, and Renee

For more than two centuries, immigration has made each generation of Americans more diverse, and the nation's identity ever more textured. In America today, you can't easily tell who is and who is not an "American." Perhaps only when it becomes too late will the country realize that it's best to let people come and become American rather than deciding in advance that foreigners are not American enough. Nations are "imagined communities," in the words of scholar Benedict Anderson—and each generation is entitled to imagine a new one.

PARAG KHANNA, *Move: The Forces Uprooting Us*

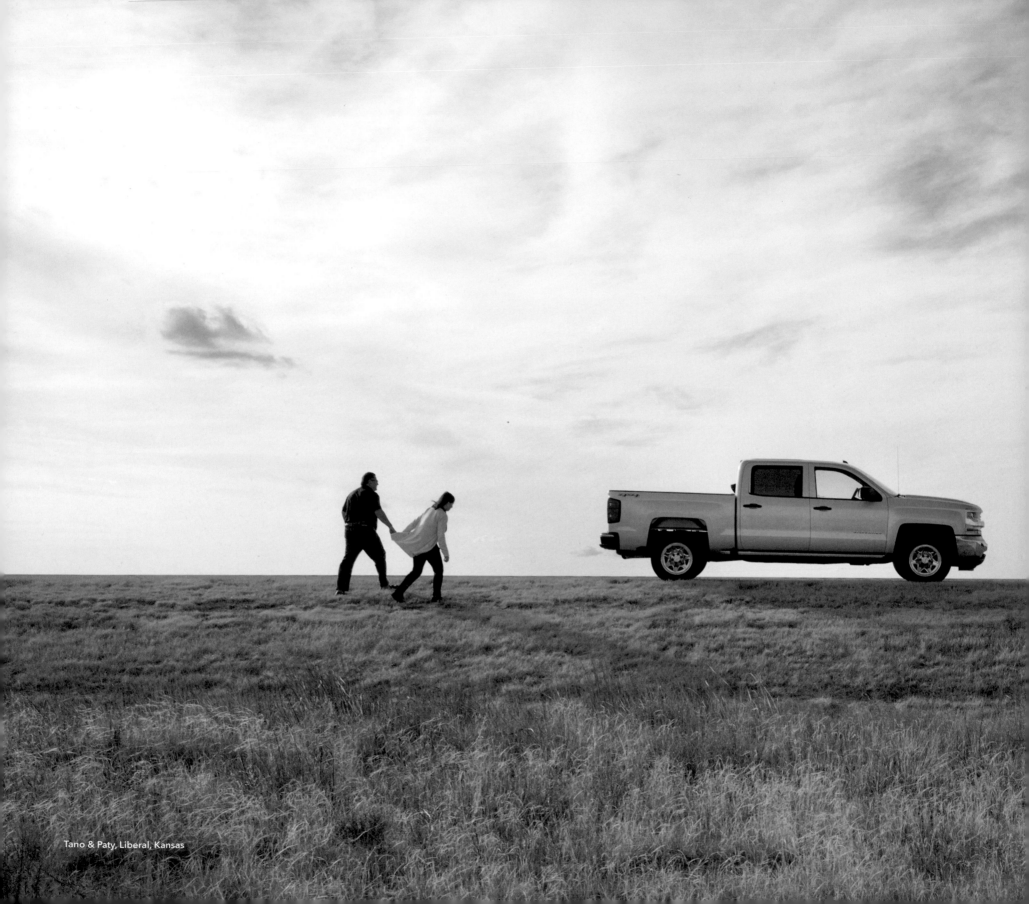

Tano & Paty, Liberal, Kansas

# Contents

# Foreword

ALI NOORANI

Migration is one of our most natural acts.

Moving, whether it's across town, across the country, or around the world, is as exhilarating as it is terrifying. No matter how far that move is, we are crossing a border—geographic or emotional. Our day-to-day lives change; our community changes. Our lives are fundamentally different.

Our migration stories are passed down across generations. Whether our families are of the original peoples of this land, or if we belong with the 97 percent of Americans whose families come from another land, we take pride in the journeys of those before us. Yet, today's public discourse leads many of us to look warily upon the stories of immigrants.

Since the late 1800s, immigration has been a powerful source of political division. From the Chinese Exclusion Act to "no Irish need apply" to Operation Wetback, untold millions of people have been removed or barred from our shores. Over time, the numbers are so great, the human tragedy so vast, that immigrants and refugees often exist in the abstract world of data sets and policy proposals.

Stories of migration are notoriously complicated. Understanding why one decides to immigrate to the United States, how their lives change, and their aspirations for an uncertain future requires the skills of a nuanced storyteller. Sharing these stories at a national scale—given the geographic and cultural diversity of the United States—is an overwhelming task.

Historically, those who moved to the United States from around the world gravitated to major metropolitan centers. New York, San Francisco, Los Angeles, Chicago, Houston. These were the immigration hubs that gave birth to the American dream of generations past.

Over time, immigration to the United States became more diverse in two important ways. First, the most common national origins of new arrivals shifted from Europe and Mexico to Asia, Central America, and Africa. And, although their numbers may not be as large, recent influxes of Afghan and Ukrainian refugees have captured public attention. Second, although nearly half of the nation's immigrants live in California, Texas, and Florida, growing numbers are making their homes in smaller cities and suburban communities. Rural America is clamoring for immigrants and refugees to meet workforce needs and secure its tax base.

These changes are taking place amid a heated political debate that focuses on border security and legal status—a debate devoid of human story; a debate that drives down public support for immigrants and immigration.

During nearly two decades serving in leadership roles at the local and national levels of the pro-immigration movement, I have visited close to every state in the union. In getting to know immigrants and refugees, pastors, police chiefs, business leaders, and so many others, I have seen how immigration plays out in different communities across the country. I have had the honor of sharing many of these stories through two books and countless media interviews.

I have also seen how perceptions of immigrants often do not match reality, and how sharing stories about immigrants can change minds. Stories can help Americans understand their own history as well as the contributions of their newest neighbors.

Our national inability to come to terms with the value of immigrants and immigration has put the United States at an inflection point. Our global competitiveness relies on our ability to train, recruit, and retain a talented workforce of engineers and farmworkers alike. Our financial health depends on a population that is growing. Our national security is inextricably linked to our ability to relate to the rest of the world.

None of this is possible without a robust immigration system that serves the interests of Americans and their families. Yet, our national conversation around immigration is as calcified as our politics: Stuck. Regressive. Based on fear. We need to recenter our understanding of immigration around the stories of today's immigrants and refugees.

This is why *Finding American* could not have come at a better time. The power of the pages that follow is found in the images and words.

The story of Sophia (p. 196) hit home for me, in part because my parents also came from Pakistan and their experiences have informed so much of what I do. Sophia grew up in Pakistan and lived in Little Rock after 9/11. Her leadership of an interfaith center at a local Episcopalian church since 2012 and her founding of a mosque in 2016 have helped to grow intercultural understanding in a largely conservative and rural state—none of which would have been possible in Pakistan; none of which was simple in America.

A few chapters earlier, Christina holds a formal family portrait while Jorge tends the grill and their son sits on a bike in the background (p. 105). Christina escaped an abusive marriage to find new love with Jorge. In working to secure permanent residency for Jorge, their lives were turned upside down by bad legal advice and a persistent misunderstanding. After years of expensive legal battles, Jorge was deported. Christina and family remain in Englewood, Colorado, fighting to be reunited.

These are two encounters—illuminated by powerful images and compelling stories—in view of which we begin to understand the challenge of finding the meaning of "American." Through their journeys, Sophia and Christina face new challenges and new opportunities. Their lives have been changed fundamentally. And, whether it is their communities or their immediate families, nothing will ever be the same.

Dozens upon dozens of such stories in the ensuing pages help us find American. We quickly realize that there is no one definition of American. There is only a future where we are always moving, always changing, always trying to make our lives—our family's lives—better.

Nothing could be more natural.

**Ali Noorani** is the author of *Crossing Borders: The Reconciliation of a Nation of Immigrants* and the former executive director of the National Immigration Forum.

# A Short Note

Thank you for being here and for caring about these stories, for taking time out of your day to reflect on the experiences of someone else. Before you see and hear from the participants, I want to clarify how they came to be in this book. It was important to me that every person included truly wanted to share their story and knew what they were getting into. Not once did I walk up to someone on the street and ask if they had a story to share. Most meetings were carefully planned, often months in advance, to make sure the participants were mentally and emotionally prepared to talk to me about their lives. Given the intensely collaborative nature of the project, I've tried to involve the participants as much as possible in crafting the stories you're about to read (some have been keen on this while others were harder to keep in touch with). Several of the most powerful and compelling stories I heard have been excluded at the request of participants. The guiding principle of this project is that every participant feels respected, appreciated, and centered. What is being shared here is on the participants' terms.

I want to address the language used in this book. When referring to a particular group that can be identified by many different names, I tried to use the words that a specific participant used for their story (Hispanic, Latine, Latinx, Latino, as examples). Much of the text is written in the third person but derives directly from interviews. In some cases, quotes have been lightly edited for brevity and clarity.

I spent a lot of sleepless nights trying to decide on the book's title—and yes I know it is grammatically a bit... strange. But it can't be Finding America, because I'm not on a voyage looking for a place, and Finding Americans wouldn't work either—not everyone in the book would want to be labeled American. I hope the title, *Finding American*, promotes reflection on what exactly this label, "American," means.

The book is arranged in sections I found relevant to immigration overall, loosely organized by major themes that came up again and again in conversations as I traversed the country. I have tried my best to include experiences that, together, tell a well-rounded story. Above all, I hope this book captures a picture of the United States' relationship to immigration in the twenty-first century—the good, the bad, and the in-between—and documents people's stories to be learned from and remembered.

# LEGACIES

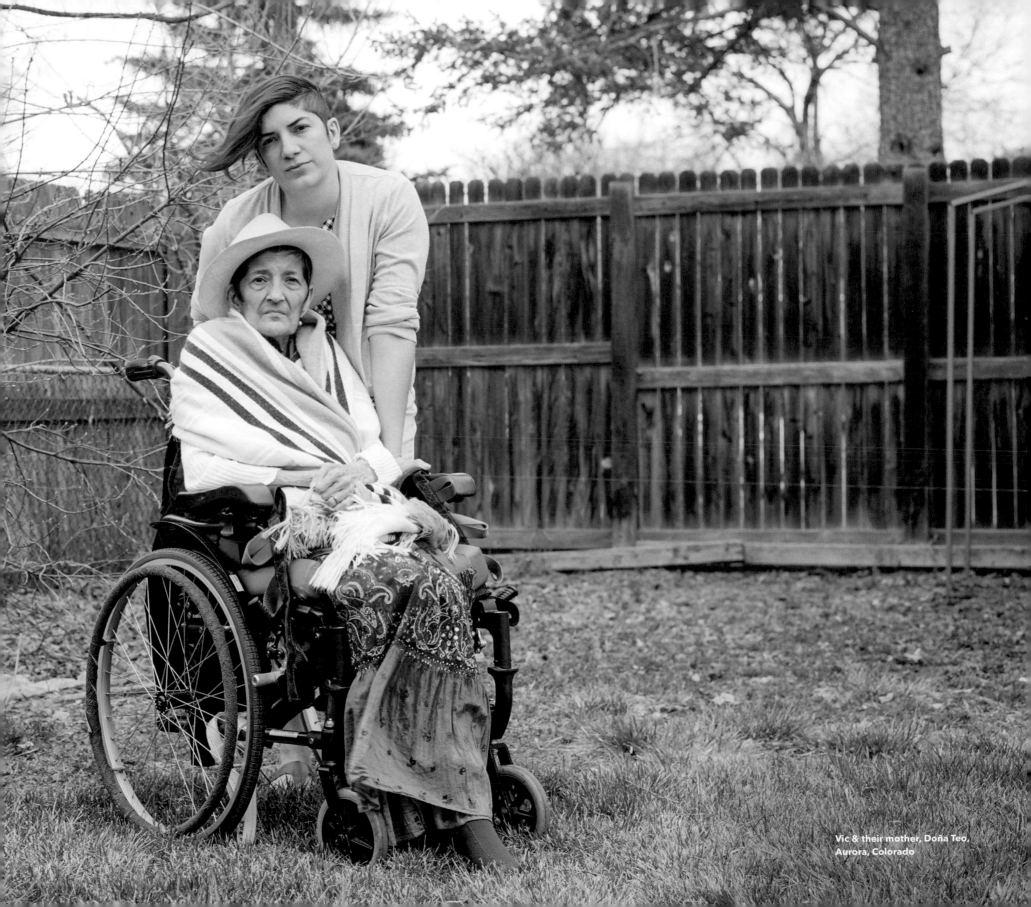

Vic & their mother, Doña Teo,
Aurora, Colorado

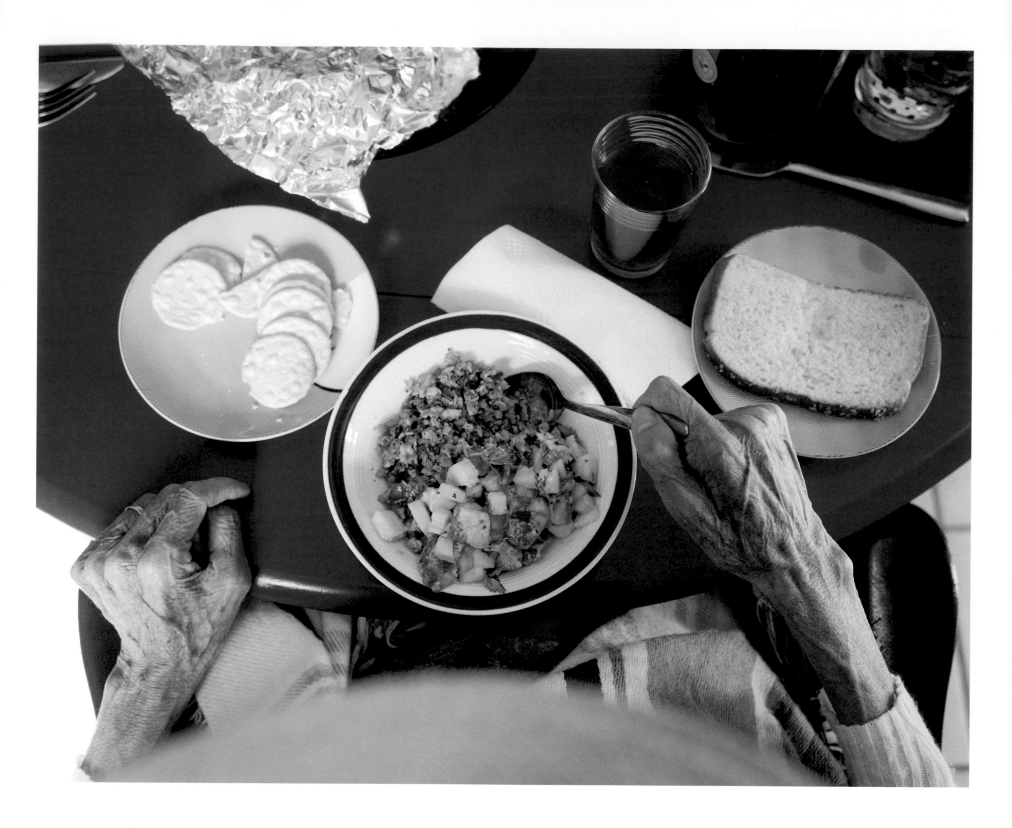

## Vic

Aurora, Colorado

"I got my social justice vein from Mom, who was always taking care of other people. On Sundays, we would wake up, bake muffins, then take them to a nursing home and spend the afternoon."

When Vic's father died in Venezuela, their mother, Doña Teo, was living with an advanced disability and Vic was in Colorado, unemployed and unhoused, having just left an abusive, violent marriage. Vic's half brother took over their father's estate, leaving Doña Teo destitute. "It became my life's mission to get back on my feet so I could get her into a better situation. I decided that I needed to care for her, and that's what I have done—against all odds."

Vic worked any job they could find—house cleaner, receptionist—and scrabbled together enough money to rent a room and send money back to Venezuela for Doña Teo. Attorneys said Doña Teo would likely not be granted a tourist visa since she had nothing to anchor her to Venezuela. Vic couldn't believe it when she actually got the visa in 2012.

Vic works full-time while also caring for Doña Teo, spends around $700 a month on their mother's care, and is dealing with their own health issues associated with disability. Their rent goes up every year as the area where they live gentrifies, but they hope to stay.

"Unfortunately, because of our migratory status, we are banned from services—we are not able to seek public assistance of any kind. My mother is uninsured because, by law, I cannot add her to my medical plan; she is neither my child nor my spouse. My only other option is to purchase private insurance, and that is not something I can afford. Luckily, her health is stable. I've looked for private help with nonprofits, but because of what I make—I'm not poor, by definition—I'm ineligible for private support. We are in this limbo."

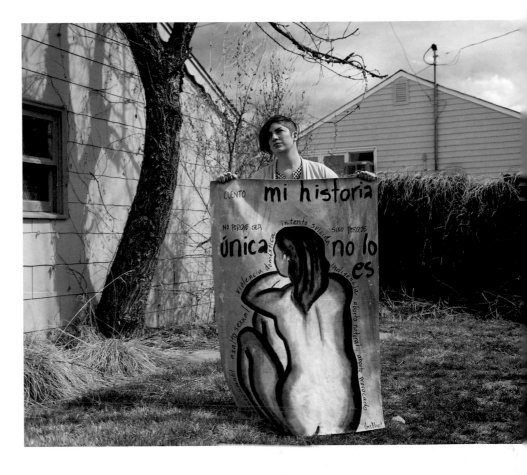

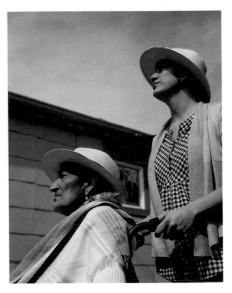

↑ "This piece symbolizes the luminosity within a person despite being surrounded by a darkness— child abuse, sexual assault, homelessness. The human essence can remain luminous in spite of the great challenges and struggles people can face."

→ Vic and Doña Teo are ineligible for eldercare support because of their status in the U.S. "I do a lot to care for my elder. I wake up at five o'clock every day because of all the things I need to do—cleaning, washing, diapering, dressing, meal prep—before work at nine. She has complex needs."

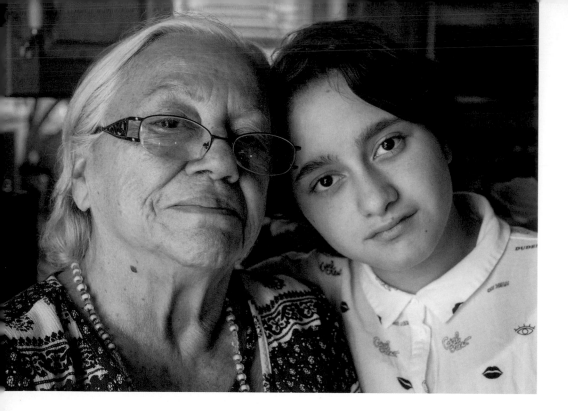

## Noah
Riverton, Utah

"My grandma is my best friend. She is always there to support me—always checking on me. I was out of the house for a week, and my grandma thought I had passed away! She made a shrine for me using stuff from my room."

"When my grandma, Abuelita Carmen, wasn't in a state of dementia, she used to tell me stories. She told me how she owned a hotel in Venezuela, and my mom (Raquel; see p. 285) worked there. I never thought that my grandma could do that. Even though she is struggling a lot these days, she is still smiling. Whenever I'm sad, she is sad with me. I know she cares about me a lot. She's my inspiration. She's not going to be here for much longer, so I want to make sure my grandma is happy and able to live every day like it is her last."

## Joanne
Columbus, Ohio

Joanne often thinks about her maternal grandmother, Sudha, who at age sixteen migrated from India for an arranged marriage. "My grandmother left her entire family to go to Malaya [now Malaysia] to be with a man she barely knew. I connect with her story now, as an immigrant myself, but I realize that she never had the same opportunities I have."

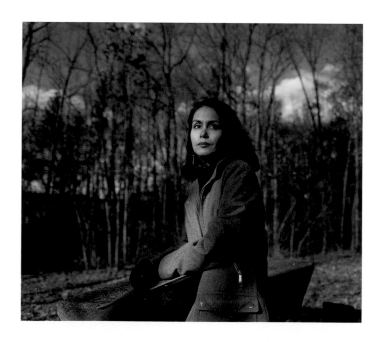

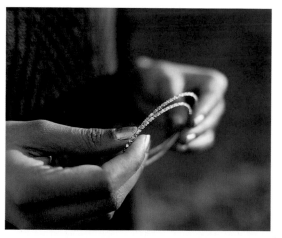

↑ In 2012, Sudha started giving her jewelry away to her grandchildren. "These bangles are a nice reminder of my grandmother. I hold on to them and hope that one day I can pass them on to my grandkids."

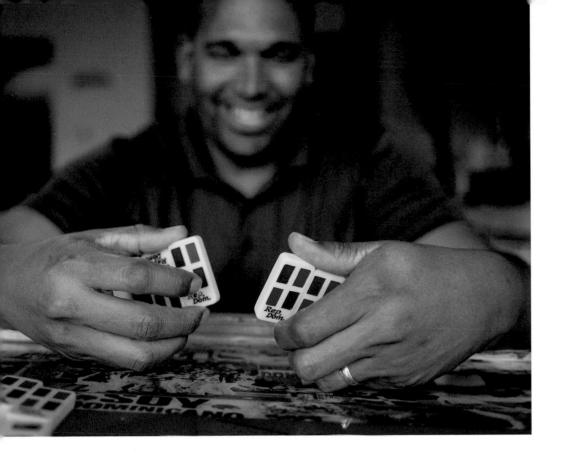

## Raul
Orlando, Florida

All the men in Raul's family play dominoes. Raul loves the game and says it is mostly about conversation with friends. He learned to play from his father, Luis, and now plays with a custom-made Dominican-themed board and "bones."

"My dad would go out at six in the afternoon and play until four or five in the morning. I remember one time when I was a kid, my dad was playing dominoes and he was so into the game that he didn't want to get up—so he gave me his cigarette and asked me to light it!"

## Dam
Seneca, South Carolina

Shortly after moving to Seneca, Dam, whose mom is Thu Ha (see p. 167), started volunteering at an assisted-living facility for seniors. "The residents remind me of my grandparents. I like helping the elderly. It's sad sometimes, how their kids leave them here, but that is why I come to cheer them up."

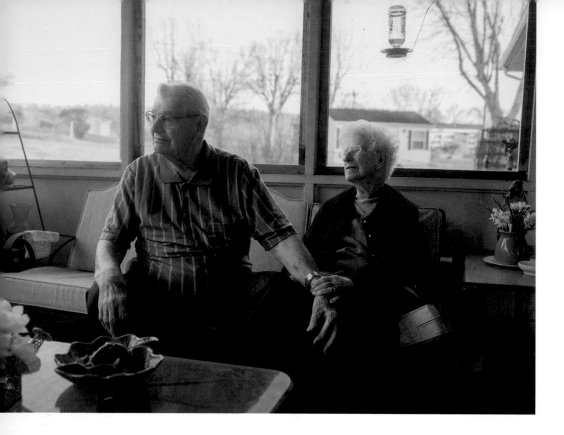

# Phil

## Knoxville, Tennessee

Phil's brother lived in the U.S. and wanted Phil to join him; he wrote letters describing how Americans decorate trees and put gifts under them. Phil (whose birth name was Feridun) read the letters over and over, dreaming of moving there also. Eventually, somehow, his mother was able to afford it. Phil arrived in Istanbul without a visa, not speaking a word of English. But he found an attorney who arranged a face-to-face meeting with Türkiye's minister of education, for a fee. A minute into the meeting, the minister practically threw the visa at Phil. Later, he learned that his attorney was the lover of someone high up in the Turkish government.

Phil boarded a Norwegian cargo boat with nine other passengers for the twenty-three-day trip. Almost seventy-five years later, he still remembers the sound of its horn, the melancholy of leaving Türkiye, and his horrible seasickness when the ship hit its first storm.

The ship stopped in Gibraltar on March 27, 1949. It was a beautiful day, with monkeys sunning themselves on the rocks, and Phil felt inspired to start his diary. Two ladies on the ship—"North Carolina tobacco people"—wrote messages in it, as well as the captain's wife, in both Norwegian and English. "I wrote back then with a pen that you dip in ink. I'm still writing in my diary today, although now I can hardly read what I am writing! In these pages, I opened my heart, love, life, whatever it was. I put everything in there."

Upon Phil's arrival in Virginia, his brother made him buy two suits and a twelve-volume record set called *Essential English*, then found him a job as janitor at a German restaurant. Phil worked eighty hours a week for a fifteen-dollar paycheck. "I decided to mail pictures to my mother to show her I had a job. My mother cried all week after finding out her son had gone all the way to America to be a janitor!"

Phil was dancing with friends at the YWCA when he spotted Lou. "I saw this girl, blondie, with one foot against the wall, and thought, 'Gosh, I am going to dance with her.'" Phil remembers Lou offering her number first, but Lou remembers vividly: "He wrote his phone number down on a napkin and gave it to me. I said, 'What can I do with this?' My mother would have killed me if I called boys!"

↑↑ Following Turkish custom, Phil asked his mother's permission before proposing. "Lou gave me a picture to mail to my mother in Türkiye. My mother wrote back: 'She is beautiful and wonderful, and your life is yours. I wish I could be there for the wedding.'" Lou's family welcomed Phil too. "No one ever spoke of him as a foreigner. Everyone in my family loved him. Why not? He was so appealing, polite, gracious, and kind. My mother and father loved him so dearly and always spoke about him like a son."

↖ Phil touches the diary that he started on the voyage from Istanbul to Newport News, Virginia, in 1949.

↑ Phil holds a photograph of himself working as janitor.

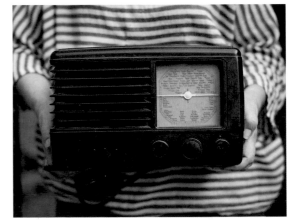

## Mira

Essex, Vermont

During World War II, Mira's father used this radio to illegally listen to the anti-Nazi programming of Radio Moscow. Later, Mira used the same receiver to listen to Radio Luxembourg in her parents' kitchen. The station played all the Western music that wasn't allowed in Bulgaria during communism.

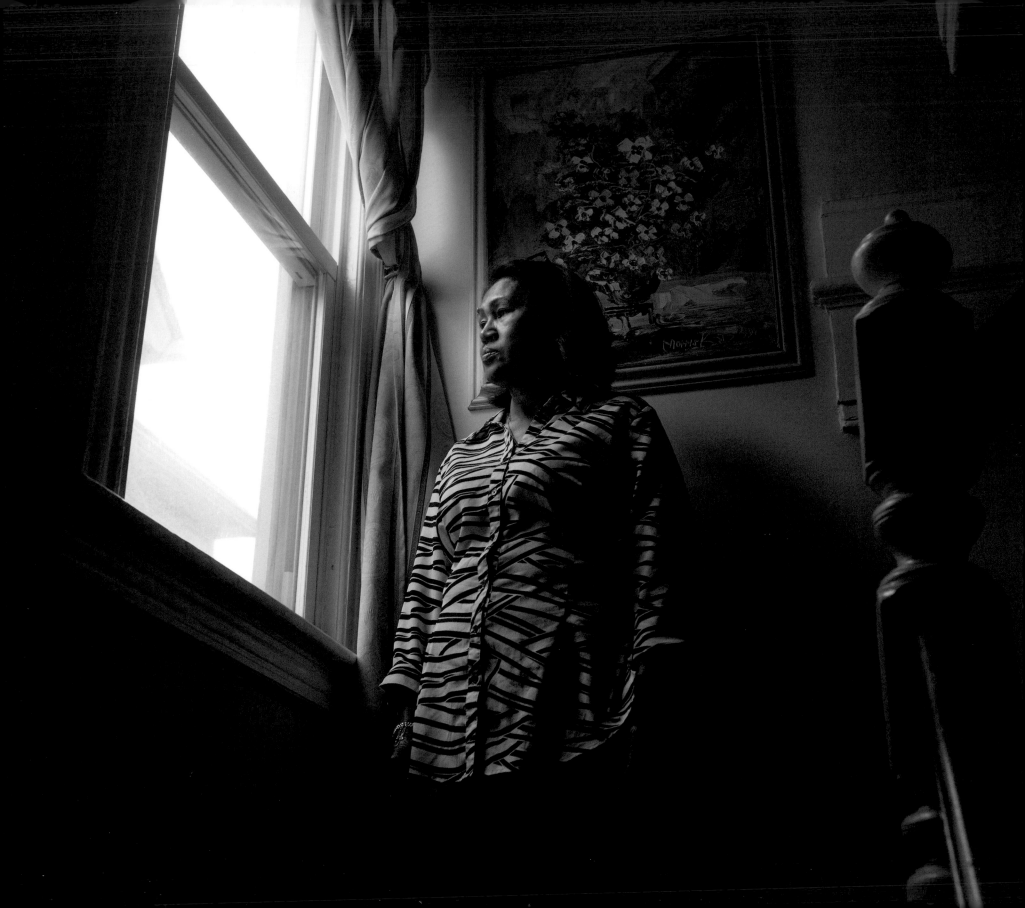

## Sally
Woodbridge, New Jersey

The Khmer Rouge killed as many as two million people during the Cambodian genocide, including Sally's uncle, twenty-five of her cousins, her best friend, and her grandmother. Sally was a teenager when the military tore her from her family in 1975 and sent her to a concentration camp for girls. Five years later, she was able to flee to Thailand with her parents and four younger siblings. The family lived in six different refugee camps in Thailand and the Philippines before moving to the U.S. in 1982. They had no money, but they did have jewelry, much of it family heirlooms, which they sold to survive in the camps. They brought with them the one piece of jewelry they would never sell: Sally's great-grandmother's blue-purple sapphire ring from the village of Bah Hoi, Cambodia (see below).

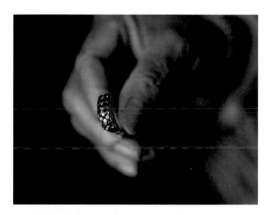

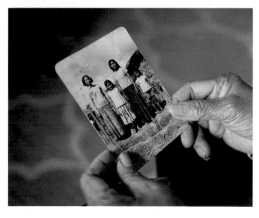

↑ One day, a man with a camera visited their refugee camp, and Sally's aunt paid him to take a picture (*from left to right*) of her, her daughter, Sally, and Sally's little sister.

## Tano
Liberal, Kansas

Tano, who works in the swine industry, started playing defensive end at age seventeen. He knew his father, Estanislao Sr., wouldn't approve, fearing it would interfere with his studies, so for the first two years, Tano didn't tell him. If his father asked where a bruise came from, Tano would say it was from one of the cows. Estanislao Sr. learned of his son's athletic pursuits when a local radio station interviewed Tano about his rookie-of-the-year award. Tano will never forget the first game his father came to watch and how he tried to play his best. After the game, his dad told him, "If all of these players had a real job, Mexico would be different." Still, Tano learned recently that after a sports magazine featured him, his father carried the article around and showed it to everybody. It meant a lot to Tano to know that his father was proud of him, even if he hid it. "My dad was everything. He was my role model. He always showed me the right thing."

# Nusrat
## Silver Spring, Maryland

Nusrat's first trip to the U.S. was to give birth to her daughter, Yvonne. "It was December 26, 1976—snow was everywhere and it was beautiful. The airplane landed at Ronald Reagan Airport, and I was anxious to meet my mother-in-law. As soon as she saw me, she said, 'She's colored. Send her back!' From that point on, it was an odd situation."

Nusrat endured emotional and physical violence from her in-laws as well as her husband. Yvonne remembers: "It wasn't easy for my mom being an immigrant here and navigating the court system. My father would beat up my mother, the police would come, but they would apologize to my father, saying, 'I'm sorry for bothering you.' She was the one who called them, and they could even see the bruises on her face! That's why she turned to religion for support. It was very hard to be a child and watch my mother done very wrong by my father, while trying to navigate a system that was not made for her. It was created for her to fail."

Yvonne understands the sacrifices her mother made and wonders if her mother would have been happier in Iran than she was in the U.S. "What does the American dream mean to me and my mother? People come for a better life. Is it unpatriotic if you come here and you don't have a better life—if your life is shittier? Does that mean you are ungrateful? I hope that before she leaves the earth, she does feel that coming here for me was worth it."

After her divorce, Nusrat spent more time with Muslim women in her community. For two decades, she hosted a Qur'anic study circle in her home, where they prayed and fellowshipped over her much-sought-after Persian cuisine. When Muslims from around Maryland began asking her to perform marriage and funeral services, she learned the ceremonies from the books of her grandfather, who was a religious leader in Iran. Though it wasn't her intention, she became a pillar of the Islamic community in Maryland.

Yvonne says that Nusrat essentially acted as an imam, though she never called herself that nor sought to lead Friday prayers. "My mother never wanted to be in that role. She has laid very low. I think her story is compelling and there is a lot to learn from it in this day and age—politically and culturally. It can open up a lot of people's eyes about women in Islam. My mother would not be able to be an imam in Iran. That happened here in this country, and that's pretty cool."

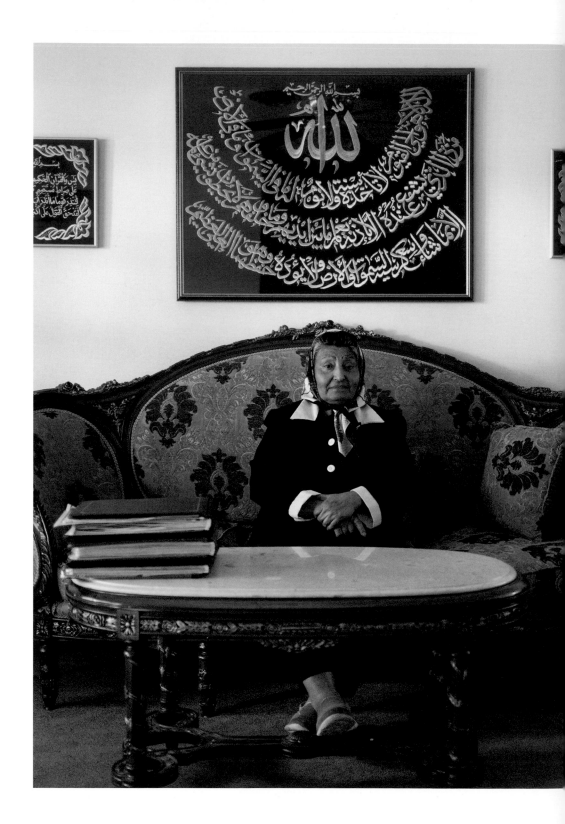

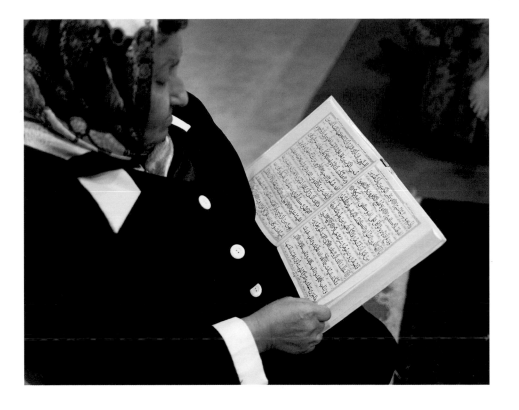

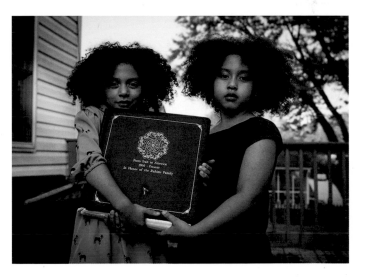

↑ At the first wedding Nusrat conducted, the bride's father was Muslim and her mother was Catholic. After the Catholic ceremony, Nusrat performed the "nikah" (contract) in the church. "I read this Ayah when I say verses of the Qur'an for marriage: 'God created man and woman and put mercy and love between their hearts.'"

↗ Yvonne, Nusrat's daughter, often reflects on the difficult life her mother lived. "My mom didn't have dreams or aspirations to come to America. She left what she knew to face beatings and discrimination."

→ Nusrat hopes the wisdom she gained and shared from Islam will help her grandchildren, Samira (*left*) and Layla, thrive in twenty-first-century America.

# Ernie
## Scottsdale, Arizona

In second grade, along with other Jewish children, Ernie was thrown out of school. His mother, Hedwig, and the other mothers organized an informal school. Ernie remembers boys from the Hitler Youth waiting outside the Jewish school to throw stones at them as they exited. "We gave as good as we got—they beat us up, we beat them up. Once, we captured one of the Hitler Youth and took him home. This poor kid was terrified because he was missing a Hitler Youth meeting." Despite the conflict, Ernie also remembers feeling envious of the Hugo Boss-designed ensemble the Nazi children wore. "They had such nice uniforms, and I would have liked to wear nice uniforms too."

Ernie's father, Fritz, worked as an investment banker and advisor. When Hitler came to power in 1933, Hedwig told her husband they should leave. Fritz said no—he knew only one thing, German investments, and only one language, German. Four years later, Fritz was in Berlin on business. A non-Jewish colleague asked Fritz to go for a walk and warned him of what was coming. "If this conversation is overheard, we are both dead men. Go home, get your family, and get the hell out of Germany." A brother of Fritz's maternal grandmother had immigrated to San Francisco a few years earlier and established a successful business: Simon Mattress Factory. He sent Fritz's family "life-saving documents": visas.

"We left on a luxury train. We did not leave on a one-way cattle car to Auschwitz. My kids and grandkids can never forget how lucky we were."

Fritz regretted waiting so long to leave. Because of his good reputation in Karlsruhe, many other Jewish people decided to stay longer too. "If the Simons are here, what's the hurry?" He believed that many others perished because of his choice, and he blamed himself for the rest of his life. After arriving in the U.S., Fritz tried to round up as many visas as he could to mail back to other Jews in Karlsruhe who hadn't left or been sent to concentration camps. Sadly, most of the visas came back marked "return to sender," including those sent to Ernie's grandparents.

Ernie's family arrived in San Francisco in 1938, when Ernie was nine. His first week of school in the U.S. went well. "There was a spelling bee with twenty-four words, and I got ten of them right. The teacher called me up to the front of the class and put a gold star on my paper. I will

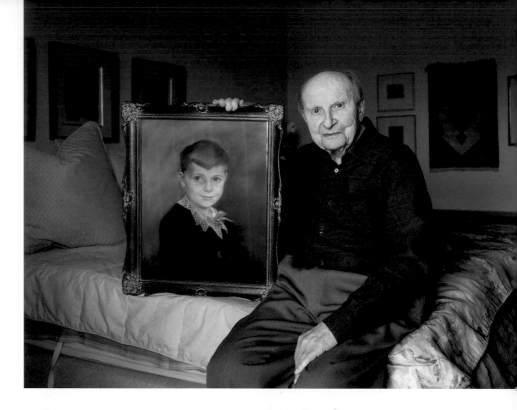

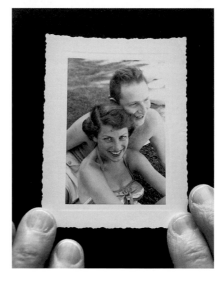

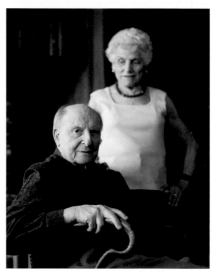

↑↑ Ernie remembers his mother, Hedwig, taking him to the painter's house near the castle and sitting there for a few hours every day, over many weeks.

↖ Ernie holds a photo from the summer he met Eve. Friends set Ernie up on a blind date with Eve in 1949, and their "summer romance" began. Eve had also left Germany in the lead-up to World War II, aided by an uncle in the U.S. who helped her family resettle in Chicago.

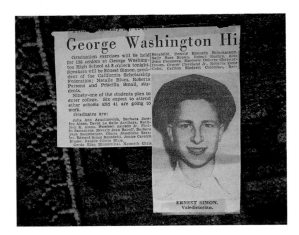

Ernie went on to graduate from Harvard medical school and became a noted hematologist and medical ethicist.

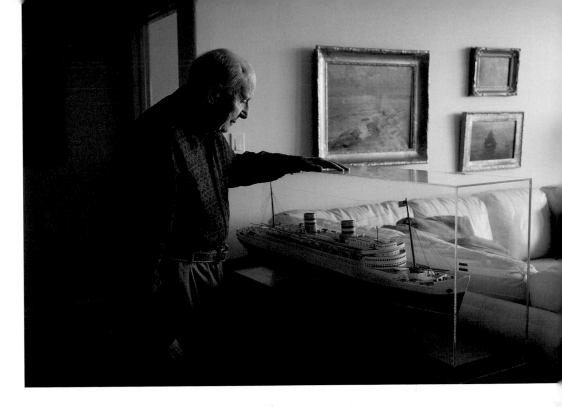

never forget that moment." At Christmas time, the teacher asked Ernie to sing the class a German carol. He stood up to sing "O Tannenbaum" and realized he had forgotten the words. "I had become so Americanized in two months."

Ernie is dismayed by the anti-immigrant sentiments that seem to be growing in popularity. He believes welcoming newcomers to America is not only moral but, in the context of declining birth rates and an aging population, makes economic sense.

Ernie is a retired hematologist. In science, he says, there is progression, and scientists learn from one another—but this doesn't seem to happen in the social sphere. "We haven't learned. We had the Holocaust, and Eisenhower took the photographs of the camps in the hope that the world will never forget. And look what happened: we have had Rwanda and other genocides since. We even have Holocaust deniers!"

After Ernie recounts the verses of "Der gute Kamerad" ("The Good Comrade," the German equivalent of "Taps," played at military funerals), he lingers on the last line, which describes a soldier watching his friend die on the battlefield: "He wants to reach out his hand to me, / for the last time while I am loading. / I cannot give you my hand / Stay in eternal life, my good comrade." The soldier withholding comfort from his dying friend so he can shoot another man's friend is "insanity," says Ernie, and reflective of our current world. "Regretfully, it doesn't surprise me that we continue to have holocausts. It saddens me. We have enough natural disasters, hurricanes, floods, fires—why do we need to add to them and put so many people in harm's way?"

↑ Getting old hasn't been easy for Ernie. He has a few health issues, including asymptomatic metastatic prostate cancer, and he misses his independence—though he tries not to restrict Eve's activities, which include water aerobics, biking, and skiing. "The things I used to do without thinking about, she does for me. I don't like that. The great likelihood is that I die first, but that is not certain. If she died first, I would be in trouble."

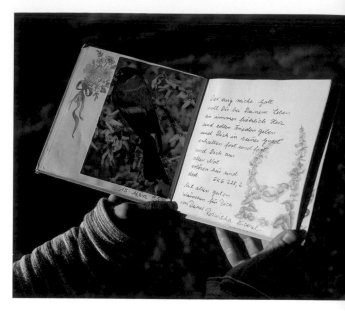

← Belma poses with her mother, Emira.

↑ "This was written in my diary by my third-grade teacher, Roswitha Stroetzel. She accepted me for who I was—a refugee student and a language learner. She helped me learn German after class and helped me integrate into the classroom."

# Belma
Boise, Idaho

Belma describes her childhood before the war as idyllic. Her parents had great jobs, a car, a nice apartment. When she was eight, she started hearing air-raid warnings on the radio and then came the sirens. Soon she wasn't allowed to play outside or go to school. Still, she didn't understand why they had to leave everything she knew, especially her grandmother, Selima. The family left Bosnia in 1993, leaving on Orthodox Christian Christmas in the hope of fewer checkpoints, and made their way to Germany. Seven years later, her uncle sponsored the family and helped them move to Idaho. Today, as a professor, Belma prepares teachers to create more inclusive and welcoming classrooms, and advocates for refugee students to pursue higher education.

"I don't remember everything. I think it has to do with the trauma. I've repressed some of the memories—not voluntarily, obviously, because I wish I could remember some of the beautiful things."

# Monica

Naperville, Illinois

"When I was born, my biological father, Mario, had just opened one of the most famous and popular nightclubs in São Paulo at the time—Telecoteco. Every time my family went on vacation, he stayed behind. He promised that he would meet us there and then never showed up. My mom never said to me that he was coming—she was protecting me from disappointment—but later in life she shared how sad and disappointed she always was. This photo captures the one time that my father actually met us on vacation."

Mario began an affair with a woman he met at the club, soon buying her an apartment and spending some nights with her instead of with the family. When Monica's mom found out, she was devastated, and they soon divorced. Monica's mom went to Chicago to study while Monica, age six, stayed in Brazil with her grandparents.

"I didn't see my father from the age of four or five until I was twelve. He remarried and had just had a little girl—my half sister. All in Brazil. He called my mom, asking if he could share the news with me about my sister, and that's when I reconnected with him. Mario passed away a few years ago. We had a nice relationship, and I was able to say goodbye."

Monica's mom started a new family in the U.S. and returned for her two years later, but Monica didn't want to leave her grandparents. She remembers her first day of school in Chicago, a cold, snowy January day in 1978. She couldn't speak more than a couple of words in English. "There was no such thing as English as a second language back then. Luckily, my dear principal, Mrs. Hurley, would take me into her office every day and do flashcards with me for one hour. After my fourth day of school, I brought home a friend—Jennifer! I have no clue how we communicated, but I remember that we played." After five months, Monica was fluent and her accent had disappeared. "No one would ever know that I'm from Brazil unless I tell them or they hear me talking to my mom."

↗ Monica shows a photo of one of the few times her father joined the family on vacation. "My mom was probably happy that he actually showed up—it captures a beautiful moment within a tumultuous time. It shows a lot of tenderness and love—something I had forgotten or didn't even remember."

→ Monica holds a painting that used to hang in her grandparents' home in São Paulo. "I loved being around my grandma, so naturally I imagine this painting is of her and me."

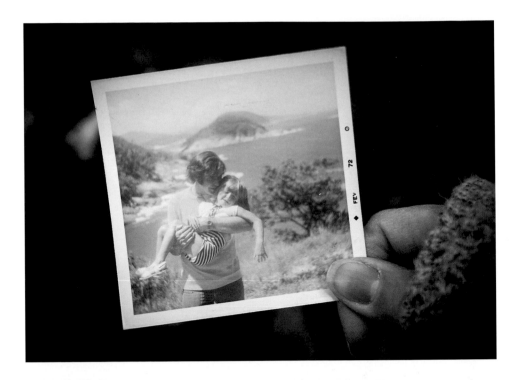

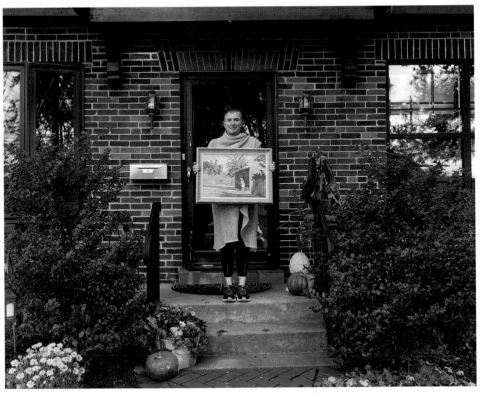

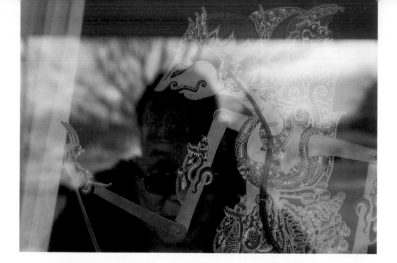

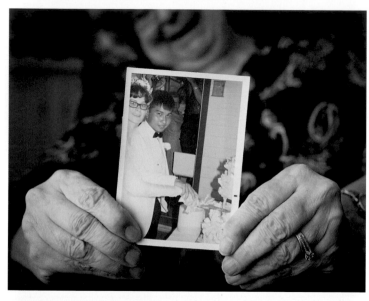

# Paul
## South Bend, Indiana

Go Tjong Hie was born in 1945, the first year of the Indonesian National Revolution. Education was very important to his parents. To get into the top school in Jakarta, he needed to be Catholic, but they were not a religious family. "Dad and Mom's idea was for me to say I am Catholic. I needed a name though—a Christian name—and we decided on Paul. I went to church, took communion, and even became an altar boy. I didn't understand it—I just thought it was like a club."

In his sophomore year of high school, Paul was told he should be confirmed, for which he needed a baptismal certificate. On his mom's advice, he claimed it was burned in the church during the revolution, and so he received the sacrament. "I got confirmed before I got baptized!"

Paul moved to Chicago from Indonesia to study at DePaul University. In 1968, he started a PhD in physics at Notre Dame, which he chose largely because he liked their football team. Before he left for Indiana, he received a letter from Doris Ward of the Christian Family Movement offering housing and help in learning about American customs. 'I already have a place to live and I know American customs,' Paul thought. 'What else do I need?' "Then it dawned on me … maybe they have a daughter? That was my honest motivation to say yes to that letter."

Doris's daughter, Peggy, met Paul at the bus station. She remembers immediately finding him cocky, but cute. Six months later, when Peggy was home from school, Doris invited Paul for dinner, after which he asked Peggy to go see the movie *Camelot* with him. Three weeks after they started dating, Paul asked Peggy to marry him. She laughed, so he dropped it, but the next day, Peggy mentioned the proposal and said, "The answer is yes." They married in 1969 and went on to have eight children.

↑ Paul holds a shadow puppet depicting Arjuna from the Hindu epic *The Mahabharata*, frequently performed in the Javanese wayang kulit theater tradition.

↖ Paul and Peggy married in 1969. "Biracial marriages are common now, but back then they were quite uncommon."

← Paul has long volunteered with the soup kitchen at First Methodist Church. Mary, one of the organizers, says that "He loves to talk. Paul talks all the time, which is a good thing down here because people need someone to talk to. He will find people who are isolated and seek them out. People need volunteers like Paul."

## Jum
Charlottesville, Virginia

A tradition among the Lanna people of Northern Thailand is to throw coins wrapped in ribbon along the route of a funeral procession, so the soul of the departed can pay entry into the afterlife. Jum kept this coin as a memory of her grandmother and buried it in Virginia "to let her, and the memory of her death, go."

## Jo
Eugene, Oregon

While Jo was taking online courses to become an ordained minister and certified medium, they started hearing "spirit rapping," the sound of knocking, all around the room. They felt their grandpa Eli, a minister who founded a church, and their uncle Jean-Ma, an elder in that church, encouraging them on this path.

"A huge part of developing your intuitive gifts is trusting yourself so you can begin listening to your intuition. It's relatively easy to communicate with family since we already have some kind of connection in terms of our frequency—our energy."

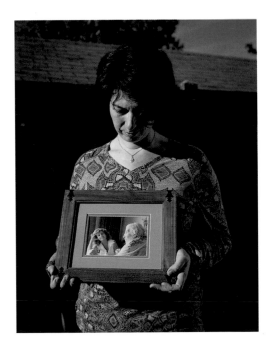

← Jo took this candid photo of their mom and grandmother at their grandmother's home in Pau, France. "My mom is in spirit, and I know that she is around. I get signs from her at various times."

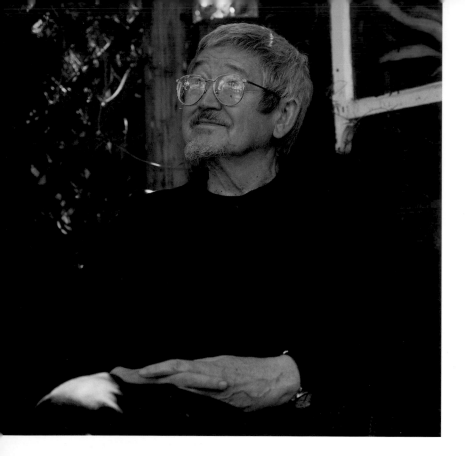

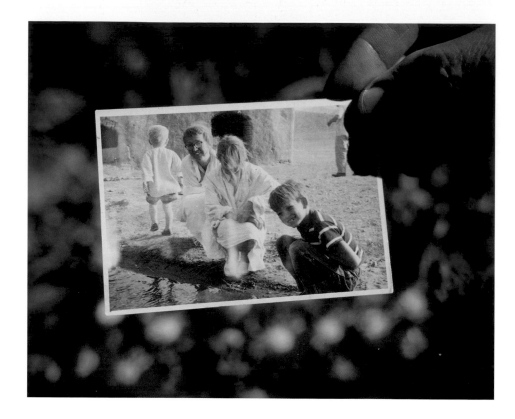

# Tamim

San Francisco, California

In 1939, Tamim's father, Amanuddin, was sent to the U.S. with explicit instructions: "Do not mess around with the women over there." Six years into his American education, Amanuddin decided to marry his American girlfriend. In retaliation, his parents had his scholarship cancelled and requested that he return immediately. Terttu, his fiancée, shocked his family by returning with him. She stayed in Afghanistan for more than two decades and raised three children, including Tamim. She is believed to be one of the first American women to marry an Afghan man and live in Afghanistan.

Tamim's Afghan family, the Ansarys, take great pride in the art of storytelling—the roots of his career as a writer. "Some relatives were famously good storytellers—famous within our village. We clustered around the grown-ups who knew how to tell stories. One of them was my grandmother—she was a wonderful storyteller. I remember her stories in a dreamlike way."

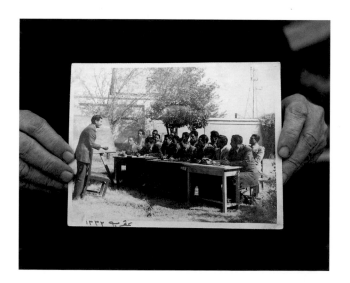

↑ Tamim holds a photo of his mother with him (*far right*) and his siblings during a dust storm on a journey to Herat.

← Tamim with a photo of his father teaching a class at Kabul University.

## Cindy

Albuquerque, New Mexico

Cindy has always been a "preguntona." Her late grandmother, Yaya, an avid reader and self-taught intellectual whose formal education ended at third grade, constantly encouraged Cindy to read and learn. "You would have thought Yaya had a PhD. That's where my education began."

Yaya was untraditional, even "weird," judged by the norms of her generation. She told Cindy stories of hiding from her childhood chores to read books, and instead of marriage or kids, her dream was to become a nun and go to college. Yaya ended up working as a maid her entire life. Her earnings went toward the college education of her younger sister, who became a professor. Yaya's life reinforced for Cindy the importance of education, a value she devotedly passed on to her granddaughter.

When Cindy was seven and they crossed the border into El Paso, her parents assured her they were going "somewhere that would be so much better." In New Mexico, her father worked in construction during the day and at night helped her mother clean houses, banks, offices, and libraries—with the kids in tow. "There was this library they would clean, and my parents let us sit and read books. I always dreamed of studying."

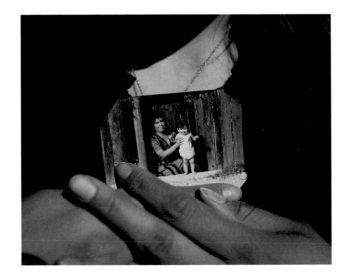

↑ Cindy's grandmother, Yaya, never fulfilled her own dream of a higher education, but she instilled a deep passion for learning in Cindy, who received her master's in educational leadership and policy at University of New Mexico.

→ Cindy hugs a photo of herself with her grandmother. "This woman became my second mother. All my best memories from Mexico are in relation to her."

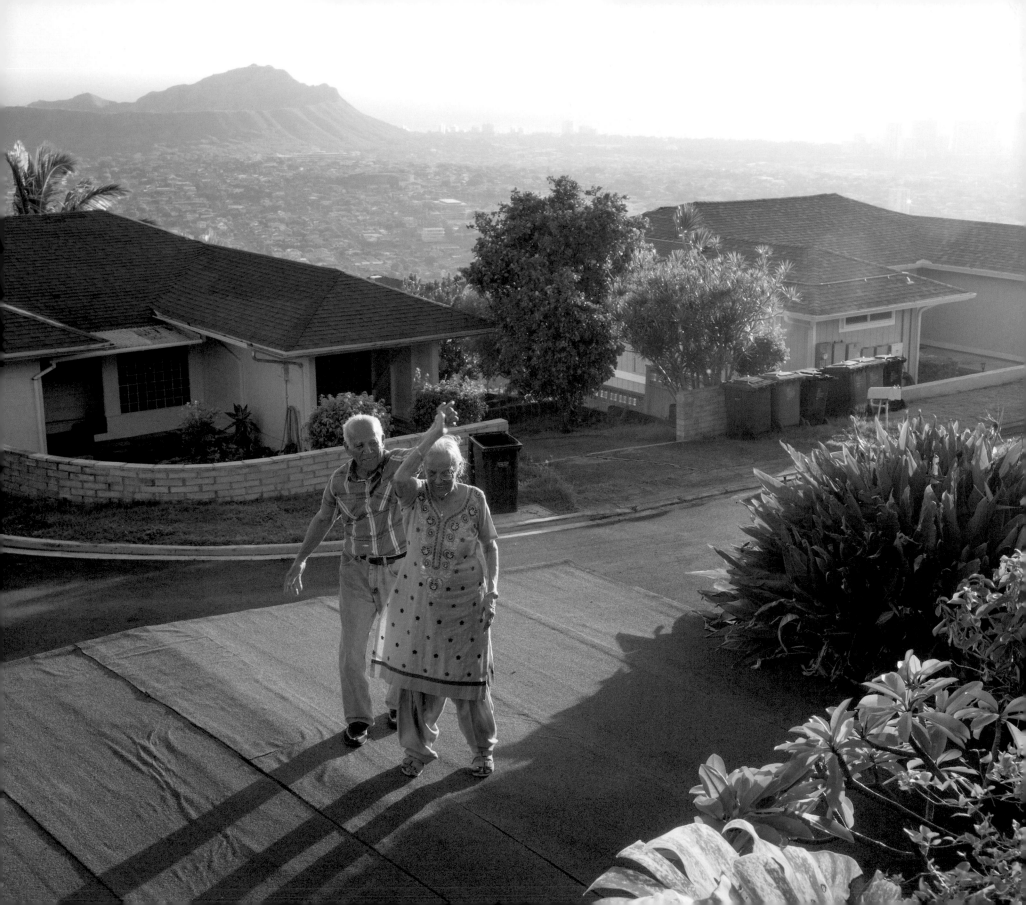

# Manjit
Honolulu, Hawai'i

In Tanzania, Manjit was attending university to study education when she met Ronald, who was there with Teach for Africa. Manjit couldn't help but notice this loud, gregarious storyteller who ate his lunches in the women's dormitory. He offered her tennis lessons and she accepted. He was so much more relaxed than the conservative guy she was dating. When Ronald returned to America, they wrote to each other and their feelings soon became clear.

Manjit's parents liked Ronald but weren't happy about her plans to marry him. "Finally, my parents said, 'Okay, you can do it but get married when we are not in town.' I was doing something completely unheard of at the time. We wanted to get married in the Sikh temple, but the priest there would not marry us. I was determined to get married in a holy place, so I said, 'Okay, I guess we will get married in a church.'"

The third priest they asked said he would marry them if they promised to raise their children Catholic. In 1968, they wed by the seashore in a big cathedral.

After learning how to tap dance at the local community center, Manjit and Ronald joined a dance troupe that travels the island, performing shows at care facilities. "People wake up when they hear a song from their era," says Ronald. "We dance with people in wheelchairs, and what many of these people need is to be touched. I was surprised when Manjit said she would join. She doesn't know any of the music we dance to, because she didn't grow up here."

When their daughter, Desha, was six months old, Manjit traveled with her to Baltimore while Ronald had to stay back for work. Manjit had never met Ronald's family or been to the U.S. before. "When our car pulled up, we received the most pleasant welcome I've ever had. They were happy, and they hugged me. My father-in-law said, 'Today is my Christmas, my Easter, my Thanksgiving—my son's wife is here with our granddaughter!' That was my introduction to America."

Manjit and Ronald moved to Hawai'i in 1969 for him to attend medical school. Right away, Manjit felt a sense of spirituality in Hawai'i, despite the absence of a Sikh community. One day, she answered a call that changed her path. A Sikh student had died on the island and none of his family could be present, so they were looking for someone to do the cremation services. Manjit had never done this but she knew what was required. As more Sikhs arrived in Hawai'i, they began gathering for prayers, but that ritual was paused after Manjit and Ronald moved to the mainland with their kids. When they returned to the islands after twenty-five years away, Manjit began hosting kirtan every second Sunday at her house.

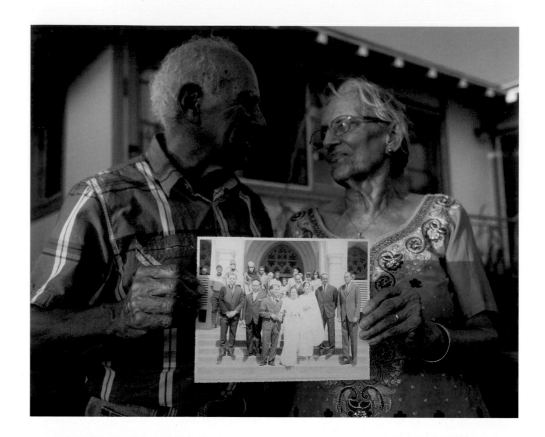

"I have a feeling that after I go, the kirtan services will not happen, and that makes me sad… I am also concerned about Ron since I do all the cooking. If there is no food prepared, he will just eat chocolate and ice cream—not even fruit! What is going to happen to him after I'm gone? I worry about that."

→ Manjit grew up in a family of seven living in a gurdwara compound in Dar es Salaam. "The gurdwara and its care were an integral part of our daily life. We learned about and lived Sikhi, which gave us a contented way of life." Manjit's father, Bhaghat Singh, was a laborer and priest. Her mother, Nand Kaur, taught Punjabi classes.

→→ Manjit plays the harmonium she uses for kirtan. She and her husband built an addition onto their house so they could host the devotional singing services, which usually attract a few dozen people, including many non-Sikhs.

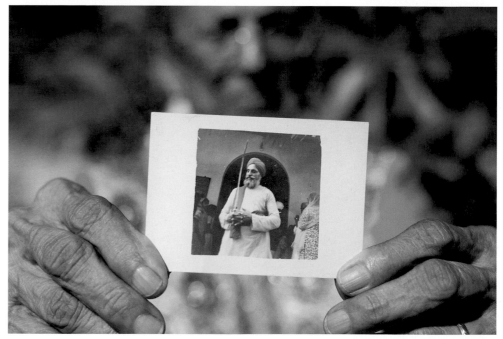

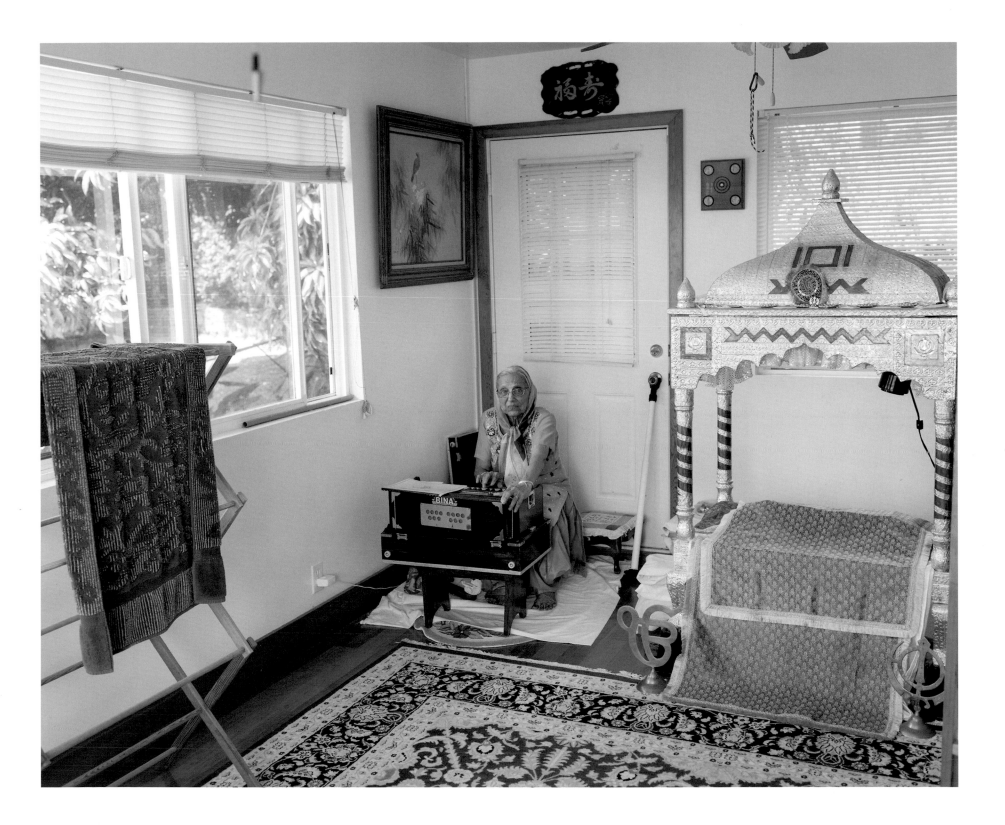

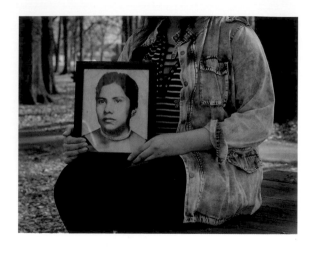

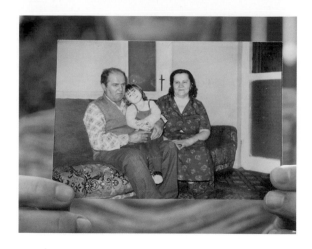

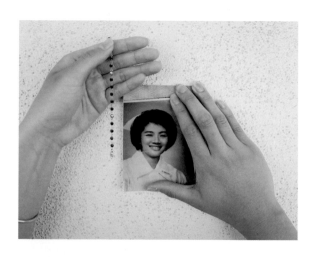

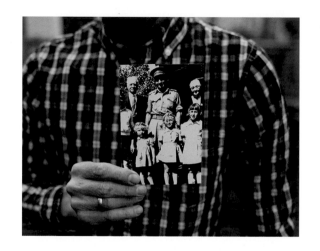

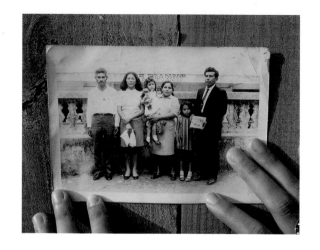

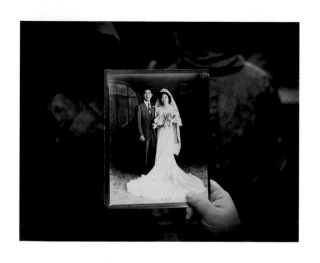

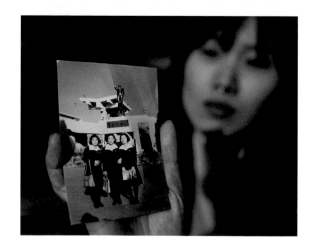

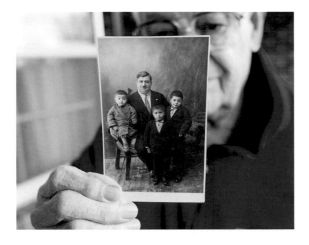

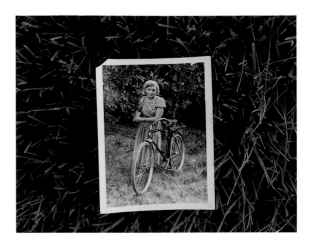

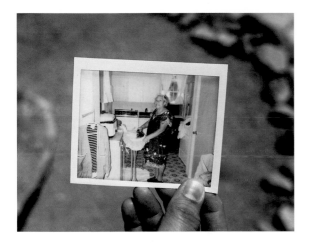

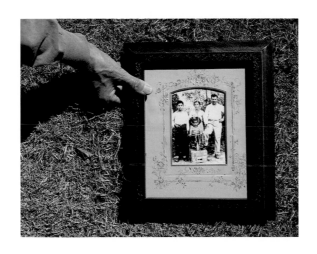

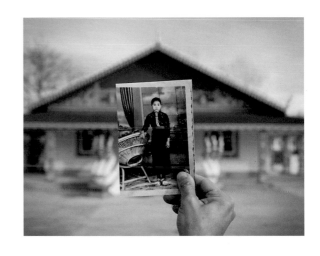

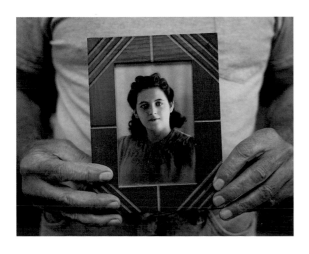

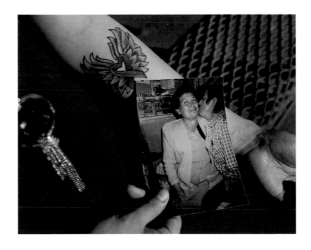

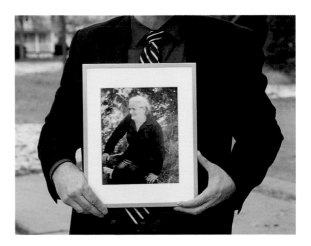

# JOURNEYS

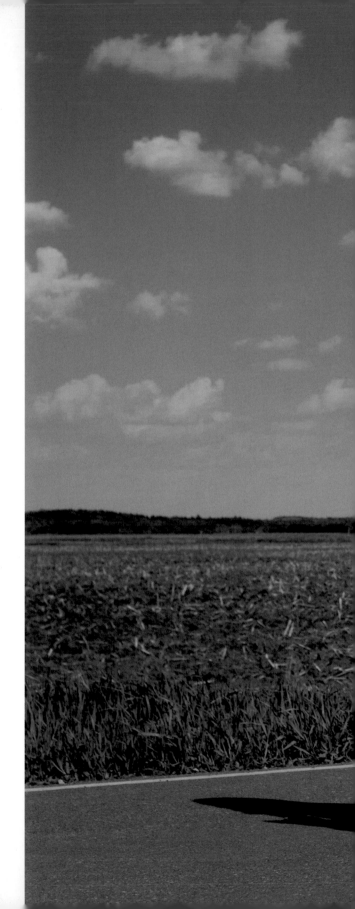

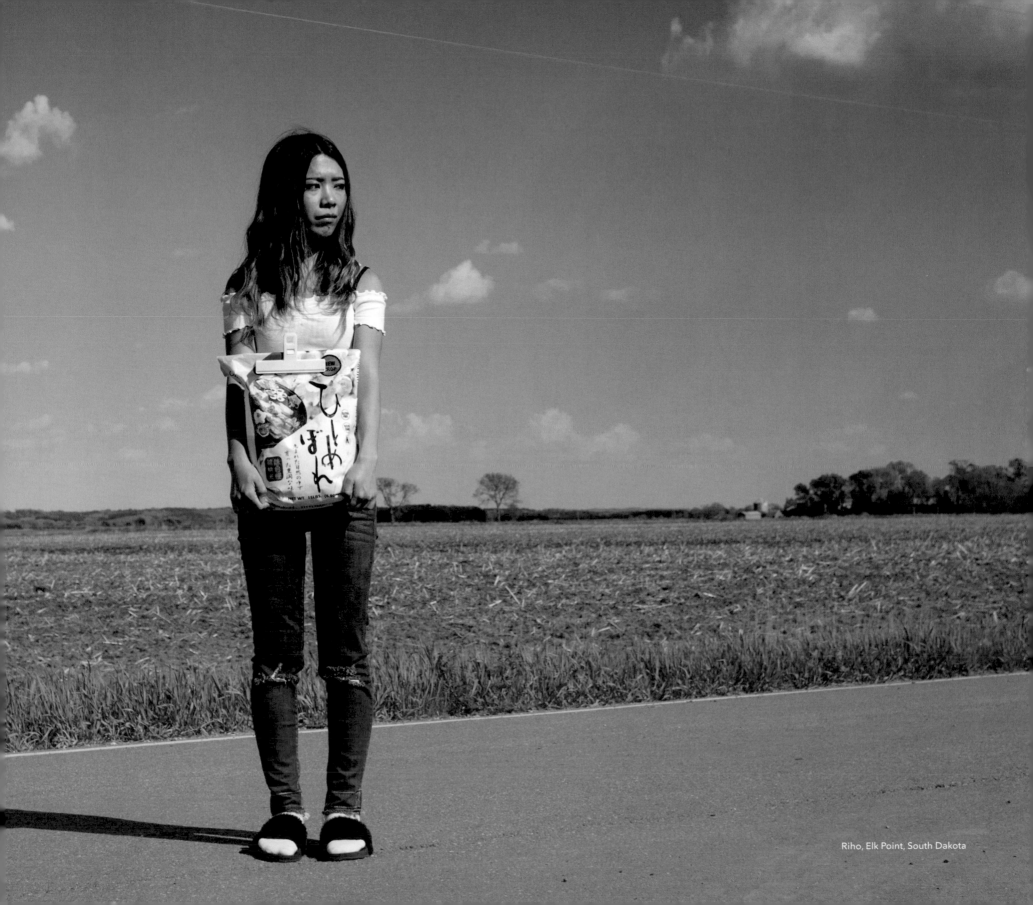

Riho, Elk Point, South Dakota

## Riho

Elk Point, South Dakota

In 2017, Riho went to Hawai'i to study English and wasn't expecting to find her future husband. Riho met Steven online while looking for someone to practice her English with. He had been stationed in Hawai'i with the Marines and was back for a vacation. They hit it off, and Riho moved to rural South Dakota to live with Steven on his farm and to continue studying English. He warned her about the cold, but when she arrived on Christmas Day in 2017, it was still a shock.

"The first week we just spent inside. I missed Japanese food so much. Steven only has pizza, chicken, and all this other super-American food. I need rice! We worked out how to get Japanese food online. Now almost every day I cook Japanese food for him."

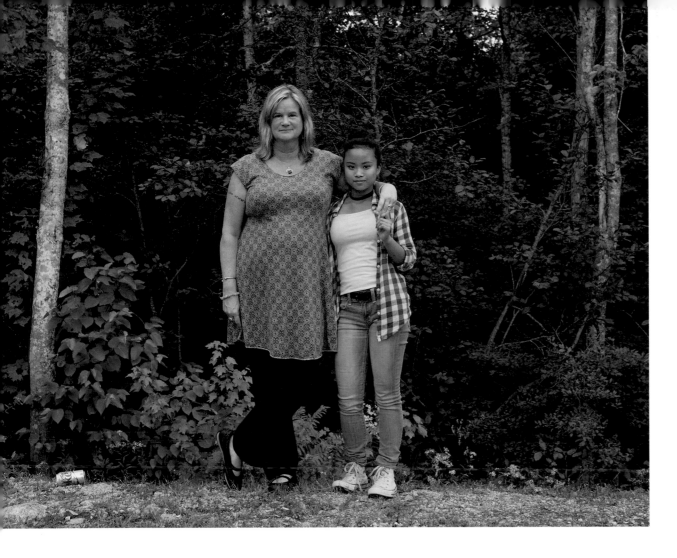

"The day that made her most afraid was the day that made me most happy."

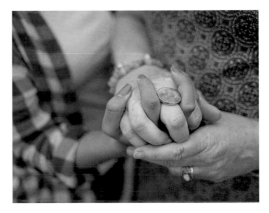

Yasumin remembers the social worker's van pulling up and tall white strangers climbing out.

# Yasumin

Blue Hill, Maine

Kat moved to Thailand in her twenties to work with the Peace Corps. In the small village where she lived, she saw kids she felt she could help. "I decided at some point I was going to adopt a Thai daughter. I set it as a goal. There were times when I thought it was never going to happen. But I knew there was somebody who was waiting for me." Kat waited almost a decade for the adoption agency to call. In 2011, she was teaching in Bangkok when her phone rang. Yasumin, an eight-year-old girl, had been placed with the agency for adoption.

Kat remembers seeing Yasumin hiding behind her foster mother. She handed her a bag of goldfish crackers and spoke in her best Thai: "Hi, my name is Kat. Don't be afraid, because you are very brave." The next morning, Kat returned to pick up Yasumin, who cried the entire drive to Bangkok. They lived there for two years before moving to Maine.

"Adopting Yasumin was a deal I made with the divine. I would have done whatever it took to find this person. I knew she was in Thailand. I had to fight for it and figure it out. It was like being given the gift you were looking for but, at the same time, she was so traumatized and scared—and rightfully so. She had to change her environment and take this huge leap of faith. God knows who the person putting her in that van could have been, and she just had to go with me. It wasn't until much later—until she found the English words to express it—that she told me how it was the scariest day of her life."

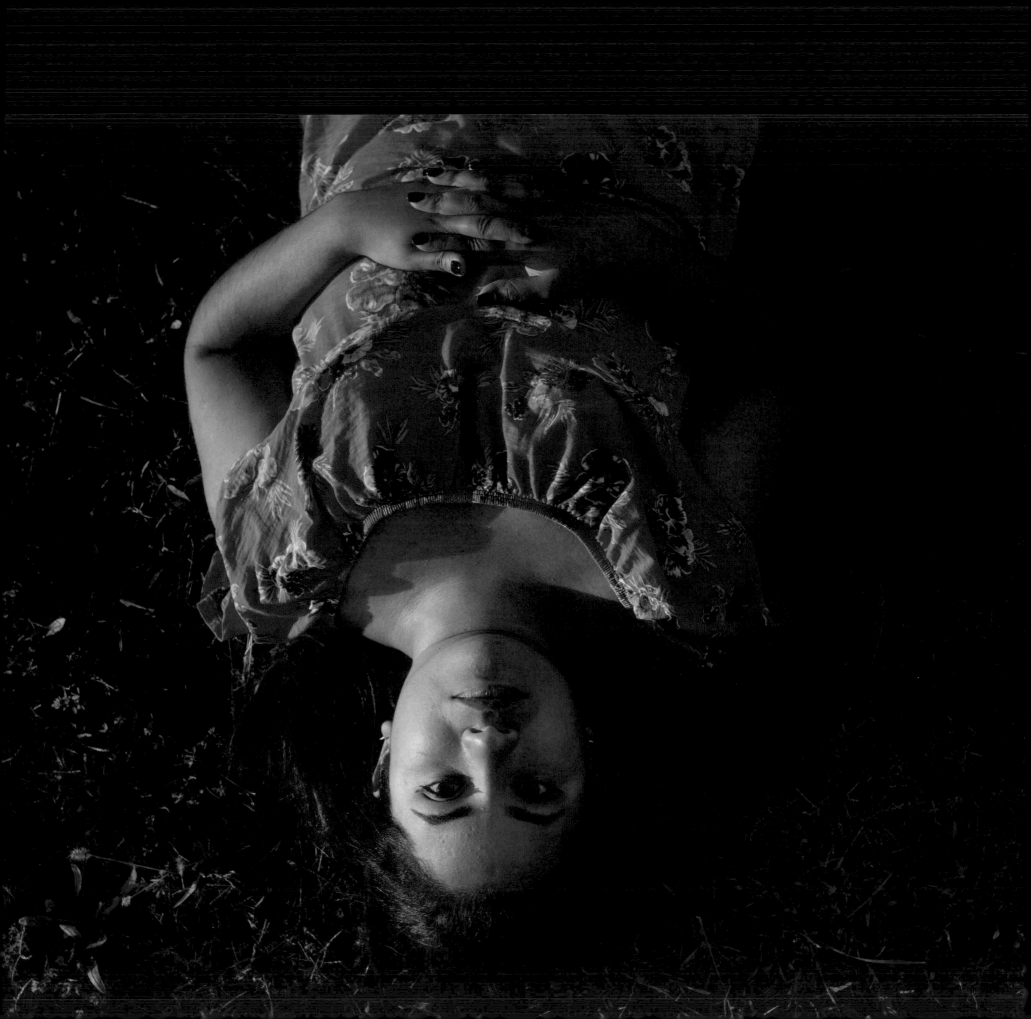

# Monse

Delmar, Delaware

When Monse was six, her widowed mom, Graciela, started traveling to Maryland for seasonal work in a crabmeat cannery. She needed money, but she also needed to escape an abusive boyfriend, who beat her children with pieces of wood. Three years later, Graciela moved to the U.S. permanently, entrusting Monse and her older sister, Maria, to the care of their aunt. Monse and Maria started panhandling for money, most of which went to their older cousin. Someone reported them to family services, and they were put in a convent, where they lived for three years.

In 2003, their aunt wrapped money into their hair, made them memorize the phone numbers they needed, and put the sisters and their little brother, Alan, on a bus north to be with their mom. Monse, who was twelve, still remembers her outfit that day—a yellow shirt with white letters, blue jeans, and new bright-white sneakers. She took care with her hair and makeup, wanting to look nice when she saw her mom for the first time in three years.

At the Reynosa-Tamaulipas border, they met their coyote—the person who helped them cross the border—and waited in a hotel room. Nine-year-old Alan was smuggled across the bridge by female coyotes. Monse and Maria were to cross the Río Bravo. "I didn't know there was any other way to come to the United States." They walked with a group to the riverbank, hiding in bushes when helicopters flew overhead. Monse was cold, so Maria gave her the sweater she was wearing. They crossed with inner tubes, walking through deep mud and swarms of mosquitoes, praying and holding hands so as not to be swept away. On the other side, they hid in a ditch while a border patrol truck's blinding light searched the ground, then were instructed to run to the light of a nearby mobile home. They rested inside and waited for their ride. Monse's new shoes and clothes were black with mud, her hair ruined. She felt stupid for dressing up. Monse lay in the truck's bed looking up at the stars as they drove toward an interior immigration checkpoint. They had fake documents—Monse's new name was Bianca—but she was asleep when they passed without incident. On the drive from Texas to Delaware, they crossed the Chesapeake Bay Bridge, and Monse saw the ocean for the first time.

In Delmar, Monse's mom and her two U.S.-born children were living in a two-room trailer shared with another family.

"When we arrived, everybody jumped out of the car to go see Mom. I stayed in the car, so she came to look for me. I looked up at her, and she looked at me and said, 'What are you doing, my love?' I replied, 'Are you my mommy?'—because at that moment I wasn't sure if she was my mom."

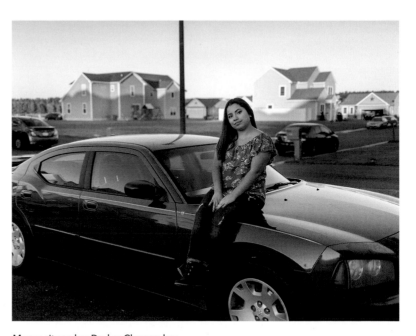

Monse sits on her Dodge Charger, her first major purchase after receiving DACA (Deferred Action for Childhood Arrivals) and getting her driver's license.

# Wissam

Lincoln, Nebraska

Wissam grew up in the Sinjar district of northern Iraq, a major population center of Yazidis. He was accepted at the University of Mosul in 2007, but Mosul wasn't safe at the time, so his classes were postponed. Wissam had long been interested in English and America—whenever U.S. soldiers were in town, he'd find them and practice his English—so while he waited for school to begin, he applied to be a translator for the U.S. Army. At the base in Tal Afar, the sergeant gave him the nickname "Ricky Bobby." A year later, Wissam returned to university but classes were halted again after his best friend was murdered and left at the school's main gate. With the ongoing American invasion and the Islamic State on the rise, persecution of non-Muslim groups was increasing. Wissam transferred to another university, in Iraqi Kurdistan, where he continued to work with the army while completing his degree. In 2012, he began teaching high school English.

Back in Sinjar for summer break in 2014, Wissam was sleeping upstairs in his family's home when his mother woke him. "Get your documents. We need to leave." Half asleep, Wissam went outside to look at the Kurdish base on the hill, which was normally adorned with flags and weapons to assure civilians of their protection. On that morning there was nothing—the soldiers had retreated. ISIS was advancing into the district.

They went to an uncle's house and decided to flee together to Syria. Wissam remembers two women from the YPG (a mainly Kurdish militia from Syria) fighting off ISIS attackers so his family could escape. His uncle's car was hit by a bullet, but no one was harmed. It was the beginning of the Yazidi genocide, which would see five thousand killed and tens of thousands displaced. Wissam is certain many more Yazidis would have died if it weren't for the efforts of the YPG.

When they reached safety, Wissam went on Facebook to ask his U.S. Army coworkers for help. A message was waiting for him: "My wife and I are praying for you guys. We know what you went through." One officer wrote a glowing recommendation for Wissam's Special Immigrant Visa application. In 2015, Wissam landed in the U.S. with dreams of becoming an American citizen and continuing his teaching career.

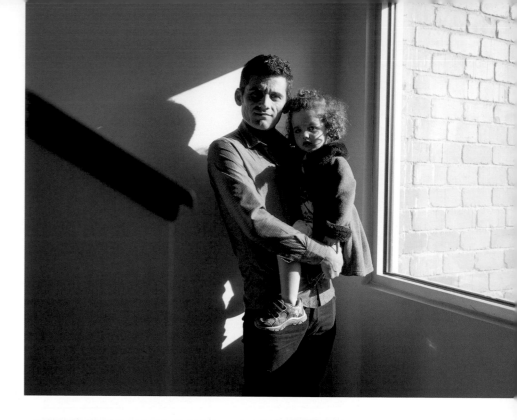

↑ Wissam worked as a translator for the U.S. Amy. During downtime in the tank or on patrol, he would pull out his notebook to review English military vocabulary.

→ Liza was born in America. Wissam and his wife, Aza, never felt like they could have a child in Iraq. "We could barely take care of ourselves and stay alive, so why would we make our load heavier? All the emotional stuff—especially if the kid got killed— we would never forget that."

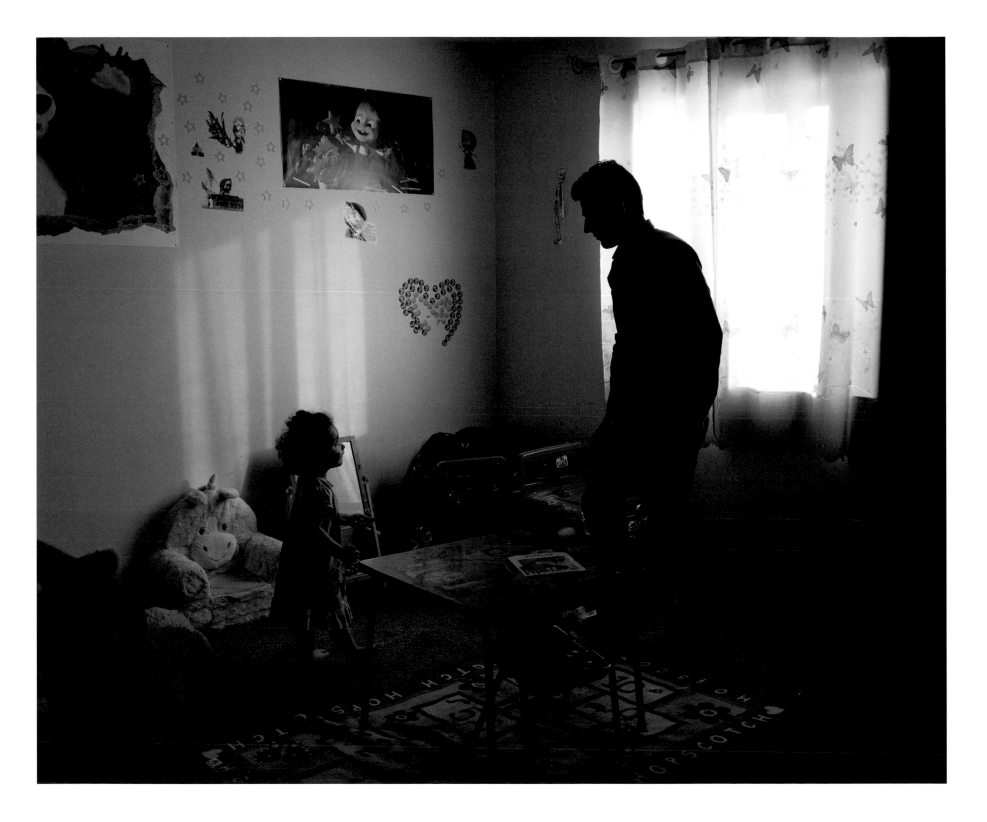

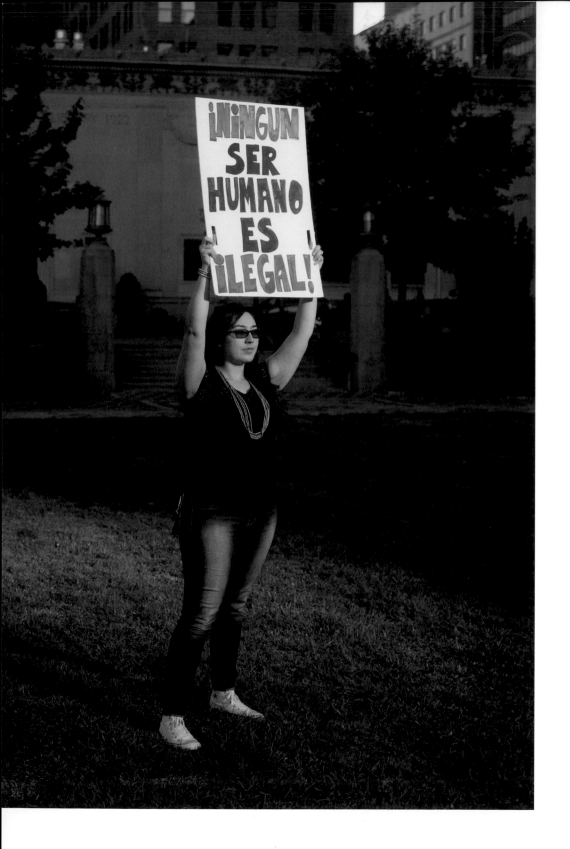

## Laura
Wilmington, Delaware

Laura flew with her family from Honduras to Orlando to join her uncle and grandparents. She remembers her fear as they went through the green card process: completing paperwork, being fingerprinted and photographed, and waiting in a room full of uniformed men.

"I was really scared. I was a nine-year-old kid in this room full of people who don't look anything like my people. They were very serious-looking men who looked like cops, and I felt like we were imposing. After hours and hours, we finally finished, and when we got our cards, they had 'ALIEN' written on them."

Laura's parents paid a lot of money and waited over a decade for their visas. Before she learned more about the system, it bothered her to hear about people coming to the U.S. "illegally."

"As a kid, I remember thinking, wait your turn in line and pay your dues. That way of thinking has definitely changed for me. I never realized as a kid just how privileged I was. Yeah, my parents did it the 'right way,' but they had the means to do so; they had access to the financial and legal means to do so."

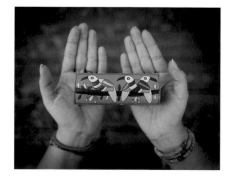

↖ Laura advocates for undocumented people in her work at the Latin American Community Center.

← Before she left Honduras, Laura's childhood friend gave her this hand-painted box. "It's one of the few things I brought with me."

# Rodain

Phoenix, Arizona

"I used to scream, and the whole neighborhood would hear. I wanted to go back to school."

When she was fifteen, Rodain was taken out of school to care for her brother who had fallen ill—and she was forced to work at her family's restaurant in Damascus. Customers loved the food she made, but her brothers received all the praise, and if she made a mistake in the kitchen, they hit her. One time they broke her finger, an injury that affects her to this day.

Rodain was still working at the family restaurant when the revolution began in 2011. Seeking safety, she moved with her husband, Khaled, and three children to Jordan. Life was difficult there. The children were bullied in school, and it was impossible for her husband, a Syrian, to find work. When Khaled went to another city on the job hunt, Rodain, alone and broke, had to leave her baby in the care of her eldest son while she worked as a cleaner. Her husband returned without having found employment and, desperate, they were forced to move to the Zaatari refugee camp, where her son suffered a severe allergic reaction to all the dust. After seven months, they left and rented a small apartment. To supplement the meager assistance from the Jordanian government, Rodain sold televisions on the black market and her husband found work in a restaurant. If anyone asked, he said he was Jordanian.

In 2016, three years after registering for resettlement to a safe third country, the family moved to Arizona. Khaled got a job at the airport, and the children were happy in school, but Rodain felt stuck at home. The resettlement agency suggested that she use the bus to get around, but she didn't know English and in Syria she never went out without her husband. "My heart felt dead."

When Rodain heard about the Syrian Sweets Exchange, she took them some samples of her baking and they were impressed. Tan, who started the Phoenix chapter to create a positive cultural-exchange environment during a time of negative rhetoric toward refugees, helps Rodain with branding and English. Rodain joined the twenty-three other bakers at events in local churches, synagogues, bookstores, and universities. She dreams of one day opening a food truck serving chicken, falafel, and, of course, sweets.

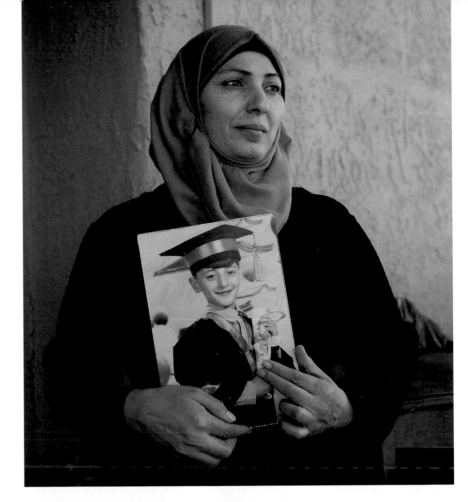

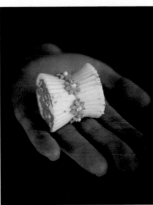

↑↑ Rodain holds her son's school photo. "I hope my three kids get a good education and university degrees—a dream I couldn't reach in Syria."

↑ Rodain holds a treat she made for the Syrian Sweets Exchange.

↑ "People in Syria always grow jasmine and fresh mint. Instead of saying I miss Damascus, I say I miss the jasmine and mint. These two plants mean a lot for Syrians because they remind us of our country."

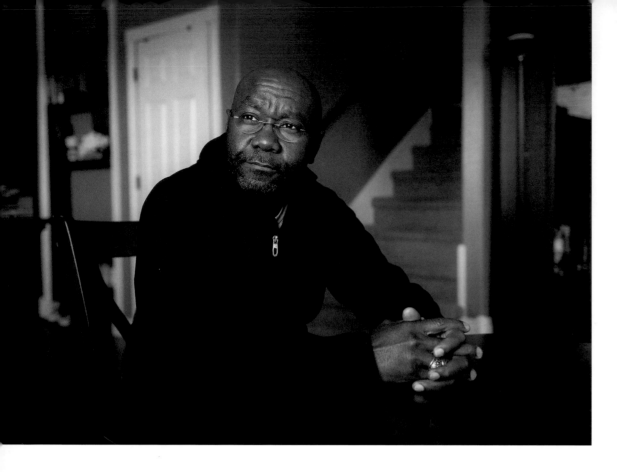

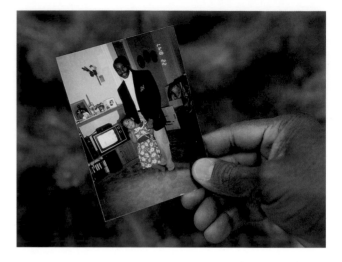

↑ Wilmot arrived in Montana in 1994, four years after fleeing Liberia's civil war. "I saw my daughter for the first time one month before her second birthday. When I held her… wow… that feeling. Hold my daughter—that was all I wanted to do."

# Wilmot

Helena, Montana

Wilmot and his family enjoyed a comfortable upper-middle-class life in Monrovia until the First Liberian Civil War began in 1989. With rebel and military forces fighting in the streets, it was time to escape. "The rebels killed a brother of mine. The soldiers killed a brother of mine. To whom do I owe allegiance? It was like picking between two evils."

Hoping the rebels would never attack a hospital, the family sought shelter at the medical school where Maddie, Wilmot's wife, studied. But the rebels did attack, so they fled to Wilmot's sister's house. The rebels came there too. "There was intense fighting; stray bullets went through the house. We stayed on the ground for three days and three nights! When we got out of my sister's place, we were literally jumping over bodies." Desperate, they went to the American Embassy, and a woman living nearby recognized Wilmot's mother and invited them to stay in her house. For two weeks, they stayed in a room packed with so many people that they had to sleep sitting up.

In October 1990, they heard of a Nigerian cargo ship they could try to board to leave Liberia. Wilmot's mother refused; she wasn't in good health, and in her prayers the Lord told her not to go. Before they left, she handed Wilmot five dollars and said, "God be with you." Wilmot and Maddie joined a mile-long line and waited for three days, finally boarding the standing-room-only ship ten minutes before it stopped accepting passengers. Only after they boarded did they learn it was sailing to Ghana, a three-day voyage. They hadn't brought food or water, but others shared theirs. The first night was cold and wet, and many passengers didn't survive. Wilmot will never forget the sounds of people crying and bodies being thrown overboard. He was happy his mother hadn't come. "If my mom had passed, I don't know if I would have had the fortitude to lift her up and dump her overboard. I thank God every day I couldn't convince her to come."

In Accra, they went to the SOS Children's Village, an organization Wilmot had worked with in Liberia. "The director asked, 'How do I know you are Wilmot Collins?' For the first time in my life, I could not prove who I was." Luckily, some of his former students were there and recognized him. "I thought they would be happy, but they cried. I found out why when I went to the restroom and looked in the mirror for the first time in six months. When the war began, I was a hundred and seventy-two pounds, but that day I was ninety-two pounds."

After six months in Ghana, Maddie contacted the family in Helena, Montana, that had hosted her for a student exchange in high school. They had been searching for her, wanting to help, and soon Maddie was offered a nursing scholarship to Carroll College. A week before her departure, Wilmot and Maddie learned she was pregnant, but they decided it was still best for her to go. Wilmot registered to be resettled through the UN Refugee Agency, a process that would take more than two years. "My wife was going to America with our child, and I didn't know when I would see them again."

Wilmot's sister lived in the U.S. and couldn't believe they were moving to Montana—when she visited once, it snowed the whole time and she didn't see a single Black person. After her arrival, Maddie reassured Wilmot of Montana's beauty. "The only place I wanted to go to was Montana, where my family lived."

A teacher in Liberia, Wilmot started working as an elementary school janitor in Helena until a second-grade teacher went on maternity leave. "This little girl said, 'Oh my God, oh my God, the janitor is our teacher!'" Six months later, Wilmot joined the National Guard, then worked with Homeland Security as an immigration officer, and later worked in child protection.

In 2017, when the incumbent mayor of Helena decided not to run for reelection, Wilmot's son came to him with a surprising idea: "Dad, I think it is time you get into politics. You should run for mayor." He won with 51 percent of the vote and was soon fielding calls from major media outlets asking him how it felt to make history. He was the first Black mayor in the history of Montana, as well as the first refugee. "I turned to my son and said, 'Did you know that we were making history?' He replied, 'Oh yeah, Dad, I knew that!'"

Wilmot was reelected with two-thirds of the vote in 2021.

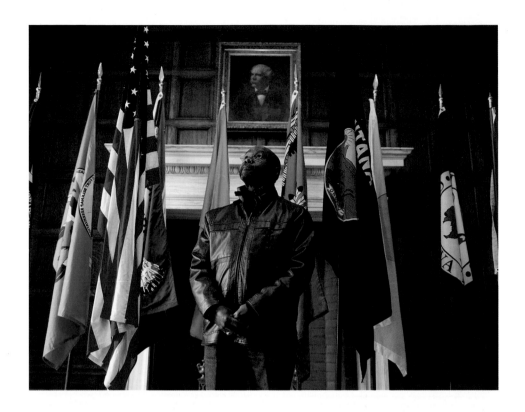

Wilmot, a Liberian refugee and the first Black mayor in all of Montana, poses in the Montana State Capitol building.

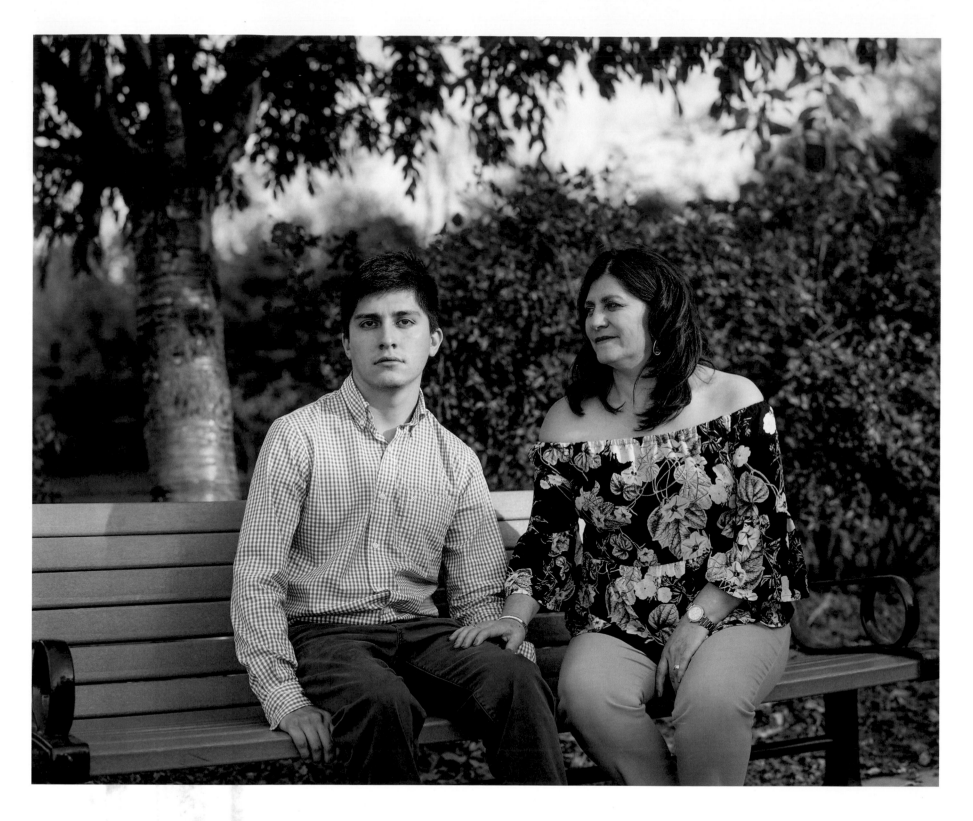

# Maria

Bel Air, Maryland

Maria and Carlos's first year of marriage was a happy time, until she had a miscarriage. The couple was devastated, but Maria, who was nineteen, asked God for another child and became pregnant again. After three days of traumatic labor, their son, Carlos Santiago (or "Santy"), was born, but the nurses didn't bring her the baby. She was told he had been deprived of oxygen for too long during the birth and likely wouldn't make it. "Why let him live," the doctor said, "if he won't be able to walk, talk, or hear." Maria and Carlos told the doctors to keep him on life-support. "This was the hardest moment of my life," says Maria. "The doctors in Ecuador gave us one prognosis but, with love, we found another."

Maria and Carlos knew, from covering and uncovering his eyes to test his reaction to light, that Santy could get better. They devised homegrown therapies to help develop his muscles and spent all their money on his care and treatment, sometimes going days without food for themselves. Despite the limited therapy options in Ecuador, Santy displayed signs of dramatic, unexpected improvement. The family had little support through those early years. "When someone has special needs in my country, people are afraid of them, talk badly about them, and criticize them—even in my own family, people were cruel. It's ignorance."

These experiences hardened Maria and Carlos's determination to do everything possible to give their son a better life. They wanted Santy to be seen for more than his disability and believed the U.S. was his best hope. Carlos went to New York with no clear plan for how or when Maria and Santy would join him. It didn't go well at first. Maria remembers: "He told me, 'No, you can't come here. It's impossible—don't do it—I don't want to lose you or my son. Don't do it.'" Maria was unswayed. She applied for visas, unsuccessfully. Her husband, her family, and the U.S. government didn't want her to go, but she was determined.

Maria's cousin arranged for coyotes to help her get to the U.S. "I took my son in my arms and said, 'Here we go.' I didn't know how far I'd have to walk, I didn't know how many countries I'd have to cross, I didn't know that it was so far to get to the United States." They flew to Panama and then traveled by bus, truck, and foot. "I had a four-year-old son with special needs who didn't talk, who didn't walk, who needed medicine, who needed a lot of things to get through the day. I started to think, 'Oh no! What am I doing? How can you carry your son to a place you don't know?' A mother's love can do so many things that no one understands."

When Maria and Santy got to Mexico, she thought they were in the U.S. "I was so happy. I thought all my suffering was over, but no. My suffering was just starting." After weeks of walking, they arrived in Nogales, Sonora, where Maria was assaulted and robbed. Maria and Santy crossed the border with nothing but the clothes they were wearing. "After all the suffering, hunger, pain, and tiredness before we crossed the border, there was more suffering once we arrived in the U.S." Maria and Santy were kidnapped, and the kidnappers demanded a ransom. After five days of captivity, Carlos sent money and they were released. "This is how I got to the U.S. It was very difficult and cruel, but the beautiful part is that I came with my son, and we survived."

The family was finally reunited, but penniless. In those early days, Maria cried a lot, asking herself, "Why did I come?" But then she found hospitals to help her son. Santy received the therapies he needed, thrived in the U.S., and now has a business degree from Goucher College. Maria knows the ordeal was worth it.

"Anything can be accomplished if it's done with love. There are no limits in life. My son is an example of that. A family's love can solve anything."

"I was a nine-year-old who was pointed at by three different guns in a matter of days."

## Javier
San Rafael, California

Javier was born shortly after his teenage parents' "shotgun wedding." He grew up in a home with dirt floors, an outhouse, and no running water in La Herradura, El Salvador, a town of five hundred people about a mile from a bay of mangroves. He remembers the fiddler crabs at low tide scurrying as he tried to catch and put them in plastic bags.

When Javier was a year old, his dad, a fisherman, moved to the U.S. for work. "My relationship with Dad was only letters, cassette tapes, and videotapes." Javier lived with his mom, two aunts, and his grandma until he was four. One morning, his mom woke him with a kiss on the cheek and said she was moving to the U.S. too.

Five years later, Javier's own journey north began. His grandfather took him to Tecún, Guatemala, where Javier waited for two weeks in a house full of strangers and then took a twenty-seven-hour boat ride to Oaxaca, Mexico. Most of the group continued on by truck, but Javier and a few others were left stranded on the beach. The "Federales" showed up, robbed everyone at gunpoint, and left. Javier hitchhiked to Acapulco with a small group, found a new coyote, and traveled fifteen hundred miles to Nogales.

It took Javier three tries to cross the border. On his first attempt, border patrol found the group; Javier was held at gunpoint and deported back to Mexico. On his next attempt, the group got lost in the desert. After several days, Javier—hallucinating from dehydration—and three others stumbled upon a ranch, where a tall white man pointed a shotgun at Javier. A border agent picked them up and, again, released them at the border.

On his final attempt, Javier made it to Tucson, Arizona. He slept on the floor of a room full of people "stacked like sardines, smelling of shit and piss and the desert." Throughout his journey, Javier's parents never knew where he was. When they picked him up, he didn't recognize his dad, whom he hadn't seen for eight years. They took him to a department store, washed him in the restroom, and bought him new clothes, then flew to California. Arriving at his new home, the living room of a one-bedroom apartment, was heartbreaking—it didn't look anything like what Javier had seen on *Friends* or *Full House*.

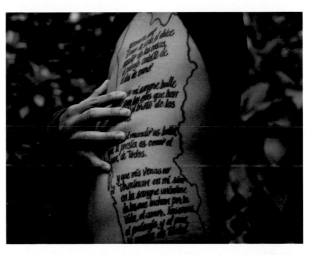

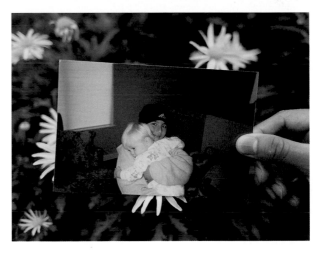

↗↗↗ During his first week in the U.S., a school counselor helped Javier, age nine, create a book describing his journey north. When he wrote about seeing a dead "coyote" in the desert, he realized she thought he meant an animal. Rather than explain to her that it was a human, Javier drew an animal.

↗↗ Javier's 2022 memoir, *Solito,* is a *New York Times* bestseller. He plans to get a tattoo to commemorate each book he publishes. This is "Como Tú," his favorite poem by El Salvador's Roque Dalton.

→ Javier's mom's first job in the U.S. was at Toys R Us, where she wore the giraffe mascot costume, but by the time Javier arrived, she was working in childcare. "In a way, my mom became a babysitter because she missed me. This is me with the kid that replaced me."

# Ric
Chicago, Illinois

When Ric was four, both his parents left Salvatierra, a one-employer town, to look for work in Chicago.

He lived with his grandparents and two younger siblings for three years, until 1973, when they finally joined their parents. Ric was seven, and excited. "We had to practice new names for the drive over. My name was Victor; I remember that. I got it, but my little brother didn't. They kept asking him his name, and he said "Arturo," which was his real name—not his name for crossing!"

In Nuevo Laredo, the grandparents passed Ric and his siblings to the coyotes who would take them across the border. By the time they met their mother, Ric's sister was missing—the coyotes had decided to hold her hostage for more money. Ric doesn't know how his parents found money to pay the ransom, but they did. "When I saw my mother after we crossed, I felt elation and joy, but my younger brother wanted no part in that. He wanted to go back home to Mexico. He didn't even remember our parents."

When Ric and his siblings joined their parents in Chicago, they lived in a small basement apartment beside Cook County Jail, one of the largest in the country. "We were always in the shadow of that prison. You can imagine what that means for a kid—to be always in the presence of a jail."

At the time, many of the neighborhood's Czechoslovakian and Polish immigrants were moving out, while Mexicans and other Latinos were moving in.

"I didn't grow up thinking I was either poor or a minority, because most of the people I saw looked like me. The poorest in the neighborhood were either white or Black, so I didn't grow up realizing that I was actually a poor Mexican kid."

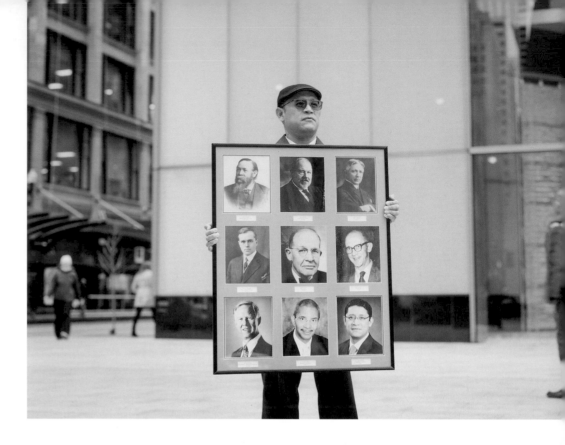

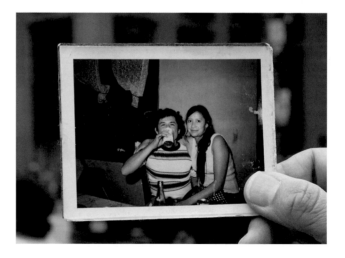

↑↑ Ric is the CEO of Metropolitan Family Services (MFS), one of Chicago's largest nonprofits, which serves the city's low-income and working poor families. Ric holds a collage showing the past heads of MFS. "If you look at the names on Chicago's streets, a lot of those people were on this board or had a part in founding and developing this organization."

↑ Ric holds a photo of his parents taken in Chicago in the early 1970s.

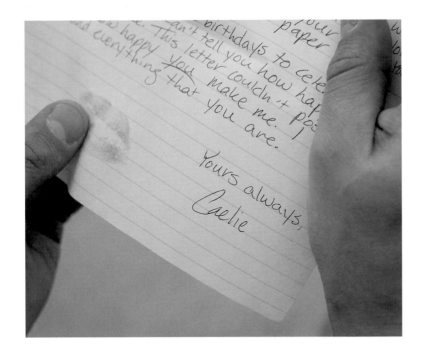

# Mike

Norman, Oklahoma

Mike was scrolling through thumbnails of camgirls when Caelie's red hair caught his attention. He clicked, and they started talking. After only a few conversations, it was clear they had a real connection. "I was just looking for someone who listens to me and makes me feel special. The more I got to know her, the more I liked her, and the fact that it was reciprocated was even more shocking to me. I was just paying to be there!"

Caelie noticed right away that Mike was different from her usual clients. "He didn't come in and be like, 'Show me your boobs!' He was more like, 'What kind of music do you like? Do you have a college degree? Who's your favorite artist?' We started talking more and more in this casual way online. He was engaging, interesting, and kind. I felt like I was being seen and heard—and that was a new experience for me."

Things moved fast, and soon they were mailing handwritten love letters to each other. As Caelie explains, "That was my way of sharing a part of myself with him and being vulnerable. Sometimes the internet feels very impersonal. To have something that someone has touched is special. We had to grasp at straws to create intimacy because of the distance, and writing was a way for me to do that."

In 2011, Mike flew to the U.S. to meet the woman he'd been video-chatting with for months. He was ready for a change from his life in the UK but not yet intending to relocate. The intensity of that first hug in the airport changed his plans. "That first time we got to share the same physical space was incredible. It confirmed how we felt, and from that moment there was no question. The people around us asked lots of questions, but we never doubted our love."

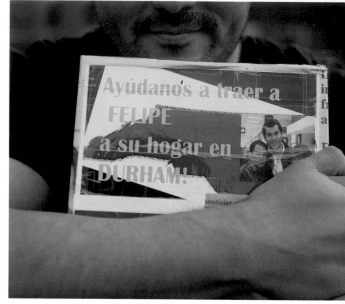

# Felipe
Durham, North Carolina

When Felipe turned five, his mother migrated north to help support the family. A few years later, Felipe was in bed watching *Pokémon* when a woman he didn't recognize opened the door. It was his mother. She told him and his two sisters to grab their stuff. They crossed at night through Arizona's farmland with the help of teenage coyotes. Felipe wore LA Gear shoes that lit up with each step; he remembers the coyotes yelling at his mother to cover his shoes. They almost got lost, but a lightning storm illuminated the way, which Felipe's mother saw as a sign from God. After a couple of days, they made it to an airport and used fake IDs to fly to New York, where Felipe's aunt lived. He remembers that day as the first time he ate at Burger King.

Felipe's mother worked thirteen-hour days, while Felipe concentrated on school. "I wanted to play sports, but my mom never let me because I didn't have health insurance. If I ever got injured, it was going to cost too much." In his senior year, he realized that despite having good grades, he couldn't apply for most scholarships, like his friends, because he didn't have a Social Security number. After graduating in 2009 with few options for schools in the U.S., he decided to move to Mexico to attend college.

Returning as a young adult to the country he'd only known as a young child wasn't easy. "My sexuality was one of the only things I could hold on to—no one could take it away from me. I started being more openly

gay, and that didn't turn out so good because people in Mexico are conservative." Felipe endured homophobic attacks ranging from verbal abuse to police harassment to beatings and hurled bottles. "When it started getting more physical, that's when I decided I couldn't be there anymore."

Felipe completed his Mexican college degree in 2013 and wanted to return home to North Carolina. He tried to cross the border with a large group but was caught by the border authority. He was in shorts and had no bags, so they thought he was a coyote and put him in "the coolers" (detention). For three weeks he slept on the floor or a cement bench and had to use the toilet with forty other people watching.

An immigrant-rights organization told Felipe he had a case for political asylum and prepared him for the interview.

"It was degrading when I was in detention, especially the credible fear interview. They put chains on my hands and feet, then you walk in public into the court where they do the interview. I shouldn't have cared, because they don't know me. Ashamed, degraded, and restrained—and there is nothing you can do about it. You know you are not a criminal. When you are in the hands of immigration, you literally have no power."

After another three months in a detention center, Felipe could get out on bond, but a U.S. citizen had to sign for him. That citizen was Francisco, his longtime friend. While his case wound through the immigration system, they became closer. "For a long time, I didn't want to have a relationship. How can I have a serious relationship if I don't even know if my future will be stable? He's been with me, he's been fighting for me, and he told me he doesn't want to let my immigration situation stop us from being together. After we won the deportation case, our lawyer talked to us and said, 'I can't tell you to do this, but if you ever plan to get married, now would be a good time.'" So, in 2017, they did just that.

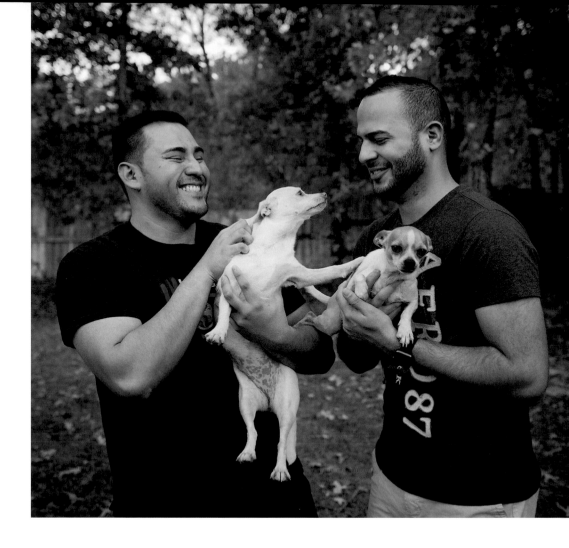

↖↖ "I work as a server but, after all I've been through, I want to be a nurse. It is one of the careers that can stabilize my life. My parents are getting older. They don't have insurance. Maybe if I learn how to be a nurse, someday I can take care of them like how they cared for us."

↖ Felipe holds a collection box friends and family used to fundraise for his legal costs. He had to pay a $7,500 bond and $13,000 to his coyotes.

↑ Felipe and his husband, Francisco, play with their dogs, Chikorita and Muñeco.

# Liyah
## Twin Falls, Idaho

Until the First Nagorno-Karabakh War began in 1988, Liyah's ethnically Armenian family lived comfortably in Baku, Azerbaijan, with a constant flow of friends and family visiting their twelfth-floor apartment. Pogroms and ethnic cleansing upended this life. When Liyah's parents put her and her older brother on a bus to Armenia when she was seven years old, she didn't know if she would ever see them again. In May 1989, her parents left on "the last train out of Baku." Soon after they fled, her aunt Lola was murdered.

"I remember the last time I saw her. I was brushing my teeth, and she said if you put your hand like this, you can make a little cup to rinse your mouth. Every time I brush my teeth, I think about her."

With the help of a kind custodian, Liyah's family lived in hiding for four years, in a storage closet at Yeghvard School No. 1 in Armenia, the same school Liyah attended. They had no electricity or plumbing, and sleeping was a challenge. At night, Liyah could hear rats eating the walls and had nightmares of them consuming her family.

Liyah arrived in Twin Falls at the beginning of the school year in 1992. Her teacher made a space for her between two girls, Angela and Bonnie. Liyah didn't speak English and had no school supplies. "Bonnie gave me two pieces of paper and a pencil. She leaned over and showed me her little plastic compact with Lip Smacker chapstick—pineapple, cherry, and apple. We were using sign language. I took my finger, put it in the jelly, and ate it—I thought it was candy! I couldn't believe how horrible the candy in America tasted. Bonnie still reminds me to this day of what I did!"

↗ Liyah's aunt, Lola, was killed in Azerbaijan. "Look how beautiful she was. I always think about her last moments. They have haunted me all my life. For her to not have any of us there to help her . . . It haunts my family. How could we not have taken our whole family out of there?"

→ Liyah visits the elementary school she attended when she came to Idaho. "I thought I would have to live at the school. I didn't understand I was just going to school and at the end of each day I would go home, since I had just lived for four years in a school storage closet in Armenia. It was confusing."

# Heval
## Clarkston, Georgia

When Heval was born, the Syrian government refused to register his name, which means "friend" in Kurdish. His dad had to pay a bribe. "To an American, this probably seems unheard of—why would a name make the government feel like you are being rebellious? Where I'm from, a simple name could be dangerous to a family."

When Heval was eleven, his father, a prominent Kurdish lawyer, was falsely accused of conspiring against the Syrian government. Police came to Heval's home, beat him and his mother, and arrested and tortured his father. Heval's father was imprisoned for three months, until the family paid for his release. Afterward, they fled to Türkiye and then to Germany, where they lived in a refugee camp for five years.

"Then 9/11 happened—devastating because of the number of people killed for no reason. At the same time, it was very personal for us as a Muslim family. We thought, 'America is not going to take Muslim refugees after just getting attacked by Islamic terrorists.'" But on September 21, 2001, Heval's family learned that their tickets and visas were ready and they would be leaving in three days for Georgia, aided by a Christian organization. They couldn't believe it.

"We were very scared when we arrived in the U.S. Our friends were telling us to be careful—that we were going to get beat up. My mother wears a hijab. I remember sitting in JFK. We don't speak English, and this one white guy—tall, wearing a business suit, like a TV character—sat next to me and started talking in English. And then he showed me a picture of his dog on his BlackBerry. What I realize now is that he thought I was an American like him. That's not common in Europe—when you look like a foreigner, they speak to you in a language that is broken. I will never forget that."

"I try to educate people about my ethnicity and my religion not by talking about the details but by being a good human."

← When Heval made these drawings to submit to a popular Syrian children's magazine, his mom made sure he didn't use too much red, yellow, and green—Kurdish colors. "For me as an American now, this is ridiculous. Why would the drawing of an eleven-year-old kid be a political statement? It just blows my mind."

# Jazmin

Philadelphia, Pennsylvania

Growing up undocumented in Philadelphia was tough. "I felt like I didn't belong here. All my friends were getting their driver's license, planning to go to college, and getting financial aid. When I started the college admissions process, they asked for a Social Security number, which I thought I had, but didn't. I didn't understand the meaning of being undocumented until I was in high school and needed that SSN."

At fifteen, Jazmin returned to Mexico with an uncle so that she could go to college. But a few years later she became pregnant and decided to have her baby in the U.S. "I didn't want my daughter going through what I went through. I would have risked everything to get her U.S. citizenship and not have to jump borders like I did. I want her to have the opportunities that I didn't."

Jazmin was waiting at the border with her coyote when two trucks full of men and guns pulled up and told her to get in. She is sure the heavily armed men were part of a cartel; there was blood in the truck. They made Jazmin call her dad in the U.S., demanding $5,000 each for his daughter and her coyote, or they would kill them both. Her father said he didn't have much money, and they settled for $1,500. Her capturers said they would get Jazmin across the border. Her dad deposited the money.

For two weeks, Jazmin, eight-months pregnant, waited in a small house packed with other people waiting to cross. Twice she went to the river to cross but could see border patrol agents on the other side. On the third attempt, Jazmin and another pregnant woman sat in inflatable floating donuts and coyotes pulled them across. She thought she was going to drown. On the other side, they walked for three hours before border patrol caught them. Seeing that Jazmin was pregnant, the officer accompanied her back to Mexico and dropped her at a bus stop in Tamaulipas.

The fourth attempt took fifteen minutes. She met a guy at the bus station who listened to her situation, seemed trustworthy, and said he could take her across in his boat. The next morning, she crossed into Texas without incident. She ran to the nearest house, where a helpful Texan drove her to a gas station and said "good luck." She called her dad from the pay phone. She was back.

↓ Jazmin crossed into the U.S. from Mexico in 1996 with her mother, her aunt, and her five-year-old cousin. Jazmin, four, remembers the streetlights as they drove north. "I thought the lights were all candles. My cousin said, 'No, dummy, those aren't candles—those are matches!'"

↓ Jazmin's college graduation cap represents the traditional Mexican dance "Danza de los Viejitos." The text reads, "Fly as high as you can without forgetting where you come from"—a sentiment, Jazmin says, "we all should keep in mind."

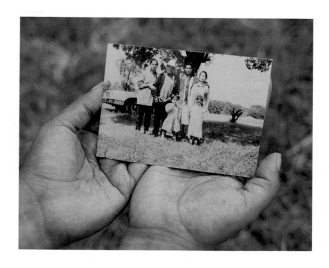

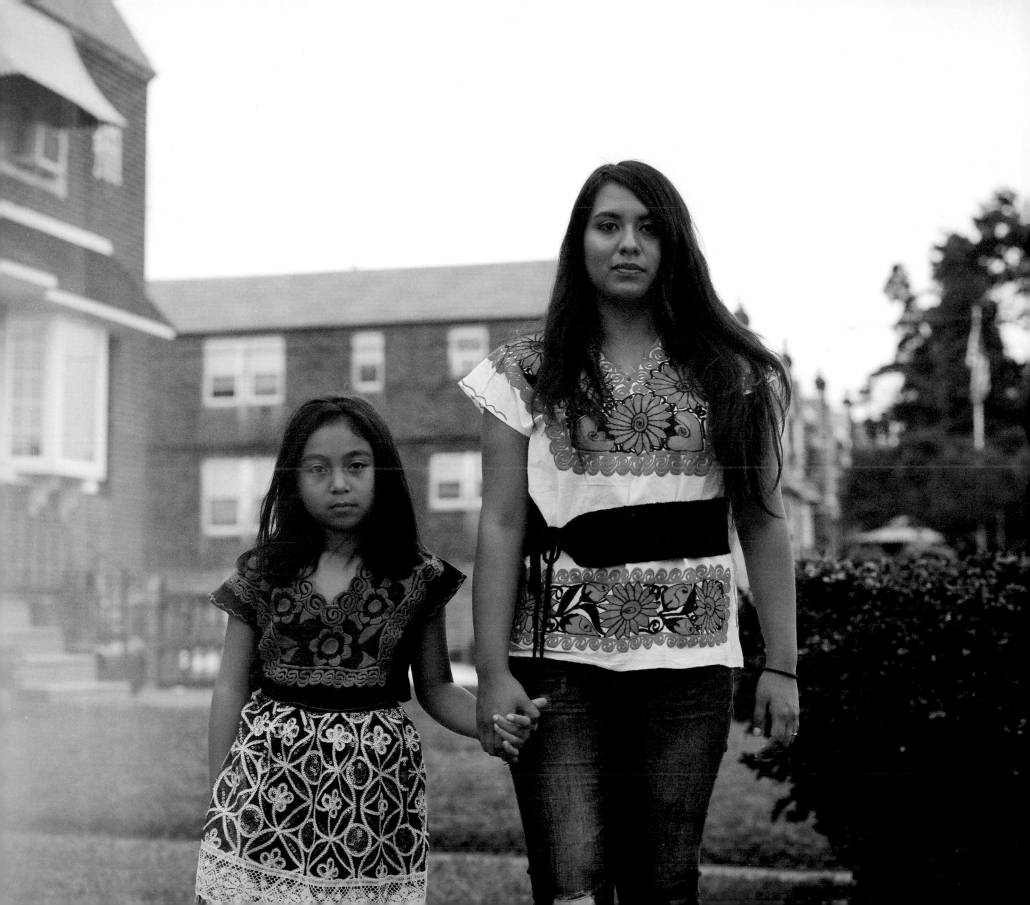

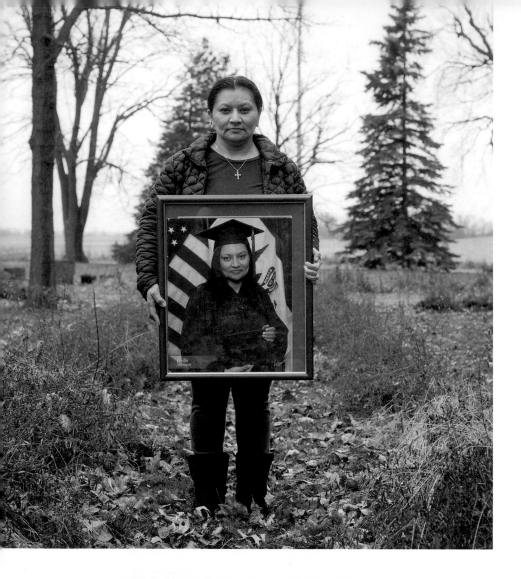

## Emilia
Storm Lake, Iowa

Emilia's mother, Arminda, moved to the U.S. in 1979 after the civil war began in El Salvador. Emilia, who was seven, stayed with her grandmother in a cliffside home that was made of mud. Emilia's grandmother was strict, old-fashioned, and, looking back, verbally, emotionally, and physically abusive. They always had food on the table though. Emilia would wake up early to feed herself and the eight other children before going to school, then return home to prepare food with her grandma. In the afternoon, all the children knocked on doors in the neighborhood to sell the food they had made. "It was a working childhood."

Emilia's grandmother always said, "If you get pregnant, you're never living in this house again." When she became pregnant at sixteen, she hid it for seven months before she was kicked out. Emilia and her fifteen-year-old boyfriend found a one-room aluminum shack to rent. "We had hard times. We used to cook rice, give my daughter the water from the rice, and we ate the rice." Emilia's boyfriend started drinking, and on one occasion he hit her. "I thought, 'My grandma treated me this way all my life, and I'm not going to let anyone treat me like this again.'"

Emilia, shaking with fear, called her mother in the U.S., even though her grandmother had said she didn't want to hear from Emilia. As soon as she answered, Emilia realized her mom had been waiting for the call. In 1992, Arminda returned to El Salvador to bring Emilia, by then eighteen, to the U.S. through the formal immigration process. As was the case with Arminda thirteen years earlier, Emilia could not bring her daughter (named after Emilia's mother). "Leaving my daughter was the most difficult thing. She was only two years old. I cried for a month after I came to the U.S."

For three years, Emilia's only contact with her daughter was phone calls and the money and gifts she mailed to her. When Emilia got her green card and papers for Arminda, she flew to El Salvador to bring her home, but Arminda's father had been expecting Emilia to marry him, and when she refused, he obtained an order preventing her from taking their daughter to the U.S. Emilia left El Salvador, again without her daughter.

They continued speaking on the phone for over a decade, by which time Emilia was a U.S. citizen. One day, Arminda, almost sixteen, called Emilia; she wanted to move to Iowa. Today, they both live in Storm Lake, and their relationship is a work in progress. "There is a gap there that is going to be hard to close."

↑ At the age of thirty-seven, Emilia graduated from Iowa Central Community College with her associate's degree in human services.

← Emilia shows a photo of her daughter wearing a dress that Emilia mailed to her from the U.S., one of many gifts she sent during their years of separation.

## Luana and Carolina
Orlando, Florida

Luana and Carolina moved with their respective families to Orlando in 2016, became friends, and have since met other local Brazilian teens. "They were a big part of my whole adaptation process," says Luana. "They made me feel close to home. I know if it wasn't for having that bit of my country, I would not have adapted as well as I did here. I would have lost it." Carolina agrees. "My friends are always there for me, and I know if they need something, I'm going to be there for them. They are my home. A house is just a house. People make the place."

Most of the friends' fathers, including Luana's and Carolina's, are CEOs or owners of large companies. "That's what gets us here," says Luana.

"It's not easy to get a green card or visa—it requires money that most people don't have. I grew up fortunate and I understand that. This is one of the reasons I want to make the most of being here."

## Irina
Grand Forks, North Dakota

Irina was awarded a Fulbright scholarship in 2017 to attend North Dakota State University. Living in the coldest state outside Alaska didn't faze her—previously, she lived in Novokuznetsk, Siberia—but the cultural differences were unexpected. "I was surprised at the attitude to religion. I grew up in an atheistic family; we have Christian holidays, but we never pay attention to them from a religious point of view. Here, I was surprised by the number of churches and how many people go there on Sunday. To me, a church was always a beautiful building and a work of architecture, but here people actually go there. Nothing opens until noon on Sundays because of church. I was shocked by this. It is different than what I saw on TV shows. I had imagined a more open, not so conservative, society."

← Afshin, a fellow international student from Iran, photographs Irina for her social media.

## Clement

New York City, New York

Clement was visiting an online video game forum when he read a post by Matt, who mentioned his sexuality in passing. Malaysian society harshly discriminates against the LGBTQI+ community—gay sex is illegal, and there is little public acceptance of homosexuality. "I didn't know many other gay people in Malaysia because they are mostly in the closet. I felt alone because I didn't know who I could talk to about this. That's why I reached out to Matt. It was nice to have someone you could chat with—to speak freely, without fear—someone who is so far away. As a result, we ended up telling each other everything."

After a four-year long-distance relationship, Clement and Matt knew they needed to be together. When the Supreme Court overturned the Defense of Marriage Act, they sealed their decision. Clement moved to New York in 2014. "I felt guilty about leaving my family behind but thought I should try to live my own life. There was a lot of internal agony."

Life in the U.S. was more challenging than he expected. Shortly after arriving in Brooklyn, Clement was mugged in front of their apartment. A few months into the visa process, Clement's mom's cancer returned and she passed away.

Despite the challenges, he enjoys being able to be more open about his sexuality, though he still has inhibitions.

"In Malaysia, I tended to be cagey about what I told people. I always used the term *partner* when I referred to Matt. Over here, I've started to use the word *husband* and it has been great. Even now, we still don't hold hands in public. I carried my suppressed sexuality from Malaysia to here."

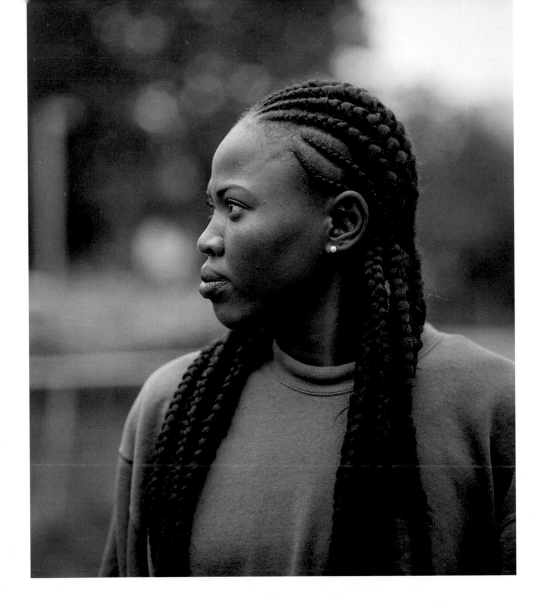

## Moon

Portland, Maine

Moon's family moved from Ethiopia to Maine when she was four, amid a massive immigrant influx to the state in 1995. Most Mainers approached these newcomers with curiosity, not stigma. Still, it didn't take long for Moon to experience racism in the 98-percent-white state.

"I remember when they called me nigger. I didn't know what that word meant. I never heard it in my country. They would say it all the time, and it didn't bring any reaction out of me. I asked my teacher what it means, and she explained it to me. After that, I developed some sort of internal complex, because she didn't reinforce that this isn't true or do anything to build me back up. I became very afraid of words because I felt like anything someone said that I didn't understand must be some sort of racial slur. I remember going outside once and someone called me 'barefoot.' I was devastated and ran inside. 'They are saying I have brown feet!' Now I realize they were just trying to tell me that I didn't have shoes on. I thought there would always be an attack that I needed to protect myself from."

Moon believes that "the persona of the immigrant has become misunderstood, vilified, and often hated," and that this can be countered by sharing their faces and stories—and helping Americans learn why they left their countries of origin.

"America was built on the foundation of being a new land of dreams and opportunity. I should not feel ashamed for asking for the freedom and opportunity offered to everyone else. I love to tell my story because, beyond being an immigrant, I'm just a passionate human."

"I often find it strange that the place I know most as 'home' isn't a place that necessarily sees my presence as a positive."

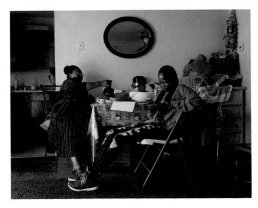

↖ "I want to empower others like me to rise above all stigma placed against us. I want to show them that an African girl can speak on prestigious platforms and that conformity isn't a transition plan we are willing to accept in this country."

← Moon still feels most comfortable amid the incense and familiar cuisine of her mother's kitchen. "If my mom is making coffee, it means everything is okay."

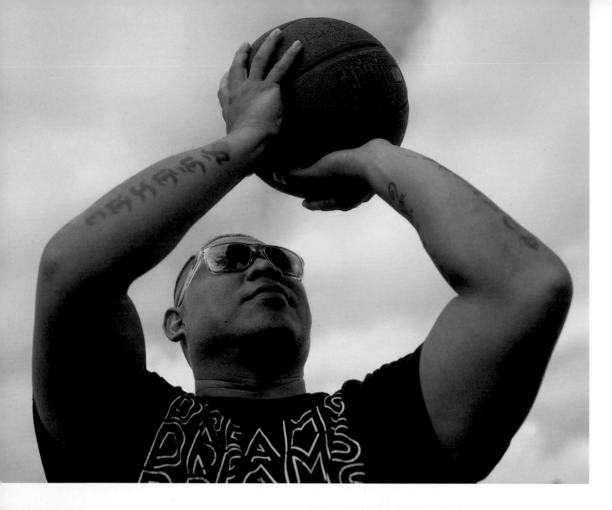

## Jonathan
Ewa Beach, Hawaiʻi

When he was a preschooler, Jonathan's birth mother placed him for adoption with a family that appeared stable but soon began to abuse him. "I didn't really have a childhood. I experienced a lot of physical, mental, and sexual abuse starting at the age of four. I never understood why my stepbrothers did this to me. I got beat every day in those early years. Some days I got beat so bad I couldn't walk to school. One time I was locked in a closet for three days with no food or drink. I think they forgot me there. That memory will always be with me. It was inhumane. In the Philippines, when it comes to child abuse, it doesn't get stopped, because people don't get into other families' matters."

Jonathan moved to Virginia Beach at age nine and eventually came to Hawaiʻi, where he joined a welcoming community. "The Caceres family on the Big Island was the first family I met at church—my first true experience of what aloha means. I was a stranger to them, but they offered their home to me. Uncle 'D' showed me unconditional love and respect, and he educated me on the cultural practices of Hawaiʻi. I'm a better person and father to my kids because of him."

↖ Jonathan got his first basketball at age four. "The game provided moments when I was able to be a kid, enjoy myself, and escape from the reality of what I was experiencing every day. Basketball taught me how to communicate and relate with other kids—it was a language for me to connect. It gave me a little bit of security and helped me have some self-confidence, which was constantly being destroyed at home. As crazy as it sounds, I bonded with my basketball. This game literally saved my life."

←← Jonathan's tattoo is by Whang-od Oggay, who at a hundred and five years old is believed to be the last living "mambabatok" (traditional Kalinga tattooist). "It was a spiritual journey seeking her out through dangerous terrain in a remote village in Buscalan. It's a reminder of being proud of who I am and where I come from."

← Jonathan holds the traditional "maile lei" used in the burial ceremony of Doiron Caceres, who welcomed him to Hawaii "with open arms."

## Mukesha
Louisville, Kentucky

Before boarding a plane to the U.S. in 2014, a caseworker handed Mukesha's family their resettlement package and said, "Oh, by the way, you're going to Kentucky." Mukesha, from Rwanda, was twenty-one and had been living in South Africa for fifteen years. She had heard of Los Angeles and New York, but not Kentucky. To make matters more confusing, the address on their package was for a local office of Catholic Charities USA, which was run out of a church.

"I was like, 'Mom, they are taking us to a church!' I was already mad that we were going to Kentucky, and now we were going to be living in church! My mom said the novena like ten times and prayed the rosary: 'God, hopefully we are not going to live in a church.' I was freaking out. This is America; I'm expecting big things!"

When Mukesha's family arrived in Kentucky, the volunteer who drove them to their new home warned them that the apartment and neighborhood weren't the best. Mukesha didn't see it that way at all. "For me, it seemed like a nice apartment with three bedrooms! I could share a room with my sister, and my room had a door that you could close! The fridge was stocked, we had vouchers, and we ate as a family for the first time in years. It's important to remember perspective—you can only see what you see based on where you are standing."

Mukesha learned that she was going to a place called "Kentucky" moments before she boarded the plane with her family. She googled the state and panicked when she saw mostly photos of farms. Flying over the state, she saw bridges and buildings and realized Kentucky wasn't only farmland.

## Chhuani and Lao
Battle Creek, Michigan

Chhuani and Lao were high school sweethearts in Zimte village, near Myanmar's border with India, until the country's political turmoil separated them for two decades. "We loved each other when we were fourteen-year-olds, but we did not say anything about love, because we were shy," says Chhuani. "We understood from our faces and our eyes that we were in love." Lao jokes, "I liked her, but she really loved me."

Chhuani grew up on a farm. Soldiers from a military base half a mile away regularly helped themselves to the family's livestock and vegetables. They forcibly enlisted villagers as laborers to work on a road being built, and to carry their rice, guns, and ammunition. Beginning at age fourteen, Lao carried sixty-five-pound loads day and night. He expected to do this unpaid labor until he died from it. "They didn't give us anything—no drink and no food." At seventeen, Chhuani moved to a different village and wrote a letter to Lao expressing her love. He wrote back that he felt the same.

In 2009, Chhuani paid an agent to help her escape to Malaysia, where she joined many others from the Chin community, which has faced heavy persecution in Myanmar since the 1962 coup. "We needed to save our lives. At the time, there was no other place to go." Malaysia doesn't recognize refugees so she lacked basic rights and couldn't work. Chhuani applied with the UNHCR for resettlement to a safe third country.

It was in Malaysia that Chhuani reconnected with Lao; they married in 2013. A year later, they moved to Michigan, where Lao's sister was living. Lao now works in an auto factory and Chhuani looks after their two children. Chhuani dreams of returning to Chin State. "We want to go back to our country when it is totally safe for everyone. We want to reunite with our family."

## Thomas
Sharon Hill, Pennsylvania

In 2014, Thomas, a peace activist from Liberia, attended a United Nations peace-building summer school in New York. Liberia was in the midst of an Ebola outbreak, and Thomas, scared to return, decided to stay.

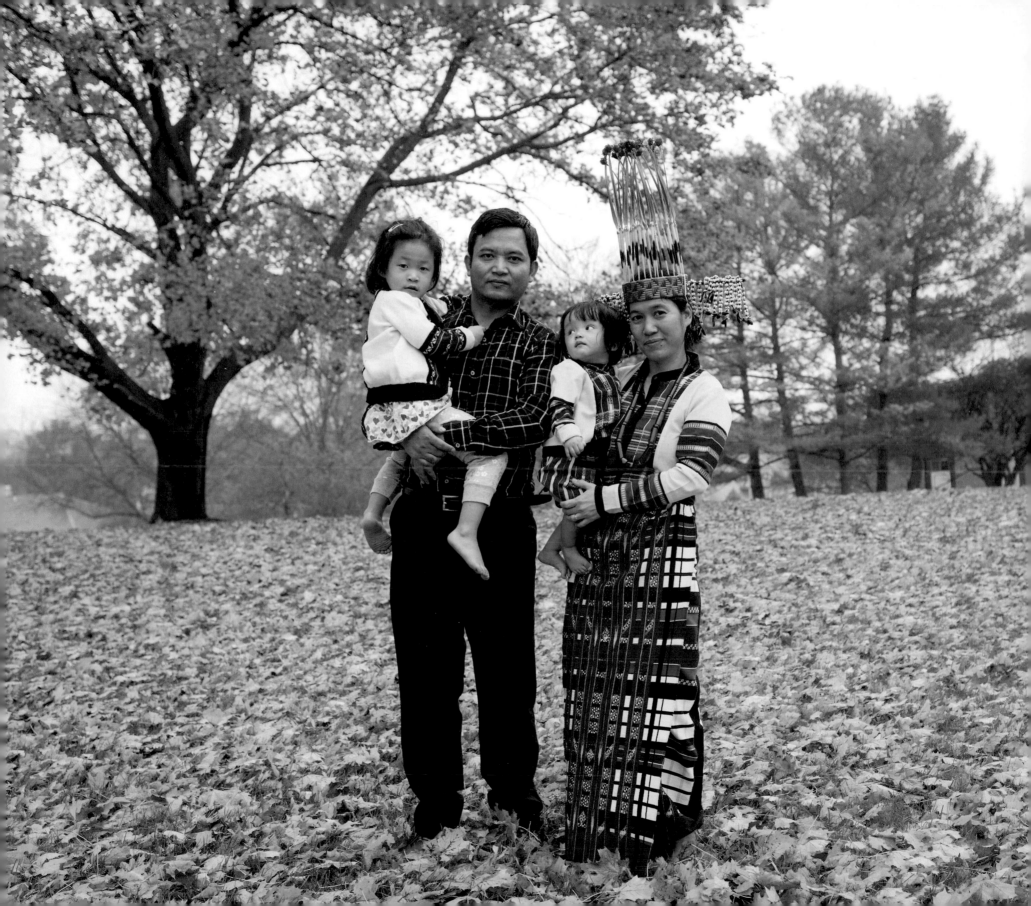

## Amal's Family
New Haven, Connecticut

In 2008, Aamir escaped unlawful confinement in a Sudanese prison and fled to Egypt with his wife, Amal, and their four-year-old son, Ahmed. After five difficult years in Egypt, an agency called Integrated Refugee and Immigrant Services helped them move to Connecticut. That first morning after their arrival is one Ahmed will never forget.

"I had never seen snow in my life, so I thought I was seeing flour on the ground. I figured that throwing flour everywhere was some sort of cultural tradition. I thought Americans were crazy! But then my mother explained to me that it was snow. When I went outside, I didn't wear anything heavy, so I froze in no time! It was cold outside, but inside it was warm. That was a good day."

Aamir learned to weld pipelines in Egypt; he washes dishes today but hopes to work as an engineer or pipeline inspector. Amal works in the produce section of Whole Foods and is studying English and culinary arts/baking. "We need to improve ourselves and improve our language," she says. "We must be one of them [Americans]. We came to this country, have our own culture and traditions, but we need to know about these people. At first, we felt like guests, but I think after five years we are a part of this community."

Amal (*left*), her husband, Aamir, and their son, Ahmed, all lived in an Egyptian refugee camp for five years after fleeing political persecution in Sudan.

## David

Norman, Oklahoma

David was born in Brownsville, Texas, to Mexican parents. His father worked for a cattle rancher. When he was seven, his parents bought a house and the family moved to Mexico, but when David turned eighteen in 1965, he learned that his mandatory Mexican military service would void his U.S. citizenship. He decided to move to the U.S. instead. He knew no English and hadn't finished high school, but his parents supported the idea and gave him a hundred dollars cash to help him get north. He didn't know where to go, but a family friend gave him the address of an old friend in Oklahoma, a Dr. Bartlett, so David boarded a bus heading there.

He reached Sapulpa, Oklahoma, with twenty-nine dollars left and sat in the bus station, unsure of where to go. A kind woman helped him find Dr. Bartlett, who had become a prominent community member and part owner of the hospital in town. When David met him, the doctor remembered David's family friend despite the decades that had passed. He took David out for something to eat, then showed him to an examination room and said, "This is your bed for tonight."

In the morning, Dr. Bartlett said he and his wife would like to help David. The doctor found him a job washing dishes at the hospital for five dollars a week along with a place to stay, and they hired an English tutor. "This man gave me such a positive attitude that nothing bad was ever going to happen in Oklahoma."

That September, David returned to high school while continuing to work at the hospital, where he was eventually promoted to lab tech. He married an Oklahoman, Carol, had two children, and taught Spanish and then art for almost four decades. "I was 'teacher of the year,' twice!"

"It's a happy story—there is nothing sad about it. I lived through it; that's why I get emotional thinking about it."

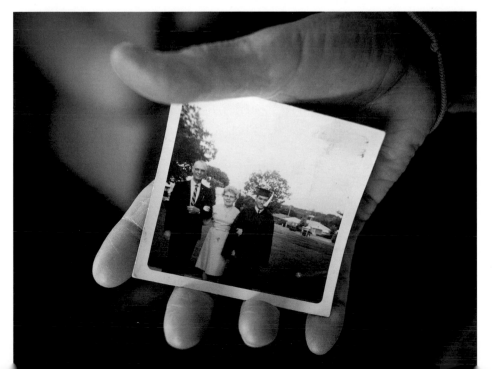

← At his high school graduation, David poses with the Bartletts, who helped him start a new life in the U.S.

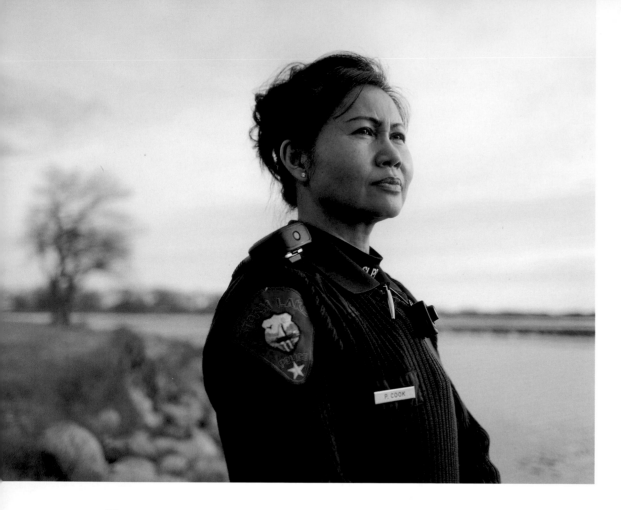

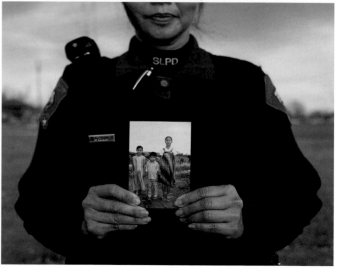

# Pom

Storm Lake, Iowa

After two years in a refugee camp, Pom's family moved to Iowa in 1981. Her new, mostly white classmates were curious about Pom. Shy and unable to speak English, she would nod and say yes to everything. One cold day during recess, Mark and Charlie threw snow at her playfully. The teacher came over after and asked Pom a question. She didn't understand but nodded and said yes. She soon realized she had confirmed the teacher's suspicions and had told on the boys. They avoided her after that.

Pom's first Valentine's Day was even more embarrassing. "We had to buy Valentine's cards for each person in the class, with a little heart candy to go inside. I asked my cousin, 'What do I write? What do people normally write?' He said, 'Write *I love you*.' I didn't know he was joking!"

↖ Pom is a community service officer with the Storm Lake Police Department. She was hired in 1992 to help the force better communicate with and serve the local Asian community. She taught officers not to touch people's heads when ushering them into cars, since the head is sacred in many Asian cultures. Pom also explained that eye contact isn't the norm in her community, so officers shouldn't interpret averted eyes as a sign of noncompliance.

↑ Pom holds a photo taken in 1980 of her, age thirteen, and her siblings in a refugee camp in the Philippines. She remembers borrowing the sandals for the photo since they were a newer pair than the ones she had.

# Ihssan

New Orleans, Louisiana

Ihssan graduated as a chemist but had to join the Iraqi army in 2000. When the U.S. invaded in 2003, he worked as an interpreter with American forces. "I saw a lot of blood lost—I lost three of my American fellows, and I've lost more than ten of my Iraqi colleagues." In 2007, Ihssan married and left the army to work in a hospital's tumor center.

Because of his previous work with U.S. forces and his views on democracy, he received death threats and on one occasion was shot at. After seeking help from the UN office in Baghdad, his family was able to move to Louisiana in 2009. For three years he worked the night shift at a gas station. "Can you imagine my wife—she didn't even speak the language—alone in the apartment with our children during the night? It was tough on her. During the first six months, I didn't even take a day off because our financial situation was so bad. I needed to stand on my feet again."

Ihssan began volunteering with the resettlement organization Catholic Charities Archdiocese of New Orleans, and it eventually turned into a full time position. "I am thanking God every day for having a job like this—helping refugees and immigrants. Because I was in the same situation, I can connect with them more than other people can."

"In 1991, Saddam rolled over people with his tanks. I saw that with my own eyes. It was a tough year, and I was only thirteen."

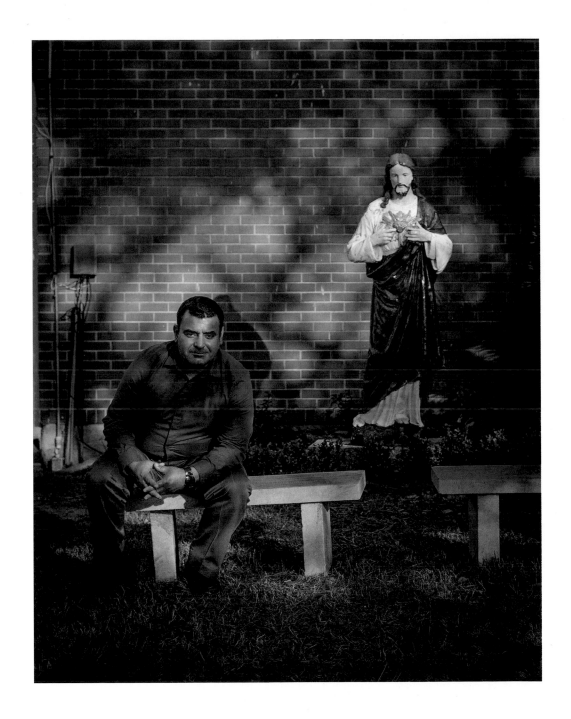

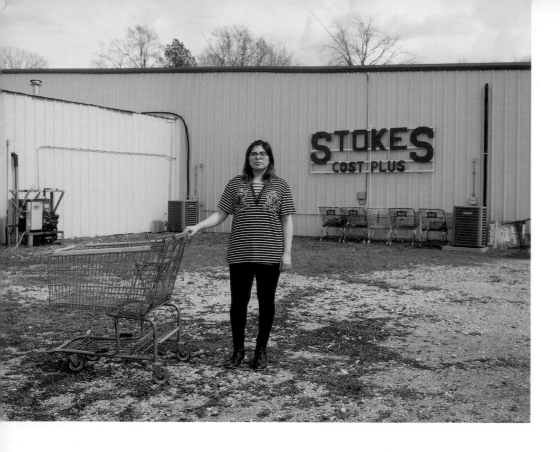

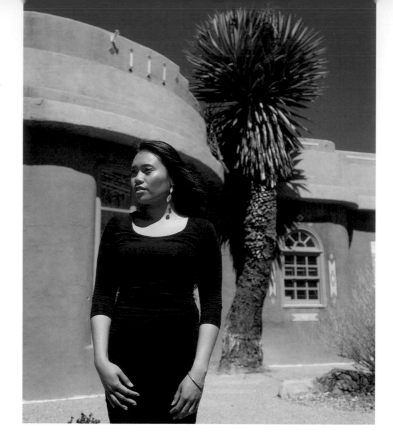

## Abi
New Albany, Mississippi

After arriving in Mississippi in 1999, Abi's mom, Rosario, worked in a furniture factory while Abi's dad, Roberto, worked in construction. Most places in town wouldn't cash their paychecks without ID, but Mr. Stokes, at the general store, was sympathetic to their situation. He cashed their checks and then asked what they missed from home. They said tortillas, which they couldn't find anywhere at the time.

"Mr. Stokes asked my parents for a list so he could order Mexican products for the store. He was one of the few people who supported immigrants in this community. Whenever we went to his store, he always told me I could take one candy."

## Maggie
Albuquerque, New Mexico

"Although I attended an English school in the Philippines and spoke fluent English, I still had a pretty heavy accent when I first arrived in New Mexico. I remember doing a spelling bee and incorrectly pronouncing the word I was given. The word was *beach*, but with my accent I pronounced it as 'bitch'—in front of the whole school. I'm still a little upset about that, but it pushed me to perfect my American accent.

"My biggest issue at school, though, was during lunchtime, and that's because I brought my own food—Filipino food. One time I brought 'bihon,' thin clear rice noodles with peppercorns. This girl thought the peppers were eyes and said, 'Oh my god, are those worms?' After a while, I asked my mom to pack only rice and chicken for my lunch."

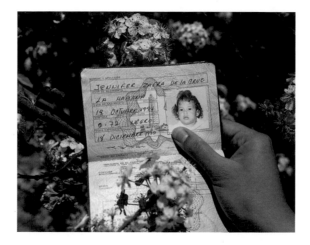

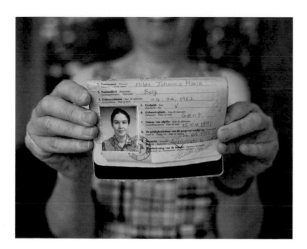

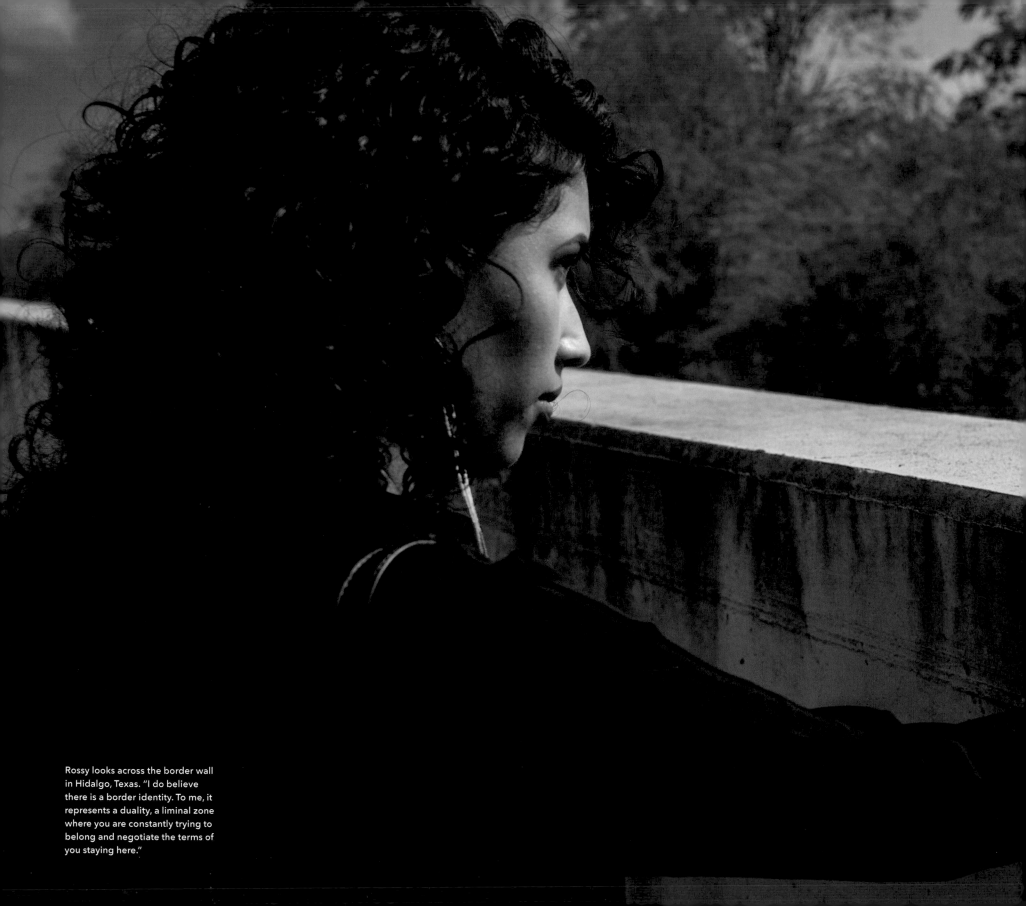

Rossy looks across the border wall in Hidalgo, Texas. "I do believe there is a border identity. To me, it represents a duality, a liminal zone where you are constantly trying to belong and negotiate the terms of you staying here."

# BORDERS

# Rossy

Donna, Texas

Rossy was twelve when her family moved to southeast Texas, near the Mexican border.

"When I arrived as an English as a second language student, I was taught by the 'special education' department. That label hinders the possibilities and the self-perception that you have. I believe it is one of the main reasons that you have so many dropouts in our community. You are constantly being labeled as someone who is "at risk"—only because you speak Spanish. It becomes a self-fulfilling prophecy."

As a teenager, Rossy used to get anxiety attacks just thinking about the border; seeing a border patrol vehicle would send her into a panic. She tried to avoid them, but they are ubiquitous in a border town. Today, she isn't avoiding anything.

"You have to confront your fears. By confronting them, I am owning the effect they have on me. I still get shaky. Recently while at the border wall, I saw clothing on the ground that made me freeze. I remember that experience of having to take your wet clothes off and changing into dry ones after crossing the river. It was a flashback. It took me a second to realize that I am not there. I am on the other side."

Rossy still has an accent, unlike many of her friends. "Why do I still have an accent if we came at the same time? Maybe that's why I went on to study linguistics. To me, my accent represents my identity and I've embraced that. For my other friends, it has been easier to navigate the system, but I believe they have also lost that connection to their culture."

"Since my grandfather Manuel was of Cuban descent, he always felt he looked his best while wearing a guayabera—a traditional shirt. I put the shirt in a plastic Ziplock bag to keep his smell on it." This is the last photo Rossy has of Manuel, who passed away in 2016.

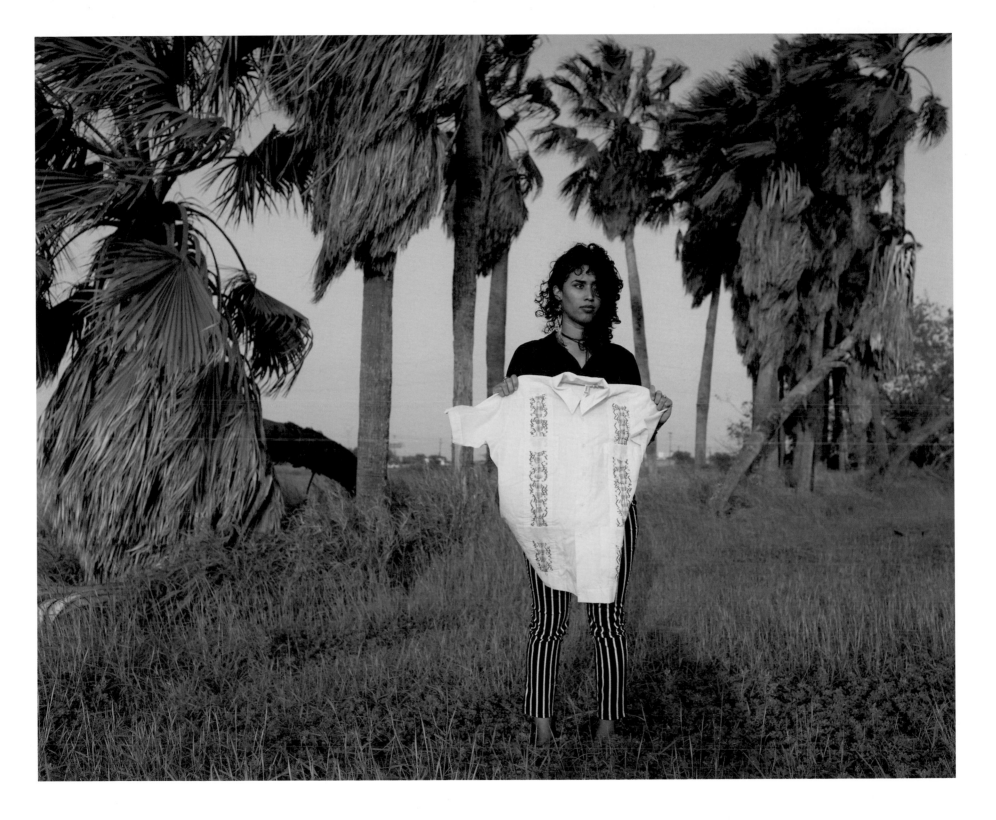

## Isabelle
Astoria, New York

Isabelle was born in Brazil and, from age eight, grew up in Queens. She got her first job by applying with some "pretty shady fake documents." To get them, Isabelle went to buy empanadas, gave her information, and left holding a bag of empanadas with documents at the bottom. "I had to do it. I had to work," but she always feared getting caught.

DACA enabled her to go to college, where she studied political science, and to find work she loves as a paralegal for the Veterans Justice Project at the New York Legal Assistance Group. But Isabelle knows DACA is temporary.

"I'm at the point where work authorization is not enough. I am as American as any of my peers, and I want the government to recognize that. I deserve the same rights and protections. The DACA program is not enough for me, and it's not enough for a lot of other people."

"I still love Brazilian food and music, but at the end of the day I'm just a kid from Queens."

## Ximena
Miami Beach, Florida

Ximena's family left Peru in 2006 and arrived in Florida with visas, but when her father's job fell through and he couldn't find another sponsor, Ximena, a senior in high school, became undocumented. When DACA was announced in 2012, Ximena applied immediately.

"I don't think I had ever felt that amount of hope before. It was like a bright light was turned on. On a rainy, miserable day in December, I checked online and saw that I was approved. I fell on the ground with happiness." DACA allowed Ximena to get a university degree and a work permit, and now she is a full-time Montessori teacher.

Ximena keeps cards she has received from her students as a reminder of the difference she makes in their lives.

# Shuangyi

Santa Fe, New Mexico

Shuangyi left school at age thirteen after a clash with the headmistress. School is compulsory in China until senior secondary, so Shuangyi had to hide during school hours to avoid a penalty. When she did venture outside, she wore an old school uniform. Shuangyi continued her education with self-directed learning. She entered China's biggest English-language competition, hoping a good result would help her get into college. She won the provincial level, earning a place in the national competition in Beijing, but when organizers noticed she hadn't listed a high school, they disqualified her. She realized that without a high school diploma, she wasn't going to college. She felt stuck.

In 2008, at age fifteen, Shuangyi volunteered at an international conference for animators. She gate-crashed a party and happened to sit beside a white man named David. They started chatting and, thinking he seemed trustworthy, she told him her story. He suggested that she travel to the U.S. to study, pointing out that homeschooling was common in the U.S. and not a barrier to college acceptance. David, who Shuangyi now refers to as her "American Dad," sent her books and coached her through the SAT prep—and she got into St. John's College.

This gave her I-20 status, meaning she could study in the U.S., but it did not help her enter the country. For this she needed a travel visa. Her application was rejected twice. A third rejection would have barred her from applying for ten years; fortunately, it was approved, and she arrived in 2012 to study liberal arts and science. It was her first time in a classroom in seven years.

"My American dad was disillusioned with the whole immigration process. He believed America was this country that welcomed everyone. It wasn't until we tried to get me here that he realized the kind of hidden xenophobia that exists in every step of the process."

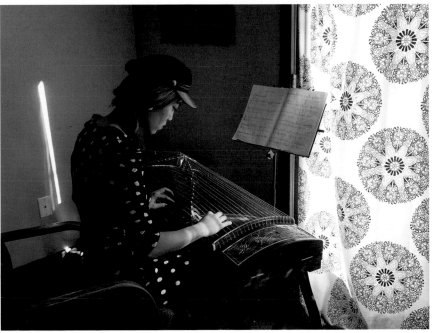

→ Shuangyi plays "Ode to Guizhōu Province" on her "ghu zheng," a twenty-one-string zither, at her home in New Mexico.

# Analisse

Waterford, Connecticut

Analisse moved to Connecticut in 2004 to play collegiate soccer and study education. Shortly after she began teaching, she met Amy, another educator. On Sundays, they went to Harkness Memorial State Park to work—or at least pretend to. "We brought a blanket and some food and wrote lesson plans. We ended up talking most of the time. I would have to go home after and actually do work!"

When Analisse tried to renew her work visa in 2011, her lawyer made a small clerical error; by the time she learned of it, the renewal deadline had passed and her visa expired. Analisse had to fly to Bolivia to restart the application process—all while helping Amy plan their wedding, which was a few months away. "We were both crying the entire month she was gone," Amy says. "That made our wedding and her green card that much more meaningful."

Analisse and Amy would like to see changes to the immigration process, which depends heavily on whether you can afford a good lawyer. "It is no wonder that people are coming here illegally; it's hard and expensive, and you have to have a lot of connections to do it legally," says Amy.

↗ Analisse holds a photo of her emotional reunion with Amy after a month of not knowing when they would see each other again.

→ Analisse grew up playing soccer with her dad and brothers and went on to play for Bolivia's national team. Today, she is a coach with Connecticut College, the school she came to study and play at when she was eighteen. "Every time I put on my cleats and am out on a soccer field, there is a special feeling that it brings back."

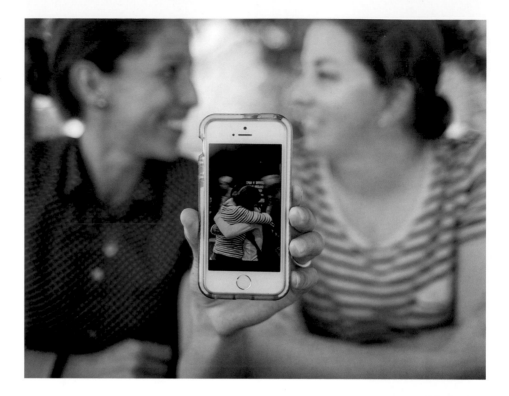

## Laura
Chelsea, Massachusetts

Laura's hometown, San José de la Montaña, is extremely religious, with a seminary and multiple convents. "When I was young, I didn't believe any of it, so I felt like an outsider. 'Why am I different from everybody?' When I was nineteen and figured out I'm gay, that made it worse. Being gay in my hometown is like having a contagious disease." It helped that she could confide in her mom, also a devout Catholic, who has always been open-minded.

In 2001, Laura moved to the U.S. on a student visa. She stayed after its expiration, unable to visit her family in Colombia for nine years. "You don't have security—at any moment they are going to send you back. I had nightmares about being sent back to Colombia."

Laura has worked at a variety of jobs in the U.S., including cleaning, fast food, a flower factory, car wash, wedding catering, and as a medical interpreter. In 2022, she started a master's degree at Johns Hopkins.

↖ Laura's mom made this rug before giving birth to her. "Since I was born, I have always had it in my room. Knowing that my mom made it makes it extra special."

← When Laura (*left*) moved out of her apartment in 2015, she was in the midst of her citizenship application and didn't want to miss any important mail. She asked the new tenant, Sharon, if they could keep in touch, and a love story began.

# Thibault

New York City, New York

"Realizing that the migration process can be challenging for a white male from France really puts things in perspective. If someone is a woman, transgender, dark-skinned, or coming from the developing world, you can imagine the type of hell they may have to go through."

↑ Thibault's mother gave him this photo of his great-grandparents Alexandrine and Adrien. "I think she looks very exotic in this picture—so young, pretty, and innocent. When I look at this picture, there is something exciting, and it makes me ask questions about our family's origins."

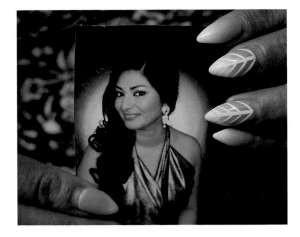

↑↑ Mayra shows a photo of her cousin Laura. Mayra wasn't able to attend Laura's funeral in 2018, which was just a couple of miles across the border, nor the funeral of her father, Eulalio, in 2021. She was approved for DACA, which allows her to fly within the country, but she can't cross borders.

↑ Mayra's grandfather gave her this rosary to protect her. While driving in an ice storm in 2009, she was hit by a sliding car; as her vehicle spun out of control and hit a wall, she looked at the rosary hanging from her rearview mirror. After the accident, she had it tattooed on her ankle.

## Mayra
Oklahoma City, Oklahoma

In 2000, when Mayra was eight, she crossed the border into California, where she met her grandfather Ignacio for the first time. When Ignacio petitioned for them to become legal residents, Mayra's mom hired someone who presented herself as an immigration lawyer but was in fact a deceitful notary. Their documents were accepted, but the notary never told Mayra's family about a meeting they were supposed to attend, and the application was rejected. Her mom was too afraid of deportation to appeal the decision.

"We found out later that this notary was crooked. She was taking people's money—taking their dreams away. A lot of people hired her and are now in a situation where they cannot get their status because of her."

# Adriana
Oakland, California

When she was five, Adriana's family moved from Mexico to Oakland, where her father's cousin lived. Adriana remembers "playing asleep" in the van, and that her name was "Isabel." In Oakland, her father drove a meat truck and her mom worked in a factory making USPS mailbags. Sometimes she brought home bags, and Adriana and her two brothers helped thread the rope ties.

Adriana learned in high school—when she wanted to apply for her first job—that she was undocumented. She had to use fake documents, including a Washington State driver's license. Once, Adriana was pulled over and the police officer asked why she didn't have a California license. She wishes she could have told him the truth: she wanted one but wasn't allowed to get it.

In 2010, Adriana was waiting at a bus stop in Oakland when two men approached her. One put a gun to her chest and demanded her phone and wallet. "After that, I couldn't sleep and when I did, I had dreams of people being shot—of me being shot. I couldn't get on a bus and if I was out, I was paranoid and thinking people were following me."

While searching for PTSD resources, she came across the U visa. "The sole purpose of the U visa is to bring people out of shadows to report crimes that they've experienced, people who otherwise wouldn't because of their fear or being undocumented."

After raising legal funds, she needed to get medical evidence of her suffering. HealthPAC, an Alameda County program for low-income residents, provided her with a doctor who diagnosed her PTSD and helped her with a year of paperwork. In 2013, three years after being mugged, she received a work permit and driver's license—and felt amazed by her future possibilities.

↗ Adriana shows the driver's license she got in high school. She lived in California, which required a Social Security number to get a license, whereas Washington did not.

→ After being mugged, Adriana needed money for a lawyer to help her pursue a U visa. Her dad gifted her his old sewing machine, and with it she made and sold $1,500 worth of bow ties through social media.

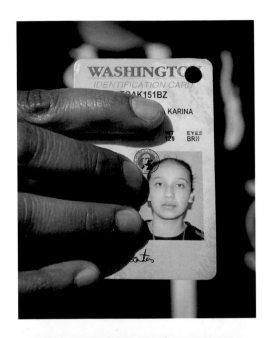

# Karla

Lakin, Kansas

After her parents' divorce, Karla and her mom, Micaela, migrated to Liberal, Kansas, where Micaela worked twelve-hour days on a hog farm. Micaela met a man who seemed nice but, they soon learned, was violent and abusive when high. Karla, who was seven at the time, remembers him suffocating her mom, dragging her along concrete, nearly running them down with his truck, and threatening to kill her and her brothers. He often left her mom with ripped clothes, black eyes, a bloody nose. He told them they'd be deported if they told anyone.

"We always lived in the shadows. I grew up scared, quiet, and without a voice. I never wanted to be recognized as an immigrant. You don't want anyone to know your story, because what will happen if it gets to the wrong hands? Deportation, being separated from my family, or simply being humiliated because of my legal status were some of my biggest fears."

Karla couldn't afford college, and her status disqualified her from financial aid. At eighteen, she ran away with a boy, whom she married and had a son with. They divorced in 2013, just as she got DACA. Karla could finally get a driver's license and a job that didn't have to pay her in cash.

She now lives in Lakin, the hometown of her husband, Jess, and works at the local hospital as a liaison to the Hispanic community. Karla—the only Spanish-speaking person in her office—can empathize with the community members she assists: people without health insurance or transportation, people who are afraid of ICE.

"I don't want others to have to be afraid and live in the shadows like we did. We all deserve to be happy and healthy, regardless of our immigration status. I'm happy now, but I want more people to be happy."

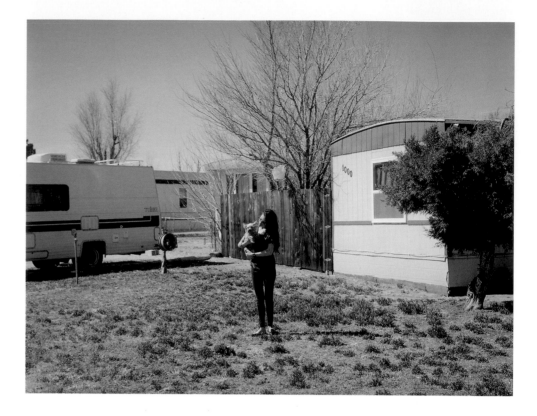

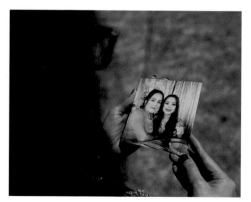

↑ Karla's passport with the stamp from when she entered the U.S. on a tourist visa as a child. "I brought this with me when I returned to Mexico twenty years later."

↗ "My mom might have hated it, but I wouldn't have known. She did always tell me, 'I don't want you doing what I'm doing, having to work like this.' I admire that lady."

↖ Ready for baseball practice. At her son Yadiel's age, Karla would have loved to be on a team, especially cheerleading, but her mom couldn't afford it.

↑ Karla got this tattoo to represent the freedom she felt after divorcing her first husband and getting DACA.

# Patricia

Harpers Ferry, West Virginia

Patricia's family moved to the U.S. from Venezuela when she was six. She participated in student government in her youth, but after getting married and becoming a mother of five, she gave up on politics. Gaining her citizenship in 2004 rekindled her political ambition.

"It was around the time Sarah Palin was running. I remember that I thought she was exciting; she also had five children and was going to be the vice presidential candidate. I took the children to one of her rallies and was inspired by her story."

Patricia learned that since many candidates in her county ran unopposed, they didn't participate in debates or even share a platform with voters. "I just thought, that's undemocratic!" She began recruiting candidates who she thought could do a good job. In 2013, she couldn't find a Republican candidate for the House of Delegates (West Virginia's lower legislative body), so she entered the primary herself. "Literally, on the night before the election, after a lot of prayer and good advice from some friends and discussion with my husband, I decided to put my name in as a candidate. It was crazy—I didn't know what I was doing." She won the primary but lost the general to the Democratic incumbent by fewer than three points. Three years later, Patricia answered "a call from God" and ran for state senate. She is now serving her second term.

"The decisions I make come from how and what I believe, and that is my faith and my church. I feel that my faith is who I am and my number one priority. Everything I do, I do after prayer. I hope to be a good person and serve people as Jesus did."

Patricia may be a Republican state senator, but she doesn't agree with the party on everything, especially immigration.

"There should be a path to citizenship for law-abiding American immigrants. Don't just say, 'No, there is nothing for you.' I wouldn't have married my husband in order to stay, and this country would have lost out. If you create that pathway, then you can legitimately tell immigrants they had a path; and if they haven't stayed on the path, then you deport them. But if you don't give them a path, how can you send them back and tear families apart. A pathway would make it a more moral process."

Patricia is a state senator and a devout Catholic. "People here in America have this separation of church and state, but there's no way I can separate them. I believe in families and in serving and acting like Christ."

# Margaret

Palacios, Texas

Margaret landed in Texas with her husband and young sons in 1981. She got a permanent green card (which isn't offered anymore) but never considered becoming a citizen. As a British Texan, she felt she contributed to the country through her work in literacy, education, and social justice, if not through voting. Becoming a grandmother, though, extended Margaret's American roots more deeply, and she decided to seek citizenship. She soon became a figurehead for principled irreligion and nonviolence—two beliefs that are antithetical to the current citizenship system.

At the Houston immigration office, the clerk told Margaret she had "missed a box" on her application. The box asked: "Will you bear arms for this country?" Margaret said, "I'm not prepared to bear arms. I'm a conscientious objector." The clerk told her to just check the box—that since she was an old lady her service would never actually be requested. Margaret refused to lie. She was told to write a statement explaining her objection, but when she returned with it, they didn't accept it, and again the clerk encouraged Margaret to lie—moments after she had been "sworn in" and promised to tell the truth. She learned that conscientious objector status requires two church deacons to verify membership to their church—and that the church opposes violence. Margaret doesn't have a church and still refused to lie. "They didn't get the point. I'm not going to do something just to get me through the system."

The Freedom from Religion Foundation learned of Margaret's plight, and the immigration office received hundreds of letters in her support. After Fox News and BBC interviewed her, a local congressman took up Margaret's cause, and soon after she was told she could become a citizen without ticking the box.

Margaret was also informed she would be taking an alternative citizenship oath that didn't involve God or bearing arms, but on the day of the ceremony the judge just read the usual oath and asked everyone to say "I do." Margaret never said a word but still got her citizenship. "The experience was so disrespectful and dishonest. Honesty was the thing that kept coming up from the beginning to the end."

↑ Margaret and Edith hold a photo from their first trip to Palacios. They met at a playground in the 1980s and a friendship blossomed as they carted their young children to and from school together. In 1985, as Edith's family was about to move to Seattle, the two decided they deserved a "mothers' getaway" before she left. They enjoyed a "sublime and ridiculous" week together in Las Vegas, a vacation that "led to a twelve-year odyssey and the discovery that we were more than just friends," says

Margaret. "It took us a long time to see that in ourselves and in each other, and to work out the logistics of not being married anymore. It was a long and exciting journey."

→ Margaret, an avid birder, knows her path to citizenship was easier than that of many other immigrants, so she wanted to use her privilege to bring attention to injustices in the system. "They wanted to have me here—but they wanted to have me because of the color of my skin."

# Christian

*Union City, New Jersey*

The restaurant Christian's father ran in Peru wasn't doing well, so he moved to the U.S. to work as a custodian and sent money back to pay for schooling for Christian and his twin brother, Nicholas. Their mother's heart broke when Nicholas told friends he didn't have a dad. "My mom didn't want us to grow up without a father figure, so she sacrificed it all, left her family, and moved us to the U.S. so we would grow up with our dad." After three years, they joined him in Union City, a predominantly Latino town where you can find a Salvadoran, Peruvian, and Colombian restaurant within a single block. "If you don't speak Spanish, you might feel a little out of place."

Some health scares have challenged Christian's family. "My dad had cancer and my mom had a brain tumor. These experiences were traumatizing because as undocumented people you lack access. If you have cancer, you think of chemo and radiation therapy, and without insurance, this is like a death sentence." Thankfully, they found Charity Care, an initiative that provides surgical and oncological care to New Jersey residents for free or at a deep discount.

Christian knows such care isn't available to everyone—most undocumented people lack access to what should be a basic human right. "My mom had to think twice about seeing a doctor for a broken arm because we couldn't afford it."

↗ Christian graduated from Stanford Medical School in 2022 and is considering a career in neurology or emergency medicine. "I'm not going to let this dream die. My parents didn't come to this country and sacrifice their life in Peru for me not to make my dream come true. I know it's going to happen."

→ Christian's mom proudly holds her new twins, Christian and Nicholas. Christian says his brother is his "everything." "I have literally felt his pain even though I wasn't hurt."

## Edgar
Austin, Texas

When Edgar was in high school, he wanted to get braces, but his family had no dental insurance. His mom's undocumented friend recommended an orthodontist who charged affordable rates. During what was supposed to be a consultation visit to the home dental office—patients waited in the living room—Edgar got his braces and was told "in six or seven months, you'll be good." He returned months later to have them removed, but the orthodontist's wife, who answered the door, said her husband had been arrested for practicing illegally. Edgar's braces stayed on until the next year, when he went to college.

"I was about to meet my new roommate, so when I arrived at my dorm, I was like, 'I've gotta get these braces off.' The wire was digging into the side of my mouth, so I grabbed some pliers, stood in front of the mirror, and just pulled every single bracket out—except the one I still have on my tooth."

Edgar shows the last remnant of his braces, which he pulled off with pliers. "A lot of Americans don't imagine that these things happen—they think you can just go to the orthodontist and get them on and get them off. But it's kinda challenging when you don't have access to the funds to pay for that."

## Johanna
Newark, New Jersey

Three years after arriving from Ecuador in 1996, Johanna was elected student council president. For more than a decade, she's worked with the New Jersey Alliance for Immigrant Justice. Since obtaining her citizenship, she feels obligated to use her privilege to help immigrants who are still undocumented and hopes others in her situation will feel the same.

"A lot of people who were once undocumented don't feel comfortable sharing their story. There is a sense of trauma and loss that comes with having lived like that. But we gotta do it. I think it's irresponsible to think that currently undocumented people should be the only ones saying something."

# Humberto
Fort Smith, Arkansas

Humberto was six when his parents moved him north. He did well in high school, placing seventh out of one hundred and twenty students in his senior year. At the graduation ceremony, when each student was called up to the stage and their scholarship money was announced, the student who placed eighth received $45,000 while Humberto received only $750. Everyone looked at him with confusion; he felt ashamed.

When Humberto registered at a community college, the receptionist asked why his application was incomplete. He hadn't listed a Social Security number. "I told the lady I didn't have one. She looked at me as though I was some sort of strange creature and asked, 'Were you born here?' I replied, 'No, I wasn't.' The next question that came out of her mouth was, 'Are you illegal?' Everyone in the building could hear what she was saying. I said, 'I'm undocumented.' She left for a while and came back and said, 'We are going to have to charge you out-of-state tuition. How are you going to pay for this?' I said, 'Cash.' Besides being attacked because of my status, I felt attacked because she thought I couldn't pay for it. I pulled out a wad of cash I had earned from being a busboy and dishwasher at a local Mexican restaurant—my first payment toward a course. I felt like she wanted to ask me how I got that money. I tried to be as confident as I could, but deep inside I was shaking to the core."

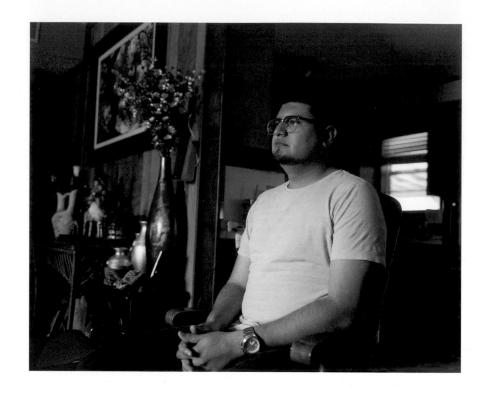

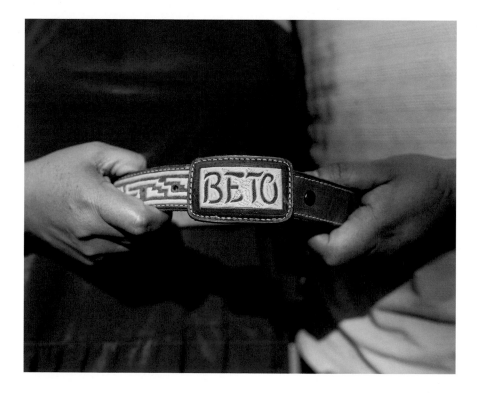

↗ Humberto's immigration status left him feeling helpless. "I started thinking, 'What can I do? This country doesn't want me, and I can't go back to Mexico.' Some people have told me I demonstrate leadership skills. Could I possibly be a person who could bring people together and create change? People made me realize that this is something I can do."

→ "My mom worked as an artisan in Mexico, embroidering leather belts and selling them at the local market. This beautiful belt, with my name embroidered on the buckle, is one of the few items I still have from my childhood."

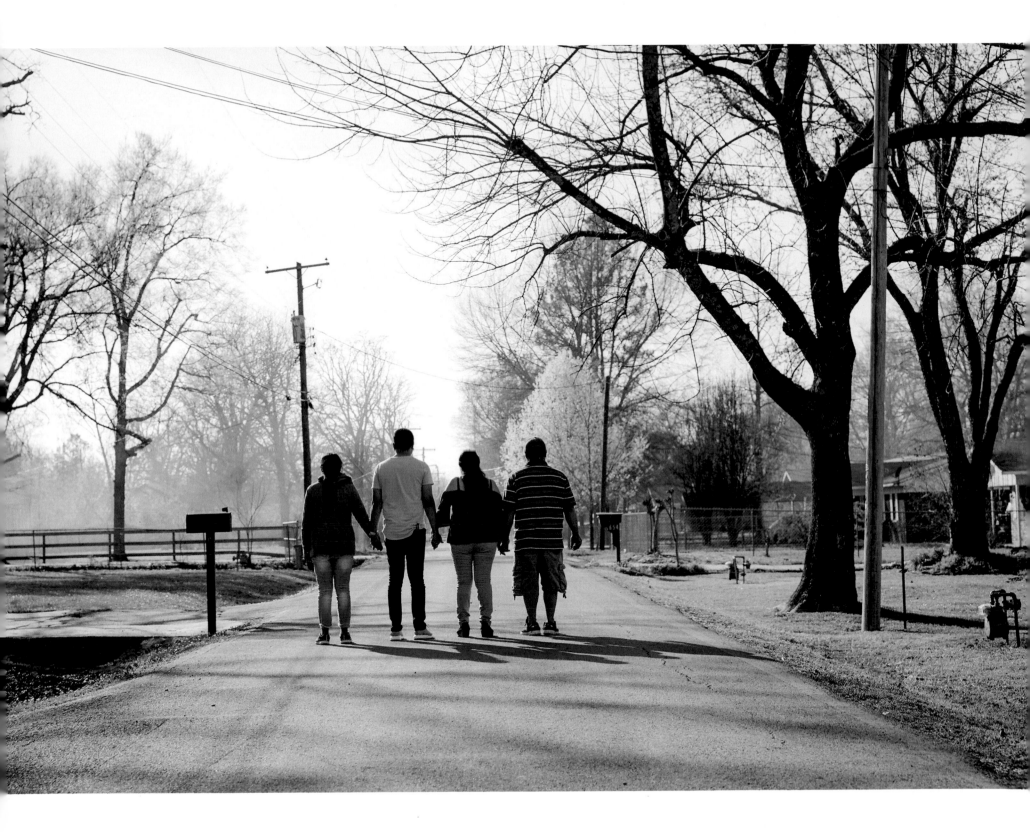

## Sabato

Northampton, Massachusetts

As an undocumented immigrant from Brazil, Sabato was always told he couldn't go to college. He applied anyway and navigated the application process without disclosing his status. The risk of deportation worried his father. Sabato was accepted at Amherst College in Massachusetts and immediately faced another challenge caused by his status: how to pay the $50,000 annual tuition without being able to apply for financial aid or find a well-paying job.

To raise the money, Sabato and his father flipped merchandise online. The business began when Sabato wanted a full-size keyboard to learn classical music; his father found a distributor with great prices, so they started selling them on eBay, with Sabato handling the listings and customer service. Together, they made enough to pay for three and a half years of Sabato's university degree.

# Yuli

Little Rock, Arkansas

Yuli's father had been going back and forth to the U.S. to work in the potato fields of Louisiana for many years. When her mom moved north to join him, Yuli stayed with her grandmother for a year, until her parents found a coyote and told her she was leaving Michoacán. Yuli, eleven, cried as her grandmother took her to the bus stop. "I didn't want to come. I was mad at the world."

She walked through the woods for an entire day and then had to hide on the floor of a car for three hours. She couldn't feel her legs after a while—and won't forget that pain. "It was hard crossing the Rio Grande and thinking of the people who had died trying. To this day, I don't know how to swim."

In Bastrop, Louisiana, they lived in a single room and had to go next door to use the restroom. The only other Spanish-speaking person at Yuli's school was her younger cousin. "Honestly, graduating high school was my biggest accomplishment."

When DACA was announced in 2012, Yuli hoped it would allow her to go to college and get a good job, but her application was denied. To be eligible, she had to have entered the U.S. before March 2007. She had arrived in December. After high school, Yuli moved to Little Rock with her parents and started bussing tables. She got a job at IHOP, but when they found out she was undocumented, she was fired. Now she is a server at two Mexican restaurants and still lives with her parents. She is tired of people asking her why she hasn't started college.

"I totally agree that I should go to college, but I'm just so lost in how to initiate my journey. I know that if I was secure—that I'm not going to get pulled over anytime and forced to leave the country—it would be easier. I'm not looking for anyone to feel sorry for me. I do hope to open the eyes of those who are against immigration reforms. I'm here working for what I have. If we ever have a DREAM Act and I could get a work permit, it would be so nice."

↗ Yuli is ineligible for DACA and worries about her future. "Being a waiter is tiring. I don't want to do this forever, but what are my choices? I want to be able to help my parents when they are older . . . I think about going back to school."

→ Yuli holds a photo of herself at her grandma's in Michoacán.

# Nithya

Washington, DC

"I do this work because I care about kids." As a director of the children's program at Capital Area Immigrants' Rights (CAIR) Coalition, Nithya worked with children in six detention centers in Virginia and Maryland.

"One thing I think is important for people to understand as a basic premise for why CAIR Coalition exists, is that immigrants—even children—don't have the right to appointed counsel in immigration court. They have the right to have an attorney, but if you are a child immigrant from Central America who has no financial resources and you don't speak the language, how are you supposed to hire an attorney? We have a system set up where the government has an attorney but the child migrant who is trying to apply for asylum doesn't. I represented a young woman from Central America over a period of about two years. For the first year, she didn't disclose anything. We knew something had happened, because she seemed so traumatized and shut down. A year into working with her, she started opening up. We learned that she had experienced violence in her home, trafficking, and a few attempted migrations to the U.S. She is a survivor of many kinds of violence. I've worked with hundreds of kids, and this is a story I will always remember because of how much she went through. She was granted asylum recently. When we got the decision at the asylum office, I told her, 'This letter means you can stay here.' She said, 'I feel like I can breathe again.' She felt like she had been holding her breath for two years."

→ Nithya holds a drawing that a local schoolkid made for her to give to children in detention.

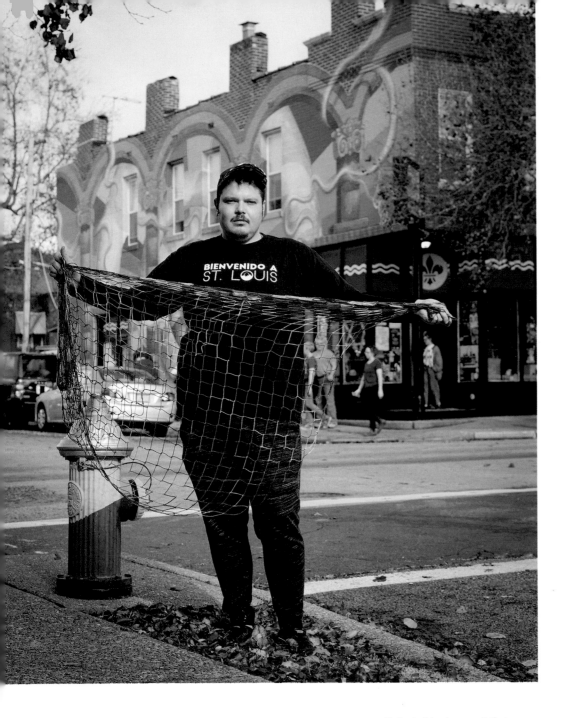

Carlos holds a hammock that his dad knit for him in Colombia, while wearing one of the shirts he sold to raise funds for his dad's immigration paperwork. The fundraising initiative received incredible local support.

## Carlos
St. Louis, Missouri

"I grew up while the cartels in Colombia were fighting each other. You would hear car bombs go off or about how your neighbor's kid got kidnapped." While Carlos's parents lived amid fear and tension, they ensured that Carlos had a "normal" childhood, for the most part. "I remember the look in their eyes when there would be an explosion somewhere. This look of worry, like, 'What are we going to do with this kid? How are we going to raise him here?'"

Two years after his parents separated, his mom moved to St. Louis to be with a man she had met. The plan was for Carlos to join her when he was fifteen. Knowing his son would be leaving in two years, Carlos's father, Luis Carlos, tried his best to make their last two years together memorable.

Carlos knows he was able to take a much easier path to citizenship than many immigrants. When his mom married her American boyfriend, Carlos got a permanent resident card and then became a citizen. "The first call I made once I got out of the citizenship ceremony was to my dad."

With his status, Carlos petitioned for his father to move to the U.S. too—a much more arduous process than he imagined. First, he needed to make more money to prove that he could provide financially for his dad; and then he needed to spend a lot of money on paperwork. He sold T-shirts to help raise funds, and Luis Carlos arrived in the U.S. on December 20, 2021.

Centerville Middle School
Renaissance
Student Of The Year
Carlos González
2005

# Carlos

Lancaster, Pennsylvania

After his father passed away when Carlos was eight, he saw how his mother struggled to pay their bills. "Education felt like the only way I could regain a sense of security, so I began to take my studies very seriously. I remember walking into my classroom on the first day of school and feeling tremendous pressure to do well. I was aware of the sacrifices my mom had made to move to the U.S., all so that my sisters and I could have access to better education and quality of life."

Carlos was named student of the year three years after arriving in the U.S. without knowing any English. Today, he is studying law at Harvard. To enable his opportunities, his mother sacrificed her own dreams, and her health: she has arthritis caused by working in various labor-intensive settings, from factories to trash-processing plants. "I hope my mom has the opportunity to step out of the shadows, legalize her immigration status, and pursue her passions."

Carlos knows he couldn't do the work she does, and he's never heard her complain. His mom, and people like her, is his motivation.

"People who are undocumented can be your neighbors, your classmates, or your colleagues. Hearing our stories humanizes us and helps to build solidarity. People who might be opposed or hostile to the undocumented community, change once they realize they know one of us. It's crucial, especially in this political climate, that we tell our stories."

## Isabel
Billings, Montana

Isabel and her four siblings were born and raised in Montana. Their father, Francisco, crossed into Arizona when he was a teenager and has lived in Billings since 1999. He has citizenship now, but it wasn't easy. Isabel knows well the struggles many undocumented people endure. None of her peers, as far as she knows, has an immigrant in their family, so she tries to be open in sharing her family's story—but it isn't always welcome. "There are students at school who are racist and don't accept me for who I am."

Isabel says she has regularly experienced adults in Billings who "just assume I don't belong here." She was in a friend's vehicle at fifteen when police pulled them over. After running their names, he came back and asked specifically to see Isabel's state ID card, but she was carrying only her school ID. "He said, 'Do you understand what I'm asking?' like three times. More cops came, and then we had to get out of the truck while they patted us down and searched the vehicle. I didn't feel comfortable. I felt secluded—like I was being singled out—and I didn't understand why."

## Chris
Nixa, Missouri

Chris bought a one-year subscription to a dating site in 2013, and for the first eleven months, none of his messages to matches were returned. With his subscription nearly expired, Chris got a message from Becca. They chatted for a month, then Chris, who says he takes relationships very seriously, took a break to figure out his emotional state. He called a trusted friend from Bible college looking for advice. "He was like, 'Do you both love Jesus? Do you both want to get in a relationship that may lead to marriage? If the answer is yes, then just do it!'" Chris told Becca he wanted to pursue a relationship with her; fortunately, she forgave him for ignoring her messages for two weeks.

In early 2015, after asking her father for permission, Chris proposed to Becca. Since her job as a hospital pharmacy tech paid more than Chris's Starbucks job in London, Ontario, they decided to start their lives together in Missouri. "Planning a wedding across a border sucks, especially when you can't be together in person. It's awful when you are waiting on immigration to get back to you, and you don't know when you can move. You can't set a date, so you set a lot of half plans."

# Jorge
## Englewood, Colorado

When they met in 2001, Jorge had been in the U.S. working since he was twenty-three, and Christina was trying to end an abusive relationship. "Jorge was too nice, and that scared me at the beginning. I didn't know how to accept kindness and love, so I pushed him away." Christina met someone else and got pregnant. She planned to raise the baby and her two young daughters alone, but Jorge's love never wavered; he assured Christina he would treat her children as his own. They married in 2005. "He raised Dyego and loves him with all his heart. He has given him everything he can from the time I told him I was pregnant. Jorge has never denied any of my kids love and support."

In 2007, they went to the American Embassy in Juárez, Mexico, for a permanent residency interview. Despite Jorge never having been in legal trouble, the interviewer said there was "something" on his record, so Jorge was refused reentry to the U.S. Christina went home alone, and days later Jorge paid a coyote to help him cross illegally.

A few weeks later he was pulled over, asked for his papers, and detained under a deportation order. Christina drew from her retirement savings to pay his $2,500 bond and then spent the next three years fighting Jorge's deportation. She tried everything: she took his case to a Tenth Circuit appeal and lost; she had help from influential immigrant rights nonprofits; she wrote letters to anyone and everyone in positions of power, including current and former presidents.

"I'm a U.S. citizen, and I was raised to fight for what's right. I know what I'm doing is right. I don't care what it costs me. Josefyna, our eldest, gave up her dream of a higher education because our family couldn't afford immigration attorneys and paying for college."

In 2010, the family finally learned what the "something" on Jorge's record was. Eight years earlier, a friend had loaned Jorge his car before a night of drinking, then forgot by morning and reported it stolen. The misunderstanding had been quickly resolved—but not before Jorge was stopped and got a booking number, which was never cleared. That is the only reason he didn't receive residency in 2007.

On January 8, 2013, Christina's appeal for help to Congressman Luis Guittérez succeeded, the Tenth Circuit was overruled, and

↑ Josefyna hugs her father, Jorge, in 2018. In January 2020, he was deported to Mexico City and, as of this writing, has been separated from his family ever since.

→ Christina holds a family portrait while Jorge tends to the grill and their son plays. The family has been struggling with the immigration system over Jorge's status for more than fifteen years.

Jorge's deportation was delayed by a year for humanitarian reasons. The couple went to the airport and watched planes depart, knowing that Jorge was supposed to be on one of them. The small taste of victory they felt that day was repeated annually for six years; each November, Jorge was granted a one-year stay of removal. But in 2019, Jorge was detained and sent to the for-profit Aurora ICE Processing Center. For two months he suffered medical neglect, verbal and mental abuse, and significant weight loss. And on January 15, 2020, he was deported to Mexico City. Since then, Jorge has been separated from his wife, five children, and grandchild.

"My only life goal now is to beat immigration," explains Christina. "I will die broke, but I will die the richest poorest person in the world. I don't know how I'm going to win this, but something has to happen. I love my husband, and he deserves justice, just like anyone else in his situation would."

"The ghost of deportation hasn't left us alone," says Jorge's daughter Yolanda. "It's especially hard to explain to my younger siblings. My dream for this country is that one day families can all be together, and we won't need to worry about immigration separating us because of where our parents came from."

# PURSUITS

Dima, San Diego, California

## Dima
### San Diego, California

When Dima was growing up in Ukraine in the 1980s, travel outside the Soviet Union was difficult. His family went to the Sea of Azov for summer holidays instead. "There was nothing to do there besides go to the beach, so I started borrowing adventure novels from this small library and reading about far-flung places. I never could have imagined that I would live somewhere with palm trees outside my door, or how I could hop on a plane and visit these exact islands that I read about as a kid."

Dima holds a map showing the more than one hundred and twenty countries he has visited. "I never thought that someday I would actually visit any of them."

# José Arnulfo
Cincinnati, Ohio

José Arnulfo crossed the border into the U.S. from Mexico when he was four. "I spent four days and three nights without my mom, with a complete stranger I had never met." His father had been in the U.S. for three years already, doing odd jobs, and after a stint in North Carolina they moved to Ohio, where his dad worked on the stadium rebuild for the Cincinnati Bengals. When José Arnulfo was eight, his father left and his mom supported the household by cleaning houses and selling beauty products and Mexican food.

Evanston, where he grew up, was one of Cincinnati's toughest neighborhoods. José Arnulfo remembers the day a SWAT team blocked the street and took down his neighbor's meth lab. One day he came home to blood all over the ground of his apartment complex. He lost a few of his middle-school friends to gun violence. "Growing up was hard because of all the gang violence and drugs. That was

more of my reality than our immigration status. It was weird to go to bed and not hear police sirens, gunshots, or people yelling and screaming."

In 2018, José Arnulfo graduated with a degree in entrepreneurship and a minor in justice and peace studies from Xavier University.

"My mom never thought I could go to college, because I was undocumented. She cleaned the houses of people who sent their kids to Xavier, but she never imagined that any of her kids could go here."

## Bomi
St. Louis, Missouri

In South Korea, Bomi studied from eight o'clock in the morning until ten at night, with no weekends or summer breaks. It was exhausting, but it was the norm. "It is an intensely competitive education. I never had a hobby, because I was so focused on school. It's kind of sad. You do what you are told to do and don't know any better. I didn't think it was abnormal."

Bomi traveled to the U.S. as a sixteen-year-old exchange student and decided to stay for the remainder of high school. It was the first year that international students attended Mater Dei Catholic High School in Breese, Illinois, a community that is 95 percent white. She made great friends and, to her surprise, was voted prom queen in her senior year.

"I didn't know American students get out of high school at three o'clock or that extracurricular activities even exist."

Bomi loves her dog, Jet, and her cat, Lion, who follows them on walks. Neighborhood kids often come out to watch the three pass by. "Everyone knows I'm the one with a greyhound and ginger cat following."

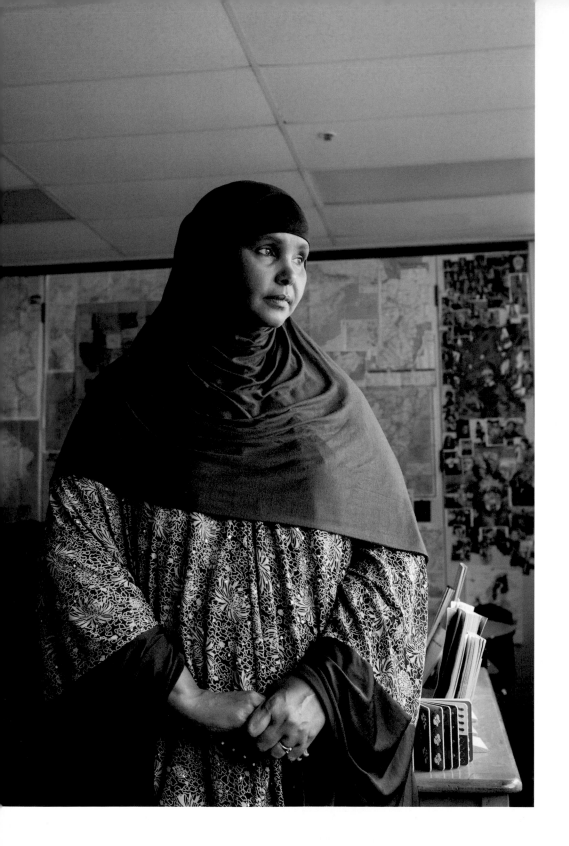

## Ruqiya
Portland, Maine

After her last day of veterinary college in 1990, Ruqiya returned home to a city destroyed by the Somali Civil War. She left there for Maine, where she worked as a janitor for nearly a decade at Lyman Moore Middle School. Now, Ruqiya is an educational technician, or ed. tech., helping teachers in the classroom and assisting ESL students. She hopes to teach math and science someday.

"My advice to others is: 'Don't give up. Look forward and follow your heart.'"

Ruqiya has switched from janitorial work to assistant teaching. Three of her nine children have attended the school while she worked there. "I have a passion for the field of education. I have been patient. I told my children, 'My time will come.'"

## Zammy
Las Vegas, Nevada

Zammy's mom, newly single, was on vacation in Las Vegas when a Cuban waiter walked up to her and asked her to marry him. She was offended by his brashness, but it worked. In 1990, Zammy, fifteen at the time, moved from Mexico with her mother and brother to Las Vegas to live with this man, who she now calls "Dad."

Zammy started her hospitality career in the casinos, where she figures she has lost about $300,000 from gambling over the years. "I remember one time waking up, staring at the ceiling, and saying I am sick and tired of making money and not having it. When I have friends who are getting too involved, I tell them to be careful, and to get help. You are gambling out of boredom, most likely, so you have to find something else to invest your time in."

## Cat
Columbus, Ohio

"Moving to the U.S. was never in my plans. If it had been, with all due respect to the people in Ohio, never, ever would it have been Ohio!" Cat moved to the Buckeye State from Australia in 2006 after falling in love with an American man. It didn't turn out as she had hoped.

"My midlife crisis started with the demise of my marriage, followed by the loss of my mother. I had just purchased a home, and then I lost my six-figure job—so the home didn't come to fruition. I was displaced and had to move in with my best friends. You don't want to be that age and displaced. I was just surviving. I decided to walk the Camino—the Way of St. James—five hundred miles across Spain. That solitary journey was, to this day, the single most wonderful thing I've done in my entire life."

# Frederic

Las Vegas, Nevada

When Frederic was a child, he saw a poster for a traveling magician. Compelled by the image of a levitating man, he asked his parents to take him to the show. He still remembers how much joy that performance brought to his quiet French village. The magician did things that no one in the audience could explain. "The impossibilities he showed us intrigued me so much that it changed my life forever. I wanted to understand how these things were done and to have that same type of freedom—to do things you thought were impossible as a human being. This is where my passion for magic started."

At age six, Frederic received a magic box, and by thirteen he was performing at restaurants and birthday parties. By fifteen, he was doing magic full-time. For his eighteenth birthday, his family gifted him a weeklong trip to Las Vegas. He loved it, and for the next fifteen years, Frederic flew from France to Vegas every chance he got, often monthly. In 2013, he opened his own show, "Paranormal," on the Vegas Strip.

*"All my life, my only goal was to have a show in Las Vegas, so now everything else is a bonus."*

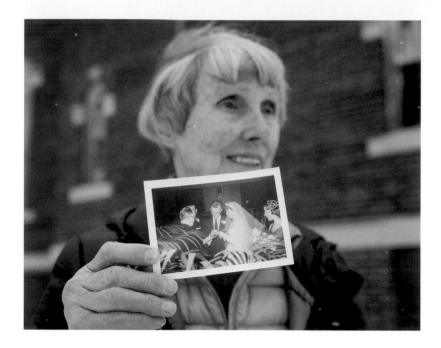

# Ruth

Detroit, Michigan

When Ruth arrived in Detroit from Wales in 1953, there were so many streetcars and buses that her family never had to own a car. "That was before they built the highways. The automobile became a big thing, with so many cars, in the postwar boom years."

Ruth rode her bicycle everywhere. She got into Detroit's bicycle racing scene, which is how she met her husband. On a group ride one day, they stopped at a cider mill, and she noticed another rider, Bill, who drank too much and got sick. Another day, Ruth came third at a road race in St. Louis and caught Bill's eye at the awards ceremony. A few weeks later, Ruth and some cycling friends went to the movies and she found herself sitting beside Bill. He invited her to breakfast the next day, and they were engaged within a month. Ruth and Bill were married for sixty-two years before Bill passed in 2016.

→ Ruth made her daughter Jayne a cycling jersey to wear while watching her dad race in the state championship. "I guess sport has kind of been our life. As my mother would say, 'Your family is nuts about sports. You should learn music or something like that!'"

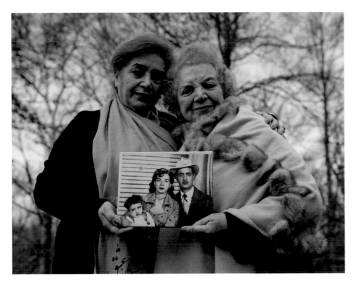

## Mahvash

Carmel, Indiana

Mahvash says her father "taught me to live life, even if I have only a piece of bread. He said, 'Remember that nothing is forever. Don't forget the people who are down, as some of them didn't forget you when you were down.'"

She remembered these lessons long after she came to the U.S. from Iran when she was seventeen. "I so badly wanted to get an education. I was determined to work hard and put myself through college. It was a new world that had so much to offer." Mahvash graduated from the University of Tulsa and ran a successful oil and gas company. When it was time to retire, she could have sold it to a larger company, but they would have laid off workers, so she sold it for less money to the employees, then moved to be with her mother, daughters, and granddaughters.

"America is a land of opportunity—work hard, get involved—and specifically for women. Never give up . . . I think I opened a different kind of door and dreams for the rest of the girls in my family."

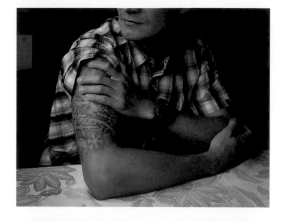

## Kakiko

Anchorage, Alaska

Kakiko, a mountain climber, dreamed of moving to Alaska since his first trip to Denali. In 2010, the Mexican consulate in Alaska was looking for someone who was good with computers, so Kakiko applied. "I like the snow. I don't know why I like to climb mountains. It's a 'sufferfest,' but it's appealing to me. I feel safer and more stable up there." Before he moved, Kakiko got a snowflake tattoo. "It's funny because a lot of people here in Alaska ask me, 'Where did you get the snowflake?' and I'm like, 'A guy in Mexico did it!'"

↑ "It's a tradition in climbing that you mark your gear, so when you climb with other people and the gear mixes, you know which gear is yours. I have the colors of the Mexican flag on mine."

## Dimple
Charlotte, North Carolina

Dimple's parents planned their emigration from India for fourteen years. When she was sixteen, they relocated to California then moved the family to North Carolina to run a motel. Dimple, a CPA, was thirty-one when she got elected to Charlotte council in 2017. Five years later, she was reelected.

"This is an American dream. My parents wanted us to have a better life than what they had."

← "Keep it simple. Vote Dimple." In 2017, voters in Charlotte elected the first Asian American and youngest woman to sit on city council. Four years later, Dimple named her daughter Charlotte.

## Jennifer
Albuquerque, New Mexico

"My dad grew up in Cuba wanting to go to the United States. That was always the goal—and that's why he named his daughters Jennifer and Jessica."

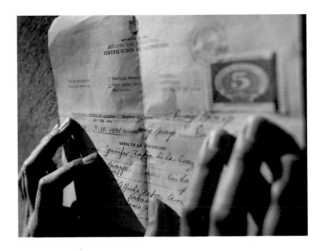

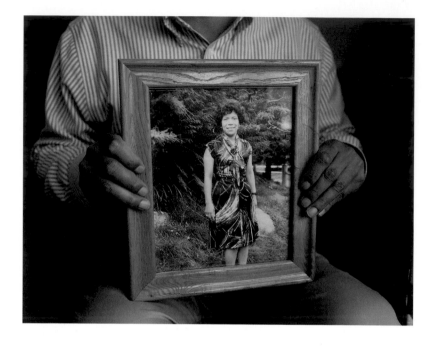

## Alex
Sioux Falls, South Dakota

When Alex was three years old, his mom, Maria, moved to California to do agricultural work, leaving Alex in the care of his grandparents. One Christmas while his mom was back visiting, a neighbor about Alex's age played a song for her on a recorder. She gave the boy a round of applause. Alex, jealous, decided he would play music too. He started with the recorder, but his goal was the guitar. He borrowed one until his mom bought him an old guitar from a neighbor.

Growing up, Alex believed that when he finally joined his mom in the U.S., he would become a famous rock star like the ones on TV. His favorite band was the Rolling Stones, and he dreamed of starting a band that covered their songs in Spanish. When he finally went to the U.S. at age seventeen, the one item he made sure to bring was that old guitar his mom had bought for him. It's been banged up over the decades—once, as a teenager, he kicked it in anger, and another time his daughter fell on it—but Alex says it still sounds great.

↑↑ Once a year, Alex's mother returned to Mexico. "It was the best whenever she visited, but when she left it was horrible. I always wanted to move to the U.S. with my mom, because every kid wants to be with their mom."

↑ Alex was excited to go to the U.S. but devastated that he had to leave his dog, Muddy, in Mexico. "I loved that dog. I loved it so much I wanted to bring it, so I left it with my friend. When I asked him how it was, he said it was fine. I didn't believe him, so he sent me this picture to prove that Muddy was okay."

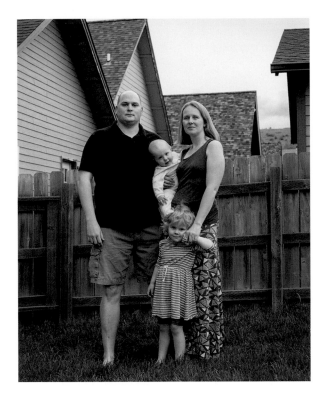

↑ Jennifer, from the UK, says she wants her kids to have lots of downtime to be creative and read books. "I think in America there is a huge tendency for children to be overcommitted to things. That wasn't my upbringing. I always had a lot of time to be on my own."

## Jennifer
Missoula, Montana

Jennifer started studying music at age ten because it offered a break from regular class, and she chose the flute because it fit in her backpack. "I had no aspirations of being a musician."

In 2007, she left the UK to do a PhD in Cincinnati. There, she met her husband, Zach, and now they are both music professors at the University of Montana. "It's hard for two musicians to get jobs anywhere, let alone in the same city!"

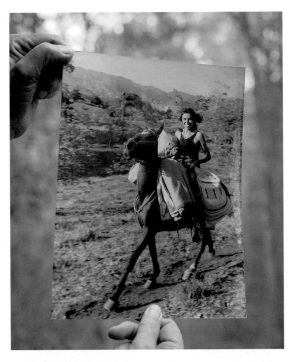

## Elke
### Mineral Bluff, Georgia

During a three-month solo adventure in Costa Rica, Elke met Tom, an American living there; the rest of her trip was not solo. Elke then went home to Germany, but soon surprised Tom by returning under the pretense of buying one of his horses. They lived together in Costa Rica for almost three years before leaving due to a complicated series of events involving guns and drugs. Through some connections with the local authorities, they were able to move to the U.S. and arrived when Elke was seven months pregnant. They've now been married a quarter century, raised a family, and built a successful trout-shipping business.

Elke's friends from Germany occasionally visit their house way up in Georgia's Appalachian Mountains. The last time was memorable. "My friend, her husband, and I were upstairs. Tom was sitting at the computer downstairs dry-firing his gun. For some reason, there was a bullet in it. Boom!" Tom shot a hole in the window that remains to this day. He jokes, "I'm famous in Germany now!"—but notes that they haven't had any German visitors since.

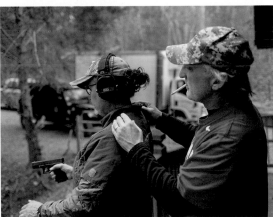

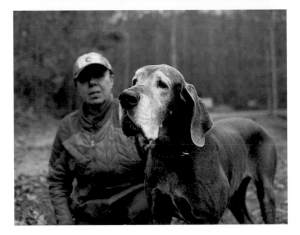

At one point, Elke and Tom had ten dogs, seven of whom were Great Danes. Now they have two, Lluvia and Luna.

# Joseph

New Haven, Connecticut

Joseph left the Democratic Republic of the Congo in 2012 in search of safety. After four years in a Kenyan refugee camp, he moved to Connecticut. "Even though we are safe here, we read and hear about what is still happening in our country. The same stress starts again. Here in the U.S., if something happens, we can call 911, but what about if something happens to my family and my relatives who are still in Congo? It's painful to think about."

Joseph hopes to reunite with his parents and siblings someday. "If we leave our country, who is supposed to build that country? It's our country, so we have to go back and rebuild it. I dream of going back."

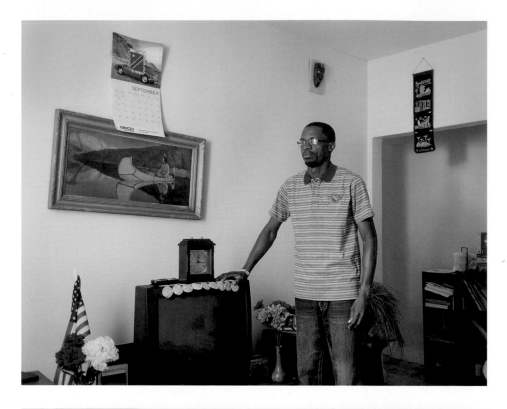

Joseph, who, like his father, was an attorney in the Democratic Republic of the Congo, works in the U.S. as an interpreter and a hotel security guard. He plans to return to school and, eventually, to Congo. "Here, I'm working with my body and my hands, but I was meant to use my brain."

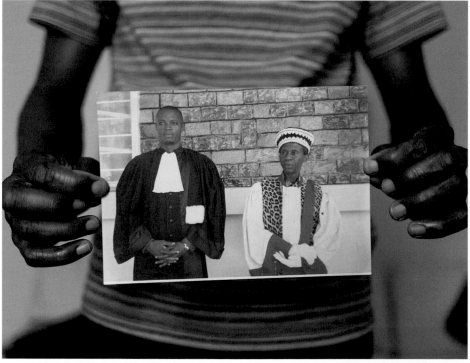

## Olivia
Morton, Pennsylvania

"I did my job with great gusto. I loved it." Olivia, from Colombia, was a school principal in Philadelphia for three decades. She is proud of the impact she believes she had on thousands of children and educators over the years, often amid extremely difficult circumstances.

"I was managing the day-to-day at an inner-city school where we dealt with poverty, parental abuse, neglect, sexual violence. Some of the things I remember most vividly are cases of sexual abuse and death. I had a student who I saw in a coffin. I still remember the suit he was wearing. They killed him over a stereo."

Olivia will never forget the reaction of a teacher who learned that a father had sold his daughter for sexual favors to get drugs. He went into the bathroom, punched the mirror, then went out and grabbed the father by the neck. Olivia had to peel the teacher off him.

The things she witnessed were never discussed at home. "That kind of pain couldn't come in here or I would have gone nuts." Now, with time to reflect, Olivia says she better understands why these traumatic episodes continue in schools.

Olivia blames politicians in Washington for the violence and despair she saw as an educator. "To them, it is just another Black kid who gets shot. They are 'just causing problems.' How can you not be causing problems when you have everything against you? The resentment has grown huge for me."

"The people in Washington are privileged and their kids go to private schools. They couldn't care less about inner-city kids who are all poor people of color. They don't care if these kids live or die— they are disposable. It is unfair and it is racist."

# Kriz
## Nashville, Tennessee

Kriz's late father, Nils-Erik, loved American country music. During family drives, he always played a mixtape of traditional Swedish music, classical music, Elvis Presley, and country music. When he encouraged Kriz to play an instrument, she chose the accordion but didn't like it. A new music teacher, who moved to the village when Kriz was twelve, encouraged her to try guitar. A year later, Kriz was writing her own country music. "I've been told that I have a Swedish accent when I speak but not when I sing." When she uploaded her music to Myspace, she connected with a musician from Tennessee. After visiting him in 2008, she decided to relocate to Nashville permanently to pursue a music career.

→ As a child, Kriz spent the summers at her family's lake house. "My father built that boat. It had a little engine on it and, when I was seven, he showed me how to drive it. He started it for me and said, 'Off you go,' and off I went."

→→ Kriz has written more than three hundred country songs since she was twelve. She still dreams of writing "that first million-dollar song."

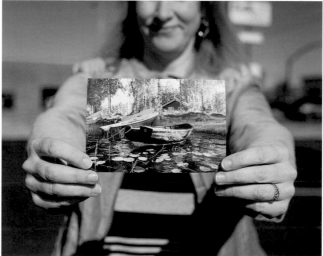

# Claudia

Arcadia, California

Claudia's parents were teenagers when she was born. For her first year of life, they lived in the darkroom of Claudia's grandfather, a news photographer, and stole milk from neighboring barns to survive.

When she was eleven, Claudia's grandfather was assigned to photograph gang members in jail. One of them told him, "If you print that picture, you are dead." Her grandfather, a strong believer in justice and the media's role in society, ignored the threat. "Journalists have a lot of power, especially in Mexico," says Claudia. "We call it 'el cuarto poder.'" Shortly after the photo was published, he was murdered.

Claudia's father also became a photojournalist. As a child, she would take any scrap of paper she could find, roll it up to pretend it was a typewriter, and dream of writing stories. When she visited her father in the newsroom, she loved the sounds of reporters at work. "For me it was like, this is what I'm going to do, and I ended up getting to do my dream."

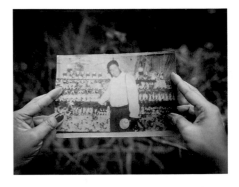

← Claudia's daughter, also named Claudia, holds a rabbit she received as a prom gift.

↑ Claudia, a third-generation journalist, holds a photo of her grandfather Cristino Solis. She interned at *El Ciglo de Torreón* when she was seventeen and is now deputy editor at the *Los Angeles Times* en Español.

# Célia

Las Vegas, Nevada

Two years after joining Maqueque, the all-women Cuban Canadian band, Célia was on tour in Canada when she decided not to return to Cuba. She crossed the Niagara Falls border into the U.S. and took a thirty-seven-hour bus ride to Miami, where Catholic Charities helped her settle in Las Vegas. For a few years, she worked as a hostess at a local steak restaurant while performing occasionally with Maqueque, but her music career felt stalled. That changed in 2018 when Célia joined her bandmates at the Grammy Awards to celebrate a nomination for their album *Oddara*.

## Erika
### Fargo, North Dakota

Erika's parents moved the family from Montreal to Idaho in 1991, when she was two years old. During her early twenties, she experienced a lot of trauma in her small town. "Everybody drank and did drugs," says Erika. "I can't even count on my hands how many people I know who have died. I didn't cope well with that."

Today, her chronic illnesses cost her between $10,000 and $15,000 a year. "It's my biggest concern. Through my last job, I could get COBRA health insurance but that will end in six months. I'm twenty-nine, so I can't be on my parents' insurance since that's cut off at twenty-six. That's always been a big question for me, whether or not I should go back to Canada. Insurance is so expensive here, and it doesn't cover everything. I've had scans that are thousands of dollars even after insurance. It could get worse because they are trying to take away Obamacare and not have options for people who can't afford insurance. I'm going to be out on my own, and I'll need to find my own insurance."

↖ Erika looks out the window of her parents' home with her cat, Topaz. The challenge of finding decent health insurance has her living with them while she considers a move back to Canada. "It's scary, honestly. Do I just find somebody to marry for the insurance? I'm kidding; actually no, I'm not!"

← Erika got a Scorpio sign tattoo in memory of her friend Stephanie, who passed away from an overdose. Stephanie had the same tattoo in the same spot.

## Jonathan
Las Vegas, Nevada

At the age of three, Jonathan became a fan of Michael Jackson, and by six, he had taught himself how to moonwalk. "By my house in Kitchener, there was a video rental store with one copy of *Moonwalker* and one copy of *Thriller*. I rented them every week, then brought them back and rented them again. They let me do that for a year and a half, then finally said, 'Just keep them.' I ended up playing *Moonwalker* so many times it melted in the VCR."

"When I was very young, one of my dreams was to fly. I have vivid memories of me walking, but I would be stepping on air. I wanted to do something amazing. Throughout my life I've continued trying to be part of something amazing."

## Sarah
Terlingua, Texas

Sarah, a singer-songwriter, left Canada in 2015 with the intention of touring her way to, and eventually living in, Los Angeles. Instead, she fell in love with an old mining town in the badlands of Texas after playing a gig there and never made it to LA. Sarah bought herself a five-acre plot just outside of town.

"They aren't making any more land, so it's good to have some," she jokes. "Just knowing that if all else fails and shit hits the fan in my life, there is a place I can go to that's my own and is already paid for—that takes away the stress."

←← Sarah sits on the land she purchased outside of Terlingua, Texas.

## Fozia
Nashville, Tennessee

Fozia lived in Hargeisa, in northern Somalia, until she was ten years old. "From what I remember, it was peaceful. I remember playing outside with my siblings and the neighbor's kids. It was not like here, where parents watch you all the time. We didn't have electricity until five o'clock in the afternoon, and once it turned on, everyone would dash inside the house to watch cartoons in Arabic, like *Ratchet & Clank* and *Pokémon*. My aunt, who lived with us, worked for a nonprofit and drove a car. At that time, it was rare for a woman to drive a car. I remember saying, 'When I grow up, I want to be like her.' That's what I'm doing right now in Tennessee—working in the nonprofit world and driving a car!"

## Ralph
Lakin, Kansas

Ralph, a missionary from Canada, was teaching Bible school in rural Kansas one evening when lightning struck, killing the power. Jerrie, who is from there, had shown up with a friend and a truck. Ralph carried on preaching, illuminated by the truck's headlights. "I met her in the dark. She didn't know what she was biting into until the lights came on!"

← Ralph stands in his workshop. He built two coffins here, one for him and one for his wife, Jerrie.

## Chris and Yadira

New Orleans, Louisiana

Chris picked up the trombone at age twelve after seeing his brother play, and he hasn't put it down since. In Canada, he felt like he was playing with musicians who had jazz degrees—who hadn't learned from actually playing. "The music didn't feel right." After his first trip to New Orleans in 2016, he knew he needed to return. So the following year, Chris and his partner, Yadira, packed a U-Haul and moved to Louisiana.

"New Orleans is amazing and 100 percent crazy," says Chris. The first person Yadira met after moving to New Orleans was so friendly she figured they were trying to rob her.

"You know someone is not from here if they don't say hi when you pass them on the street."

## Tania
Austin, Texas

Tania excelled academically in high school and helped start "The Dream Club" to raise awareness about undocumented students like herself. When a journalist from UC Berkeley interviewed her, Tania explained that she couldn't go to college due to her undocumented status and inability to get financial assistance. A Berkeley alumna who later read the interview offered to pay Tania's full four-year tuition at Berkeley.

In 2014, Tania began her PhD in Iberian and Latin American languages and cultures at the University of Texas at Austin. Her work focuses on sixteenth-century records from a Mexican town called Huexotzingo. Most of the original documents are in Europe or Mexico, so she studies digital reproductions, dreaming of the day her immigration status doesn't prevent her from traveling to see them in person.

"All I want is to be able to move, to be free. So far, what I've done has always been controlled by outside sources. I've never felt free, at least not completely."

↑ Tania points to an example of "procesal," an administrative writing style from sixteenth-century Mexico that she's studying as part of her PhD research. It feels strange, she says, to have to study her own culture from another country.

## Montserrat
New York City, New York

In 2011, Montserrat, a multidisciplinary artist from Chile, moved to Destin, Florida. "It was weird. I landed at the airport, saw my boyfriend, and was like, 'Oh my god, what am I doing here?' There was no theater or art gallery in that city. Suddenly I had nightmares of me with seven kids in a pink house in Florida."

In the hope of salvaging their relationship, they moved to New York City. Montserrat's visa had expired and her boyfriend had a mental health episode that prevented him from working, so to survive, Montserrat found a minimum-wage cleaning job at a dental office. "Cleaning was the best work I could get. I didn't have to use my mind. I just had to move my body, and my mind could do whatever it wanted— and I got paid. That's when I started taking pictures of teeth and X-rays."

All of Montserrat's art focused obsessively on the mouth. One day, an artistic director asked what she remembered about the man who had abused her as a child. Her response was unexpected, even to herself: "His mouth." "When I said that, I was like, wow—all this time I've been collecting teeth, embroidering mouths, writing about mouths. It's amazing how your brain can work."

After this realization, Montserrat stopped working, left her troubled relationship, and devoted herself fully to her art and to healing from the trauma she suffered until the age of nine. In doing so, she created a body of work she calls *La Mordida* (The Bite and the Bitten). "I went through healing by myself."

← After years of creating art that features mouths, Montserrat realized that the theme of her series of work, *La Mordida*, was a response to childhood trauma.

## Batsheba

Los Angeles, California

Having completed her Malaysian national military service, Batsheba told her parents she wanted to study fashion. But after two years of that, she realized she wanted to be an actor. Her parents had expected her to pursue a more traditional career. "Switching from fashion to acting took a lot of convincing, after an already difficult time convincing my family about fashion!" She traveled to the U.S. to study at the New York Film Academy in LA, where she met Gustav, from Florida. They bonded over their shared love of German expressionist films.

"Batsheba is a name I gave to myself—a stage name. I was born Zalika, but it didn't feel like an artist's name. Zalika is a beautiful princess, but Batsheba is the queen."

Felipe, Union Gap, Washington

# JOBS

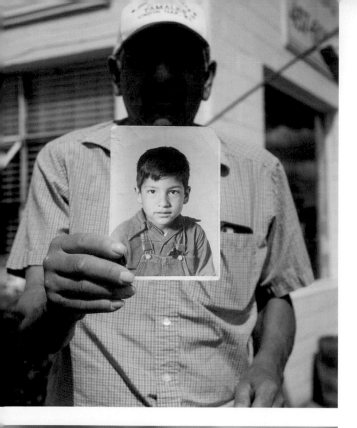

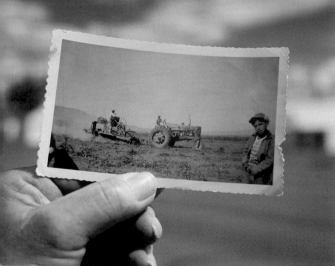

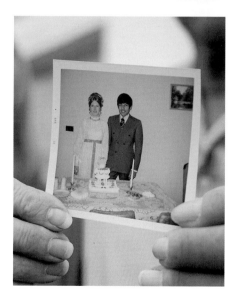

## Felipe
### Union Gap, Washington

Felipe's childhood in the 1950s was spent on the move. His parents were farmworkers who, with their eleven children, followed the agricultural seasons from Texas to Idaho to Wisconsin and Montana, harvesting cotton, potatoes, sugar beets, and cherries. He remembers as a five-year-old helping his mom to prepare tortillas for everyone's lunch, and a year later he was helping his dad in the fields. "Those are good memories. We were very good at what we did. We didn't leave weeds."

When Felipe started going to school in Wapato, Washington, he didn't have nice clothes like some of the other kids. He walked to school in canvas tennis shoes when it was 5°F. He remembers trying to arrive early to warm his feet by the heater so the other kids wouldn't see. School is where Felipe became aware that being "Hispanic" meant being different. The white kids made fun of the tacos and tortillas that his mom gave him for lunch.

Years later, after losing his sales job and doing a lot of brainstorming, Felipe and his wife, June, chose their future: tamales. Felipe's older sister, who was already making and selling them out of her home, taught him everything she knew. Doubters asked him how a shop that sold only tamales could survive. "I will make the best tamale I can, that's how!"

Los Hernandez opened in 1990. Business was good and got even better when they invented what is now their signature dish. One day in 2004, they put asparagus in the cornmeal just to see what it tasted like. It was excellent! They tested different cheeses and decided on pepper Jack. Felipe knew the asparagus tamale was delicious but didn't expect it would become the craze it is today.

"All the food is produced here. We are making American food. We should all be proud of that, and the community gets better because of that. It's good food."

↖ In 1969, twenty-one-year-old Felipe volunteered to serve in Vietnam. He returned home from basic training and was cruising the main strip, listening to music, and showing off his car—a popular weekend youth activity in the '60s and '70s—when he met June. They've been together ever since.

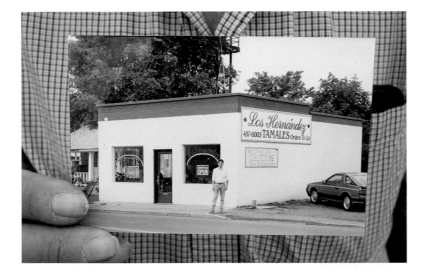

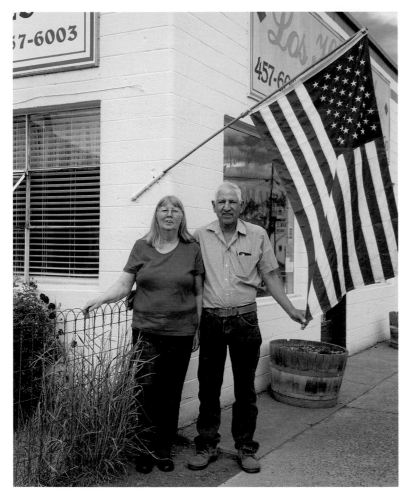

↖ Felipe stands in front of their restaurant at the time it opened (*top*) and with his wife, June, today (*bottom*).

↑↑ The asparagus tamale is their signature dish. Los Hernandez is busier in springtime–asparagus season–than at Christmas, when people traditionally eat tamales.

↑ Felipe and June have faith that in the hands of their daughter Rachel (*far left*), the restaurant will continue to thrive. Someday, they hope, one of their four grandkids will take over.

# Amelia

*Napa, California*

It was 1967, and Amelia had just finished sixth grade. Her family was picnicking by the river when her grandma excitedly approached, waving a letter from Amelia's dad, Felipe. He had moved to the U.S. as a farmworker shortly after she was born to follow harvest seasons from Washington to California. Felipe wrote to say he had settled down as the foreman on a vineyard and that all paperwork had been approved for the family to become permanent residents in the U.S. He met them in Guadalajara, and they traveled to the U.S. together, arriving in Napa during peak harvest, so the family was able to work.

As soon as Amelia arrived in California at age twelve, she went to work picking grapes alongside her family and another family that had just arrived, including Pedro. He would eventually become her husband. In 1985, Pedro and Amelia moved with their three small children from Silicon Valley to land they bought in Napa Valley and planted their vineyard. Fourteen years later, they opened Ceja Vineyards.

"We want to showcase the contribution of every worker who has touched our wines, both in the vineyards and in the cellar. Of those workers, 98 percent are of Mexican descent. I am proud of my heritage. It's so special to see my family break all barriers to build a dream. This is our version of the American dream. We want to inspire others. 'Sí, se puede!' (Yes, we can!)—with education, focus, and determination."

→ Until Amelia was twelve, she only knew her father through letters and stories. When she met him for the first time, it was to travel north with him to his home in America.

→→ Amelia remembers how kids at school treated her because her father worked in the vineyards while theirs owned the vineyards. "Now, I am very proud to be the new face of the wine industry in my adopted country."

## Surekha
Louisville, Kentucky

Surekha's husband worked for the largest private steel company in India, and she cared for their children. They lived a privileged life, which was upended shortly after their son started school. "He was failing kindergarten and we had no clue why—we had a family of overachievers. We took him to all the doctors, and they had no answers either." They sought help in the U.S. and received a dyslexia diagnosis, which they hoped would lead to his school adjusting to their son's needs, but nothing changed. Homeschooling didn't work, so they relocated to the U.S.

To sustain their new lives in Louisville, they bought a small supermarket in a working-class area. Surekha worked the cash register while her husband butchered meat. Over the years, she developed a passion for jewelry making and, in 2012, started Beaded Treasures, an initiative that helps refugee women create and sell jewelry. Surekha has since trained hundreds of women and opened a brick-and-mortar location.

"I was a housewife in India and had never worked a day in my life. I had everything done for me. The move to the U.S. was all very exciting—a life-changing experience that I wouldn't trade for anything."

← Surekha works on a jewelry piece at Beaded Treasures, the nonprofit she founded. "I think this is a small footprint, but hopefully it becomes a path to self-empowerment for the women I serve."

## Kiril
### Flagstaff, Arizona

As a professional folk dancer, Kiril lived a comfortable life, traveling the world and performing for prominent leaders such as Fidel Castro, Muammar Gaddafi, and Indira Gandhi, but he knew most Bulgarians weren't as privileged. After the fall of communism in 1989, Kiril learned family secrets that had long been kept from him—how his grandma baptized him in secret, and that the communist regime had murdered members of his family. He felt a deep need to leave Bulgaria.

Kiril's first job in the U.S. was supervising the general store at Grand Canyon National Park. The landscape inspired him to develop his photography skills and he is now a professor of photojournalism and documentary studies at Northern Arizona University.

← Kiril points to himself in this photo, taken in France in the early 1980s, that appears in a book about Bulgarian folk dance.

## Brónagh
### Salt Lake City, Utah

Brónagh grew up in Carrickmacross, County Monaghan, a small Irish town with one main street where everybody knew everybody. "I always said as a child, 'I'm going to live in America someday.'" After completing a master's degree in broadcast journalism, she crossed the pond. "Being a reporter is a great job in that every day is completely different. Your whole day can change in a heartbeat. It definitely keeps you on your toes."

# Valdir

Lahaina, Hawai'i

Valdir grew up wanting to be a farmer like his father, so he studied biology and organic agriculture at college in Brazil. In 2013, he took an internship in Hawai'i to study advanced farming techniques and learn English—but soon after arriving, it became clear his "internship" meant picking tomatoes as an unpaid laborer. After two months, he left the farm, found help, and, with eight other victims, pursued legal action against the farm, which ended in a human trafficking ruling. Valdir received a T visa and now works as a hotel concierge and as a trail guide, leading horseback tours along Maui's oceanside cliffs.

"Maui is my home now. I love it. The weather is similar to Brazil. We may be in the United States here, but the people in Hawai'i are warm, like Brazilians."

← Valdir is from Barretos, the epicenter of Brazilian cowboy culture and home to the Festa do Peão, a ten-day rodeo that attracts over a million visitors each year. He learned to ride on the family farm at an early age. "Riding horses is therapy for me. I love being around these animals—it is so calming."

## Yassin

Knoxville, Tennessee

In 2011, three years after arriving in Tennessee, Yassin, a Syrian refugee, opened Yassin's Falafel House. In 2018, *Reader's Digest* named his restaurant the "Nicest Place in America." "I would love to see more people accept immigrants and refugees who come to America, just like their great-grandparents did. Sorry we came later, but we are here. We are people too, and we came to build this country. Some of us come here without other options, and our hearts may still be in our birth country, but this is our home now. If we build this country, we build our life—they are connected."

"This sign has it all in one place together with rainbow colors! This is what I want—to welcome everybody to come to my place. This is what our store is about."

## Yolfer

Jersey City, New Jersey

While visiting his sister in New York in 2010, Yolfer learned he has diabetes. His health continued to decline after he went back to Venezuela. So, with time still left on his six-month tourist visa, he returned to the U.S., hoping for better medical care. He was relieved when the border official didn't ask why he had left and returned so quickly. Since moving to New Jersey, Yolfer has wasted no time in pursuing his passion as a baker and entrepreneur.

"My life in New Jersey is a little crazy, but I make it work. I don't have time for things that are not important to me. People invite me out to go for a drink or to the nightclub, but I don't go, because I'm doing homework or working on recipes. I take no days off, because I'm building the business. I cannot rest. I miss having more time to enjoy life—that's what I miss about Venezuela."

Yolfer is seen at his previous job; today, he runs Pabade Bakery and Café, a business he started in East Harlem with his brother and sister. "Here in America, we don't have enough time. You have to work to pay the rent—everything is about money. In my country, I used to have time for family and friends, but not here."

## Eman and Jess
New York City, New York

Three years after Eman, a Palestinian Canadian, started working on the North American comedy circuit, she met Jess, also from Canada. Eman, who identified as straight at the time, soon found herself "looking at Jess in a different light." "My curiosity spiked one night when she was at the club. She has a line in her stand-up routine about being bisexual, and I was like, 'Oh my God—I'm totally curious!' I thought if I were to fool around with a girl, it would be Jess. I didn't know I would end up marrying her though!"

Jess left her career in human rights and international law at the United Nations to also be a stand-up comedian. "Ultimately, I couldn't see myself working with the law as the main tool and language for everything I did," says Jess. "When I tapped into what else I wanted to do, it was, definitely, make people laugh." After marrying in 2016, Eman and Jess moved from Toronto to New York City to develop their comedy careers. "Beyond being a Jewish-Palestinian lesbian couple, we are very different people and there is comedy in that," says Jess. "We know each other well, so we know how to roast each other."

↑↑ Jess performs at New York Comedy Club. "I've always been the storyteller in my group of friends and felt like funny things were happening to me. I started to see how comedy could be another kind of advocacy that could reach more people."

↑ Eman always wanted to work in entertainment. "I wanted to dispel negative stereotypes. If I saw people who looked like me on TV, they were always awful terrorists—evil people. When you entertain someone, they will listen a lot more than if you are preaching."

## Mireya
Apopka, Florida

Mireya has beautiful memories of life in Mexico. But when their horse was killed, her dad knew it was time to move to a safer place. In Florida, they lived in a mobile home with the six kids sleeping on the floor. Her father, an agricultural worker, hadn't gone to school and wanted the kids to work in the fields as soon as they could be useful. Mireya's mother, though, saw the value of an education, so Mireya entered seventh grade, her first time ever attending school.

"After school, we went to work picking oranges. Instead of me on the bus thinking about my homework, I was thinking about what I was going to do to get food for my brothers and sisters. I had to cook; I couldn't have friendships or a childhood in the U.S. For me, graduating from high school was hard. I had to take the SAT three times."

## Diana
Worland, Wyoming

Diana's husband, Cordel, works in oil and gas. "I have no one else here; I came to the U.S. because I love him. He is a good provider, but he is away for a couple of weeks, then back for five days—which is not enough—and then he goes away again. This is our life. It's weird that I always had this dream of living somewhere else, but now I want to go back home to Guatemala. I want to be there and be happy, but I also want to be with my husband."

"I wish he didn't have to work so much. My job as a mother is a little bit harder when he's away. I can't say it's like being a single mom, but I can't rely on anybody else when he is gone. It is only me."

## Dhamarys
Providence, Rhode Island

When Dhamarys arrived from the Dominican, she started work almost immediately, walking three miles every day to work in an electronics factory with her parents and older siblings. The younger siblings went to school, and Dhamarys remembers feeling amazed at how quickly they picked up English. "I was jealous, as I couldn't go to school. I just had to work to help my family." She says she has never experienced discrimination because of her Dominican accent, but it makes her self-conscious.

"I have a very strong accent. I do worry about it all the time. That's why I don't like to speak. I always feel very uncomfortable."

With her father's encouragement, she eventually left the factory to work at a gas station and take ESL classes. One day, she noticed the badge on a woman buying cigarettes, a regular at the station. Dhamarys told her that one day she would be a nurse too—and years later returned to the station wearing her own nurse's badge.

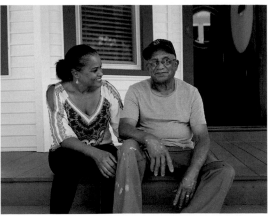

## Diana
Anderson, South Carolina

At seventeen, Diana fell in love with Miren. When a school in South Carolina offered him a full scholarship, she moved with him from Canada and started her PhD at Clemson University. Diana hoped to work in cancer research, motivated by her mother's diagnosis in 1987. In 2004, a year after losing her mother, Diana started working at Anderson University's cancer research center, where she is now the director.

One month after starting work at the cancer center, Diana found a lump and was herself diagnosed with cancer.

"I went through terrible times. Now I teach all about cancer—how to prevent it and diagnose it early. I believe this is my purpose in life."

## Kit
Wailuku, Hawai'i

Kit moved to Hawai'i in 2008 and worked various jobs in the nonprofit, private, and public sectors. Today, she owns a chili oil company and the Mystery Maui Escape Room. "It's been a journey for me, trying to make it here on my own, without having inheritance from family or anything like that. It was just me who moved with my backpack, and I had to make it on my own. It has been fulfilling. I'm happy with where I am now. Getting involved in nonprofits and other community work has fulfilled that need. I feel like I have a set of talents and skills that can have an impact on other people and make a difference."

→ Kit sits in one of the escape rooms of Mystery Maui, which she runs with her Japanese American husband, Deron. "We developed this room from our love for ramen. Players have to discover the clues to find the missing ramen chef. We created all our rooms with their own unique stories. It's pretty elaborate."

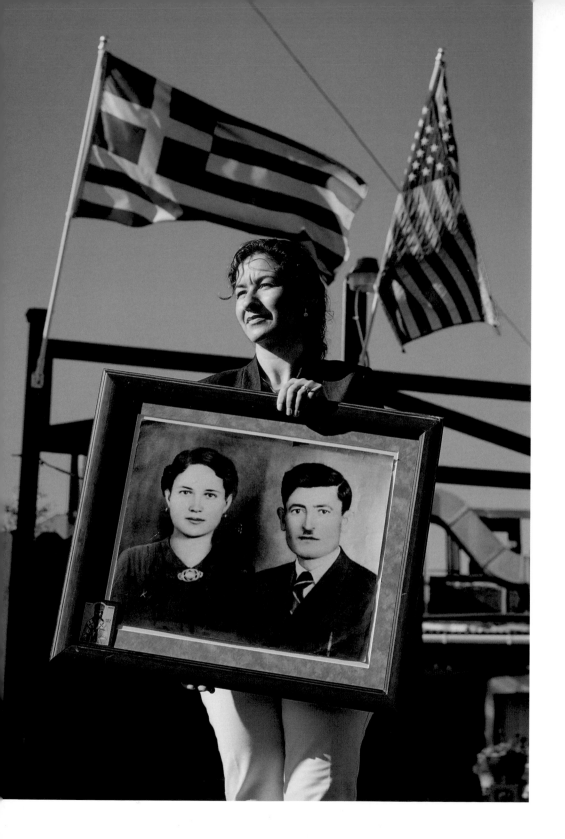

## Zoi and George
Anchorage, Alaska

Zoi's uncle moved to Alaska in the 1960s and opened a pizzeria. He spoke so highly of Alaska that her other uncle followed, and then, in 1984, Zoi's parents moved to Anchorage with their three children and opened Pizza Olympia. "My mom always says that my poor grandma lost all her children to Alaska! To her, Alaska seemed like it was at the end of the world!"

The whole family worked—or grew up—in the restaurant, with Zoi working there from the age of eight. Seeing her parents work so hard as small business owners was Zoi's "first education." After medical school in Texas, Zoi returned to Alaska and started Bambinos, an organic baby food company that uses local ingredients like wild salmon to help reduce child malnutrition.

←← Zoi stands outside of Pizza Olympia holding a portrait of her maternal grandparents.

← Zoi and George's older brother, Dimitri, was featured in the *Anchorage Daily News* when he was the seventeen-year-old chef at their family restaurant. Zoi remembers him as ambitious, generous, and loving—both a father figure and a best friend. When he passed away in 2010, Zoi returned to Alaska to help with the restaurant.

↑ "I was in a gas station, and somebody asked me, 'Young man, why do you have two flags on your motorcycle?'" George recalls. "'Greece is where I came from, and the U.S. is where I live. I support both places.' He said, 'That's pretty cool' and he drove off."

↗ George runs the family restaurant that their parents started; their mom still helps in the evenings.

# Ramon

San Francisco, California

Ramon, from the Bahamas, has accomplished two of the three life goals he set: he earned an MBA from a good school, Stanford, and he worked on Wall Street as a mortgage trader. He was "right in the middle of everything" during the 2008 financial crisis. "I was watching the world bleed. I had arguments with some of my colleagues about where we were headed. I think we generally understood and knew it wasn't going to be good. I don't think anyone foresaw the depth of how bad things were going to turn out." Seeing people repeat mistakes from the past did not bolster Ramon's confidence in the financial system.

"I wouldn't be surprised if this cycle continues to repeat itself, because the knowledge that needs to stick around— about irrational exuberance—tends to go with the people who leave after the wall gets torn down."

Today, he lives in San Francisco and is working on his third goal: "to create something that did not exist before, will outlast you, and will leave a legacy." He misses the adrenaline of Wall Street but appreciates his calmer and healthier life. "The level of intensity Wall Street required—I knew it wasn't something I wanted to do forever, because it was going to change my personality into somebody I wouldn't like to hang out with."

← Ramon's tattoo of a phoenix. "Sometimes in life you get burned down to ashes and you have to find a way to reinvent yourself. I feel like that's happened to me."

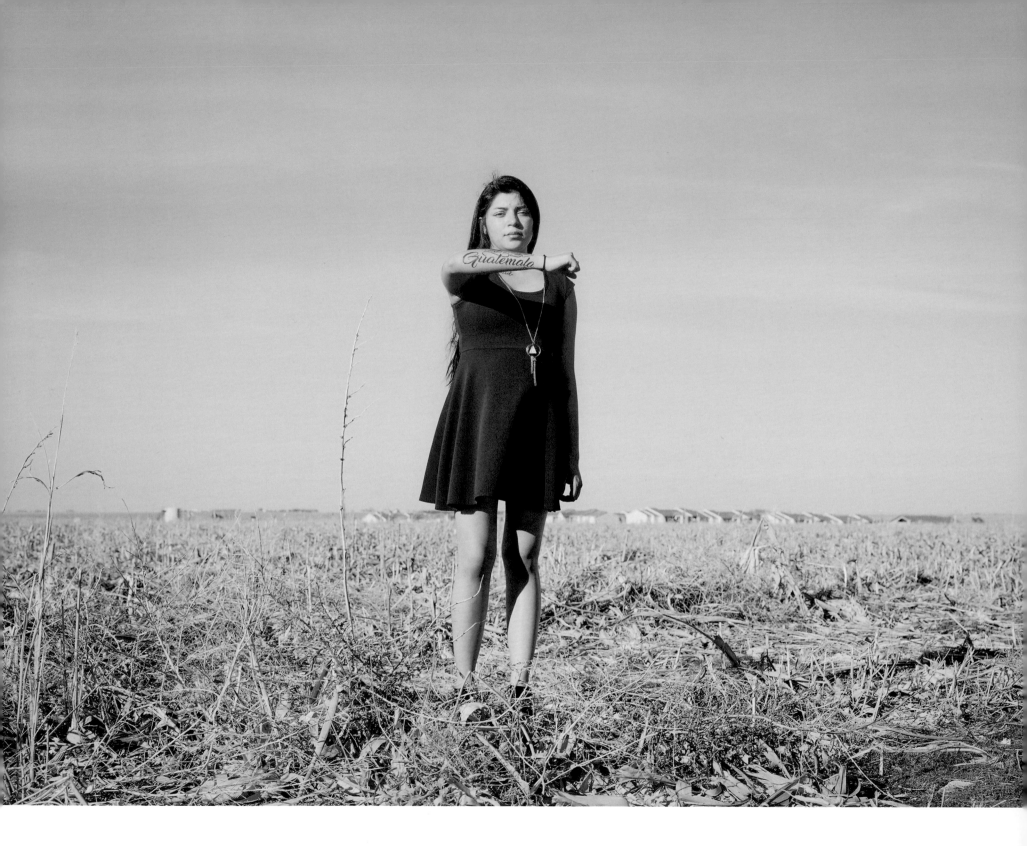

## Naty
Garden City, Kansas

Naty is a "blue hat," the supervisor of her meat-cutting line in a Tyson Foods processing plant, where she does various cuts, from tendons to heads and ears. "It is all hard, especially since I work in slaughter, on the kill floor, the hottest part of the building. The cow has been recently killed and is hanging on two hooks. You don't want it to fall on you! It's intense, but we work as a team—like family. I'm known by the nickname 'Guate,' short for Guatemalan. The people who grew up here in Kansas don't want to work there, but once you get into the company it is different from what you hear. I didn't think I would be there for more than a year, and now I'm considering the different ways I can continue on with the company."

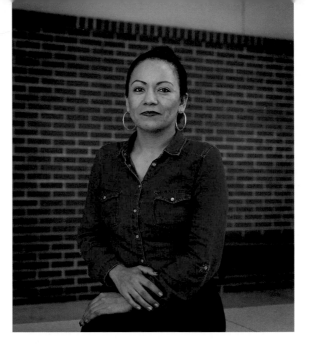

Yesica advocates for farmworkers. "We have a problem with wage theft. It's challenging, and I feel very impotent. Many people say, 'We can't do anything,' because, in Florida, we don't have a law that protects workers against this."

Naty shows a photo of her dad and a tattooed tribute to him: Naty's birthday is March 30 and her father's is March 31. She grew up thinking her father had passed away from an illness but later learned the truth: he was in a gang, and when he tried to leave he was shot fifteen times, on the street where her family lived. Naty has few memories of him; she remembers hugging him, and how he said gum would ruin her teeth. "I know my dad watches over me. It motivates me to make him proud every day."

## Yesica
Apopka, Florida

Yesica says farmworkers in Florida generally live paycheck to paycheck, providing for their family in the U.S. or in another country. When employers delay or withhold their checks, they have to find other jobs, and then the employer says, "Well, you left! You didn't wait for your check." "It's an immense frustration. It isn't fair that you work for a month and don't get paid. That's a big problem here." Yesica works with the Farmworker Association of Florida (FWAF), which represents over ten thousand Haitian, Hispanic, and African American workers, to recover stolen wages. "I am constantly learning. I want to do more for my community, but I don't always have the skills or resources."

Yesica calls delinquent employers and explains that they owe a member of her organization money. The first, best option is to arrange a payment. "The second option—we haven't done it, but I just want to scare them—will be to make a public demonstration in front of their headquarters, and we will call the press. And the third one is that we will go to court. But the paperwork never moves in court. They don't do anything. And what happens is that people get tired and don't have the resources to keep fighting for an unpaid paycheck."

## Lorenzo

Phoenix, Arizona

When Lorenzo's grandmother passed, he mourned the family culinary knowledge she took with her. Today, he studies the history of Mexican cuisine and works to revive forgotten recipes. "I want to preserve my culture, my cuisine, and to show people what real Mexican food is. I want to change the way people see our food and our culture."

Lorenzo's favorite dish is his mom's red enchiladas. "She would dip then fry the tortilla with the enchilada sauce on there, intensifying the flavor in a way that just blows your mind." When he studied culinary arts at college, though, he found the food he ate growing up was considered "peasant food." "Mexican food wasn't as appreciated as the other finer-dining cuisines like Spanish, Italian, or French. It bothered me."

Lorenzo enjoyed exploring other cuisines, but local demand and his love of his food heritage led him to open a taco truck. His offerings are costlier than some people expect; if anyone complains about the prices, Lorenzo tells them that his tacos are superior to your average street food. "I sacrifice some business in service of the quality of my food. And I'm not willing to give that up."

"One thing that Anthony Bourdain said that always stood out in my mind is that it is racist to think Mexican food is cheap."

In 2017, Lorenzo opened his food truck, Ni De Aqui Ni De Alla, a venture he says wouldn't have been possible without DACA.

## Yin

Acton, Massachusetts

Following her arrival from Taiwan, Yin learned the art of stone carving at a quarry in Connecticut. The owner, John (who people call JB), let her use it for free. She spent six months working on her first piece even through snow and freezing rain. JB once remarked, "I have never seen anyone work this hard in my life." "I had children at home," Yin says, "so I would run home to make breakfast, send the kids to school, and then run back to the quarry."

Over nine years, she carved forty pieces there and grew close to JB and his three sons. Yin's "quarry father," as she called him, often left a page from the Bible and a piece of chocolate for her on the stone she was carving. When he encouraged her to find her own quarry, she established Contemporary Arts International in Acton. "We built up this place with our hands."

"When I was a little kid the economy was poor. For one U.S. dollar, you could buy a lot of things, at least two or three people's lunch."

Yin, a stone carver, and her partner spent months removing bullet shells, broken glass, discarded furniture, and twenty-seven cars from an abandoned quarry. The transformed space now includes a large studio and an artist residency house.

## Edi and Etrit
Rochester, Michigan

Edi was fourteen when he arrived in the U.S. in 1999. He lied and said he was sixteen to get his first job, washing dishes at an Italian restaurant. His father, Mikel, who was a professor in Kosovo, worked at McDonald's and as a roofer, while his mother, Bora, an elementary school teacher, worked in a factory as a machine operator.

Both Edi and his brother, Etrit, have had great success in the tech industry and are helping revitalize Detroit. They attribute their creativity and resourcefulness in business to lessons learned while fleeing war in Kosovo; their mom, for example, sewed money into their jeans so that if they got separated from their parents, they could bribe their way out of the country.

↖ Etrit (*left*) and Edi played soccer at Rochester High School when they arrived in the U.S.— and Edi went on to win a state championship.

↑↑ Etrit (*left*) and Edi (*right*) stand with their parents, Bora and Mikel.

↑ Edi's father, Mikel, holds a photo of Etrit and Edi. Seated behind them are Mikel and his father, in their old house in Kosovo.

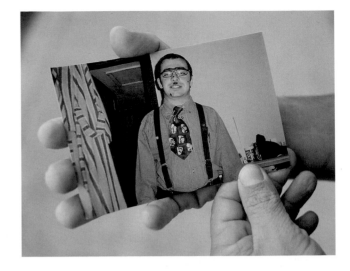

# Maya and Nazmi

Mobile, Alabama

Nazmi was working at TGI Fridays when he met Maya. She grew up in Germany after fleeing Bosnia with her family as a child, and he knew some German from working at resorts in Türkiye, so they had a conversation in German. Six years later, he bumped into her three times within weeks, and then his best friend said she found the perfect blind date for him—and it was Maya. "It's like we had no choice but to start dating after all those coincidences."

↑↑ Nazmi's first Halloween in America was spent waiting tables at TGI Fridays. "I was a nerd, and I was in character all night—people couldn't stop laughing."

↑ Nazmi serves a customer at one of his smoothie franchises. "I always say I came to the U.S. to make a difference. My mindset is to add some value—to the country, the community, and the business."

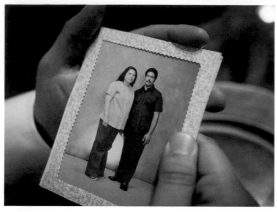

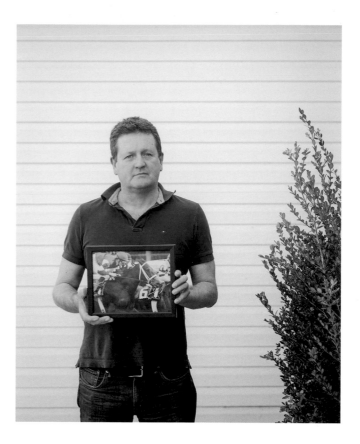

## Federico
Charlotte, North Carolina

Federico's mother, Sofia, emigrated from Colombia in the 1960s. For thirty years, she worked in food preparation at JFK airport, a physically demanding job that destroyed her knee cartilage and gave her severe arthritis. Her husband, Alejandro, moved to New York from Puerto Rico. He spent some time living under the Williamsburg Bridge, but with cooking and plumbing skills he eventually found steady work. When Federico was five, Alejandro fell into a tank of scalding water and oil at his maintenance job, leaving him permanently disabled—but he still found jobs to provide for the family.

Federico is the assistant director of the Office of Equity, Mobility & Immigrant Integration for the City of Charlotte. "I sometimes feel a sense of guilt because my parents worked their butts off to provide us with a quality Catholic school education. They struggled because of their desire to provide the opportunities that they did not have."

## Vicky and Pat
Lexington, Kentucky

"When we came to the U.S., I said, 'I'm never going to ride a horse again.' I was done with that. And then you find you miss them, they are in your blood, and you just can't stay away."

Vicky and her husband, Pat, are lifelong horse people. "Just being around horses every day is good for your soul," she says. "They don't ask too much of you. I mean, they drive you crazy: they bite and kick and push you around, and they don't do what you want them to do. But they are so beautiful."

"I prefer being around horses to people. They don't judge you, and they forgive you. I guess I'm half horse!"

Vicky and Pat moved to Kentucky from the UK so their son Jack could pursue a career as a jockey. She has been the barn forewoman at WinStar Farm since 2016.

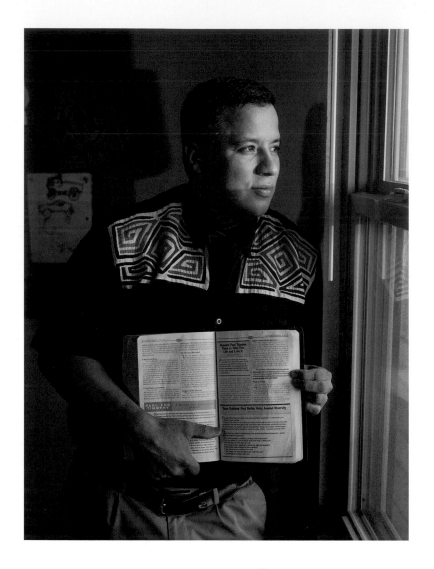

# Andy
Springfield, Missouri

Andy's mountain village in Panama had fewer than one hundred and fifty residents, no electricity, and no running water. He woke up every morning at four thirty to milk the cows, and by six in the evening he was in bed. While studying animal science in Costa Rica, a visiting professor from Missouri State was so impressed with Andy's efforts to bridge the language gap with the American students that he offered him a farm internship. After the internship, Andy began full-time studies at the university.

Andy was still struggling with English in his first year, didn't have any friends, and legally could only work on campus. Until the cafeteria hired him, he ate food from trash bins to survive. "I figured I would work in the cafeteria because there at least I would have food."

After suffering a serious ladder fall at his previous job, Andy began a career in massage therapy. While he enjoys helping people relieve physical pain, his ultimate goals are spiritual—as a Seventh-day Adventist, he hopes to connect people to God.

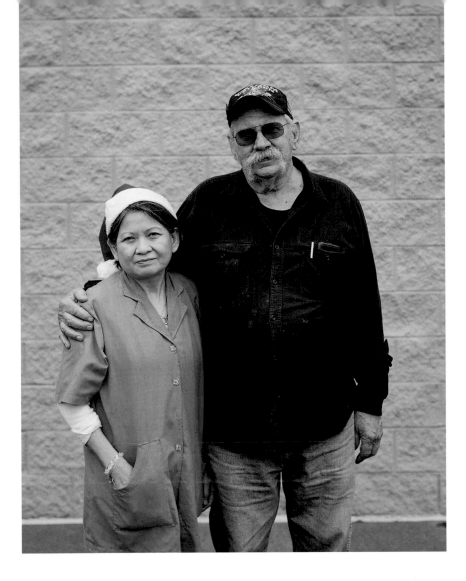

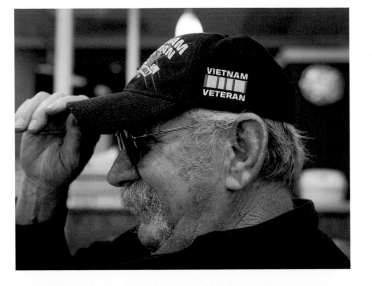

## Thu Ha

Seneca, South Carolina

Working twelve-hour days, it was hard for Thu Ha to date. But in 2017, she met Jerry, a retired Vietnam veteran who said he always felt a special connection to Vietnamese people. "I left Vietnam, but it never left me." He walked to Walmart every morning just for something to do and noticed Thu Ha in her salon. "I was married when I went to Vietnam, but when I came back my wife had three or four boyfriends. I stayed single all these years. You can see what my attraction was to Thu Ha—and she gives big hugs! How can I not come to visit her every day?" Thu Ha said finding Jerry was a miracle sent by God. Jerry said he spent fifty years looking for Thu Ha.

"My dad told me to learn how to do nails as it was the fastest way to make money, survive, and be independent." Thu Ha has been doing nails since arriving in the U.S. in the early 1990s. In 2017, she bought a nail salon inside Seneca's Walmart.

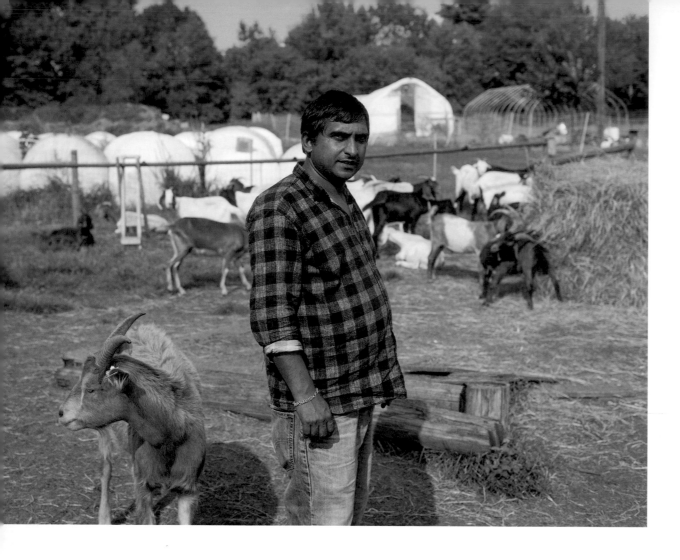

## Chuda
Colchester, Vermont

Chuda (*pictured*) and Gita's goat farm is one of three independent businesses operating at Pine Island Community Farm, "a place where New Americans can produce food and enjoy the land." The couple from Bhutan lived in a refugee camp in Nepal for twenty years before resettling in Burlington in 2009. Since starting their business in 2013, the herd has grown to more than four hundred goats.

# Jacqueline

Bentonville, Arkansas

Jacqueline and Brian had never considered moving to the U.S. until they met with cerebral palsy specialists who recommended that they take their daughter, Rorie, there for surgery. Coming from Canada, the cost would be at least $200,000 out of pocket. Luckily, a recruiter from Walmart called Brian out of the blue. Moving to Arkansas—with health insurance and accommodation—made their daughter's surgery much more affordable.

Of the five hundred thousand people living in the area, thirty thousand work at Walmart, and most of the others are employed by a Walmart vendor. Whenever Brian and Jacqueline go out, they run into "Walmart people." "When you go to a dance recital, you see at least five people from work," says Jacqueline. "You go to Walmart on the weekend, and you see people from work. You go to church and see people from work. It's a tight community because everyone is going in the same direction."

→ Jacqueline, a full-time mom to Rorie and Grayson, enjoys the amenities in their gated community like the pool and the kids' club that affords her an hour break. "When you are parenting two special-needs children for eleven hours straight, with no relief, each day, any breaks make a difference."

↙ Grayson visits with his behavioral therapists while his sister, Rorie, plays in the living room.

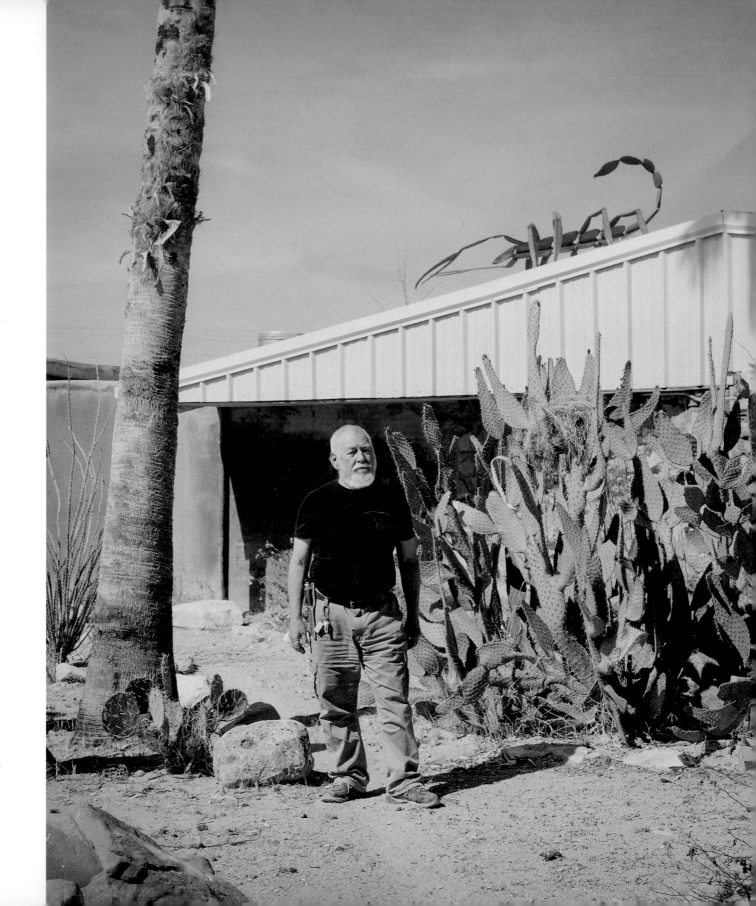

John and Josie, originally from the
UK, are now the proprietors of La Kiva,
a cavernous dinosaur-themed bar
and restaurant. It had closed after its
previous owner was murdered.

## John and Josie

Terlingua, Texas

A year after moving to Oklahoma in 1980, John and Josie were looking for someplace warmer to spend Christmas. They unfolded a large map—this was "BG, before Google," John explains—and saw a large green blotch on the Texas border: Big Bend National Park. They loved the desert scenery and the little "ghost town" of Terlingua, population one hundred, and during many return visits they became friends with the locals.

In 2014, Glenn Felts, the popular owner of Terlingua's oldest bar, was murdered. The ramshackle, partially underground La Kiva struggled to attract a new owner. John was retired and looking for a new project. "The tricky part is saying, 'Honey, guess what? We are going to move to southwest Texas and run a bar!'"

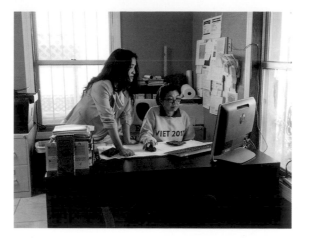

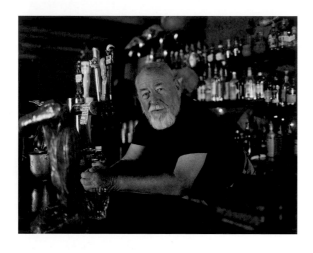

# COMMUNITIES

Luis tends to some of the four hundred free-range chickens at Innisfree Village, a voluntary community of caregivers and adults with intellectual disabilities.

# Luis
## Crozet, Virginia

Luis, who was a photographer in Colombia, has worked a variety of jobs since moving to Florida with his family in 1981. Now divorced, he lives and works as a residential volunteer alongside adults with intellectual disabilities at Innisfree Village, a therapeutic lifesharing community. "The same pattern has continued throughout my life: upheaval, and then this peacefulness."

Luis carried intense anger from the turmoil he endured as a young man—until he was fifty, when a friend suggested Luis's problem was that he didn't love himself. He attributes it to a Catholic upbringing that emphasized loving others rather than oneself. "Once I learned that, oh the peace I gained. I learned through Buddhism and meditation that you can live in the middle of this chaos and turmoil and still be peaceful. A lot of people are anxious about the government, the world, the environment. I'm not worried about any of those things. I have a calm inside of me—whatever happens, I can accept it. In spite of all the turmoil in my life, I have been able to get there. I didn't know any better and now I do. Today, I live an incredibly peaceful life. I think I have things to teach people."

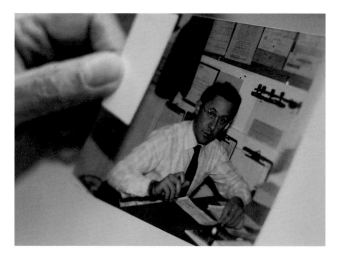

↑ Luis holds a screen print made from a photograph he took shortly before leaving Colombia.

←← Mark, a community member at Innisfree, places a khata, a ceremonial Tibetan Buddhist scarf, around Luis's shoulders. A khata is often gifted as a sign of good will; Luis received this one upon leaving a Buddhist center in Berkeley, California, where he lived and worked for six years before relocating to Virginia.

← In the early 1980s, Luis managed a Denny's in Florida.

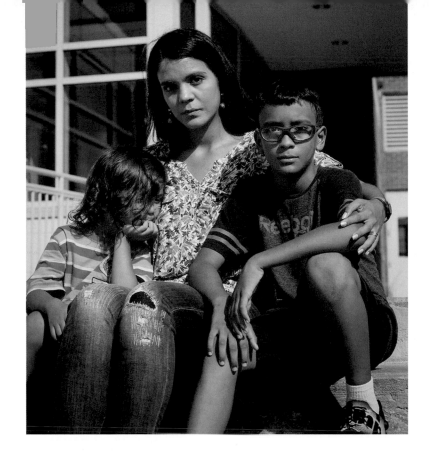

## Violeta
New London, Connecticut

"I still cry every single day."

Violeta would rather be in Venezuela, but she felt compelled to move. "It's about my life and my children's lives. It's not about having a dream or wanting to be rich. It's something that I had to do. You do it or you can die. I have my memories. I miss my family, my food, my weather, my job, my friends, my car, my house."

## Priscilla
Bedford, New Hampshire

For Priscilla, Brazil will always be home. "I can adapt anywhere but fitting in is different. I feel that when I look around here, I can't find anyone like me ... The people in Brazil seem happier than the people here. You see a lot of poverty there, but you also see a lot of happy faces, even when life is rough."

# Mobina

## Bear, Delaware

Mobina, a professor, and her husband, an engineer, both had great jobs in Pakistan and a spacious home. Still, their conviction that their children would get a better education and future in America enticed them to emigrate in 1983. "It was not easy. We moved across the ocean, and we were alone. We had a chauffeur and servants there, and then we were living in a one-bedroom apartment with three children."

Twenty years after Mobina and her husband left a comfortable life in Pakistan for New Jersey, he started a business, so the family moved to Delaware. Right away, Mobina noticed a difference. "When I went out to the malls here, I didn't see any Muslims. My daughter was the only Muslim in her school. New Jersey was a very diverse state, so I was comfortable, but being here in Delaware, I wasn't."

Arriving in Delaware shortly after 9/11, Mobina felt like people somehow associated her with that attack. She has overheard negative remarks about Muslims. When a white family moved in next door, she nevertheless wanted to share some food with her neighbors, a custom she grew up with—but her husband worried they might think she was trying to poison them, or they'd get sick and sue. Mobina decided to risk it.

"I took the plate of rice and went to their house and said, 'I cooked this food and would like you to have some if you are comfortable eating it.' And this new neighbor replied, 'I would love to try your food.' Mary and I became very good friends. At that time, when I was alone and lonely, it meant a lot. She was my first friend."

↑ Mobina (*left*) welcomed Mary to the neighborhood with a home-cooked meal, and the two have been friends since. "It's nice when you meet a fellow American who is white, not prejudiced, and welcomes you. It means a lot to us."

←← Mobina's first job, at KFC, was also the first time in her life she wore pants.

← Today, Mobina runs Happy Times Learning Center from her home in Delaware.

# Marta

Providence, Rhode Island

When she was four, Marta moved with her family to the border city of El Paso, Texas. "Where I grew up, we could literally see the Rio Grande and Juárez, Mexico. It was like there was no border, and then suddenly there was one."

In El Paso, she attended an all-girls boarding school. "Most of the girls at the school came from Juárez. They would live at the school and go home on weekends or at night. I do have memories of some of them just... disappearing. Whenever a uniformed man with a hat knocked on the classroom door, you knew they were going to take somebody—another friend would disappear. This happened to two good friends who I never saw again."

When Marta arrived at Providence College in 1976 to study journalism, she was the only Latina on campus. "I was a curiosity. I didn't like being the center of attention. It was actually lonely." Marta started learning about the state's strong and diverse Latino history and, years later, founded the Hispanic Heritage Committee (now Rhode Island Latino Arts).

When she met Josefina "Doña Fefa" Rosario, "the mother of the Hispanic community," Doña Fefa's grandchildren gathered around to hear her tell of opening a bodega in the Broad Street neighborhood, and of what it was like being the first Dominican family to live in Rhode Island. The experience inspired Marta to launch a new program within RILA. As director of Nuestras Raíces, an oral history project, Marta collects local stories that are missing from official history books.

"Sometimes, without notice, the border patrol would come into the school and take girls away."

Marta is a community oral historian. "I give Barrio Tours, and the Broad Street neighborhood serves as a reminder of those immigrants who came before the Latinos—and of a place where we all will inevitably end up. Cemeteries are places where we go to remember deceased loved ones and a place where one can learn about a community's history."

## Goran

Martinsville, Indiana

Goran has been a practitioner of capoeira, the Afro-Brazilian martial art, since he took his first class in Croatia in 2005. When he moved to the U.S. in 2014, the capoeira community welcomed him and eased his adjustment. "It's like an international family—anywhere you go in the world, you can always find friends who do capoeira."

Goran holds a berimbau, a musical bow used in capoeira.

## Mimi

Eugene, Oregon

"Right after the 2016 election, I was distraught and angry. I asked, 'What can I do?'" To reengage with her community and counter negative stereotypes, Mimi began photographing immigrants in Eugene and sharing their portraits and stories on social media and in exhibitions for her project *Our Stories: Immigrants of America*.

"Everybody's story is unique. People always say, 'My story is not interesting.' You share it and it resonates with other people; you give them the sense that they are not alone. That has always been the binding element with the project. So they don't feel alone."

Mimi shares photos and stories of immigrants in her community, a project she says is enabled by her strong sense of empathy. "Maybe it's a gift or a curse. There are moments when I just wish I didn't feel so much."

# Adelina

Atlanta, Georgia

When Adelina, a trained teacher from Mexico, arrived in the U.S. in 1996, she worked unfulfilling jobs making salads and filling invoices, but found purpose in her volunteer work. She noticed the lack of rights—civil, consumer, human, labor—for Latinos in communities outside Atlanta, and a lack of attention to the problem. Adelina started volunteering for Georgia Latino Alliance for Human Rights (GLAHR) in 1999 and, by 2007, it became her full-time job. Racial profiling and police harassment are some of the major issues they are tackling.

Rather than only talking to political representatives, GLAHR uses direct action. They create "committees populares" around the state as a way to work and organize locally, and they go out and knock on people's doors to make services available, rather than waiting for people to find them. Adelina dismisses criticism of their methods as too radical.

"We are creating a culture of resistance at the grassroots level. If something is going to sustain the movement, it is going to be the grass roots—not the status quo. Of course, we are not politically correct so are not welcome in many places, but it doesn't matter. For us, it is very clear where we are going. We have the right to be here and stay here. Immigrants are working and paying taxes here, and we refuse to play this game where I want you now, but tomorrow, no."

Volunteers with the Georgia Latino Alliance for Human Rights made 6,919 hummingbirds to represent the people across the Carolinas and Georgia who were detained and processed for deportation in a span of seven months. "When we go to the streets, seminars, or panels and I mention 6,919 people, it's a number. But when you see 6,919 hummingbirds hanging all over the place, that gives you an idea of the outrageous amount of people."

## Luis
Morton, Mississippi

Luis joined his family in the U.S. in 1990, after seven years of waiting back in Chile for a visa. He noticed that Mississippi churches are racially segregated and wishes people of faith could be less divided. "I personally believe we have to destroy these walls." For now, he attends an "American church" on Sundays, with two hundred mostly white congregants, and he leads his own congregation on Saturdays in Spanish.

↑ Luis's father was a carpenter whose small shop in Chile grew into a full-size furniture factory. "Juan Cartegena S. Muebles Finos Para Radios" made wooden furniture for radios—until plastic came onto the market and business collapsed. "Plastic changed everything."

← Luis leads a Spanish-language sermon at Iglesia De Dios "Casa Del Alfarero," his own church, housed in a trailer. "It doesn't matter that we are very few. For me, what is most important is the mission. They don't pay me to be the pastor, but I accomplish the mission."

## Youness
Burlington, Vermont

Youness was working as a tour guide in Morocco when he met a woman from Vermont. They decided to marry, and he moved to the U.S. in 2000.

Youness attends the Islamic Society of Vermont, the state's only mosque, which serves a few thousand devotees from across Vermont.

"We have a few interfaith groups—they come to our mosque, and we go to their synagogues or churches. I fell in love with Vermont."

## Nasir
Chicago, Illinois

Since 1982, Myanmar has denied citizenship to the Rohingya, a predominantly Muslim ethnic group, rendering them stateless and restricting their access to education, work, and travel. The Rohingya people, who maintain they have millennium-old ties to the region, have faced many outbursts of ethnic violence, including a genocide in 2017 that displaced half the population.

"The Rohingya people are spread out all over the world, but they don't have power—our people are struggling as refugees. We are here in the U.S., so we have a chance to go to Congress, the White House, UN Security Council. Most of our people in other countries can't even address authorities or raise their voices. We are Americans and Rohingya, so we are responsible for saving and protecting our brothers and sisters who are still in refugee camps."

Nasir was among the first of about a thousand Rohingya refugees to arrive in Chicago. He founded the Rohingya Cultural Center in 2016 to serve the needs of the city's growing Rohingya community.

↑ *Left to right*: Three members of Making Movies—Enrique, Juan-Carlos, and Diego—and Andres hold an original sign featuring the former name of Kansas City's West Side. The band combines various Latin American styles with blues and rock 'n' roll, all infused with a clear message. "'We are all immigrants' has become our sort of rallying cry, and we are happy to keep elevating these communities," says Enrique Chi.

↗ Enrique Chaurand, father of Juan-Carlos and himself a rock star in Mexico during the 1970s, gazes out from La Fonda El Taquito, the family restaurant. Juan-Carlos's maternal grandfather (*bottom*) and grandmother opened a small Mexican taqueria in 1979 and expanded into the current premises. Juan-Carlos's mother, Maria, and aunt, Sandy, run the restaurant today.

← Enrique Chi (*left*) and Diego, brothers from Panama, stand in front of the band's tour van.

## Making Movies
### Kansas City, Missouri

"Latinos helped build this community from the ground up," says Enrique Chaurand. "People don't realize how old the Mexican community is here. My great-grandpa started coming here to work on the railroads, and other Mexicans came for meatpacking. Kansas City has a rich Latino history."

"Many times on our Immigrants are Beautiful tour, journalists would ask, 'Why did you give your tour such a controversial name?'" says Enrique Chi. "I couldn't help but think, 'What world do we live in where that is controversial?' By saying immigrants are beautiful, you are saying humans are beautiful—the human story is beautiful. I guess statements like that are controversial if you are racist. They hear 'immigrant' but they don't hear 'person.'"

↖ Juan-Carlos (*right*) and his brother Andres enjoy beers in the original Union Cultural Mexicana. The UCM began in the 1920s as a credit union and a space for quinceañeras and other events. Downstairs was a bar called El Pozo, where, Juan-Carlos says, "men like our grandfather used to come to drink and sing until their kids had to come and drag them out!"

← Diego shows his tattoo of Eleguá, a spirit responsible for roads and paths in Yoruba tradition. "He is the owner of crossroads and all paths and is responsible for leading those who have passed into the afterlife. It represents the pathways in life and those who cross our path for a moment, for a season, or for the entire journey."

# Yauo

Wausau, Wisconsin

Americans recruited thousands of Hmong in Laos to fight alongside them against the North Vietnamese, but when the Americans pulled out of Laos in 1973, the Hmong were left to fend for themselves. This abandonment catalyzed the Hmong genocide, when the North Vietnamese sought revenge. During the entire Vietnam War, over a hundred thousand Hmong people died and many more fled the country.

Yauo's parents had to trek through the jungle toward Thailand, along with their three children plus Yauo in his mother's womb. After three weeks, they crossed the Mekong River. His parents made it to Thailand, but their children did not. All of Yauo's siblings died from disease or malnutrition during the escape.

In 1980, they arrived at the Ban Vinai Refugee Camp, where Yauo was born. His father joined the guerilla force and wasn't around for Yauo's early years, but the camp's elders helped out by pouring love into the parents' only surviving child.

"I'm just blessed to be alive, because if my mom had died, I would have gone with her."

Shortly after arriving in the U.S. in 1987, Yauo's first Christmas approached. He learned that all the white kids in his second-grade class had a Christmas tree at home with presents waiting for them, so he asked his mom if he and his siblings would get presents too.

The answer was no—they were on government assistance and trying to save every penny.

Before the holiday break, Yauo's ESL teacher, Mrs. Merryfield, invited him and his family to her house to celebrate Christmas. "I never had this experience before. I remember baking Christmas cookies for the first time in my life, and my teacher saying, 'I want you to come over here and see these presents.' For the first time in my life, there were Christmas presents with my name on them."

Yauo started his second year of college on September 11, 2001. That day was "a defining moment" for him. "I felt like it was a personal attack. I felt a person's obligation to protect my country." He joined the National Guard, against the urging of friends and family and, in 2004, received active-duty orders. Hmong elders couldn't understand why Yauo, whose parents had fought so hard to escape war, would volunteer for it. "If we are going to stop the enemy, it is going to be on the front lines, so I said I wanted to be a combat soldier. That's the most dangerous job you can have."

On Boxing Day in 2004, Yauo was walking through Samarra, Iraq, on a routine night mission, enforcing curfew. An IED exploded right in front of him—"like a sledgehammer to your stomach"—killing the staff sergeant Yauo had been chatting with moments earlier. "If they had waited a few more seconds to detonate the bomb, that would have been me in that place instead. You realize you are no longer immortal. You are very mortal." Yauo soon lost another friend. "I knew I could be next. I got desperate. I said, 'God, if you can get my butt out of Iraq alive, when I get back to Wisconsin, I will do whatever you want me to do. I will serve you.'"

Nearly a decade after returning, weekly churchgoing was the extent of Yauo's service. Then in 2013, a minister asked him to lead discipleship at his church, and in 2015, two different pastors asked if he was interested in "church planting." Yauo is now the pastor at The Cross, the multiethnic, nondenominational church he started in 2016 to help people who are "down and out," an experience his family can relate to.

"I have not forgotten what it is like to have nothing, and then have kind people pour love on you."

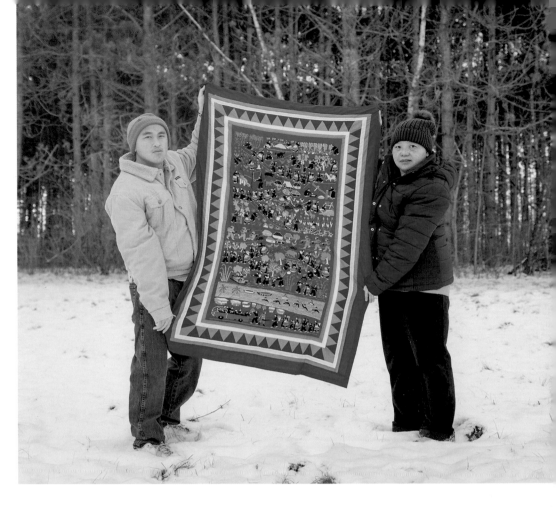

↖ Yauo poses with a flag given to him by "Mike," an Iraqi interpreter. "Every time I look at that flag, it reminds me of the friendships I made in Iraq."

↑↑ Yauo and his wife, Mayla, hold a tapestry that tells the Hmong people's story.

↖ Yauo's Hmong Bible.

↗ The Cross began in Yauo's living room with seven Hmong families and now serves a diverse congregation out of the YWCA building in downtown Wausau.

# Winnie

Twin Falls, Idaho

Winnie moved from Kenya to Idaho when she was sixteen and found herself the only African at her high school. When classmates asked her questions inspired by genuine ignorance, like, "Do you wear clothes in Africa?" she played along, saying they only had coconut leaves to cover their breasts.

In 2014, Winnie founded the Miss Africa Idaho pageant. Instead of swimsuits, contestants display traditional outfits and talents, and identify changes they are making in their local community and in the African country they represent. Winnie speaks to youth around the state about Kenyan and other African cultures.

"I hope there will be more acceptance of diversity here. I want people to be less ignorant about Africa and Africans. Africa is not a country; it is a continent. I want people to know this."

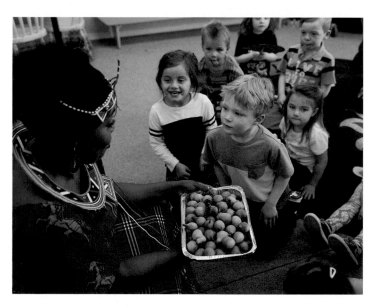

↑↑ Speaking to her son's class, Winnie explains how women in Kenya carry their babies and offers to let the kids try.

↑ Winnie shares her homemade "puff puffs," a popular West African street food, with the students.

## Paw Say's Family
Huron, South Dakota

Paw Say and Paw Suu May left their village in Myanmar in the 1990s amid ongoing military attacks against the Karen people. After a few years in Thailand, they moved to Minnesota in 2000, and six years later relocated with their seven children to the predominantly white town of Huron to work at Dakota Provisions, a turkey-processing facility. Smoky, the HR director, estimates that about two thousand five hundred Karen people have since followed. "It's cool that my father was able to start a whole new community and how far it has come," says Dah Dah Poe. "You can see how many Karen people have come to this one location."

Tha Paw explains how for the older siblings, whose childhood in Thailand was focused on survival, it was hard to get used to "normal life" in the Midwest. Before starting high school in the U.S., her only formal education was Bible study.

Kama Paw says, "It's very hard growing up so Western when your family is super traditional. It is like you have to live two separate lives. What I want is different than what my mom wants. I want to see more of the world, but it's hard for her to let me venture out on my own. I want to go to college and grad school. I want to show the world what I can do."

Smoky explains how these days Dakota Provisions has more Karen employees than any other business in the country, and among the lowest turnover rates in the industry. It finances all the ESL classes in town (even for non-employees), offers citizenship classes, and built a giant community garden where members of the Karen community can get to know their neighbors.

↖ Dah Dah Poe holds a portrait of his father, Paw Say, a pillar of the Karen community in Huron. Paw Say passed away in 2017 and will be remembered for his fearlessness, says Dah Dah Poe.

← "Our family is like a pack," says Kama Paw. "We all stay together."

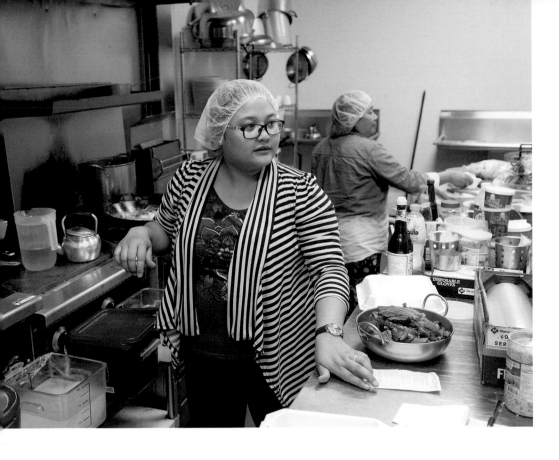

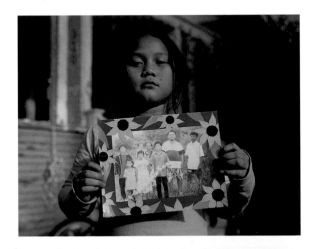

↖ Wah Wah Tah (*left*) and her mother, Paw Suu May, work at the family's restaurant, Taste of Karen. "This is my dad's dream, to open a restaurant and grocery store. He passed away before we opened. We thought we wouldn't do it anymore, but my mom said, 'Follow Dad's dreams,' so we opened in 2018."

↑↑ Kama Paw's daughter holds a photo of the family in Thailand.

↑ Smoky, the HR director at Dakota Provisions, recruited Paw Say and Paw Suu May to work in a turkey-processing plant (*seen in photo at left*).

# Kayse
Portland, Oregon

Kayse's family lived a nomadic life. At sunrise, his mother milked the goats, and his father milked the camel. After breakfast, the adults and teenagers tended to the grazing livestock, and the children took care of the baby livestock. "In nomadic life, everyone in the family has a role, including children. It is like an ecosystem." His formal education began at the age of eight in Somalia's capital, Mogadishu, a two-and-a-half-day journey from home. "I had never been to a big city before. Lights, bridges—all completely alien to me. I didn't know how to interact with other kids at school. It was the first time I felt different." Kayse planned to continue on to college, but three months after he graduated high school, the civil war began. "Nothing is planned. You live by the day, by the hour."

When Kayse left Somalia in search of a safer home, he went first to Kenya and then Canada, before arriving in San Diego. There, he worked in a Somalian restaurant for three months until his asylum case was approved, then Kayse took a Greyhound bus to Portland, where someone he knew from his clan was already settled.

In 2002, after 9/11 and hearing stories from women in the local Somali community who were being harassed, he cofounded the Center for Intercultural Organizing (now Unite Oregon). The nonprofit organizes communities—urban and rural people of color, immigrants and refugees, and people experiencing poverty in pursuit of justice—in the hope of bringing together marginalized groups.

Kayse was elected a Democratic state senator in 2021. "I consider myself an Oregonian. Whether you were born here or somewhere else, our fate is intertwined, and we need to make sure that everybody is included—that we are always asking, 'Who is at the table?' This is a commitment to justice."

Kayse holds a photo of himself with his two older siblings. He is the first Muslim to serve in Oregon's legislature and the first refugee to serve in Oregon's senate. "I started from scratch in Portland. I think I've done well."

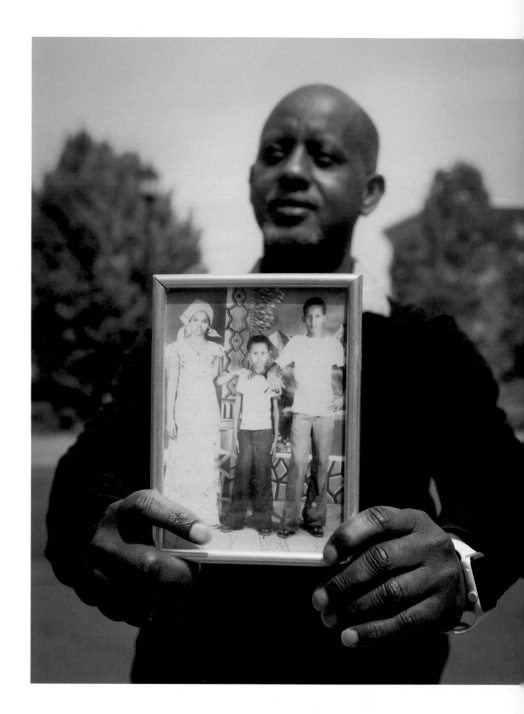

# James
St. Louis, Missouri

"One thing I realized after moving to America is that it is very religious here in a way that England is not. I encountered for the first time, people who had never met a non-religious person. Other grad students at Harvard thought it impossible to imagine living life without religion. It soon became clear that for a long time, a particular version of Christianity has had a stronghold on the discussion of values in America, to such a degree that even the word *values* is considered a right-wing Christian word. I was very intrigued and wanted to explore these ideas, but I wasn't a Christian and certainly not right wing. That pushed me to engage with the humanist community at Harvard in a deeper way than I had when I was back in England."

James arrived at the Ethical Society of Saint Louis as a clergy trainee in 2014. A few months later, white police officer Darren Wilson shot and killed Black teenager Michael Brown in nearby Ferguson, and protest and calls for racial justice filled the streets. James's first six months in Missouri were devoted to supporting the uprising by offering jail support and joining events like sit-ins, die-ins, and mall takeovers. He was arrested once, which complicated his immigration process. James tried to communicate the importance of racial justice work to his congregation, which was "overwhelmingly white and well educated." They lost some members but gained even more.

"I thought that we had to be involved in what was happening because our whole thing was about equal worth and dignity of every person, and this was a movement about how Black lives matter, in a way that is not often reflected in our criminal justice system, educational system, economic system, and culture. In every system in American society, since its founding, there has been this embedded racism."

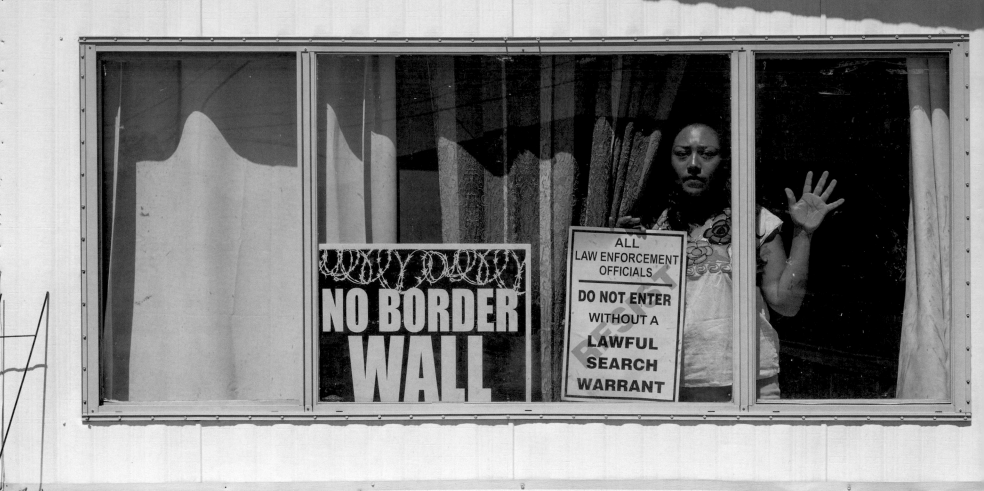

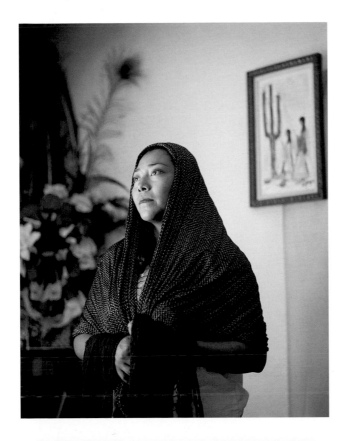

## Monica
Tucson, Arizona

"For many years, I lived with my luggage ready. When they started announcing deportations and creating fear in the community, I said, 'I'm leaving!' But then I started thinking about how, if we went back to Mexico, it would be to nothing, and my children would be away from their dad."

Monica felt isolated in the U.S. until a friend invited her to "Paisanos Unidos," a community group that offers legal education, mutual aid, and support to those facing detention and deportation. Newly empowered, Monica decided to give back. "Now, it's not about what the community can do for me, it's about what I can give to my community."

Monica was diagnosed with cervical cancer but today it is in remission. "I tell my three children, 'Today we are here, tomorrow we don't know.' I make sure they know that they are my pride, and that whether I'm able to grow old with them, or not, it has been a pleasure to watch them grow. They know that no matter what, their community will be there for them."

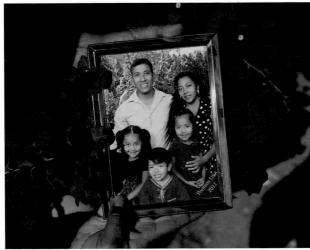

"Every time I see or wear the rebozo, I remember the dedication my grandma, Petra Mesinas, had for her eighteen children. She grew up speaking Mixteco Alto but learned Spanish so they could move forward; and that's what I'm doing in learning English."

## Sophia
Little Rock, Arkansas

In the dangerous days after 9/11, when many Americans rallied around a narrative of Muslim terrorists attacking freedom itself, Sophia asked herself: "Is my faith really out there to usurp others' freedoms?" The disconnect prompted her to learn more about her faith. She knew the stories on TV weren't representative of Islam, nor was her patriarchal education in Pakistan.

When classmates called her son a terrorist one day, he tried to reassure Sophia, saying, "Mom, just ignore it—it's no big deal. Everyone thinks Muslims are terrorists." Her daughter proudly said she had insulted the Hindu boy back. Sophia was mortified, worried that her son was internalizing Islamophobia and her daughter was turning into a bully. Sophia started wearing a headscarf every day (despite her husband urging otherwise) and doing more and more interfaith work to help those around her better understand Muslims. In 2012, St. Margaret's Episcopal Church in Little Rock invited her to help lead The Interfaith Center of Arkansas. It was perfect timing.

"We want to move from diversity to pluralism. Diversity means that people from different faith and race backgrounds live in the same community. However, if diverse communities do not engage with each other, it could be toxic. Pluralism is when diverse communities are actively engaging with each other with a commitment to the common good. They communicate and create an inclusive community where every voice is heard."

Sophia is aware that many people find her mere presence at the church where she works disconcerting. Once, when she was warming her lunch in the cafeteria, a new congregation member came in and asked, "Can I help you?"

"I laughed a little and replied, 'No, I'm fine, I'm right at home. May I help *you*?' We have these mental barriers we have created about who belongs where, and they are becoming more distinct and harsh since the 2016 election—where Muslims belong, where Christians belong. If we see a Christian

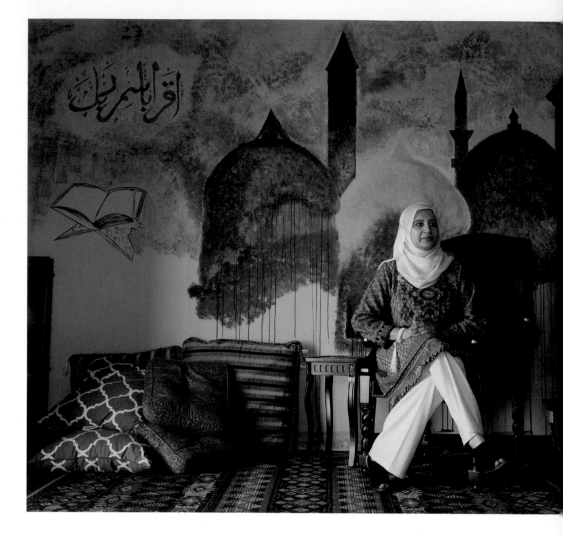

in a mosque, and we say, 'What are you doing here?' that needs to change. Our public spaces need to be more inclusive. That's my hope, and I will continue working at it until the last day of my life."

The spiritual journey Sophia took after 9/11 led her to open her own mosque in 2016, something she never imagined was possible as a young girl from Pakistan. There are still some worries about religious tension in the community, but Sophia is adamant that her mosque will remain open and welcoming.

"Religious persecution in America is against basic American ideals. I think I have a responsibility to protect the freedoms I have enjoyed—and protect them for my children."

# Julia

Ithaca, New York

When Julia and her husband, Rod, learned of ecovillages in the early 1990s, both thought they sounded like the perfect setting to raise their young children. Ecovillages arose out of the cohousing movement of the 1980s. They strive for social, environmental, and economic sustainability. Julia and Rod joined a fledgling community in Ithaca that now has a hundred homes on a hundred and seventy-five acres and neighborhoods named Frog, Song, and Tree.

Until the pandemic, Julia ran a bed-and-breakfast out of their home, made organic wine with the fruit they grow, and helped the ecovillage's cook team make community meals for residents.

## Isaías

Denver, Colorado

After realizing that almost half of their graduating class in high school was also undocumented, Isaías decided to put the work ethic they had learned from their parents into community organizing. "I had nothing else to lose, so I became very vocal about my story. I always said, 'I don't have a hobby; I organize.'"

The Globeville neighborhood where Isaías grew up used to be known as "Little Guadalupe." Today, it is undergoing intense gentrification. Isaías's family was able to stay there because their rent hadn't increased in ten years, but recently they learned their house would be put up for sale. The landlord said they could buy it, but they don't have the money.

"All the people we knew are no longer here. Rent has skyrocketed, so the only people of color still here are the few who were able to buy a house."

↗ Isaías protests the gentrification that is displacing their neighbors and threatens their own family. "My family is so attached to this neighborhood and this house. We would rather go back to Mexico than have to find a new place."

↑ Isaías's father has worked in road construction for more than two decades.

→ Isaías's mother stands in the kitchen of their Globeville home.

⬋ Chompoo helped shave the head of her father, Prasert, when he became a Buddhist monk. It was exciting, but it also meant he would be away from the family for months—and she worried that she wouldn't be able to hug him, since in Thailand, Chompoo says, women are not supposed to touch monks.

→ Chompoo attends the Wat Dhamma Bhavana Buddhist Center in Anchorage. "The Thai community here is strong," says Chompoo. "We support each other."

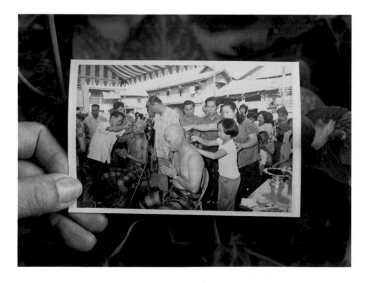

## Chompoo
Anchorage, Alaska

Rob got to chatting with his Thai neighbor Suneeya while they both shoveled their driveways on a snowy day in 2004. She told him she knew someone he should meet and passed along Chompoo's email address. Chompoo remembers feeling unsure about the whole thing, but her family encouraged her, saying, "At least you can practice English." Rob emailed and introduced himself. With the help of an English dictionary and her brother, Chompoo eventually responded. Despite the fifteen-hour time difference, the correspondence continued—and in 2006, Chompoo moved to Alaska.

## Ben
### Corvallis, Oregon

Ben moved to Oregon in 2014 to join his brother, who was there studying. He knew racism was a problem in the U.S., but he wasn't expecting to encounter it within a week of arriving. He was walking to the bus with his brother when a passerby said something Ben didn't understand. He smiled at the man; later, his brother told him it was a racist comment.

"You could find yourself in a room of two hundred people here on campus and only two Black people in the room. If a teacher starts a conversation about slavery or Black people, you will have everyone look at you like you are an expert."

Ben found a community of support in the Black Students Union. He sees himself as a cultural ambassador on campus. "We think that by rejecting our origins or who we are, it will help us be accepted. I don't think this is the case. Once you reject your origin or your culture so that you don't have a unique identity, it is harder for people to accept you."

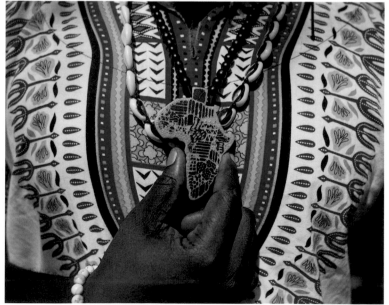

Ben finds that most of his fellow students know nothing about the Congo—and little about Africa in general. "People talk about Africa as though it is a country, not a continent. People will ask, 'What is it like to live in Africa?' I don't know, because I've only lived in my country!"

# Saleha

Chicago, Illinois

Saleha flew from India to the U.S. in 2005 to study. Her dad had been there working since 1998. She felt afraid every time she heard police sirens. "I'm thinking, he's undocumented, he's going to get picked up. You never know when that will happen. I had to grapple with that for the first few years. I was nineteen and living without my mother for the first time. I love my dad, and I didn't know if he was going to be taken away. The reality is you could become homeless or get stuck in jail. Things can happen."

After grad school, Saleha joined the military as a medic but quickly realized she had a better means to heal soldiers. In 2020, she became the U.S. military's first female Muslim chaplain.

"I face so much opposition from certain parts of the Muslim community here in Chicago. How can you fight with them? The issues are with policies and I'm not here for policies. I'm here for people—everything boils down to the human element. That's what I love about chaplaincy. My job is to cater to the emotional, psychological, and religious needs of the community. If you have the uniform on, I am there for you, regardless of religion. A family doesn't just come in blood. Family is who is connected to your heart. I have a crazy big family now, and I'm grateful to God for that."

↗ Saleha sits on a bench at North Park, the private Evangelical Christian university she attended. When she told another student she was Muslim, they asked if she practiced Islam or if it was just a label. Nobody had asked Saleha that before. Reflecting on the question led her to develop a deeper connection to Islam, and she switched her major from business to theology.

→ Saleha, a military chaplain from India, wears wings that her retiring colonel pinned on her. "I'm an American, a soldier, and a hijabi."

→ → Saleha holds a photo of her hugging her father after nearly a decade apart. "It was a very emotional reunion."

# IDENTITIES

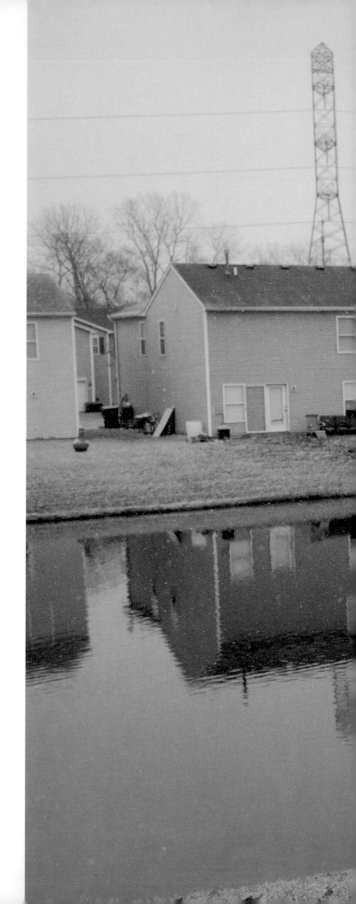

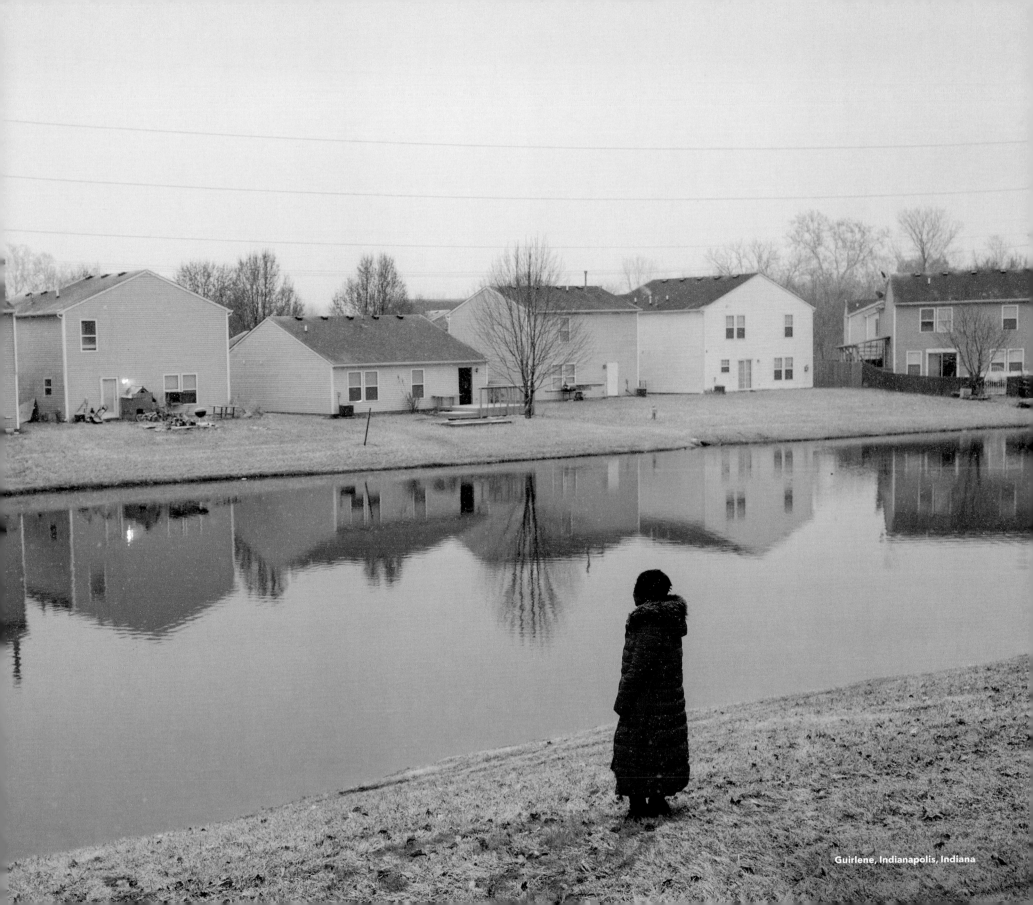

Guirlene, Indianapolis, Indiana

# Guirlene

Indianapolis, Indiana

In the 1970s, Guirlene's father, Flerius Petit Frere, known as "Thomas," moved to Florida and began saving money in the hope that his children could join him one day. For their own safety, Guirlene and her older sister, Weslyne, weren't allowed to tell anyone of the plan. When they were reunited with their father in 1980, Guirlene was happy but shocked by how old her father looked. "I remember singing in church and my dad looking so proud. He said, 'That's my daughter. Those are my children!'"

To escape the Duvalier dictatorship, many Haitians moved to the U.S. in the 1980s but found that negative stereotypes and prejudice were common. Guirlene and Weslyne were the only Haitians in their school, and bullies tormented them daily. Guirlene remembers being called "boat people" and "HBO" (Haitian Body Odor), and being told that Haitians brought HIV/AIDS to the U.S. "The other kids tried to fight with us almost every day after school, so my sister found creative ways to deal with them—like growing her nails out or getting pepper spray."

Thomas died suddenly in 1981, after only a year with his daughters. Haitian practice is for mourners to wear all black for a year. The other kids began calling Guirlene and Weslyne "witches." They begged their mom to let them wear something else, and after six months she relented.

"Many Haitians hide who they are because of the stigma and bad names. It seems like wherever we go they don't treat us too well. Also, when Americans think about Haiti, all they think about is a poor country—'the poorest country in the Western Hemisphere.' Yes, we are poor, but we are rich in heart. My sister and I both want to rewrite this story."

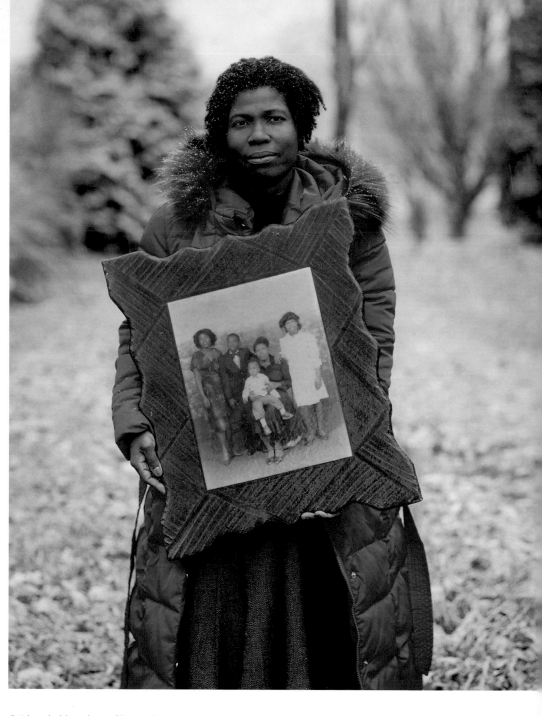

Guirlene holds a photo of her (*right*) with her mom and siblings, taken sometime after her father passed.

# Armando

## Los Angeles, California

When Armando was growing up, it was common for people to ask about the skin shade of a newborn baby or to describe someone marrying a person with lighter skin as "mejorando la raza" (improving the race). As a child, he got hooked on classic films and once went with his cousins to a film festival where all the presenters were Mexican telenovela stars. For the first time, Armando realized how white they were—even though they often portrayed darker-skinned people like himself on television. "At that moment I understood that artists and celebrities are white people—they are 'pretty people.' We are brown and not meant for TV—we are 'ugly people.'" For many years, despite his passion for film, Armando never dreamed of working in the industry, due to his ethnicity. Today, he is a filmmaker and creator of the popular web series *Undocumented Tales*.

↑ Armando keeps the shirt he wore to cross into the U.S. as a reminder of the injustices his family endured in hopes of a better life. "I need to keep this shirt to remind me why I came to this country, so we can continue making the future better for others. Education is the only power we have in our fight for change—telling our stories so people can witness our humanity. Still, this shirt is painful to look at."

## Abel, Helen, and Rediet
Morgantown, West Virginia

Rediet and Helen are twins, and their brother, Abel, is one year younger. They lost their father, Mustafa, when they were toddlers, and then their mother, Abonesh, a few years later. In 2009, at ages eight and seven, they learned they would be leaving their Ethiopian orphanage to live with Laird and Barbara in West Virginia. The siblings had never heard of West Virginia or met an American. Laird and Barbara mailed them letters and care packages with photos of their new sister and dog.

The couple flew to Ethiopia to bring Rediet, Helen, and Abel home. "That day when we met our kids was one of the most joyful days of our lives," says Laird. "I wasn't prepared for it and didn't expect it would be that powerful—my cheeks were sore from grinning and laughing. They all climbed up on our laps. You can't forget moments like that. It's an incredible human connection."

Helen remembers being so confused by the fact that there were Black people who were born in the U.S. "Even though our skin color matched, our culture was different. I thought that if you were Black, you must be from another country. When I asked where they were from, they would say they are from here. That was a big surprise."

She doesn't plan to stay in West Virginia. "I've always wanted something more diverse. I want to get involved in, and know more about, my culture. I don't know enough about myself. I want to move somewhere where there are a bunch of Ethiopians."

← Barbara holds a photograph of her children playing with their mother and a family friend (in white) in Ethiopia.

→ In the orphanage, the siblings received letters and care packages with photos of their new sister and dog.

→ → Helen hopes to one day live in an Ethiopian community where she can relearn and practice Amharic, her native language. "I should have fought more to keep the language of my culture. I gave up easily, and that's the one thing I regret. I feel so connected to Ethiopia but at the same time, I don't. I'm losing the culture."

→ → → Laird holds framed Polaroids of the kids' first ice cream cones in the U.S.

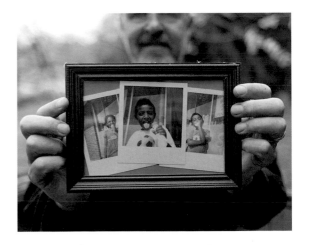

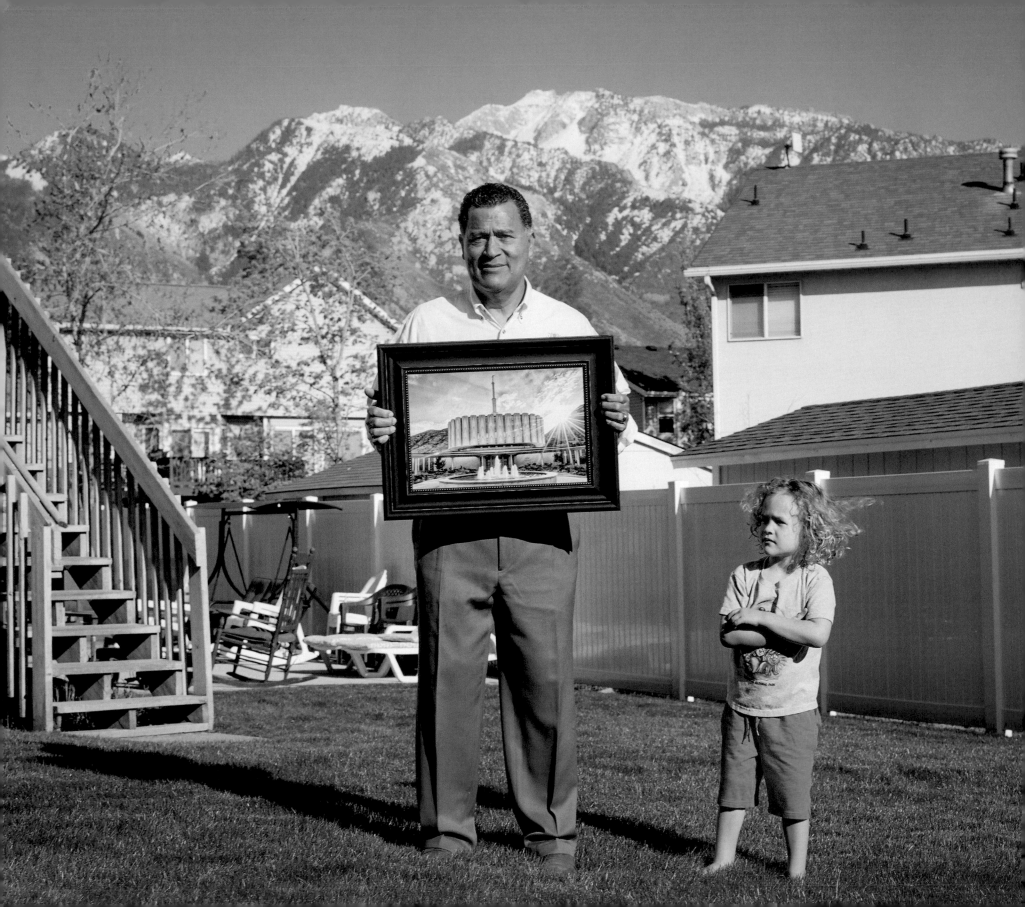

## Joel
### Salt Lake City, Utah

Joel grew up in a small village with a family of twelve children. There were roads but no cars, so everyone walked or rode in a horse and buggy. Joel waited in long lines to fetch water from the village's only well. He doesn't remember wearing shoes until he left the island at age fifteen. "I had only one pair of shorts, and we had to wash it every few days. We didn't have a washing machine. I was the washing machine!"

In the late 1960s, there was no postsecondary education available in Tonga, so Joel moved to the U.S. to study and play football. He met his wife, Cindy, shortly after, while performing a traditional Tongan fire dance at a wedding.

"When I count in my heart, I count in Tongan. My wife said that when I talk in my sleep, I talk in Tongan. She doesn't understand Tongan and always says, 'Dang, I wish I knew what you were saying!'"

←← Joel, with his grandson, holds a photo of the Mormon temple in Provo, where he and his wife, Cindy, were "sealed [in marriage] for time and all eternity."

↑ The conch shell is an ancient way of communicating in Tonga. Once used as a signal in war, it is now blown to call children in for dinner.

↖ Joel's grandson points to Joel in the only photograph of him as a child, which appears in *Pictures of Tonga, 1936-1958*. The book was compiled by Lorraine Morton Ashton, the daughter of a Mormon missionary who lived in Tonga for a decade.

← Joel and his wife, Cindy (*right*), have eight children and twenty-three grandkids.

## Simone
Takoma Park, Maryland

Simone moved to the U.S. with her husband in 1997 to attend grad school. She was surprised by how hands-off Americans are. "Here in the U.S., I once hugged a professor—she was Midwestern, stiff, and mortified! I have literally felt starved of a physical connection. People here look at you lovingly, but they don't touch. By the time it was noon at university in Brazil, I would have hugged and kissed a hundred people!"

She also has a troubled relationship with patriotism. "The first celebration I attended at the university here in the U.S., they were playing these patriotic songs. I was rolling my eyes because our dictatorship in Brazil, like other parts of Latin America, was backed by the U.S. People came here to train in torture!"

When Simone's kindergartener came home singing Woody Guthrie's "This Land is My Land," they researched the singer and wondered how such a progressive figure could write that song. Simone's daughter said, "To change something, you have to love it." "That response changed my perception and opened my heart to the possibility of finding allies here."

Simone, a dog behaviorist and animal-sanctuary volunteer, holds Valente.

## Hilde
New Lebanon, New Hampshire

Hilde moved to the U.S. in 1993 and has spent most of her time since then caring for her two children, who are autistic. "I never ever dreamed in my childhood that I would leave Ghent's village life. It was backward, but pleasantly backward."

One thing Hilde has never gotten used to in the U.S. is patriotism. "It is very weird to see it in action. For me, if Belgium wins in the Olympics, it is, 'Hey, the other teams must have had a really bad day!'"

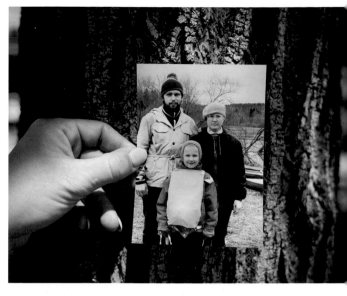

## Mariya

Walnut Creek, California

Mariya arrived in California with her parents in 1999, when she was nine years old. Within a year she discovered synchronized swimming. At the 2012 and 2016 Olympic Games, Mariya competed for Team USA. "I felt pride listening to the Russian national anthem and watching the flag go up, but I also feel proud listening to the U.S. national anthem. I have always been even in my pride and allegiance to both countries, and it was hard for people to understand that."

↖ Mariya stands on the deck of her local pool. In 2013, she returned to Russia for the first time to compete for Team USA. "When I walked out on the deck and the Russian audience saw my name, which is clearly Russian, they all started cheering. It was like coming home."

# Yemi

Anchorage, Alaska

"People don't know where to put me. I definitely can't hang out with the girls, and I can't hang out with the boys. It makes for a hard social life in that sense, so you just live with it. Androgyny isn't a sexual orientation; it's a personal identity. Androgyny also isn't 95 percent of a person's life—it's like 2 percent. Honestly, there are so many different things to talk about besides the fact that someone wears pants or a skirt. Another thing about androgyny is that people think I don't think of myself as attractive. I know I'm pretty attractive!"

In 2015, Yemi went to Jackson State University to run track and study environmental biology. "I felt secluded in Barbados, because I didn't feel like people understood my experience. I wanted to come to America to experience expressing and dressing freely, because my parents didn't allow it and society frowned upon it. I wanted to go anywhere, but America was the easiest because of sports scholarships."

Mississippi wasn't much more accepting. Yemi was always being called an "illegal immigrant" or told they "dressed white," amid other cultural clashes, so they transferred to the University of Alaska Anchorage.

They started using the name "Yemi," from the Yoruba tribe in Nigeria partly for its gender neutrality. "I wanted to start a new page, a new identity, and to be totally myself."

"In Alaska, I was understood and accepted. I found a loving community."

↑ Yemi shows a childhood picture. "I've always looked like both genders. This is my physical disposition without trying."

→ Yemi wears their tie from Combermere, a prestigious high school in Barbados. "The person I am now was formed during those years—I had both good experiences and bad experiences. I learned a lot."

# Ming Yuan

Philadelphia, Pennsylvania

"My first name is Ming Yuan. Yuan was a hard word for a lot of Texans to pronounce, so I decided to drop the Yuan and just go with Ming. But in my generation, everyone is a 'Ming' something; it's a generational name, not a first name. I dropped that essential and personal part of what makes me, me. Here in Philadelphia, people have started to address me as Ming Yuan again."

Ming Yuan moved from Malaysia and studied in Texas, New York, and Pennsylvania, where he did his PhD in music therapy at Drexel University. In his work, he helps educators better understand the nuanced needs of international students, who may misconstrue jokes or interpret suggestions as commands.

"As American professors, they need to be aware. A big part of the business of universities in America is run on money from international students, so it is important for them to do right by the people who are paying to be here."

"From the way I have been questioned, it seems like people here are exoticizing my identity and history. I have had to do a lot of explaining about who I am, and I've had to make sacrifices to make things easier."

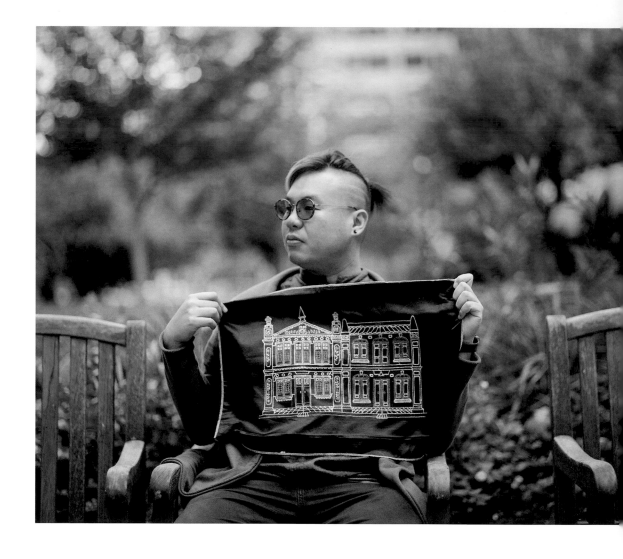

# Miriam

Tiffin, Iowa

Miriam's late father was a huge fan of Lucha Libre. Though she disliked it at first, she would watch with him while he explained the characters and rules, and Miriam came to appreciate his passion. "I love Lucha Libre because it combines a lot of things. Luchadores have to be great athletes, but it's also like a theater and circus with all the colorful outfits and acrobatic movements, performing and creating emotions that make the spectators react and be part of the show. The luchadores feed off that energy."

After moving to Iowa in 2002, Miriam noticed that the local Latino community was "completely invisible." In 2017, she started a portrait series called *Luchadores Immigrants in Iowa*. Because many of the participants want to remain anonymous, she custom designs a "máscara" (wrestling mask) for each portrait.

"The máscara is a symbol of our entire culture. It includes everyone. There are women luchadores, little people, people who are gay, and people of all different ages. Also, the spectators are from lower-income families or very rich families but, with Lucha Libre, are all in the same space—screaming for their favorite luchador."

→ Miriam's children were fascinated by the snow during their first week in Iowa. Miriam remembers using a broom to clear it away. She had never seen a snow shovel.

## Jesus
*Tucson, Arizona*

Jesus's mother lived in Tucson, Arizona, but when she was four months pregnant, his father was deported, so she left for Mexico too. Jesus was born in a small mining town about forty miles from the U.S. border. He started working at the age of eight, harvesting and selling the corn and green chilies that his grandparents grew.

At Christmas when he was eleven, an accident happened while the family was driving home with a car full of presents, and his sister died instantly. The years that followed were exceptionally difficult for his mother. She lost a lot of weight and struggled to give attention to her other children. Jesus began selling candies in front of the clinic where she worked as a cleaner; everyone in the area knew his mom and bought his candies to support her.

Growing up, and even through university, Jesus had to hide aspects of himself. "I had to invent girlfriends to tell my mom about. You learn to live with these things. This distanced me from relatives, who saw me as a free spirit and always asked, 'Why don't you stop traveling, get married, and have children?' I didn't know what to say."

In 2002, Jesus was working in Nogales and every weekend would visit his mom, who was by then living in Tucson. While playing beach volleyball on one of these visits, he met his partner. "My mom always talked about him as 'my friend.' Everyone in my family stopped asking me when I am getting married. They met him a few times and know that I've lived with 'my friend' for almost two decades. For my mom, until the day she dies, he is going to be 'my friend.' It's a secret that everyone knows about."

← Jesus has lived with his partner for two decades, but his mom still thinks of him as Jesus's "friend."

## Laura
Houston, Texas

At career day in Laura's last year of high school, she spoke to a recruiter and shortly after joined the Army. In 2010, she graduated her military training and shipped out to Africa as part of Task Force Raptor. Laura's military police unit provided security to bases in Djibouti and Kenya.

Before joining the military, Laura, who moved to the U.S. from Ecuador, didn't see herself as American. "The military allowed me to connect with a society that I felt rejected me before then. I'm part of the 1 percent of the U.S. population that decides to join the military, and on top of that, I'm part of a small percentage of soldiers who are women. The military allowed me to gain confidence in myself."

## Melyssa
Miami, Florida

"I realized a lot about my identity when I first got here, meeting all these people who were so proud of their heritage—that's something we [French Algerians] in France are not. I'm sure most French people would be like, 'You are paranoid,' but they are not in my shoes. I know it and I see it so much—either you deny who you are or be embarrassed of your religion or language. There is this very French idea that when you become French you have to leave everything at the 'French door,' and you embrace this nationalistic narrative. But France is the result of all these beautiful migrations!

"The U.S. has helped me tremendously—seeing how here you can be all of these layers, this hybridity, without being 'anti.' I also realized when I got here how French I was in the way I think, dress, speak, and eat—which I never thought I was. What is an Algerian? What is French? There are cultural traits that are not going to disappear. It's difficult to have these conversations in France because of the huge paranoia of immigrants taking over: 'They are invading our national culture and ethos.' No, we are adding on—we are not replacing anything. There will always be baguettes in France; we can add couscous. It is about adding more layers and more beauty and better food! Being here has helped me, and now I am just myself."

## Michelle
### Los Angeles, California

Michelle's parents moved from South Korea to Argentina for business, got married, and had three children. The country's economic crash in 2001 pushed them to move to California. Michelle thought it was just a vacation. "I was supposed to go visit my friend Tatiana at her home the day we left Buenos Aires, but I didn't tell her I couldn't make it. We reconnected years later, and she asked me to visit her in Argentina, but due to my immigration status, I couldn't."

Today, Michelle works in immigration policy. "Home was always hard to define for me. Now, home is wherever my loved ones are—my family, my friends, my amazing coworkers. I realized that 'home' is transient. It's not tied to a location but to the people. Because my people are here, I consider the United States my home."

↑ "I am Korean-Argentinean-American. None of them individually would be good enough to describe me."

## Sofia
### Kansas City, Kansas

The death of Sofia's nineteen-year-old brother due to poor medical care in Pakistan following a motorcycle accident pushed her father to move the entire family to America in 1986. Sofia stayed in Pakistan for five more years to finish medical school before joining her family permanently in the U.S. As a physician, she strives to provide her patients with the excellent care her brother didn't receive—and to do it without compromising her identity.

"I put my scarf on after 9/11 as rebellion because I was sick of people changing their Muslim-sounding last names or removing headscarves to be more western-looking so people wouldn't target them. No, I want to embrace my religion. I wanted to challenge people's thinking. You liked me before I put this piece of cloth on my head, so what difference does it make? I am the same person, and this is a country with religious freedom... I realized people weren't just looking at Dr. Khan. They were looking at the Muslim Dr. Khan, the female Dr. Khan. In their mind, they had the idea that my husband forced me to wear a hijab. Everything I do gets a big label. It's pretty annoying and it's a much bigger burden to carry. The scarf doesn't change who I am."

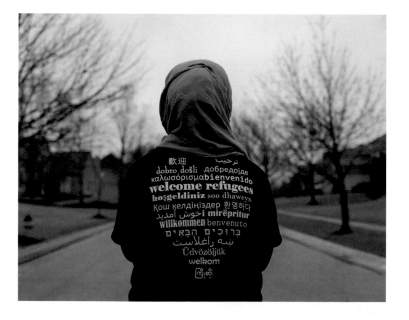

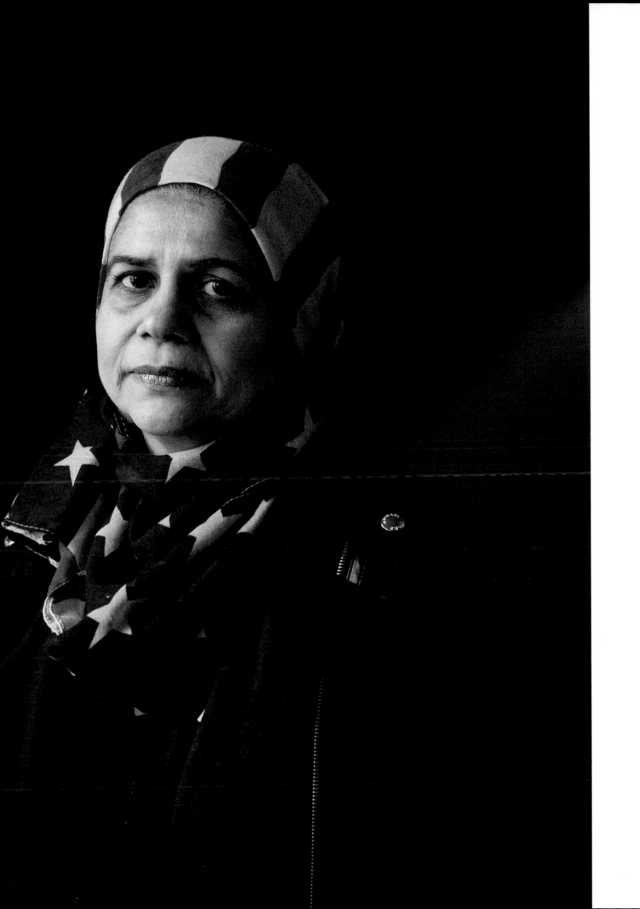

Sofia wears a headscarf in defiance of pressures to assimilate, but she feels the weight of people's preconceptions. "It's been a journey for me. I am an unapologetic Muslim American. I am who I am."

# Phanat

New Iberia, Louisiana

Phanat was born in 1981 in his namesake refugee camp, Phanat Nikhom, in Thailand. A few months later, his family's resettlement was approved. The Diocese of Lafayette was helping bring refugees to Louisiana, which had plenty of low-wage jobs needing to be filled. In New Iberia, Phanat lived in a three-bedroom trailer with his two siblings, his parents, and six people from two other families. "We didn't have a bed to sleep on, so my mom found a mattress on the side of the road and pulled it into the trailer." Phanat's parents slept on the floor.

His parents' first job was canning potatoes for a dollar and eighty cents per hour. Later, they peeled crawfish and shucked oysters; Phanat remembers how they always smelled like seafood. When they opened a grocery business, Phanat and his siblings helped as soon as they were able. "We stocked shelves, worked the register, watched over customers, mopped floors. One of my earliest memories was counting paper food stamps and stamping them for weekly deposits. If you existed and were eating, you needed to do something to help."

After completing his studies in architecture and urban design, Phanat started the nonprofit Envision da Berry in 2010, with the mission to "build creative businesses, establish cultural resources, and breathe fresh life back into our community." As a socially liberal immigrant from Thailand, it took time for Phanat to build trust with a community that is predominantly African American and Catholic or Baptist. Eight years later, the minister of Star Pilgrim, a one-hundred-and-fifty-year-old African American Baptist church, told Phanat that the church was giving him the Pacesetter's Award as part of their Black history program. Phanat responded, "You do know I'm gay, Asian, and Buddhist, right?"

→ Phanat stands inside the community garden co-op he runs in New Iberia. When his family resettled there and opened a grocery store in 1985, his mother, Phouthone, noticed a lack of fresh produce for the local Asian community.

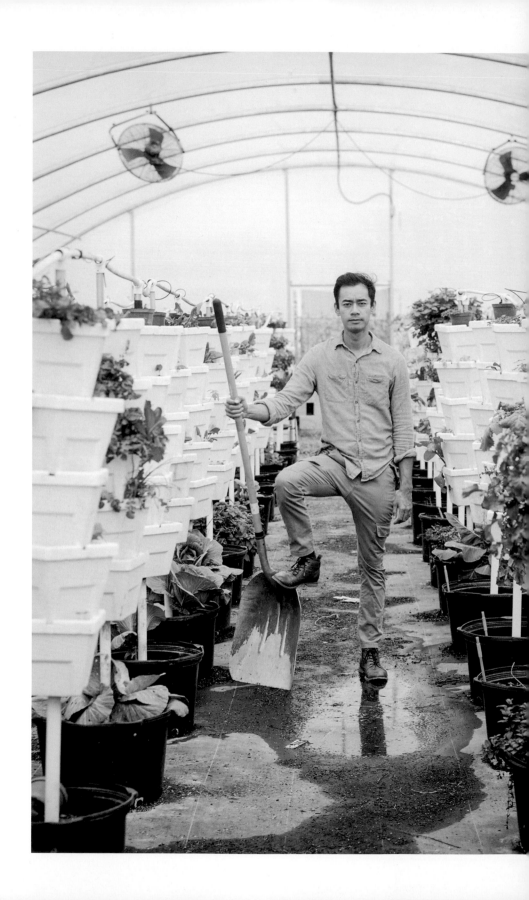

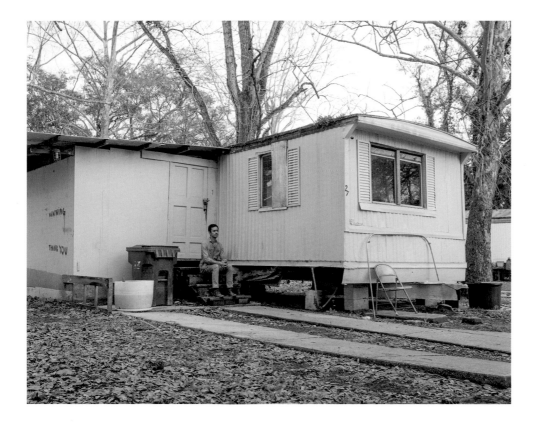

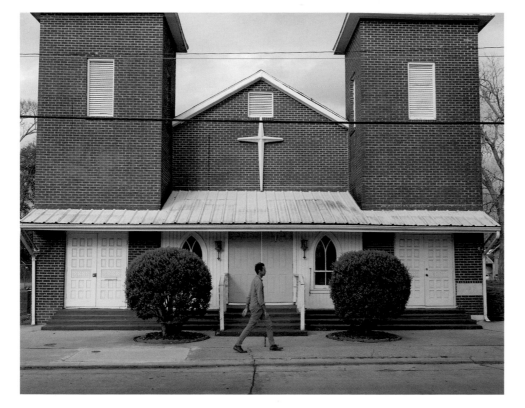

↖ Phanat sits in front of his first home in America, which he shared with ten other people.

← Phanat walks in front of Star Pilgrim Baptist Church, which gave him an award he is deeply proud of. He sees a paradigm shift in his community, with people accepted and celebrated regardless of their sexual orientation, faith, or origin.

# Ihab
Harrisonburg, Virginia

"Our house was hit once with a bomb. I remember packing so many times—packing our stuff and going from one place to another. And I remember losing my friends. We didn't live for more than two or three years in one place, which was very frustrating—it just became so much harder for me to make friends. It's not worth it to make friends, then lose them in a year or two. We had to leave so many places."

Ihab is a bow hunter, a snowboarder, and a dental surgeon. When he started working at the local hospital in 2013, many patients thought he was too young, or they didn't trust him because of his accent and background. So these patients would seek a second opinion. Ihab remembers the other doctor always telling them, "You need to go back to him; he's the specialist!" "They tried to run away from the Middle Eastern guy with an accent. Now, a lot of those patients don't want to see anyone but me!"

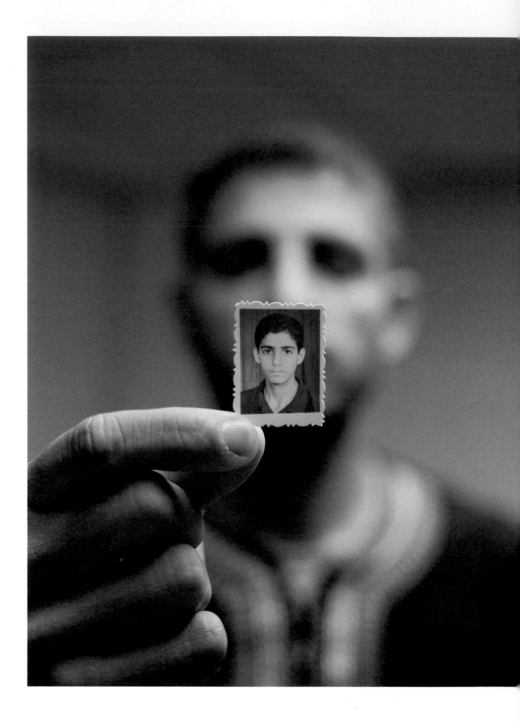

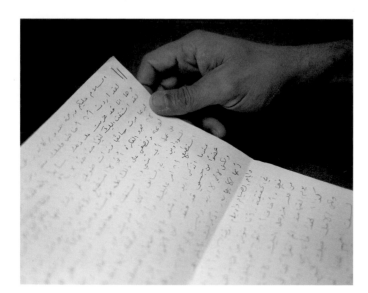

↑ Ihab keeps letters from his late father and his sister. "Every time I feel bad, I open these letters. I start reading, and I feel good. My dad always reminded me that I moved to the U.S. for a reason—'Don't waste your time; do not forget that lots of people are waiting to be helped by you. Always be kind to others. Don't forget me.'"

## Germaine

Honolulu, Hawai'i

Germaine was eleven when, along with her younger brother and her father, she joined her mother's side of the family in Hawai'i. Moving in 2011 was an economic decision: the money was better in the U.S., even working jobs for which their advanced degrees made them overqualified.

In school, Germaine felt socially rejected. "I felt embarrassed to speak Ilokano, my native language, and started disliking other immigrant Filipinos in an attempt to differentiate myself from them. One of my classmates told me that I talk 'American'—meaning I talk like a white person. I was trying to improve my accent so people wouldn't call me 'FOB' anymore, but I further alienated myself by trying to talk like a white American."

Toward the end of high school, Germaine started learning about issues surrounding race and ethnicity and gradually embraced her Filipino identity. In college, she took courses in ethnic studies and Ilokano language and literature. She learned recently that ancestors from each side of her family relocated to Hawai'i in the early twentieth century to work as "sakadas" (Filipino contract laborers) on sugar and pineapple plantations.

↗ "Through my education, I came to understand that my family's immigration, from plantation-era Hawai'i to now, is a product of the combination of U.S. colonialism in the Philippines, racial capitalism, and the U.S.'s illegal occupation of the Kingdom of Hawai'i."

→ "These are the pearl earrings and gold jewelry that 'Nanay,' my paternal grandmother, gave me as a high school graduation gift in 2018. I haven't seen her since 2011, when I moved to Hawai'i, because I haven't been back to my hometown since I left the Philippines."

"There are a lot of Filipinos here. My hometown, Dingras, has an organization called Dingrenios of Hawai'i, which shows how many people from my hometown come here!"

# Tariq and Hina

Birmingham, Alabama

Tariq's visa was approved four days before 9/11. When he heard that Muslims were being held responsible, he was certain his immigration would be halted, but the family arrived in Kentucky the following year. A decade later, they moved to Alabama, where Tariq and Hina work in medicine.

Tariq says that since immigrating and finding himself in a religious minority for the first time, he has become more religious. "I am 120 percent more devout than when I was back home. This country made me aware of what I am as a human being and as a Muslim."

He worries about Hina wearing a headscarf in public, especially at night, but Hina says for the most part people are friendly. Sometimes strangers even stop her in stores or parking lots to tell her, "You guys are part of this country too," or "You should be proud of who you are." It can be startling, she says, but the comments make her feel good.

Since he emigrated from India, several members of Tariq's family have passed, including his grandparents, without him learning until much later. "It's hard when the last time I saw them they were all good, and now I know they are not there. Of course, it's good to be here, but this is one challenge—the price we pay for being far away. I don't know if it's worth it, but when I look at my kids and what I have here, it feels like it is worth it."

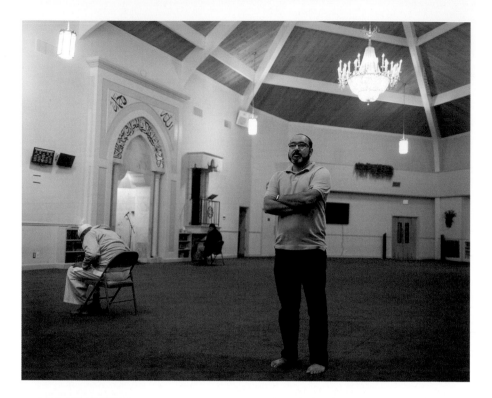

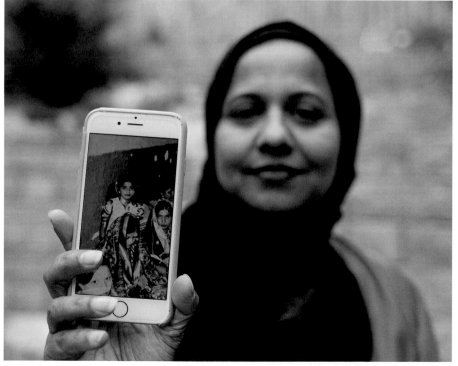

↗ "My kids were born here, and this is their country," says Tariq. "The culture here is different from how we were raised in India, and it is hard for us to maintain a balance between the two. There are a lot of things that other kids their age do that they cannot do. Now that we are here, it is our responsibility, like other immigrant moms or dads, to make sure our kids stand up for what is right and that they are part of society."

# Amber-Dawn

Santa Fe, New Mexico

"Growing up in the '70s, I was completely embarrassed about my last name, Bear Robe. I just wanted to be white and normal. In high school, I took my stepfather's very British surname, Fruen."

Amber-Dawn is Blackfoot from Siksika Nation in Alberta, Canada. She immigrated to the U.S. for grad school in Arizona but always figured she would end up in New Mexico, where she often traveled for the Gathering of Nations, the largest powwow in North America. In 2012, Amber-Dawn started teaching art history at the Institute of American Indian Arts in Santa Fe, and there, in 2014, she founded the Southwestern Association for American Indian Arts (SWAIA) Fashion Show, the preeminent event in North America for premiering new collections from Indigenous fashion designers. Amber-Dawn says it is an exciting time for Indigenous art, fashion, and language, and hopes her students will always be proud to be Native, an identity that took her many years to embrace.

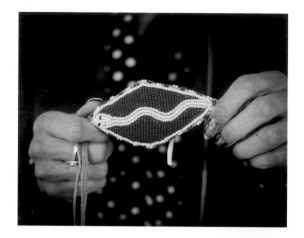

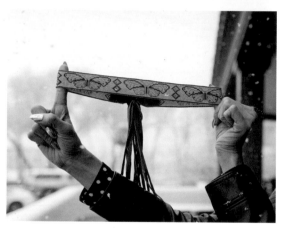

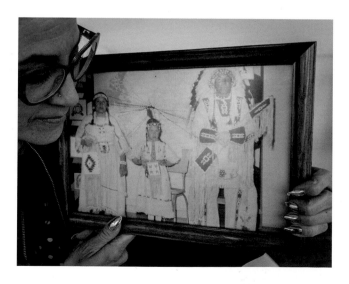

↑↑ This traditional Blackfoot lizard amulet contains Amber-Dawn's umbilical cord and attaches to the back of her dance dress. "This connects me back to Canada—to my family roots—so I always have it with me."

↑ This hatband, made by an artisan in New Mexico, symbolizes the Blackfoot name Amber-Dawn received during a powwow when she was four. The name translates to "many butterfly woman." "My great-uncle Ben Calf Robe was talking in Blackfoot about a dream he had of a teepee covered in butterflies; after a while, they became animated and flew off, which is exactly what I did. I left the reserve."

## Imad

Oklahoma City, Oklahoma

Imad grew up in Palestinian refugee camps in Lebanon, surrounded by war and witness to massacres.

*"I thank God for exposing me to so much hatred and violence so that I could be a voice for love and peace."*

Imad is the founder, imam, and president of the Islamic Society of Greater Oklahoma City, which emphasizes interfaith outreach. "It's a collaboration that is all about going beyond coexistence. People of the interfaith community stood with us when local politicians tried to attack us. And we will stand with them. My two best friends are rabbis. I have seventy-two different ethnicities represented here at the mosque, all brought together toward a common goal."

That goal is simply for Muslims to be treated as equal citizens. "Muslims have been called 'a cancer' by a local politician. I want us to be looked at as a vital organ in the body of this city. The only Muslim connection to cancer in this city that I know of are the six Muslim doctors who are working to try to cure cancer!"

Imad helped establish OKC's first accredited Islamic school. "We had to install this fence. Fear and Islamophobia are at an all-time high. I hate fences, but when parents are worried about their kids' safety, what can you do? Normally, raising money is hard, but we raised money for the fence in five minutes."

## Alaa and Joanna

North Ridgeville, Ohio

Alaa, a Palestinian Canadian from Kuwait, and his wife, Joanna, a Croatian Canadian, moved to the U.S. in 2006. The couple now has three children and lives in a Cleveland suburb. In his physical therapy practice, Alaa goes by "Al" to avoid any possibility of an Arab name eliciting prejudice from his patients. He has overheard patients speaking negatively about Islam, not realizing the person helping them is Muslim.

"I definitely want our kids to know about both Catholicism and Islam. It's important they know their culture, traditions, religion, and what they are all about—so they can pass them on to their kids. It's part of who they are."

## Kwesi

Indianapolis, Indiana

Kwesi is the program coordinator at a nonprofit that supports newcomers to America. "Home will always be Ghana," he says. "My grandfather would tell you that 'The wood can remain in the river for a thousand years, but that will never turn it into a crocodile; it would still be wood.' No matter what I do here, I will be Kwesi from Ghana. I work so hard to keep my accent so that you'll ask, 'Where do you come from?' and I'll tell you, 'I'm from Ghana.'"

The Immigrant Welcome Center saw a surge of support after the 2016 presidential election. "Ever since he came to power, we have seen a hike—because of anger—in donors," says Kwesi. "This organization is funded by individual donors. A lot of people have stepped up now. They say, 'I've heard about what you do, thank you,' and they donate. The president boosted our donors—but he also boosted those who need our help."

# Lee

## Maplewood, Minnesota

After the Laotian Civil War, the new Pathet Lao government began searching mountain villages for "American collaborators"—those who, like members of Lee's family, had fought with the Americans in the Vietnam War. By 1987, Lee's parents knew it was time to leave. They packed up what they could carry, and the family left their small village of Muang Don. Lee walked through the jungle for two weeks with his older sister, two adopted sisters, and parents. Along the banks of the Mekong River, they paid a Thai fisherman to smuggle them across and soon entered the Ban Vinai refugee camp. Lee remembers how some people in the camp watched planes leaving and thought "America is all the way up in the sky."

Lee experienced significant discrimination growing up as a Hmong American. The experience drove him to a career in education, first as a teacher and now as a principal. "We need our students of color to see another person of color in a leadership role."

He wants students to feel proud of who they are, which didn't happen for him until college. "Growing up, I didn't want people to know who I was, but now, having gone through it, I don't want my Hmong students to be afraid to show who they are. You are Hmong and you have to be proud of it."

Stepping outside your comfort zone builds character, Lee believes, so he and his friends ski and snowboard, play broomball, and complete triathlons—"things that aren't normal for people who look like us."

→ Lee's daughter practices at the local rink. He encourages her to try activities that aren't typical for a young Asian girl. "You don't see a lot of Asian hockey players. I want Florence to see if she likes it."

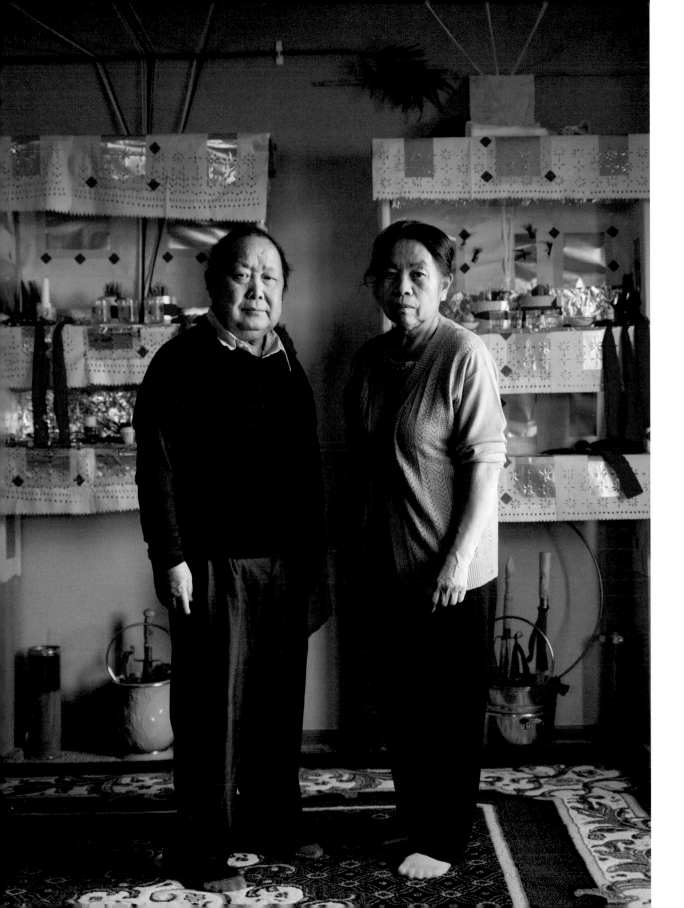

↖ Lee's home has two living rooms, one of which houses the altars of his parents, Mai Ya and Kia Sue, who are shamans. Community members often visit to ask the parents to channel mediums who will help them heal.

↑↑ Florence holds a photo of her father in the Ban Vinai Refugee Camp.

↑ Lee was hiking with his all-Hmong Boy Scout troop when a car drove by and the passengers spat at them. The men called the scouts derogatory names and shot them with paintball guns. Later, another group of men chased the boys with bats. In response to these hateful acts, an anti-racism group organized a discussion and hike for the whole community.

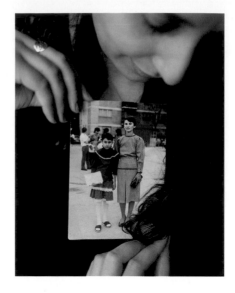

# Cristiana
*New York City, New York*

Cristiana hated her short hair. She remembers a doctor telling her once that if she weren't wearing earrings, he would have thought she was a boy. "I was this dark skinny kid with very short hair. Being beautiful was the last thing on my mind. I just hoped nobody would hold it against me that I was ugly. Nothing about me was girlish. It was hard."

Hiding her identity was challenging, but it spared Cristiana from daily discrimination. "You learn how to keep a family secret in order to fit in. I did fear that I would be treated badly as a Roma, so I found coping mechanisms—never inviting kids home and separating my school life from my family life. As a kid, you want to fit in, and you do everything you can to be accepted by others. Looking back, it is so heartbreaking." Her existence was isolating, but she wasn't the type of person to get bored. She had a great imagination and spent many hours reading stories and dreaming.

Cristiana still dreams of Romania. In 2017, she launched the Roma Peoples Project, a forum for, and collection of, voices by and about the Roma, hosted by the Center for Justice at Columbia University. "This is all part of my personal search and desire to understand a complex identity that is not yet properly explored or understood."

↑ Every summer as a child, she enjoyed the treasure hunt of helping her grandparents harvest their potatoes. In New York City, Cristiana lives near the Metropolitan Museum of Art and regularly walks around the great lawn. In a dream, "I was in my grandparents' village in the potato garden, but instead of finding potatoes I was finding art objects from the museum! Maybe the next dream will be about finding potatoes instead of art objects here in Manhattan's Upper East Side?"

↗ Growing up in Romania, Cristiana's parents kept her hair short and dressed her in muted colors so she wouldn't resemble "the stereotype of a flashy gypsy with shiny clothes and long hair."

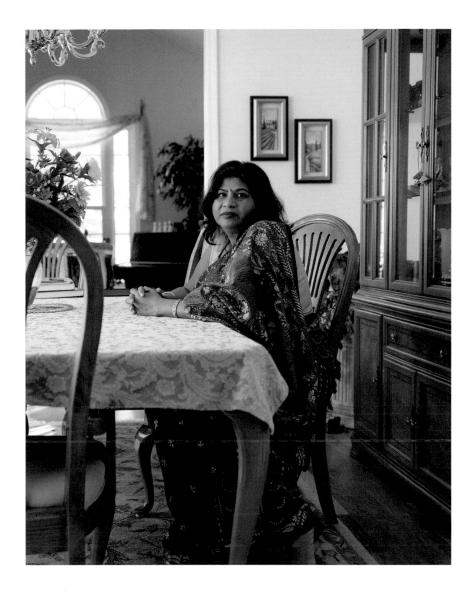

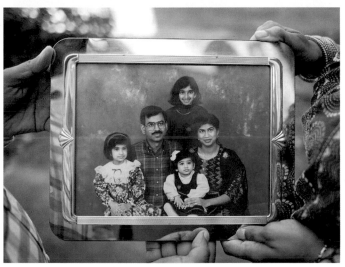

# Sapna and Nirmal

Columbia, South Carolina

While their daughters were growing up, Sapna worked in the home and her husband, Nirmal, worked as an engineer. "For me, being a housewife, sometimes I wish I could have done something with my life, to prove that I made it. But then I do look back and look at my three girls, how they succeed in life, and it brings me joy. I associate myself with their success and how they do."

↑↑ Nirmal still has his grandfather's handwritten Bhagavad Gita, a Hindu holy scripture. "I get scared opening it because of how fragile and precious it is. It probably has his DNA somewhere here."

↑ Sapna and Nirmal's daughters have completed university degrees, with two working in healthcare and one in law. "We both value education a lot," says Sapna. "That's what we think is the key to opening doors for you in life. Our parents did that for us and we made sure our girls got that."

# E.J.
### Anchorage, Alaska

E.J.'s mother used to take him to the toy store every month. The price of almost every toy was negotiable—except for his favorite, the G.I. Joe action figures. E.J.'s mother ("the best bargainer in the world") tried to haggle a lower price, but she never succeeded. All the merchant had to tell her was that the toy came from the U.S. This idea stuck with E.J. "The message I received as a kid is that anything made in the U.S. is more valuable, more precious, and better than anything made in the Philippines."

After arriving in Utqiaġvik (then known as Barrow), E.J. wanted to become as American as possible. But the world he saw in shows like *Boy Meets World* and *Saved by the Bell* was very different from the Utqiaġvik community he lived in. While the Indigenous community around him fought the erasure of their language and culture, E.J. was trying to rid himself of his own. "Not only did I literally leave the Philippines but, now that I'm in the U.S., I'm trying to erase or hide the little bits or pieces hanging on to me. It got to the point where I was discriminating against other Filipinos."

In his junior year of high school, someone left an anonymous message on his locker: "You are Filipino. Act like it!" It made E.J. reflect on how he was treating local Filipinos. "Have I abandoned them? Have I forgotten them? Why was I trying so hard to get rid of my accent and be American?"

These questions spurred him into the academic work he does today. As an associate professor of psychology at the University of Alaska Anchorage, he focuses on the effects of colonialism on people's self-perception, culture, and mental health. "I turned my personal experience into a career."

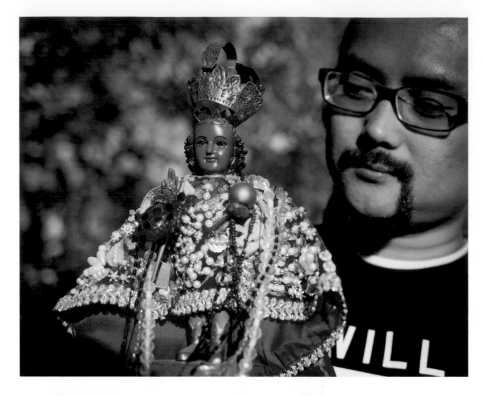

↑↑ Before getting pregnant with him, E.J.'s mom prayed to Santo Niño to give her a child. When E.J. went to live with his father in Alaska, she gave him a Santo Niño figure in the hope that it would take care of her teenage son.

↑ E.J.'s father drove a jeepney, the primary form of public transportation in the Philippines. From age three, E.J. worked as his father's "barker," sitting at the front of the jeepney calling out to possible passengers.

↖ "I want my kids to use their roots as superpowers." E.J. and his wife, Margaret, have nurtured their four children to grow up understanding both their Filipino and Koyukon (an Athabascan Native people) heritage. "We try to tell stories and talk about our family. They have the privilege of these different heritages. Along with that, they have this responsibility of figuring out how they want to help our communities."

←← Margaret, a midwife, holds a traditional Alaskan Athabascan baby belt.

← E.J. studies internalized oppression—the kind he experienced when moving from the Philippines to Alaska. "Eventually, you don't need to tell people these oppressive messages anymore, because they start telling themselves those oppressive messages. They start believing it."

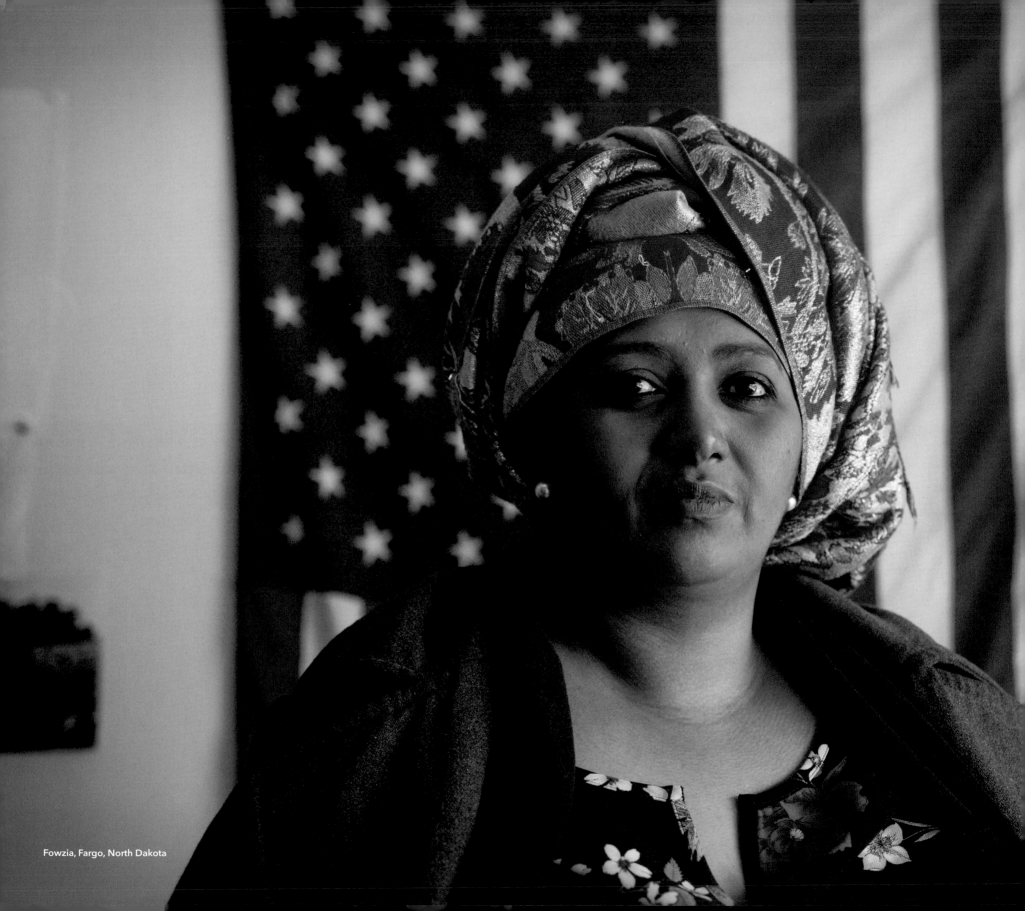

Fowzia, Fargo, North Dakota

# ADVOCATES

# Fowzia

## Fargo, North Dakota

Fowzia is the mother of five children and the founder and executive director of the Immigrant Development Center, a nonprofit that helps local refugees and immigrants gain economic independence. "In my youth, I never thought I would be going to a country that is not mine. I never had that kind of dream." She was in ninth grade when the war began.

"I was sitting in my class taking a test when I heard the sounds of bombing. 'Is that rain coming?'" Fowzia's family moved from place to place in search of safety. In Mogadishu, militia members found them hiding in her grandfather's basement and planned to torture them until Fowzia's grandma said they could loot her daughter's nearby store. The militia members left, and Fowzia's family fled to Brava, where her parents are from.

"We suffered so much. There was no money, no food, no nothing. We didn't know where my father was. The money my mom had was in the bank and the bank was gone. Everything collapsed. We couldn't believe what was going on. To keep our hope alive—and to survive— we talked about things we used to have: the dishwasher, laundry machine, even the soaps that we used. That's how my sisters and I kept entertained."

Fowzia left Somalia on a fishing boat packed with people. Three months later, reunited with her mother, she arrived in a United Nations refugee camp in Kenya. They lived there for seven years before choosing to settle in North Dakota, where they knew people from the camp.

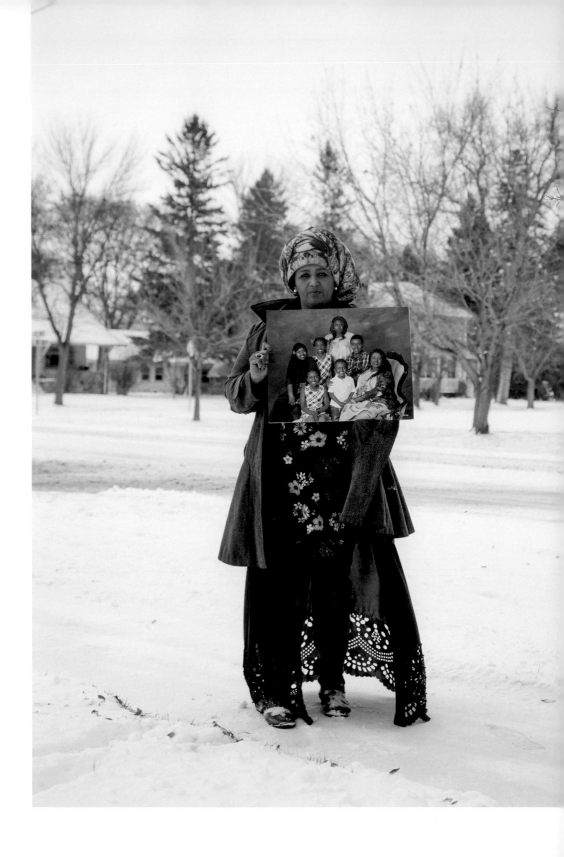

Since its inception, the IDC has helped more than fifty immigrant entrepreneurs start businesses and build economic independence. "Poor people have a problem with credit," says Fowzia. "The payday loan is powerful in our community here—payday loans and North Dakota sleep in the same bed legislatively. Every other business you see is a payday loan company, and that money is coming from the refugee community, or new Americans, or the poor families. They prey on poor families. They give them $400 and they want six hundred back. They keep our people poor. It's their job."

From a Nigerian American woman opening an elder care home, to a Bosnian American woman starting a cleaning business, the people Fowzia works with are "tenacious, talented, smart, and they want to succeed by any means. They are going after it. I work with people who make more money than I make. People with a lot of dreams."

New Americans create most of the new businesses in Fargo-Moorhead, but Fowzia feels they are still not truly accepted in the community. "What is happening in our area—we say, in my language—is like, 'Hold me but don't touch me.' It doesn't make sense; how can I hold you and not touch you?"

←← Fowzia holds a bowl of "fuud ari" (lamb soup).

← The Immigrant Development Center helped Momo, born in Sierra Leone, open The Africana Wardrobe, a shop in the International Market Plaza.

## Suud

Minneapolis, Minnesota

Suud lived in the Dadaab refugee complex in Kenya from infancy to the age of nineteen. He remembers swimming in dirty water during the rainy season with his five siblings. "It was a tough situation. We never had access to education, quality food... It was miserable." In 2012, he moved to Nashville alone, got a job, and started sending money back to his family. After working in an Amazon warehouse for about a year, the organization that assisted him in resettlement hired him as a caseworker to help new refugees. He moved again—to Minnesota in 2015, to join its large Somali community and is now attending St. Cloud State University, with big plans for the future.

"I want to help find a durable solution for refugees, because my life was hard. I want to become an advocate for these people—tell their stories. I want to make this world a better place for all people—more peace, prosperity, access to education—especially for young girls, and help alleviate extreme poverty. I want to run for public office in Somalia or in the U.S. and become one of those people who make decisions. That's my dream."

## Franck

Omaha, Nebraska

Franck's friends always said that if anyone was going to leave Gabon and move to the U.S., it would be him. From an early age, the native French speaker was fascinated by the English language. Franck even started the "Martin Luther King Jr. English Club" at his high school in Libreville. In 2005, right after graduating high school, he proved his friends right and became the first person in his family to move to the U.S. Shortly after arriving, Franck learned that his Gabonese scholarship was frozen and he would have to pay the tuition himself or lose his visa. He called his dad to say he was coming home, but his father encouraged him to stay and follow his dream—they would figure things out financially. Franck got a job selling the *New York Times* outside the subway every morning. After his shift, he would go to class or study.

"I recall one morning, standing there literally crying and asking myself what, exactly, am I doing here. In my country, no one would have imagined the son of a doctor selling newspapers on the street!"

Things weren't going as planned in New York City, so in 2012, Franck moved to Nebraska to join an uncle who ran a business exporting used cars to Africa. At the bus station on his way to Omaha, he talked to another Black man, who was shocked at Franck's destination—he couldn't understand why any Black person would want to go to Nebraska. Franck laughs thinking back on that day.

On his first visit back to Gabon, he saw a woman from Benin outside the airport selling newspapers. He made sure to stop and buy a newspaper from her. "I appreciated her in a way I never could before. Now when I see immigrants in my country, I know their struggle—I can relate."

## Leezia
Washington, DC

Leezia's parents were floundering financially in Alberta. Her father found a job in Texas, the family's visas were processed, and they moved south when Leezia was six. "I came to the U.S. on a visa. Growing up, I always had a Social Security number and a driver's license. There was no indication that I was anything but 'legal.'" In 2010, the Department of Homeland Security sent her a Notice to Appear, the first step of deportation. "I was completely blindsided. I was having trouble reconciling what I was reading in that letter—that I was an undocumented immigrant—with the all-American life I was living."

After Leezia registered for Deferred Action for Childhood Arrivals in 2012, she was able to get a job, buy a home, and pay off more than $100,000 in student loans. "Even more than the ability to work, DACA gave people peace of mind, clarity, and opportunity to see further into the future. When you are undocumented, you wake up every day and ask yourself if today is the day you will be sent to a country you have no memory of. For a lot of us, it gave us a chance to think bigger and do bigger."

Today, Leezia is the communications director for Define American, where she works to change the immigration conversation and, ultimately, the system.

← Leezia speaks to congresspeople and senators at a Capitol Hill press conference in support of the DREAM Act, which would strengthen protections for childhood immigrants. "I am asking Congress to push for a permanent legislative solution that will allow me to stay here and continue contributing to the only country I've ever called home."

↑ Leezia sees an immigration system riddled with subpar lawyers, untrustworthy employers, and arbitrary caps and waiting periods for citizens of certain countries. "A lot of people are undocumented not for a lack of trying, but because we have a system that has disenfranchised them."

# Seydi

Detroit, Michigan

On the way back from her honeymoon in 2003, during her first year living in the U.S., Seydi was waiting for a flight when an official approached and told her she had left the U.S. without travel authorization, technically self-deporting, and wouldn't be allowed back in the country. They finally let her go—"a favor," they said—but by then she had missed her flight and the experience spoiled the honeymoon. "I was so mad. I still get upset when I think about that scene. It left a bad taste in my mouth."

Seydi went on to learn more about immigrant rights and saw how the Latino community seemed better organized than African and Black immigrants. In 2007, she founded the African Bureau of Immigration and Social Affairs (ABISA) to empower immigrants and refugees and to promote social and economic justice.

"If I know something, you will know something. If I can help, then let's do this. They might not be your brother and sister from the same blood, but they don't have anybody else here; they speak your language and eat your food. We can't pray for racial and immigrant justice to happen in the U.S. We have to work diligently."

Her mission is exhausting, but Seydi feels compelled to work to realize the promises of the civil rights era. "I get tired. I'm about to break down. I need to check out, but at the same time, checking out is not an option. It's a hard fight. Today was supposed to be when everything worked out and the dream was realized. We are far from it. America is far from that dream."

← Seydi describes her racial justice work as difficult but necessary. "I need my daughter, Hawlaane, to grow up in a society where she can walk out the door with no fear in her belly, and no fear in her mom's belly. I want her kids to remember that I didn't sit on the sidelines just hoping and praying."

→ Hawlaane (*center*) dances in an African dance class taught by her mother, Seydi (*left*). Seydi's first job in the U.S. was teaching African dance, which she still does, in addition to her work as the founder of the African Bureau of Immigration and Social Affairs.

# John

## Cochrane, Wisconsin

John was one of the first farmers in Buffalo County to employ immigrants. When he was a kid, they had forty head of cattle, but slim margins led them to expand by buying neighboring farms, and today he has 550 head on 1,000 acres. At this scale, family members can't do all the labor, so he hires help—and locals aren't interested. "If I put advertisements in the paper for a year, I would get no response from local, native-born Americans. There is another group of people who find this work rewarding: immigrants from Mexico and Central America. In Wisconsin, about 80 percent of milk harvested today is by immigrants. Twenty-five years ago, 95 percent was harvested by citizens of Wisconsin."

John cares deeply about his employees and understands the sacrifices they make—missing their wives, the birth of their children, their parents' death, children's graduation. He's tried hard to learn his workers' stories, which he says have forever changed him, and their language and culture. In 2001, he visited a mountain village in Vera Cruz to meet the family of one of his workers at the time. "His daughter Lydia was less than a year old. I touched her little hand. I did that even before he saw her." During a visit to a different worker's village, he met a child named John, who the family had named after him. He gets emotional recalling the experience.

On his many trips to Mexico over the years, he's brought hundreds of other farmers with him, mostly Republicans. While they disagree on many things (John is a Democrat), they share an appreciation of the immigrant labor that their farms rely on. "Those homes in Mexico that I've visited are made possible because they come to work when it's twenty below. They take care of our cows, and all I have to do is pay them."

John's great-great-grandparents settled in Wisconsin and established the family farm in 1857. Four generations of John's ancestors are buried in the cemetery outside a local church that they also established. "It was preordained that I would be a dairy farmer."

← Armando has been working at John's farm for a few years, filling bags of compost, roofing, and fixing the machinery. He's earning money to build a house in Mexico for his wife and child.

↙ ↓ Roberto milks the cows, cares for the calves, and is the farm's "fix-it guy." He's also the only Mexican on the farm who speaks English, so he often serves as a translator. The money Roberto earns goes to support seventeen people in Mexico, including his three kids and their education.

## Juan
Mobile, Alabama

Juan's father, Filimon, made money smoking fish. Juan and his brothers woke up at five o'clock most mornings to gut, scale, and prepare more than a hundred pounds for smoking. "He showed me everything he knew how to do and, in that sense, he was a good father. If we needed to wake up at three o'clock to move rocks, he woke up with us and moved the first rock. He showed us by example." After school, they sold the fish their father hadn't sold that day to the neighborhood. When Filimon didn't have money to buy fish—he struggled with alcoholism—the children had to earn tips on the street by shining shoes, carrying bags, or selling gum so the family could eat. "We didn't wait to be told there was no food—working was an ingrained family duty passed down from my older brothers and sisters. They did it. You saw it and knew you were next."

At age fourteen, Juan was working as a hotel dishwasher in Acapulco. One day, he walked by a clothing store for tourists and stopped to admire a blazer. The prices were higher than he'd ever seen. A man saw him staring and asked, in halting Spanish, "Do you like that?" Father Tony, a priest and missionary, was the first white person Juan had ever talked to. He told Juan that someday he could buy the blazer if he really wanted it. He also asked why Juan wasn't in school and other deep questions Juan hadn't considered before. It was the start of a long friendship that led to Father Tony helping Juan immigrate to the U.S. in 1988 for school. Today, Juan runs BELONG, an organization that helps immigrant children and their families adjust to life in Alabama.

←← Juan and his daughter, Sofia, look out the window from their living room in Mobile.

← Juan holds a photo of himself as a teenager with Father Tony.

## Cyndi
New Orleans, Louisiana

Cyndi, who came to the U.S. after the fall of Saigon, shows her flag of South Vietnam. Now a mother of six, she cofounded the nonprofit Vietnamese Initiatives in Economic Training in 2001, and in 2017 became the first Vietnamese American woman elected to New Orleans city council.

## Arthena
Charles Town, West Virginia

Arthena is the cultural diversity facilitator for Jefferson County Schools. "I hope West Virginia continues to get more and more diverse, because with every new group of people that comes in, I learn and they teach others."

## Sue

New London, Connecticut

Sue has worked with kids at the Regional Multicultural Magnet School, established in 1992 to offer an innovative multicultural curriculum, for more than two decades. She emphasizes to students the importance of being proud of their name even if it is difficult for English speakers to pronounce, and of learning their parents' native language. Sue says immigrants often face such prejudice in the U.S. that they don't teach their children their language. "I want parents to realize that their language is a gift they can give to their children."

"I can look at twenty kids and tell you something deep and important about each one of them. Every culture I've been exposed to has enriched me."

## El Zócalo Immigrant Resource Center

Little Rock, Arkansas

"People who have lived here their entire lives do things that may be difficult for an immigrant," says Kelsey, the center's director—"like making medical appointments, mailing an official document, or going to the bank. All of these—the language, not knowing the system, and transportation—can have so many levels of difficulty for an immigrant. And a lot of our clients have lived with the tragedy associated with their need to come here, and they continue to deal with that—health problems, complicated legal situations. Having our program advocate for them, make sure they get care, and be supportive—I think that's a unique thing."

← Kelsey (*left*) and Michael sort clothes in the donation room at El Zócalo, a grassroots organization that describes its mission as "creating spaces where diverse people come together, help each other, and share in each other's lives."

# Navid

Honolulu, Hawai'i

Navid remembers the air raids and violence of life under a fundamentalist dictatorship. "I saw women get pulled out of their cars and whipped in the street. I saw that as a seven-year-old." When his family decided to leave Iran in 1986, his father, a mechanic, hid gold in the ventilation system of their car and drove to Türkiye, where he sold the gold to pay their way to the U.S. The family posed as tourists, and he used a counterfeit passport to get a three-month visitor visa. Navid was eight years old. "I didn't exactly understand what was going on, but I saw the tears of joy from my parents when we got the visa."

They flew to New York and his father immediately applied for political asylum. Navid considers himself lucky to have escaped, but for a long time he wasn't comfortable sharing his story. This began to change when he discovered hip-hop and as he learned more about Hawaiian culture.

"It took me forever to embrace my own story. Hawaiians taught me the importance of your ancestry and knowing your roots. When Hawaiians meet each other, they introduce themselves by saying who they are, where they are from, and who their parents, grandparents, great-grandparents are. It's called the "mo'okū'auhau" (your lineage). I have a big family and a lot of us got dispersed—we went wherever we could go throughout the world, including Sweden, Germany, the U.S. And I still have a lot of family back in Iran. Before, many of us were disconnected, but with social media I am now more connected to my family than I ever was before. It has taken me a long time to overcome the barriers and blocks I had to embracing my own story. I always had guilt—like survivor's guilt."

Since moving from Iran to Hawai'i in 2001, Navid has educated himself about the history of his new home. "Hawai'i has been illegally occupied since 1893. Before that, the Kingdom of Hawai'i was an independent sovereign nation, recognized by other nations around the world. Hawai'i and Persia were both trying to establish themselves as non-European powers in an age of European imperialism. I feel like my people and the Hawaiian people have a long history of solidarity. I see myself as responsible for continuing that history—standing in solidarity with Hawaiians who are trying to regain their independence. The people who grew up here, who are not Hawaiian, don't want to talk about the legal status of Hawai'i because it affects them personally."

The Kū'ē (opposition) Petitions of 1897 were signed by most native Hawaiians, a sign of fierce opposition to annexation at the time. "It was always taught to Hawaiians that there was no resistance—that America came in and Hawaiians willingly got on board. No. There was huge resistance. Luckily, a new generation of Hawaiians are learning these facts. Ultimately, I feel like Hawaiians should be the ones making the decisions about this place. Hawaiians should have the loudest voice."

Navid stands in Thomas Square, where, in 1843, the British transferred ownership of the islands back to King Kamehameha III after a rogue admiral had illegally overthrown the kingdom for five months. Lā Ho'iho'i Ea (Restoration Day) was celebrated until the Americans arrived in 1893, but the holiday is coming back. Each year, Navid and other hip-hop artists throw a concert featuring sovereignty music.

## Christine
Boston, Massachusetts

Of Christine's eight siblings, only two survived the 1994 genocide against the Tutsi in Rwanda. She also lost her father and many other close relatives. "They destroyed our house. I don't have any childhood pictures. I always wished I had some to show my kids."

Christine was able to move to the U.S. in 2000, when her husband got a student visa. Today, she directs a program at the Massachusetts Immigrant and Refugee Advocacy Coalition, which helps new immigrants navigate the challenges she faced decades ago.

"Sometimes people fail because they compare themselves to others. Be yourself and use what you have until you can get more. For example, you can't compare yourself to someone who has been here in the U.S. for a long time. If someone comes here now and sees me driving a car, they may think I have been driving a car since I arrived. It is not like that. I took public transportation for a long time—with two kids and a baby on my back—to get groceries."

## Bikes for Refugees
Harrisonburg, Virginia

Bikes for Refugees offers bicycles and lessons in safety to help people get around. Ritchie and the Shenandoah Valley Bicycle Coalition started the program in 2015 after speaking with a group of refugee women. "When refugees and immigrants get here, they are expected to hit the ground running to their schools or jobs, but getting a driver's license, a car, and insurance takes time and is expensive. So this is a way they can fix some of their transportation issues."

← Monique (*right*), from the Democratic Republic of the Congo, receives cycling tips from Ritchie (*left*). Monique says, laughing, "This is why you need to teach your kids how to ride a bicycle when they are young!"

## Narad
Columbus, Ohio

Narad, who is from Nepal, is the program manager at Community Refugee & Immigration Services. "It all starts with a job. This is a place where, even with a basic education and no knowledge of English, you can get a job. There are so many manufacturing jobs here. It's a welcoming city, and people are nice. Yes, there have been problems because of the larger picture in the U.S. around immigration. But I also think these problems give the community an opportunity to express support for people like us—to show how much they appreciate new neighbors. During the political backlash against immigrants, so much support poured in from the city. At the height of it all, someone dropped off a bouquet of flowers at the reception—to say we are doing a great job."

## Pascale
Apopka, Florida

"Many people in the farmworking industry love doing their jobs. I've seen that." As coordinator of the vocational rehabilitation program at the Farmworkers Association of Florida, Pascale, from Haiti, helps farmworkers who are suffering from job-related ailments such as pesticide-related diseases. FWAF enables workers to see specialists and get treatment, when needed. If they are deemed unfit to continue in their job, the program helps them go back to school to retrain for another job.

"One of the main problems we see is, because people don't have sick days, they are afraid to take a day off to see the doctor to deal with their sickness. They need to pay their bills at the end of the week. Getting a break and being able to call in sick—that would be an ideal change in the agricultural industry."

Pascale helps injured farmworkers who labor under a compensation system that encourages overwork and enables exploitation. "I would like to see piecework done away with."

## Michael
Lynchburg, Virginia

Michael, a financial advisor from Virginia, completed a Teaching English as a Second Language (TESL) program in 2017, thinking it would be useful during his frequent work trips to Central America. When a local library director found out he was TESL-certified, she invited him to teach, and he started doing five classes a week with students from Mexico, Venezuela, India, China, and Honduras.

"My students are all extremely eager to learn the language. They are in the U.S. for the same reasons my ancestors left six generations ago to come here—they want more opportunity and a better chance. That's why they work fifty hours a week, then walk to the library on Saturday with kids in tow, just to get an English class. This has been a very rewarding experience."

← Poornima (*left*) is from India and is learning English so she can communicate better with her daughter and help her with homework.

## Paty
Liberal, Kansas

After visiting her sister in Texas, Paty told her husband, Tano (see p. 21), that they needed to move to the U.S. Mexico felt increasingly dangerous, and she was concerned about kidnappings. She wanted to raise their children somewhere safe.

Paty was a private school teacher in Mexico, but she couldn't work legally in Kansas at first, so she cared for their children, ages four and two, and babysat other children to supplement their income. Later, Paty became a teacher's aide, then went back to university, and in 2017, at age forty-nine, she earned her American teaching degree. "The moment I put my foot down in the school, I was back in my element."

Paty says the Hispanic students in her class benefit from having a teacher who is bilingual and bicultural. Once, a white child mocked her accent when she spoke the word *scissors*. Paty asked him if he could say "perro." When the Spanish-speaking students laughed at his embarrassed attempt, she told them not to—he was trying his best and that is all that matters; everyone has ancestors who spoke with accents. The boy ended up being one of the students she felt most connected with.

↑ Paty sits in her fourth-grade classroom. She believes immigrants should embrace the culture of their new home. "You have to adapt to the culture. Don't expect the country you moved to, to adapt to you. Even if you love your culture, don't get rid of it, but you are in a new country."

## Billy Ireland Cartoon Library & Museum

Columbus, Ohio

Julie stands in front of the *Looking Backward, Looking Forward* exhibition she curated, which explores one hundred and fifty years of U.S. immigration through political cartoons, comics, and graphic novels.

"Cartoons and comics can enlighten us and bring attention to injustices. They can also reflect and magnify our fears and prejudices. The exhibition aims to inform the current debate as we move forward with a story that is fundamental to the American experiment itself."

## Isabel

Birmingham, Alabama

As she saw the Latino population in Alabama triple between 1990 and 2010, Isabel, a social worker, asked herself, "Who is working with immigrant Latinos to make sure they are supported in transitioning to life in this unfamiliar society?" In response, she founded ¡HICA! in 1999 to help with healthcare access, education, economic development, and legal issues.

"Everybody says, 'I'm not opposed to having Latinos here, I just want them to come the right way.' Well, let me tell you about how the 'right way' works. People have no idea. Immigration is so difficult, particularly for people who come from Mexico. It's a huge issue."

# Fresh Start Farms
Manchester, New Hampshire

Fresh Start Farms is a program of the Organization for Refugee and Immigrant Success that grows and sells produce at markets, wholesale, and through subscription boxes. Tom, a farm manager, says, "Agriculture is a dying profession, and the government has decided we need more people trained in agriculture. And by chance, many of the refugees who have come to the U.S. are former farmers who would like to work in agriculture."

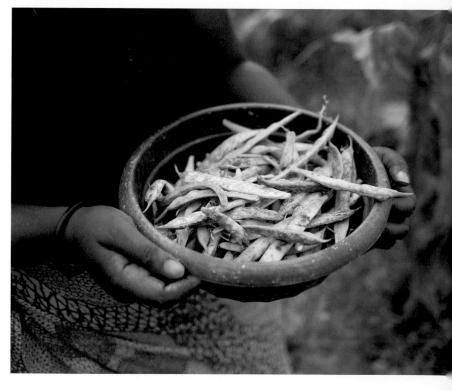

↑ Tom (*left*), a manager at Fresh Start, stands with Lakshmi, a third-generation farmer from Bhutan who moved to the U.S. in 2008 after almost two decades in a refugee camp in Nepal. "My life is a farming life."

→ Most farmers are from Somalia, Rwanda, Congo, or Bhutan. Mary, from Burundi, works in housekeeping to support her children and farms whenever she has time off.

→ → Asli, who worked as a farmer in Somalia, relocated to the U.S. in 2005 with her seven children. They help her garden sometimes, but she doesn't think any of them will become farmers.

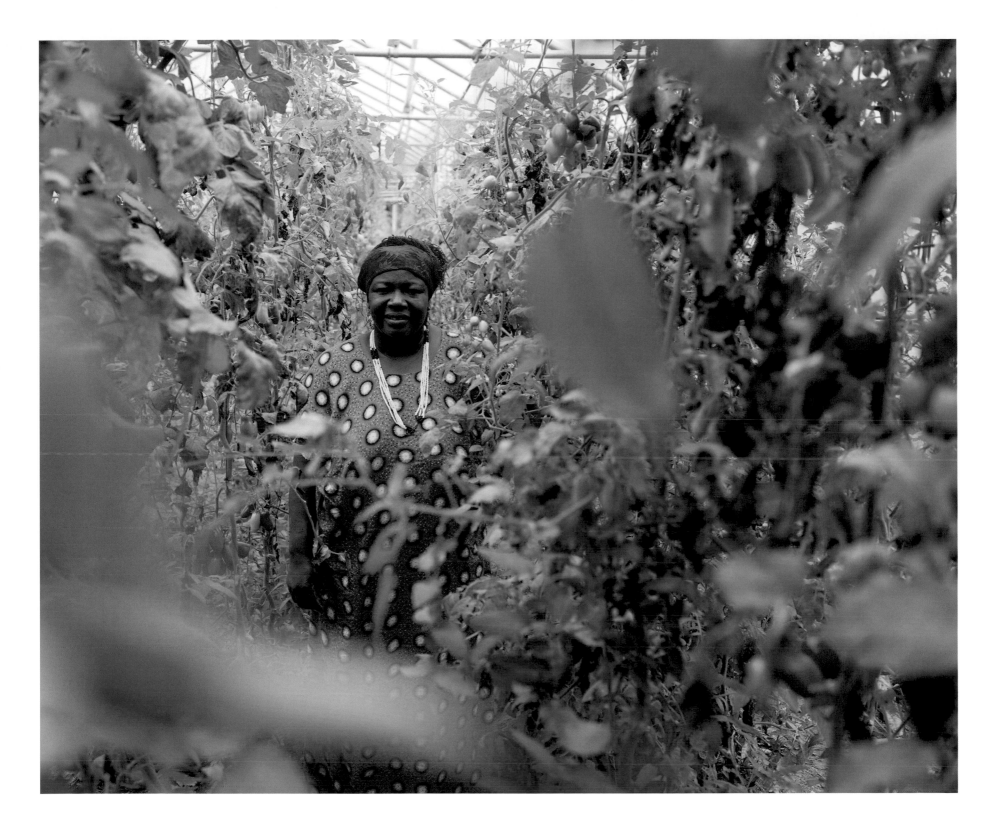

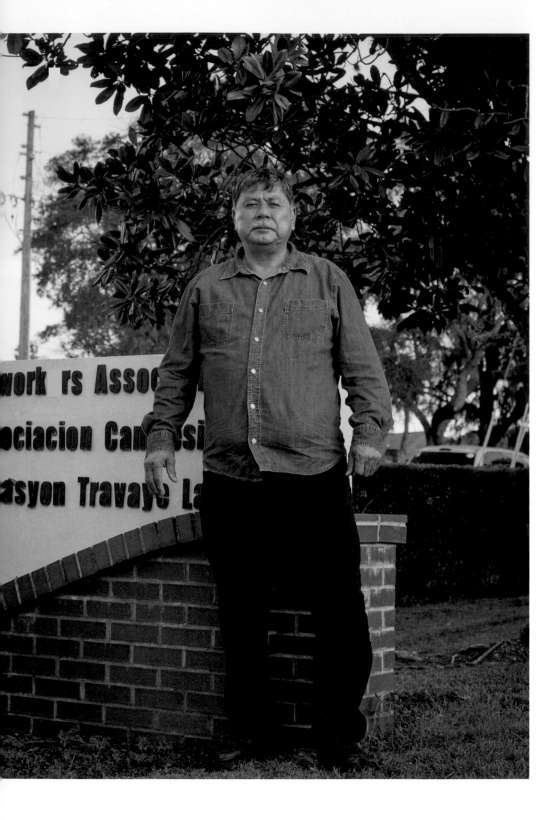

## Tirso
Apopka, Florida

"We have to do this work ourselves. We can't get it done alone, so we teach others about their rights and how to help themselves. These families have been denied opportunities many times. But I believe in myself, and I believe in my people. We believe in ourselves."

After a decade as a migrant farmworker in the U.S., Tirso helped organize and establish the Farmworker Association of Florida and served as its general coordinator for more than three decades. The FWAF's membership has access to educational programs and training, immigrants' rights and health and safety advocacy, legal assistance, a credit union, and their own community gardens.

"We are part of an industry that makes a lot of profits. They spend more money sometimes trying to defend themselves from the workers getting organized than they would spend to pay workers and give them what they deserve. They come up with new tricks every time. There is a lot more discrimination now, openly, against immigrants of color. Farmworkers should have rights that other workers have—the same protections for a healthy, safe, work environment, fair wages. They deserve the right to stay and become citizens. We need a sustainable farmworker workforce."

As a farmworker organizer, Tirso has fought for decades for the just treatment of immigrant laborers. "This society has to get involved. We all need these people to produce food and other farm products . . . We cannot live without food. Whether you are rich or poor, you need food. We need farmworkers—not slaves."

## Luisa

Miami, Florida

Luisa's parents took her to Disney World when she was eight, and they never returned to Colombia. "My mom's family convinced her to stay. We came with one suitcase and stayed after our vacation." Luisa learned she was undocumented when an application for a volunteer position asked for a Social Security number, and her parents told her she didn't have one. "My initial reaction was like, 'Great! Where do I go to get my Social Security number? Let's fill out that application!'"

In 2012, Luisa registered for DACA, and in 2015, she opened her own business, Lulu's Nitrogen Ice Cream. In running her business, she never compromises her ethics for profit. "There has got to be a way to run a business, make money, and still be a nice kind person who cares about things other than money."

One thing she cares about is ensuring her young employees learn how to manage their money. "If you aren't taught financial literacy at home, you are screwed. This is one thing I can do that can change their lives. We have financial experts come in and teach them the basics. The way you manage your money can help set you up for future success."

Many young women visit Lulu's Ice Cream because they've heard of Luisa's story. She makes an effort to inspire them in entrepreneurship, encouraging them to pursue "whatever it is that they dream of creating."

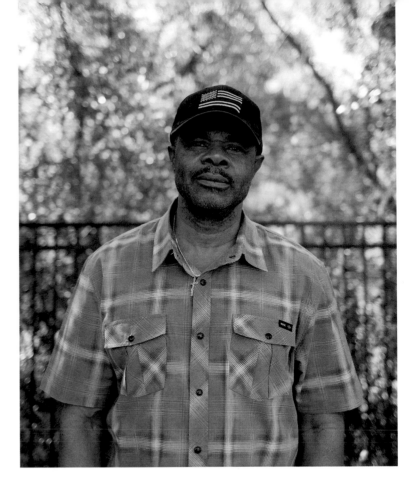

## Luckner

Apopka, Florida

"My brother was arrested and we never saw him again. He was my support while I was in school, so when he got arrested, I had to drop out." In 1978, tired of living in fear, Luckner left Haiti by boat and sought asylum in Miami. He picked fruit and tobacco, from Florida to the Carolinas.

"I don't think I ever saw more than two white guys picking fruit. It was only African Americans, Haitians, or Hispanics . . . period. I wish you could give us some credit and be grateful you have us, but people look at us as uneducated and unproductive. Immigrants from elsewhere don't get treated that way. If you have immigrants from Canada, who cares—they are white, European-like . . . but if you are Haitian or from Latin American countries, oh my God, get ready to face the consequences. I wish I could have stayed in my country. It was a lot of agony and a long journey to get here."

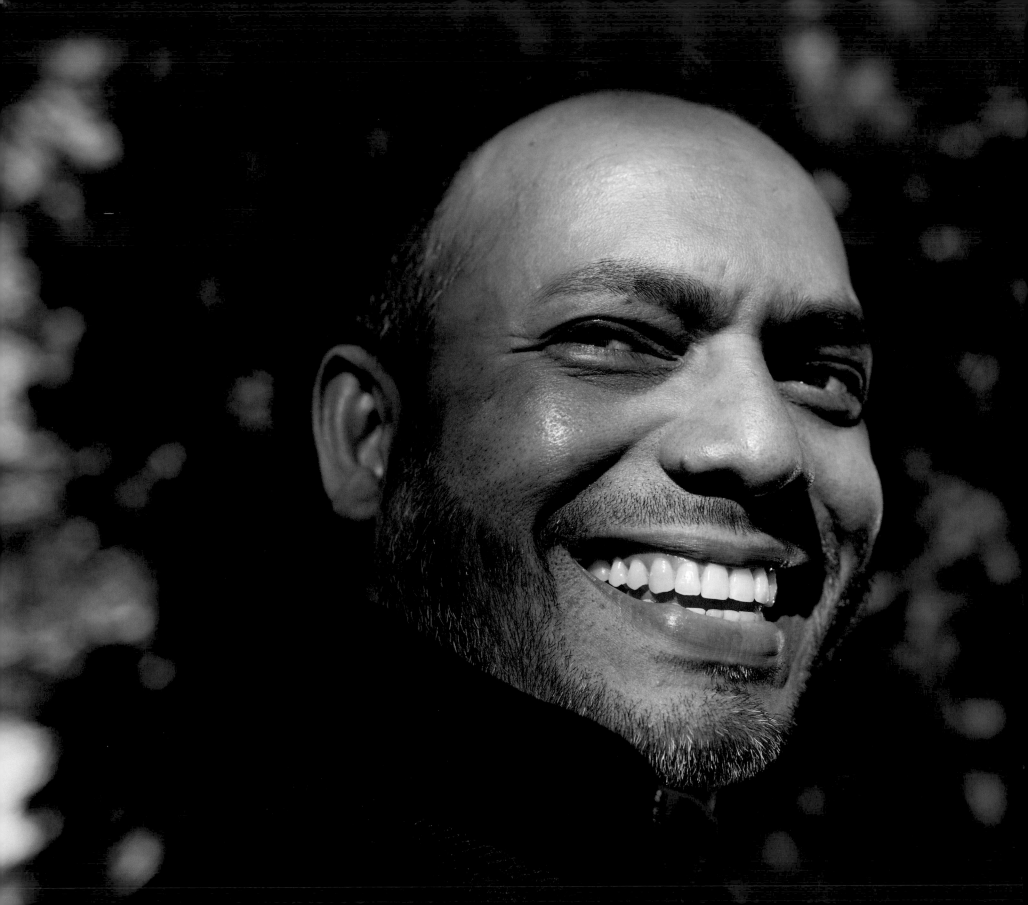

## Rais
Seattle, Washington

Rais arrived in New York City in 1999 and two years later moved to Dallas to work at his friend's gas station. Five months after arriving, 9/11 happened. As soon as he heard the attackers were Muslim, he feared a backlash but reassured himself he was safe because he had nothing to do with it. Rais was in Dallas, and he had no reason to be afraid. The days following the attacks were tense. Several white customers screamed at him. He asked his friend, the owner, what to do, and was told to ignore it—that speaking up could lead to worse violence. On September 15, a clerk at a nearby station was shot and killed.

"I freaked out. It wasn't just words anymore. I wanted to quit but felt for my friend because it was a newly opened gas station. I kept working. That led to the worst nightmare of my life."

At midday on September 25, a man walked in with a double-barreled shotgun. "He asked, 'Where are you from?' I felt cold chills go through my spine. I realized that he is not here for money; he is here for me. There was no argument or confrontation. He pulled the trigger from point blank range. I felt it and then heard the explosion. I wondered, 'Did he shoot me?' I looked down and saw the blood pouring from the right side of my head. I thought my brains were going to come out at any moment. I remember screaming for my mom."

Rais dropped to the floor and played dead, and within seconds the gunman left. He tried to dial 911 but he was shaking uncontrollably. He ran to the barbershop next door where he screamed, "Please call 911, I'm dying! I don't want to die today!" while the men looked on in horror. "I caught myself in the mirror. It was like a face in a horror movie. Minutes before, I was a healthy, smiling young man; at that moment I looked so ugly, disfigured, and I was dying."

The ambulance arrived and Rais's survival instinct from the Bangladeshi military kicked in—he ran toward it while removing his shoes and shirt, knowing every second makes a difference. The paramedics later told him they had never seen anything like it. In the ambulance, he drifted in and out of consciousness, seeing images of his family and a graveyard, and reciting verses from the Qur'an.

Rais was shot by a white supremacist two weeks after 9/11. "Who is going to tell my parents or loved ones that I died in a gas station parking lot? I kept begging, 'God, please don't take me today. You are the only one who can help me now.'"

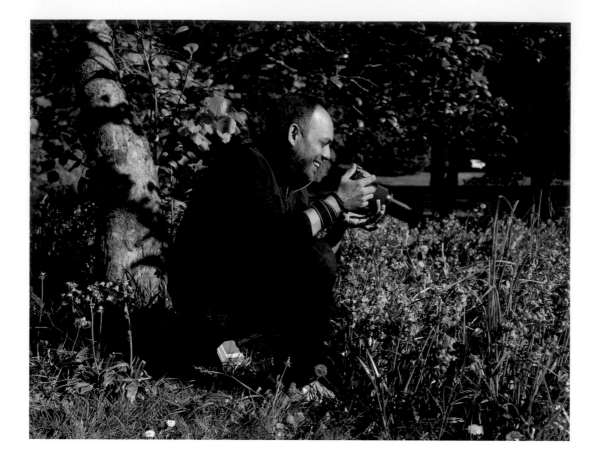

Rais survived a racist murder attempt and then advocated for his attacker's clemency. "One American shot me in the face, but a lot of Americans helped me rebuild my life. Americans are capable of compassion and grace. Many opened their hearts to me."

"I came to this country to fulfill my dream, and now I'm dying. I promised God that if he gives me a chance to live, I will dedicate my life to others."

Not long after being shot in the face, Rais came to and said, "Where am I?" He thought he had died. "I heard, 'Good morning, Mr. Buyan, you are in the hospital.' That was one of the most beautiful moments of my life. I thanked God right away."

Rais's joy didn't last long. "The second part of my American nightmare had just begun." He underwent several surgeries and lost sight in one eye; the right side of his face contains thirty-six bullet fragments he can still feel under his skin today. The hospital stay left him $60,000 in debt. His father had a stroke after hearing what happened. And Rais lost his job, his home, his fiancée, and his sense of security.

"I lost a lot of things, but I did not lose my hope or faith in God. I remembered the advice my parents passed on from the Qur'an: God will never place a burden on a soul that cannot bear it." When Rais lost his home, a friend offered a place to stay. When he needed a car, an Air Force veteran loaned him his. A Christian doctor offered to perform eye surgery regardless of pay. And a man from his mosque paid for Rais to return to school to pursue a career in IT. "With the mercy of God and the help of kind and caring Americans, I was able to get my life back on track. That was the hospitable, generous, warm, and caring America that I learned about growing up in Bangladesh."

Rais's attacker, Mark Stroman, also murdered Waqar Hasan, a Muslim immigrant from Pakistan, and Vasudev Patel, a Hindu from India. The self-identified white supremacist, who was covered in Nazi and KKK tattoos, told police he was a true American patriot and was "hunting Arabs" in retaliation for 9/11. (None of his victims were Arab.) He was sentenced to death in April 2002.

On a pilgrimage to Mecca with his mother, Rais prayed for guidance. "I questioned God—'why did you save my life, and what am I supposed to do now?' I thought about the shooter, Mark Stroman, on death row. His life was changed like mine was. By executing Mark, we would lose a human life without dealing with the root cause. I started seeing him as a human being and a victim too. By executing him, the pain and suffering would not go away from my life. I got a second chance, but I believe he deserves a second chance too."

Rais began a yearslong campaign to save Mark's life. He sued in federal court to stop the execution, pleaded for mercy in the media, and even traveled to Denmark to ask a drugmaker to urge Texas not to use their product to kill humans. When Mark heard about Rais's efforts, he was stunned. In phone conversations and letters, he called Rais a brother and thanked the Muslim community. He said his stepfather had taught him lessons he was still unlearning, and he told Rais: "Your parents are wonderful people to lead you to act this way to someone you have every right to hate." Rais kept up his fight until July 20, 2011, when Mark was executed.

In the summer of 2015, Rais met Jessica while they worked together for his nonprofit World Without Hate. Long work trips led to deep conversations, and though Jessica wasn't looking for anything, their connection was undeniable. They skipped the dating stage and got married before the end of the year. "I think our first date was when they were passing around actual dates at our wedding," says Jessica.

They planned their wedding in forty-eight hours. "'When is this dress for?' 'Today!' I don't know how we pulled it off," says Jessica. "Everybody was amazing and my parents fell in love with everyone. The whole thing was a comedy routine. Here is the most shocking part: It doesn't take more than twenty-four hours to get a gun license, but it takes seventy-two hours to get a marriage license. Marriage can wait but guns can't!"

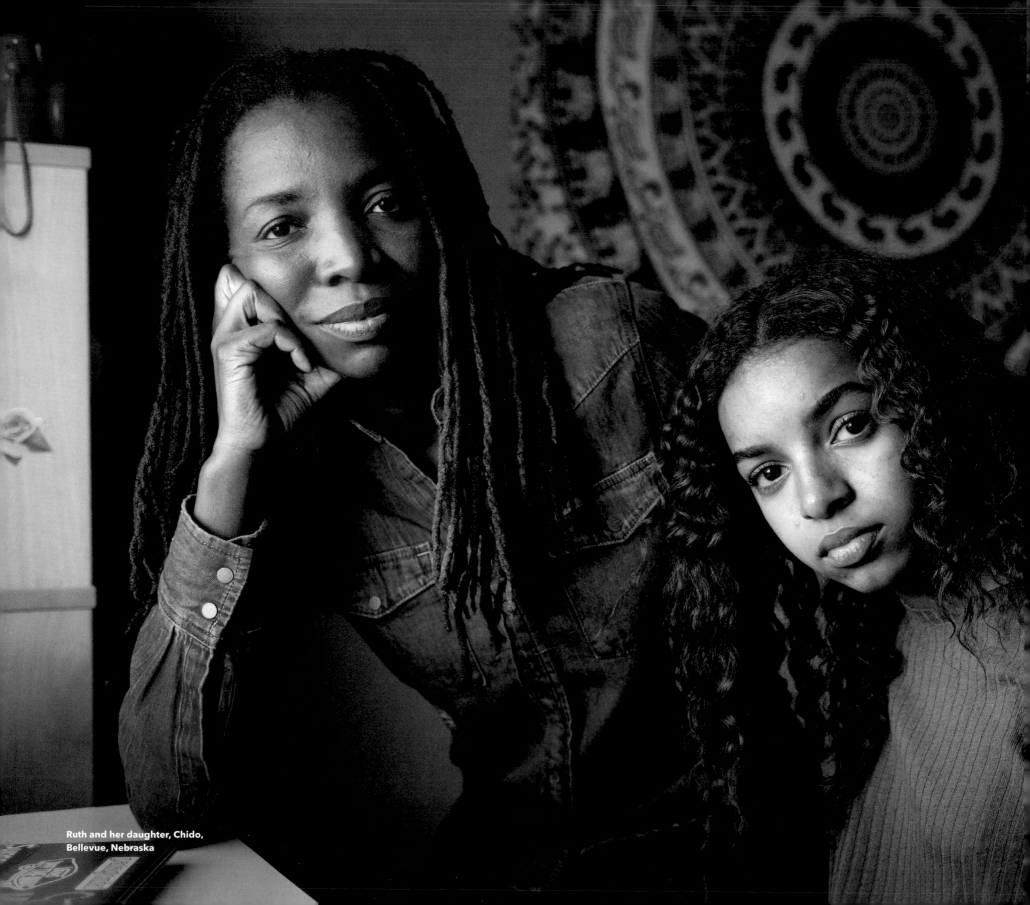

Ruth and her daughter, Chido,
Bellevue, Nebraska

# FUTURES

# Ruth

Bellevue, Nebraska

Ruth left an abusive household in Zimbabwe and an even worse situation with her ex in the U.S. and is now raising two "amazing kids."

"I had no idea it would get as horrible as it did. There is nothing he didn't try to do. When I look back now, it's very possible he could have killed me, because he wasn't in his right mind." In 2008, Ruth got a restraining order against her husband, which forced him out of the house. In retaliation, he reported Ruth to U.S. Immigration and Customs Enforcement to try to have her deported. "ICE agents showed up at our house with guns and in bulletproof vests at six in the morning."

Ruth spent a month in jail while her children stayed with an aunt in Nebraska. For the next three years, Ruth was in either divorce or immigration court every few weeks. She was granted sole custody of her children and applied for a VAWA (Violence Against Women Act) visa. The state approved her case, but the local office denied it. She is appealing, but for now she gets a yearly work permit so she can run her cleaning business. Ruth's backup plan is to file for asylum; she moved to the U.S. after leaving Zimbabwe, where homosexuality is illegal.

"The challenge of being a single parent is that I have to be the affectionate one, but I also have to be the one who gives structure. My kids started doing their own laundry in second grade and cooking at ages three and four. I read about other people's teenagers and I'm like, 'Oh my God!— that's just not my experience.'"

Ruth stands with her children, Simba (*left*) and Chido. "Not having parents gave me a different perspective. It's almost as if I parent them from the standpoint of: if I'd had a mother, what would I have wanted my mother to be like?"

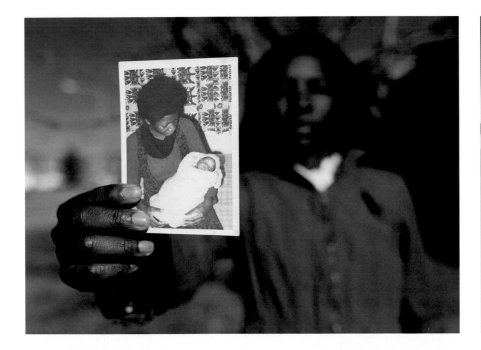

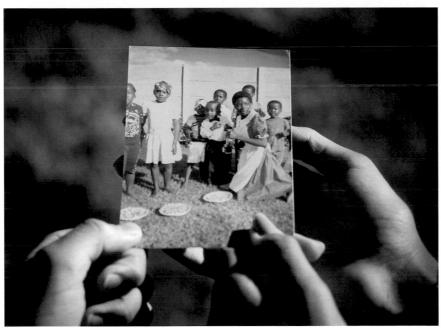

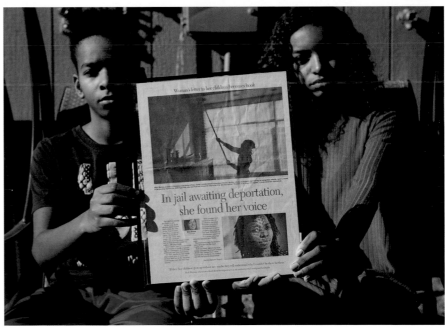

↑↑ When Ruth was five, her mother, Norah, died from suicide, and one month later, Ruth's only sister, Chidochemoyo, died from measles.

↑ Ruth (in red dress) grew up with her cousins. "I was serving them food, often treated like the help—exactly like Cinderella."

↗ As a writer, Ruth is a visible advocate for LGBTQI+ immigrants and has helped other African women write their testimonials for asylum.

## Collin and Sophie
Taylor Mill, Kentucky

In early 2004, Doug was away on business when Pam found herself listening to a Christian radio broadcast featuring a "warm fuzzy adoption story." She couldn't get it out of her mind. "Over the next five months, God began to do things we couldn't even begin to explain in our lives to show us how this was His plan for us." One night while out for a walk, Doug and Pam met a neighbor who works at a foster care agency and, out of nowhere, asked, "Have you guys ever thought about adoption?" Pam knew it was a sign from God, but she resisted, knowing that adoption would be a big change to their empty nest. "That night, I had a dream about a little Asian girl, and her name was Sophie. Three nights in a row I dreamed about this little Asian girl, and on the third night I woke up and cried, 'God, I don't want to do this! I don't want to bring a child into our home and mess this up.' That's how selfish I was at the time. I journaled about my dream. I knew that if we ever adopted a little girl, her name had to be Sophie." After a ton of paperwork and two-and-a-half years of waiting, Sophie came to live with them in 2006.

The dreams and signs from God continued. Before meeting Collin, Doug and Pam sent money for his birthday party. "The orphanage is smart at knowing how to make money off Westerners, which is fine." They adopted Collin in 2010.

Doug and Pam hope their children "put God first, and marry someone like-minded and common in their faith," Pam says. "We talk about taking them back to China when they are older. I think it would be cool for them to see their orphanage one day."

↑ Collin's best friend, Luke, lives across the street. "He's a good trash talker," says Collin. "Luke says that he is better than me at basketball, but he's not. He's funny. He's a good best friend, and he makes me laugh."

↗ A friend collected messages and made a quilt for Sophie. "Our new daughter could sleep underneath the blessings of family and friends."

→→ Doug and Pam, high school sweethearts, had three daughters in the 1980s. "That was our family—the end, or so we thought!"

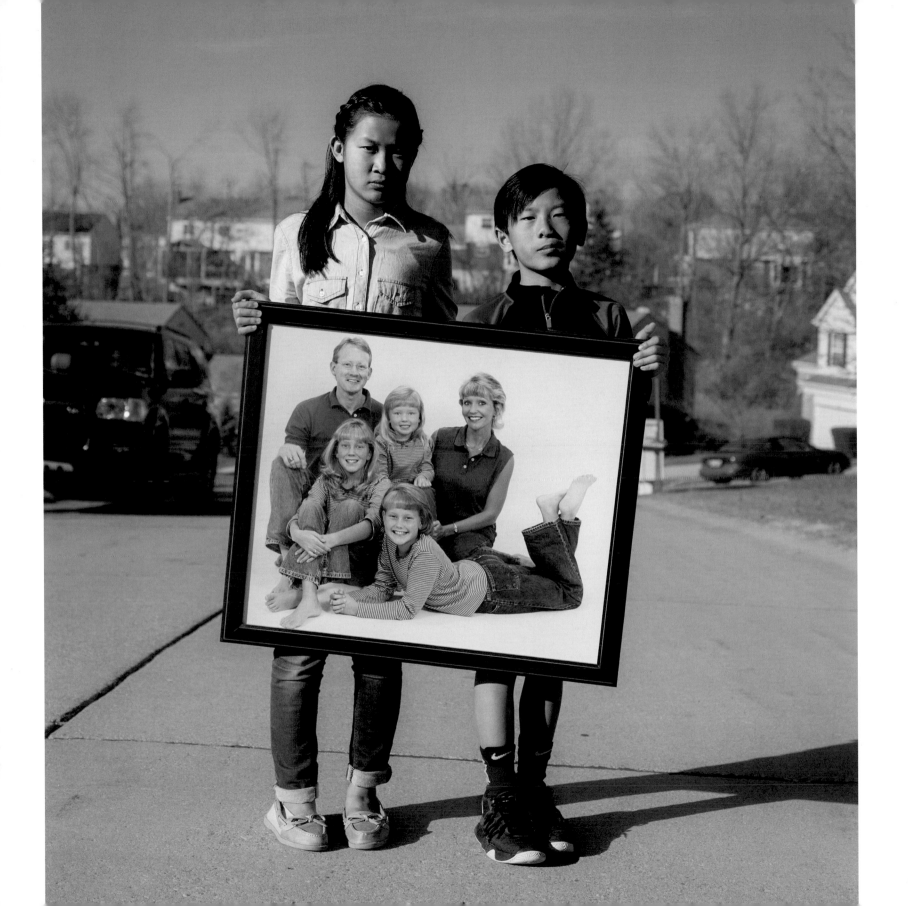

# Serghei

Plainfield, Illinois

In Serghei's first few years living in the U.S., he worked what he calls "dirty jobs" in hotels and restaurants. He started driving transport trucks in 2011, like his father does in Moldova, but Serghei grew tired of the grueling hours and long stretches away from home. He's now the yard manager for a trucking company; the office job allows for more time to help his kids with homework or rides to school.

↑ ↑ Serghei's sons, Daniel and Alexei, on their bikes outside their suburban home.

↑ Daniel holds up homework from Russian school. Serghei, from Moldova, explains, "We are trying to help our sons keep the language. They speak Russian at home. They can speak English everywhere, but not at home. Keeping the culture is even harder than keeping the language."

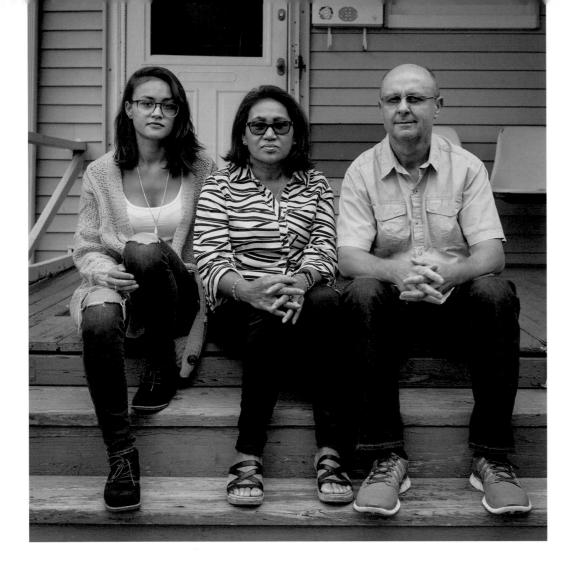

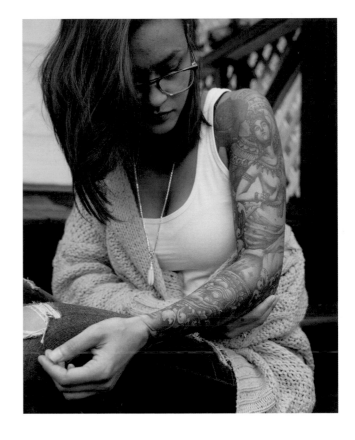

# Christina

Woodbridge, New Jersey

Christina's dad, Walter, is from Poland, and her mom, Sally (see p. 21), is from Cambodia. Christina always assumed she was American until she encountered a rigid kindergarten-placement test. "It is a day I'll never forget. I had to choose my race: white, Asian, Black, or Latino. I picked two: white and Asian, of course. The teacher erased my answers and said, 'Pick what you are.' At that moment, as a five-year-old, I had a quick identity crisis—I had to choose between my mom's heritage and my dad's."

↑ Christina's tattoo is a compilation of images from Angkor Wat, including Apsara—supernatural female beings that descended from the heavens—and Kala, a god of death.

## Anna

Lakeland, Florida

Anna, a military veteran and nurse originally from Poland, is proud that her daughters are developing critical minds. "My daughter was the only student in her class who was anti-Trump. She was the only one! When we drive together, I use that time to discuss different issues with my daughters. I try to talk on their level, and I can see the wheels turning."

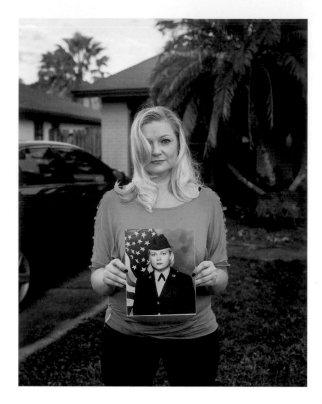

## Dom

Portland, Oregon

Dom and Amanda moved to Oregon in 2016 for his job at Nike's headquarters. They bought a house and settled into their cozy Portland neighborhood.

"It's very liberal here. Very hip. Very health conscious. We turned vegan and tried to explain what that is to my mom and my grandfather. They didn't understand what it means. In German culture there is a lot of meat. It's very different here. I'm excited about starting a family. I want to have kids and be a dad. I don't know what it's going to be like, but I'm excited about it. A new chapter." Today, Dom is a proud father.

← Dom and his wife, Amanda, sit in front of their home holding their dog, Miss Peppers.

↑ Dom, whose DJ name is Ümlaut, plays what he calls "happy music." In 2022, he opened No Requests, an electronic music nightclub in downtown Portland.

## Jani
Chicago, Illinois

Jani's was one of four Rohingya families in the entire Chicago area when they arrived in 2011. With no friends or family around, he felt isolated and alone, but he stayed busy learning English and working three jobs, with barely time to eat or sleep. "When we came here—my girls were three and four—there were no Burmese or Rohingya children in the school, so they learned English quickly. They are so smart. I am proud of my daughters."

↑ Jani describes his daughters' English as "totally perfect." "I can't even speak English in front of them— they correct me on each and every word. 'Daddy, you are a citizen of America. What are you doing?'"

## Anya and Laszlo
North Bethesda, Maryland

Anya, from Russia, and Laszlo, from Hungary, immerse their three sons in both cultures and languages. "I speak only Russian to them and my family, and Laz speaks only Hungarian to them along with his family. Our sons will be trilingual."

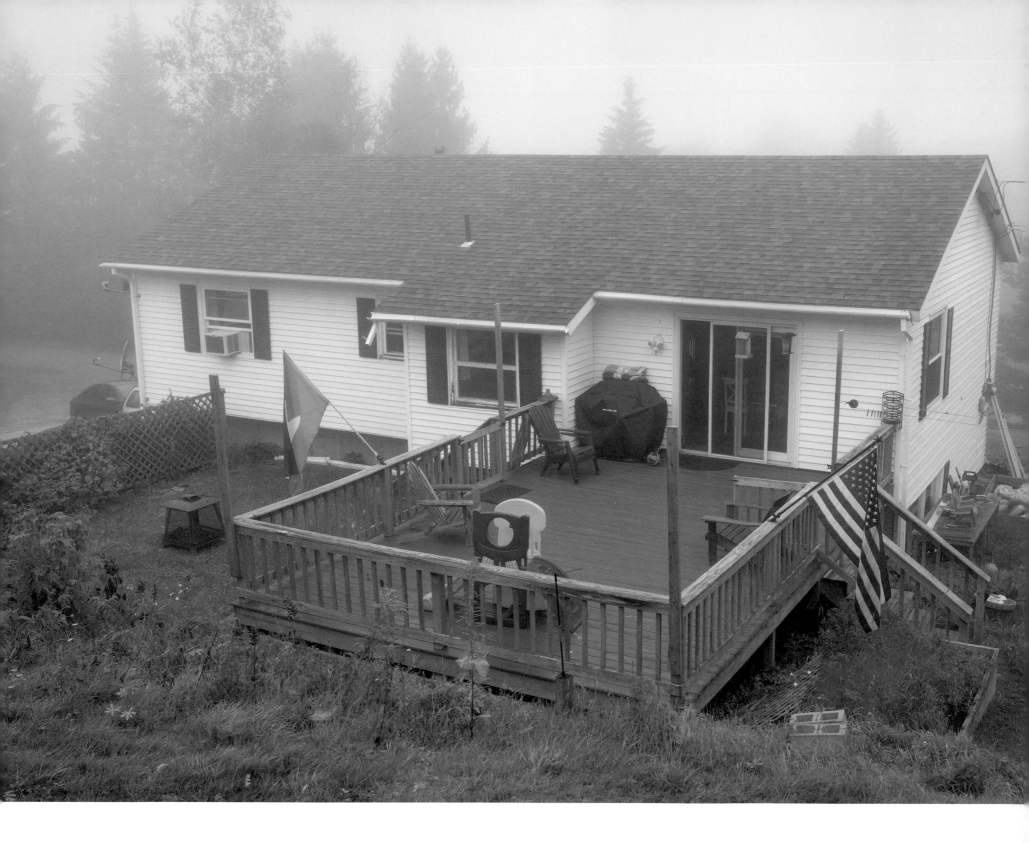

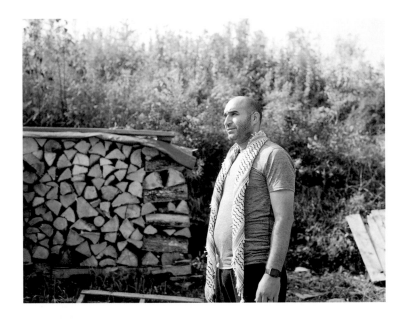

## Shadi
Barre, Vermont

Shadi met Melissa, an American from Florida, in Nazareth where she was working for a nonprofit. After she left, they Skyped regularly for four years until, in 2012, Shadi moved to the U.S. to be with Melissa. As an interfaith family, they face challenges but ultimately believe it enriches their children. They celebrate Ramadan and Eid, Christmas and Easter.

"Our kids will learn about Islam, Christianity, and other religions and faiths," says Melissa. "I'm more concerned about raising them as citizens of the world who respect others and show kindness and love—not hatred, bigotry, and xenophobia. We are teaching them to stand up for justice."

Shadi, who grew up as a Palestinian refugee in Israel, says even if he gets U.S. citizenship, he will always be a Palestinian and will ensure that his children "have Palestine in their hearts all the time." "There is a saying for most Palestinians: 'Every nation has a homeland they live in, but we Palestinians have a homeland that lives inside us.'"

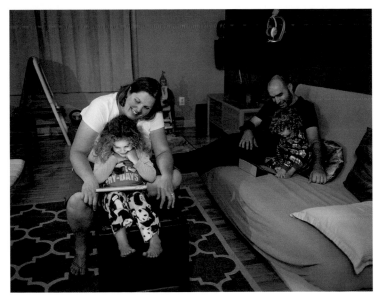

←← Shadi and Melissa's home in Vermont flies both a Palestinian and an American flag.

← Before bedtime, Amalie sits on her mom's lap while Siraj snuggles next to his baba and watches Lamsa, a kids' app that teaches Arabic language and Palestinian folklore and history.

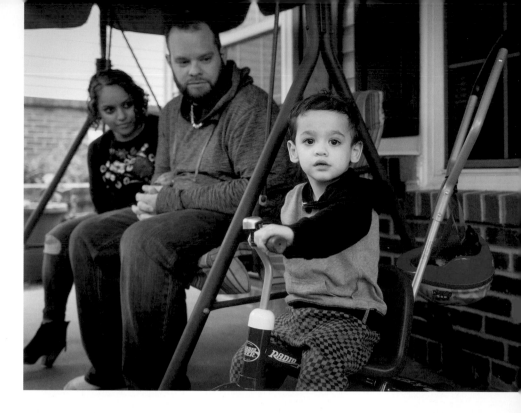

# Sohini
Duluth, Georgia

When Sohini moved from the UK to Atlanta in the 1990s, "it was a true culture shock." The city was not nearly as diverse then as it is today. On the rare occasions she met other Atlantans with Indian backgrounds, it was difficult to connect over things like food or fashion, since Sohini had never lived in India. "It wasn't a good time. I was depressed. Here we had nobody."

Sohini eventually adjusted to her new home and met Michael. The couple decided to have a baby but had difficulties conceiving. To cope with the cost of expensive fertility treatments, they sold their house and moved back in with Sohini's parents. To help with the stress of it all, Sohini read fantasy novels and crocheted.

Their first child, a girl, was stillborn at five and a half months. "We got to the point in our fertility journey where the doctor said, 'That's it. It's not good for you mentally or physically.'"

They considered adoption. A friend mentioned surrogacy, and less than a year later they flew to India to transfer Sohini's embryo to a surrogate. The whole thing was a "whirlwind" of anxiety and joy. "I remember looking at Dhilen through the window and thinking, 'This is my child. This is actually happening.' I touched his finger. He's a blessing. He's a miracle. I was reading Harry Potter and I was like, 'Oh my God, he's the boy that lived!' We couldn't be happier."

 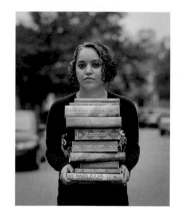 

↖ Sohini moved to Georgia when she was thirteen. Most of her classmates didn't know what to make of her. "If I told them I am Indian, I got asked what tribe. I would say I'm Asian, and they would say you don't look Asian. Add in the fact that I was born in the UK, and it was even more confusing!"

↑ Sohini holds the stack of Harry Potter books she read during her "fertility journey."

↖ ↗ Michael and Sohini have tattoos showing the time of delivery of Maya, their stillborn daughter.

## Juana

Apopka, Florida

"I expose myself daily by driving my kids to and from school and to my job. I don't know if I will get detained by the police—and from there, jail, and from jail, Mexico. What will happen to my children if that happens? Where will they stay? In Mexico, I know they will not have the opportunities they have in this country. If I didn't have my children, I would've left here a very long time ago. But my children are my commitment."

"It's true, we did something we didn't have to do, which was to come here, but we are paying a lot for that—we lost our dignity and we lost respect. Every day we live with discrimination; when you go to the store and they see that you can't speak English, they look at you like, 'What are you doing here?'"

"There's a saying, 'A todo el mundo le brilla el sol' (To everyone, the sun shines), but some of us are trying to catch small rays of that sun in order to survive."

"When you are undocumented, even the car that you drive needs to be licensed under another person's name. It's very complicated and challenging to live with such high stress."

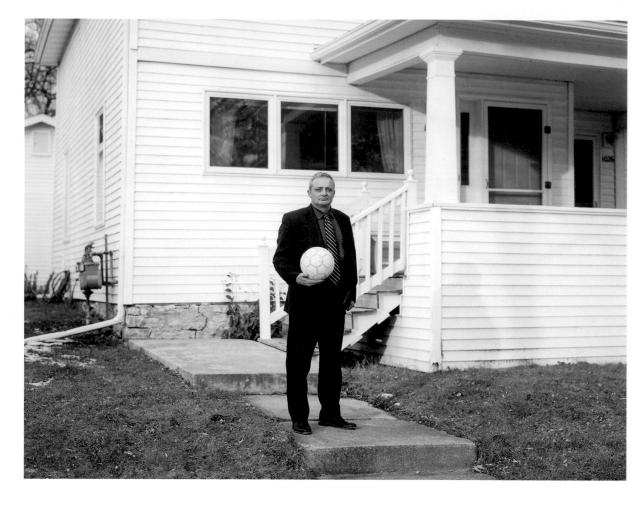

↑↑ Nikos shows a photo of him holding his daughter, Selena, for the first time.

↑ "Soccer is my passion. It's like an affair with another woman. It's something I have in the bottom of my heart." His village in Greece didn't have a field but that didn't stop Nikos and his friends from playing on the rocks. Recruited out of high school, he played semi-professionally for five years. In Wisconsin, "soccer connected me with others and allowed me to blend in. No one made fun of my accent anymore. I was talking with my feet, which is a universal language."

# Nikos
## Appleton, Wisconsin

After his mandatory service in the Greek navy, Nikos worked as a bartender at a popular Athens hotel. It was there he met his future wife, a university student from Minnesota doing a semester overseas. "I'll show you Athens by night," Nikos told her. When she became pregnant, she returned to the U.S., where their daughter was born. Nikos finally got a visa following several rejections and joined them after missing the first six months of her life.

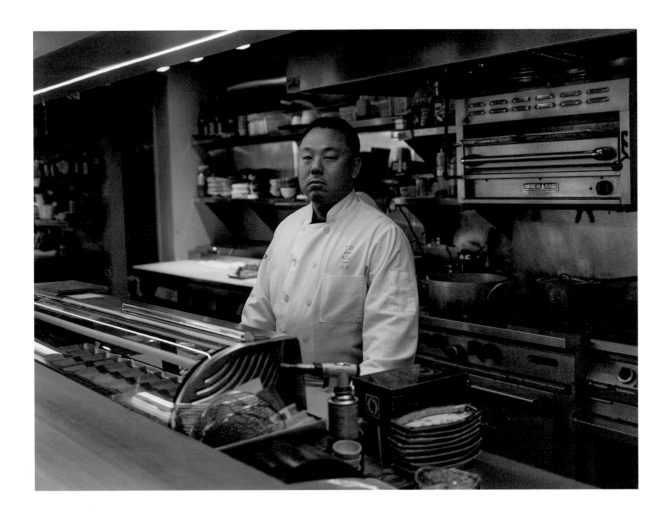

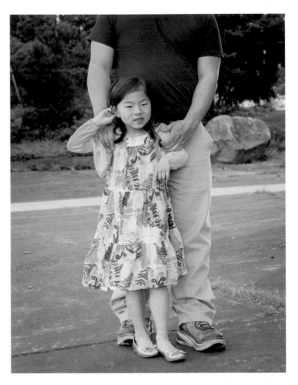

# Taichi

Seattle, Washington

Taichi, the executive chef of Sushi Kappo Tamura, thinks it's "a beautiful thing" that, thanks to the vibrant Japanese community in Seattle, his daughter can eat Japanese food three times a day and wear a kimono—and still be American. "Exposure to multiculturalism is great and hard to find in Japan. One day, my daughter is going to say, 'I come from a Japanese background,' and it is up to her how much she is going to embrace that."

"One of the joys you have as a sushi chef is growing together with the community. My guests are single, then they get married, have children, and then they come in with their children. I'm someone they can always count on seeing and sharing their stories with. It is love."

## Rosie and Matt

Seattle, Washington

The challenges of raising young children without family nearby have Rosie and her husband, Matt, planning a move back to Australia to be near the grandparents. "It's going to be a hard decision. Every time we talk about it, we're like, 'I'm not looking forward to this!'"

They have only slight reservations about their children's American citizenship. "I'm hoping it's going to be a great gift for them to have options. Or I wonder if it will ever work against them since America is unpopular in some parts of the world."

## Alhaji

Aldan, Pennsylvania

Alhaji landed in the U.S. with dreams of making up the several years of high school he had lost due to war in Sierra Leone. Instead, he soon found himself working full-time at a store. He enrolled in school two years later, but then the murder of a cousin and another murder by a cousin interrupted his studies. Still, Alhaji managed to graduate. Now he focuses on spending quality time with his daughter and making sure she gets a great education.

"The moments spent together with my wife and daughter in our small apartment are definitely my greatest accomplishments to date."

# Raquel
Riverton, Utah

Raquel was raised in a Catholic home in Venezuela. As a nineteen-year-old in 1982, she converted to Mormonism, met an American missionary, and visited the U.S. for the first time so they could be sealed in marriage. They had two sons together and later separated. In 1994, Raquel came back to the U.S. with her two sons and decided to overstay their tourist visas. She raised four children while building a successful real estate company.

Raquel left the Mormon church when she could no longer reconcile its stance on homosexuality with the fact that two of her children, Ismael and Noah (see p. 16), are in the LGBTQI+ community. "The church doesn't accept gay people. They still consider it something that people can change."

In 2015, a church policy update stated that children of gay parents couldn't be blessed or baptized until they were eighteen, and then only if they denounced same-sex marriage and no longer lived with their parents (the policy was revised in 2019). Raquel was devastated; it didn't seem "Christlike." "My son didn't pick to be gay—he was born gay. Same with my daughter—I didn't teach her to be gay. My children didn't have a choice."

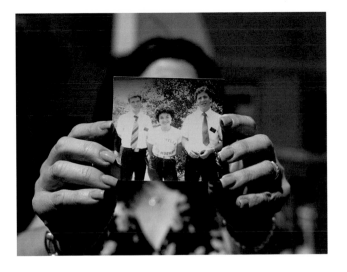

↑ Raquel holds a photo of Jesus with her children, Ismael (*left*) and Noah. "They are who they are, and I'm on their side."

← Raquel shows a photo of herself in 1982 with missionaries Elder Smith and Elder Smith at her house in Venezuela.

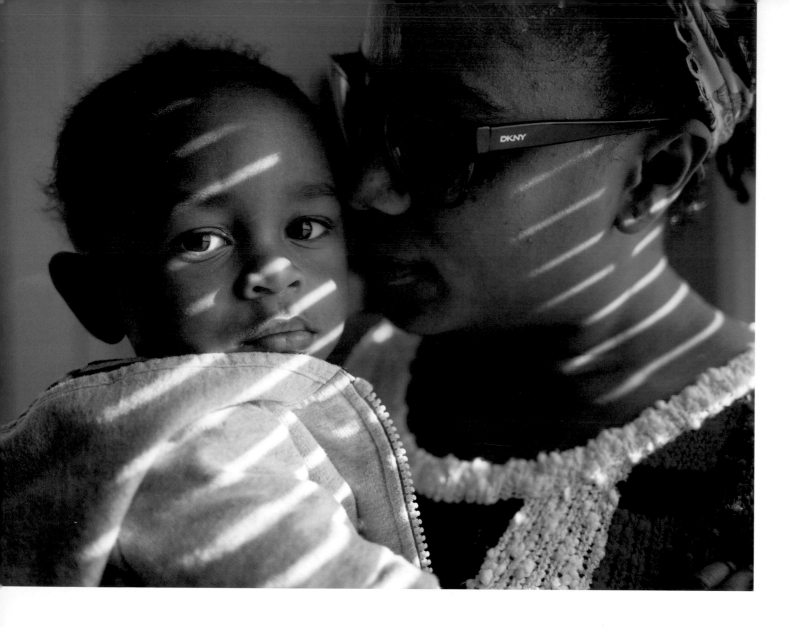

The first year of Lyran's life was hard for Gemma, with no family or close friends around. "Being a mom has been amazing and brilliant, but also hard and real. I'm aware of the lessons Lyran is here to teach me."

# Gemma

Cedar Rapids, Iowa

Gemma moved from the UK to Iowa in 2016 to be with Daniel, whom she met on a Law of Attraction cruise. Shortly after arriving, she found out she was pregnant, which was not the plan. "We had to learn, grow, and adjust. I've experienced the highest highs and the lowest lows I've ever had in my life since moving here."

Gemma wanted to give birth somewhere warm, like California or in Hawai'i with the dolphins, but she stayed in cold Iowa and had a homebirth. "If I have to go to the hospital, what am I going to do? It is like $40,000, and I don't have insurance since I'm in this weird space with no Social Security number. I was trying not to worry about that too much so I could focus on the birth."

## Sadami
Worland, Wyoming

"We gave both of our kids Japanese names, but at the same time we tried to choose names that are easy for non-Japanese people to pronounce. We wanted them to feel connected to both cultures no matter where they live."

For their eldest son's name, Sadami and her husband, Jonathan, chose Kensho. Ken (堅) means sturdy and sho (捷) means quick, or successful in hunting, which Jonathan's family likes. Yujin, the name of their second son, means calm (yu 悠) and caring, or compassionate.

↑ This calligraphy says "kennin," which means perseverance. Sadami and Jonathan borrowed the first character to use in their son Kensho's name.

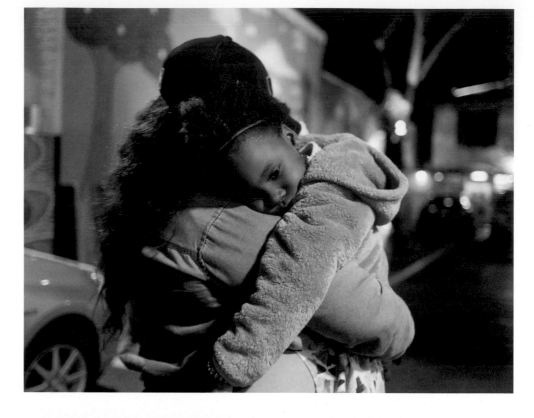

# Ivy
## Dallas, Texas

Since Kyani was born in 2012, every decision Ivy makes centers on "How will this affect my daughter?" When Ivy moved to the U.S. from Kenya at age nine, she became a "Mavs Ballkid" and is now the Dallas Mavericks' DJ, one of only two female DJs in the NBA. Her work as DJ Poizon Ivy, which includes performing nationally and internationally, consumes her "emotionally, physically, and spiritually." She often brings Kyani with her to games; some weeks, that's the only time they have together. Ivy would like to see more sharing and discussion about the challenges of motherhood, which she calls "the most beautiful thing ever." "At the end of everything is Kyani, and at the beginning of everything is Kyani."

→ Ivy DJs a Mavs game with her daughter, Kyani, nearby. "I feel like if she's around me, I'm able to influence her. I look at her, and I know I have only one chance to get this right."

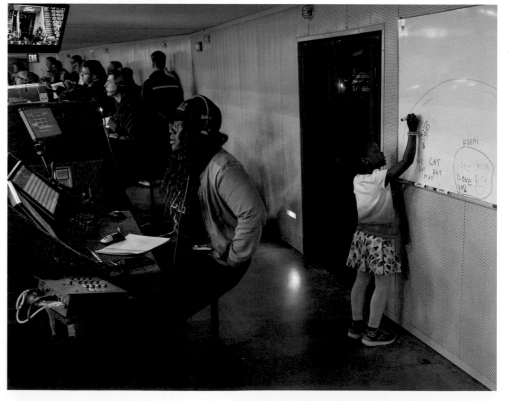

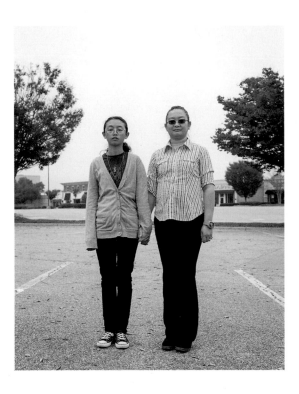

## Lei Anne
Cary, North Carolina

Lei Anne arrived in the U.S. and soon found work stocking shelves at Macy's. "This was not what I imagined it would be like in America. I told my mom that I needed to do something for myself." Eventually, she joined the Air Force and learned IT. Lei Anne missed her friends in the Philippines but loved the camaraderie of the base. She met another soldier, and they had a child, Ash.

In 2003, Lei Anne was told she would be deployed overseas. An unprecedented wave of anxiety overwhelmed her. What would happen to Ash, age three, if she and her then-husband were both deployed? In her distress, she said things she never could have imagined saying, and the Hill Air Force Base mental health clinic deemed her too much of a liability. Lei Anne was honorably discharged from the Air Force in April 2004.

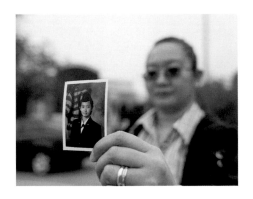

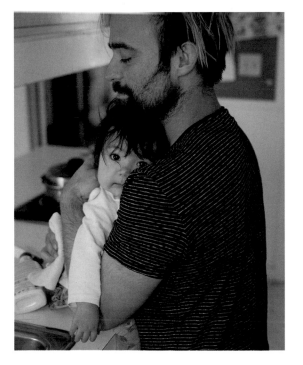

## Thierry
Los Angeles, California

Thierry, from France, completed a PhD and was working in cancer research by the age of twenty-five. That's when he decided to leave the lab and move to California to be a photographer. "I feel like photography is a mission—not only for me but for my father—to do what he would have loved to do. I hope he is proud of what I am doing." Today, Thierry also does commercial photography to provide for his American daughter, Anais.

Thierry's daughter, Anais, peeks out from his embrace. "No matter what she does, I will always love her. There is this deep connection, and it has changed my life. I have discovered what unconditional love is."

# Asani

Detroit, Michigan

When Asani traveled to the U.S. from Romania, she tried to hide her origins out of embarrassment. She told people to call her Alex, and noticing the "perfect straight smiles" everywhere, she would cover her face and avoid speaking. "I was so shocked. I had a big gap when I was a young girl, and I thought all these American people would know I was different because of my gap." The experience led Asani to her career. "Eventually I got into dental school, and I am fixing my smile. I was like, I don't want people to be so unhappy with their teeth, and I can maybe change that one day . . . and here I am, a dentist."

Asani doesn't want her children to feel like she does: torn between America and Romania. Her parents' lives didn't go as expected after they moved in 2000. Her father, Valentin, seems to like the U.S. more and more, but she believes her mom, Maria, feels guilt for any happiness she experiences away from her extended family back home. Maria always says, "We are never truly happy unless we are in Romania."

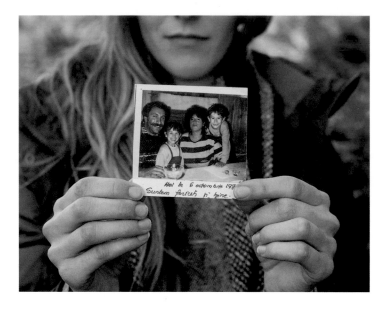

"From the first time I saw 'the American smile,' I needed to have that smile and be like these American people."

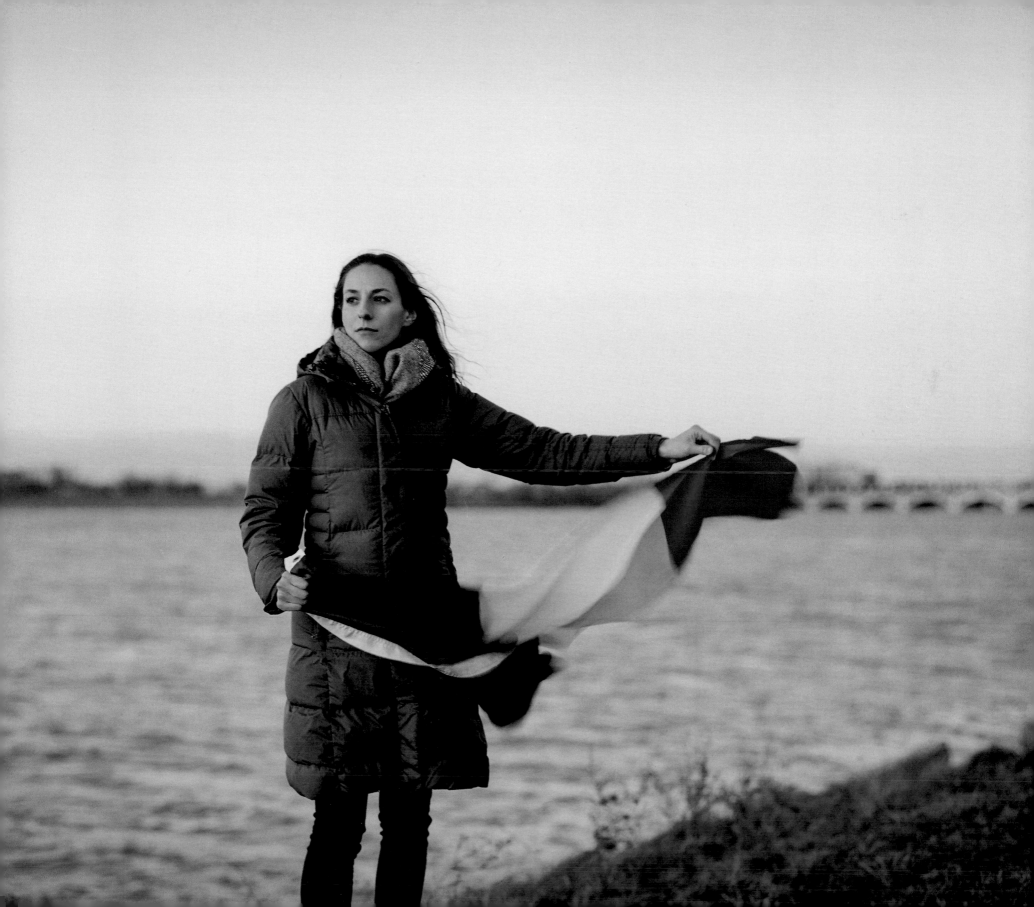

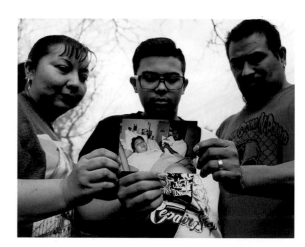

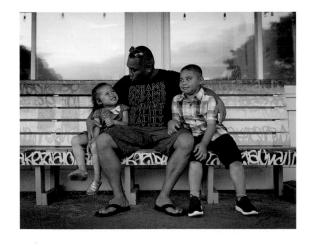
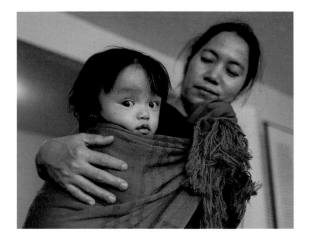
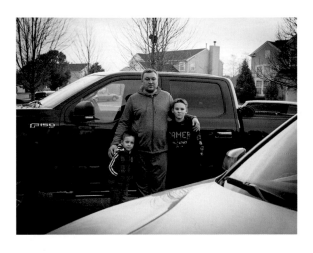
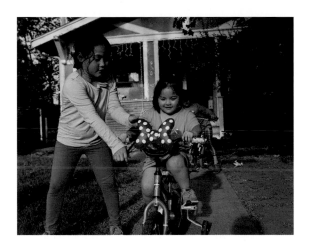

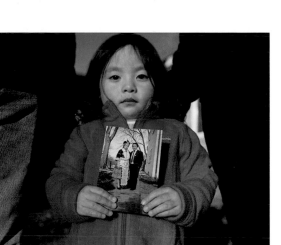

# A Longer Note

I began thinking about this project while watching the Republican candidate for president incite hatred toward immigrants in 2016. Too often the immigrant stories we see from major American news outlets focus on either heroes or villains—outliers. I wanted to do something to help humanize the narrative, and I had experience collaborating with immigrants in storytelling (most notably for the project *Cosmopolis Toronto*, which includes someone from every country of the world who calls the city home). I wanted to create a body of work that appreciates the spectrum of experiences, in a country that I felt needed to see the nuances. I hope sharing these experiences will help people see the humanity behind statistics and the diversity of immigrant experiences—and that readers can find a personal connection to the people in these pages.

In many ways, this book is for immigrants, but I hope those who may not regularly reflect on their personal relationship with immigration, whose ancestors migrated to the U.S. generations ago—and would today, without hesitation or being questioned, claim to be 100 percent American—will also engage with these experiences. Will this book make you want to learn more about your own family's history of migration? I hope so.

I am the son of immigrants to Canada—my mom, from England; my father, the United States—so I have a familial connection to this project. Still, I am a privileged white man, and throughout my life it has been easy to avoid thinking about my personal relationship to immigration. Rarely have I been asked where I am from or what my background is.

My great-great-grandfather William H. Green Sr. (1853-1941) was a professional photographer and beekeeper from Maine. His photography took him all over the USA, and at the age of thirty he moved his family to Germantown, Ohio, where he opened the town's first photo studio. When I was a kid, a couple of times a year we would make the trip to Germantown to visit my grandparents in their enormous white house on top of a hill. My grandfather Dale E. Shafer Jr. (1918-2003) was a retired two-star major general in the U.S. Air Force, and a Cincinnati Reds fan of few words. My grandma Susanne Shafer (1918-2016) was the grandma you think only exists in movies: plump, overly friendly, always in the kitchen, and continuously trying to feed you foods laden with sugar, butter, and salt. We'd arrive at their house in the middle of the night after the long drive from Kitchener, and she would offer me a huge bowl of ice cream. I was completely enamored by America. My cousins had all the toys and all the junk food I could ever hope for, and I dreamed of moving there someday. As I got older, I still loved visiting Ohio and seeing family, but I started to see other aspects of life there—the materialism, the racial divide, and the socio-economic inequality. These contrast with my upbringing in a diverse region of Ontario. I believe many people who move to the U.S. expect what I saw as a child, but what they get are the things I saw as an adult.

The creation of this book took five years—much longer than I anticipated. My initial plan was to meet at least a hundred people across the United States—one or two people each day, on three trips over two years. I used immigration demographics to create a rough plan for the proportion of participants to try to include, by state and by countries of origin. For example, there are about a dozen participants in California and only two in Montana, and many more participants born in Mexico than any other place. I reached out on social media to look for participants. I cold messaged friends of friends on Facebook, tweeted, and messaged strangers on Twitter and Instagram who I thought may have a story to share. I emailed every immigration-related organization I could find across the country. In many states, I had no personal connections, so at times it felt like I was grasping at straws. Luckily, every once in a while a friendly stranger would reply to my message and help me connect with their sister's friend's uncle's neighbor's classmate!

I created an application form, which helped me to know if someone was truly interested, since it took some effort to complete. When someone expressed an interest in participating, I tried my best to make it happen. Other than having immigrated, no other qualifications were necessary. Quite often, people would say, "my story is not interesting," and I would have to explain that this project is not about extreme stories, like people who have saved babies from burning buildings or won Olympic medals. I believe that everyone, especially those who have migrated from one place to another, has a story to tell.

I based my travel schedule on who had completed the application form in advance, and I tried to organize the road trips' routes in a logical way, but still I ended up having to loop back often. Some participants lived in remote rural locations, but I made a pact with myself to never let this deter me—I didn't want to only include people living in convenient urban centers. I must admit, it was strange covering this much territory and disregarding most of the major tourist sites. We drove right past the Grand Canyon and skipped many other national parks, like Yosemite. I had no one to meet in Charleston, so we didn't go there, but I've heard it's beautiful. In San Antonio, everyone I was supposed to photograph canceled at the last minute, so Kate and I did get to see the River Walk and the Alamo.

I usually spent at least half of a day with each person I met, sometimes a few days, and I took around three hundred photographs. I tried to spend enough time with people to hear and appreciate their complete story. If someone went off on a tangent, I listened. If it was important for them to share, it was important for me to hear, and I didn't want anyone to feel rushed. I have about an hour of recorded

## IMMIGRANT POPULATION BY STATE (2021)

| BY POPULATION | BY SHARE OF STATE POPULATION |
|---|---|
| 1. CALIFORNIA: **10,452,000** | 1. CALIFORNIA: **26.6%** |
| 2. TEXAS: **5,092,000** | 2. NEW JERSEY: **23%** |
| 3. FLORIDA: **4,609,000** | 3. NEW YORK: **22.3%** |
| 4. NEW YORK: **4,427,000** | 4. FLORIDA: **21.2%** |
| 5. NEW JERSEY: **2,135,000** | 5. HAWAI'I: **18.8%** |
| 6. ILLINOIS: **1,805,000** | 6. NEVADA: **18.4%** |
| 7. MASSACHUSETTS: **1,227,000** | 7. MASSACHUSETTS: **17.6%** |
| 8. WASHINGTON: **1,143,000** | 8. TEXAS: **17.2%** |
| 9. GEORGIA: **1,083,000** | 9. MARYLAND: **15.9%** |
| 10. VIRGINIA: **1,070,000** | 10. CONNECTICUT: **15.2%** |

Source: Migration Policy Institute tabulation of data from U.S. Census Bureau, 2010 and 2021 American Community Surveys, and 1990 and 2000 Decennial Census. https://www.migrationpolicy.org/programs/data-hub/charts/immigrant-population-state-1990-present

audio for each participant, though in some cases much more—for Ernie and Eve in Arizona, as an example, the recording is more than seven hours. (Each person now has copies of the audio recording and photographs to share with their family.) When you do a project like this, you learn incredibly personal and deep things about the individuals. I often wonder if I know some of the people in this project better than I know my longtime friends, whose most distant childhood memories or family heirlooms I don't usually ask about. I'm lucky to have remained in touch with many people featured in this book. I consider them friends and hope our paths cross again soon.

Aside from driving a small hybrid car that's good on gas and eating lots of granola bars, one way that I was able to make this financially possible was using the Couchsurfing app, which is basically Airbnb without the cost. We stayed in free accommodations offered by strangers for 90 percent of the nights on the road. I had never Couchsurfed before this, and I don't know what I would have done without this caring community. Some hosts helped me find participants, like Gary in Winchester, Virginia, who told me about the Knight family and their three adopted children in Morgantown, West Virginia (a state that wasn't the easiest to find participants in). A few of the immigrants featured in this book were actually our Couchsurfing hosts, like Olivia, the retired school principal in Pennsylvania, and Ihab, the dental surgeon in Virginia.

I feel like I could write a separate book about our hosts. In New York, I stayed with a hoarder who lived alone with his pit bulls (luckily, my wife wasn't with me at that point). We enjoyed a beer and watched TV while the dogs climbed on the mounds of stuff, and on me. At night, they curled up in my bed with me since it was the only spot not covered in stuff. In New Haven, I slept on the floor beside the bed of a medical intern from Egypt. It was strange to have someone you just met a few hours before (not my wife!) ask if he could turn off the light. In the Bronx, my host had made it clear on his profile that he was gay and a nudist, but I had missed that part. When I arrived, he quickly realized I wasn't from the community and was kind enough to wear a bathrobe during my stay. In Birmingham, Alabama, our host invited us to spend Thanksgiving at their friend's hunting lodge. It was a magical experience—and the first time I've worn blaze orange so nobody would shoot at me.

## TRIP ROUTE

Because of travel insurance and restrictions on the amount of time Canadian residents can spend abroad, we could only be in the U.S. for three months at a time and six months in a calendar year. So we took three separate three-month road trips covering almost thirty thousand miles in a little Toyota, and two trips totaling seventeen thousand miles flying to Alaska and Hawai'i. For most of the trip, Kate, my very supportive fiancée (who is now my wife!), was riding in the passenger seat.

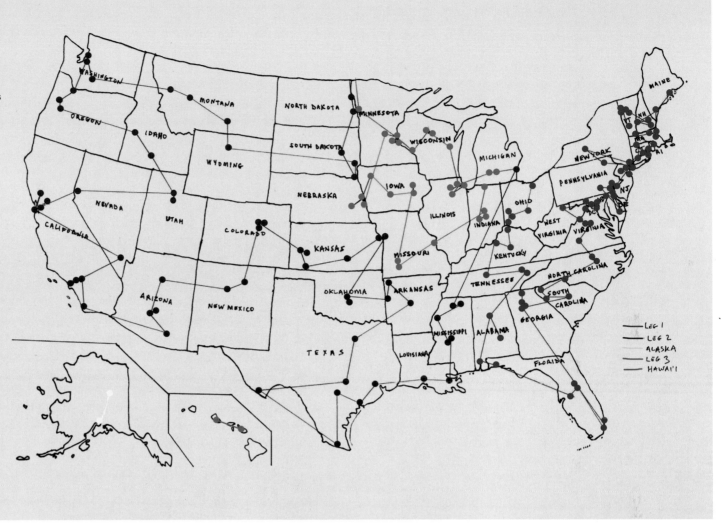

LEG 1
LEG 2
ALASKA
LEG 3
HAWAI'I

Creating a project like this is emotionally and physically draining. I spent each day for months listening to, and trying to visually document, emotionally charged personal stories, then heading to the home of my host, who was likely doing this for cultural exchange—they want to get to know you—so I'd try my best to be present and engaged and thankful for their gracious hosting. Sometimes they have a special place they want to take you, or friends they want you to meet—and you want to be a "yes" person. There were also the countless hours of driving, sometimes in heavy traffic through a busy city, trying to find another place you have never been.

I'm embarrassed to say we didn't eat very healthily. Kate and I made a pact that we would eat only at independent establishments—no chain restaurants. After a couple of weeks, that promise was broken. Fast food is everywhere, and each region we visited seemed to have a chain that we "had to try" including Cook Out in the Carolinas, Pizza Ranch in Iowa, and Bojangles in the southeast. We consumed fried everything and washed it down with gas station coffee. I'm not complaining, but I definitely knocked a few years off my life, and Kate couldn't fit into her wedding dress during her first fitting after months of traveling in the South (she gave me permission to print this). A lot has changed since we first crossed the border into Vermont in 2017, both for us (we have a three-year-old daughter now) and for the participants. Some have had children since being photographed, some have migrated again, some have been deported, some have died. We have all faced a global pandemic, which took the lives of some people in this book and has altered the lives of countless others. We have seen America pull out of Afghanistan, Russia invade Ukraine, and an unprecedented number of heatwaves, floods, droughts, and forest fires caused by global warming. It seems clear that the human need to move has only increased and will continue to increase.

Thank you for caring about these stories and for taking time out of your day to reflect on the experiences of someone else—specifically someone else who isn't famous or an influencer. I don't have a grand conclusion or a solution to the myriad of issues America, and the world, faces. I do, however, hope that future generations can look back on this book and say that things have improved for immigrants in the U.S. rather than "things were so much better then."

I'll finish with this memory from the road. Nebraska was the forty-fifth state we visited, by which point we had heard a plethora of stories from people about the discrimination they have endured. In Omaha, Kate and I met Franck from Gabon, who, to end our day together, wanted to show us Memorial Park. We were walking on the side of the road along the entrance when an old white man in a truck pulled up in front of me, and beside Kate and Franck—an Asian woman and a Black man. He rolled down his window and asked us something, but none of us heard exactly what it was. I felt a rush of adrenaline. Because of the lens I was now seeing the world through, I fully expected it to be something unkind. I asked him to repeat his question, and he said, "Have you seen the moon this evening? Doesn't it look beautiful?"

# Acknowledgements

First, I would like to thank all the participants who entrusted me with their stories. Each person in these pages deserves their own book, and I know this collection can't possibly do any individual story justice. Hopefully this is a start.

I would like to thank my wife, Kate Kamo McHugh, for joining me for most of this journey. Being in a small car together, for months on end, allows you to get to know someone very well, and it showed us that we are a couple that can handle and survive adversity! Kate supported my vision 100 percent, even if it wasn't the most reasonable of projects to take on. Honey, if you are reading this, I'm sorry you didn't make it to Hawai'i because you were too pregnant, but I know you agree that our happy, healthy daughter more than makes up for it!

Thank you to my friends and family for the love, especially my mom, Vivien Boyd, who helped the project along in many ways—like allowing Kate and I to sleep on her front room floor in between trips south, or being open to swapping cars when the stick shift on my cruise-control-less Yaris had my knees aching.

I would also like to thank the entire team at Figure 1, in particular, editorial director Mike Leyne, for the many Zoom meetings and sound advice in spite of my attempts at "fiddling" as we moved through the editing process; Naomi MacDougall, the book's designer, for her patience and the pride she took in working through the project's overwhelming amount of visuals; Viktoria Cseh, the book's copy editor and proofreader, for her careful eye.

Thanks to Ali Noorani for sharing his heart and mind in the foreword on a topic he knows well.

Certain people went above and beyond in supporting this project from their first hearing of it, like Rebecca Battistoni, Yvonne Brown, Rory Doyle, Jeannie Economos, Zakk Flash, Jodi Hilton, Patrick Horton, Kelly Kamo McHugh, Ellis Katsof, Juliana Kerr, Janice May, Chuck Munson, Drew Nash, Patrick Wood, and Anna Sabrina Sopian. I'm sure I'm forgetting many of you.

I would also like to express my appreciation to Diana Andersen, Gladys Arello, Ximena Greenhauff, and Montserrat Vargas, for helping with translations, and to university students Helan Ahmed, Camille Morales, and Tim Lyu who all had short stints as interns for this project.

Many more people helped make this happen than I am able to mention here by name, so if you are reading this and were one of the countless kind humans who passed on information to help me connect with someone within these pages, thank you from the bottom of my heart!

A special note of gratitude needs to go out to all our Couchsurfing hosts across America, listed below in order of visit. Thank you for giving us a safe place to lay our heads. Without you, we wouldn't have made it.

Meaghan and Phil (and baby Sandy) in Winooski, VT; Andrew in Lebanon, NH; David and Bess in Portland, ME; Polina and Florian in Cambridge, MA; Steve in Providence, RI; Dhamarys in Providence, RI; Bemen in New Haven, CT; Mark in Ithaca, NY; Orlando in Yonkers, NY; Jess and Eman in Brooklyn, NY; Carol and Gary in Bedminster, NJ; Tiffany and Randy in Scranton, PA; John and Morgana in Philadelphia, PA; Olivia in Morton, PA; Amelia and her siblings in Lancaster, PA; Greg in Wilmington, DE; Monserrat in Delmar, DE; Patrick and Yaz, Takoma Park, MD; Erik and Zoe, Silver Spring, MD; Ihab in Harrisonburg, VA; Wendy and Gary in Winchester, VA; Jum in Charlottesville, VA; Sarah and Rob in Durham, NC; Connie in Seneca, SC; Michelle in Columbia, SC; Zach and Lauren in Atlanta, GA; Dalya and Alex in Hollywood, FL; Sacha and Boaz in Pensacola, FL; Robert in Mobile, AL; Tim in Montgomery, AL; Patrick in Birmingham, AL; Abby in Nashville, TN; Marlana in Louisville, KY; Shane and Allie in Lexington, KY; Duty family in Taylor Mill, KY; Evan in Dayton, OH; Aunt Vicky in Germantown, OH; Steve in Hilliard, OH; Alaa and Joanna in North Ridgeville, OH; Anne Carter in Oxford, MS; Rory and Marisol in Cleveland, MS; Scott in Ridgeland, MS; Christopher and Yadira in New Orleans, LA; Phanat in New Iberia, LA; Edward in Houston, TX; Margaret and Edith in Palacios, TX; Fran and Lauren in San Antonio, TX; David in Austin, TX; Sarah in Terlingua, TX; Ashley and Matt in Dallas, TX; Amber in Little Rock, AR; Jacqueline and Brian in Bentonville, AR; Jeff and Autumn in Fort Smith, AR; Justin in Kansas City, MO; Chuck and Trang in Springfield, MO;

Zenitin in St. Louis, MO; Jodie in OKC, OK; Benjamin and Kearny County Hospital in Lakin, KS; Matt and Amy in Denver, CO; Bob in Albuquerque, NM; Tisha in Flagstaff, AZ; Diane and Tom in Glendale, AZ; Angela and family in Phoenix, AZ; Jesus in Tucson, AZ; Nic and Kristen in Los Angeles, CA; Zain and Mark in Oakland, CA; Claudia and family in Arcadia, CA; Matt and Dianne in Richmond, CA; Dima in San Diego, CA; Beau in Las Vegas, NV; Ya-Chi in Salt Lake City, UT; Dale in Twin Falls, ID; Liyah and family in Twin Falls, ID; Daniel in Eugene, OR; Amanda and Dom (and Miss Peppers) in Portland, OR; Sally in Tukwila, WA; Genny and Luis in Yakima, WA; Jennifer and Zach in Missoula, MT; Michael and David in Billings, MT; Christa and Josiah in Winnipeg, Manitoba; Angie in Sioux Falls, SD; Marc in Huron, SD; Nick in Fargo, ND; Iris in Detroit, MI; Michelle and Marc in Detroit, MI; Zach and Kate in Stillwater, MN; Greg and Jeff in Menasha, WI; K.P. in Indianapolis, IN; Juliana in Chicago, IL; and Daniel and Gemma in Cedar Rapids, WI.

Finally, thank you for being here.

A giant thank you to the book's sponsors (listed at front) and everyone who pre-ordered through IndieGoGo to help make this happen.

Abdel Abakar, Jean Abreu, AFSC Denver, Nirmal Agarwal, Amy Aguirre, Miriam Alarcón Avila, Leila Aliyeva, Ilana Allice, Brian Anderson, Benjamin Anderson, Diana Andersen, Mir Tamim Ansary, Jonathan Arsenault, Clayton Armstrong, Ashley Arguello, Gladys Arellano , Giovanna Maria Arantes de Almeida, Melissa LN Arey, Ebony Avery, Ivy Awino, Fahri Azzat, Victoria Azpurua, Rebecca Battistoni, Nandita Basu, Quint Bagcal, Hilary Barr, Shadi & Melissa Battah, Viki Baniak, Jo Bartlett, Ryan Bauman, Diane S. Bassett, Barbara Walker, Martha Bátiz, Donna Beaudet, Eric Beaudet, Tom Belyk, Roberta Beaudet, Antoine Belaieff, Rebecca Berry, Dale Belvedere, Janka Bernard, Emily Mariko Belvedere, JoAnne Beauvais, Michelle Biancardi, Alexandra Bibbo, Erin Bingley, Stephanie Bower, Colin Boucher, Peg Bowman, Elizabeth Botten, Ximena Bouroncle, Vivien Boyd, David M. Bolinsky, Cole Breiland, Helen Brunt, Jennifer Brogan, Thierry Brouard, Joan Brooks, Gretchen Brown-Waech, Beth Lee Browning, Alan Bulley, Sarah Burton, Elizabeth Burciaga, Jacquie Bunker, Bridget Burianek, Brennan Caverhill, Yolfer Carvajal, Gerardo Cantú, Kiyo Campbell, Ryan Carmichael, Ariel Ceja, Christina Cheung, Ariel Chavez, Thibault Chareton, Clement Chan, Kin Hey Chan, Grace Chapman, Greg Constantine, Luis Contreras, Martha Conley, Sandra Coliver, Brian Coops, Mailyn Cortes-Shields, Jennifer Cooper, Jeff Collins, Brenda Cressman, Amelia Crespo, Colleen Cronin, Nicole Cultraro, Ivan Ćulum, Philip Anthony Davis, Geena Dabadghav, Brandy Davis, Matt Davidson, Clemence Danko, Jean Dennison, Jaymin Desai, Ina Della Mora, Sarah Denton, Elex DeMorais, Sohini Desai Whatley, Amy De La Hunt, John & Maureen Dinner, Sokhany Dosvanna, Lynn Dolven, Rory Doyle, Margaret Doughty, Ruth Dominguez, Chris Donovan, Brendan Docherty, Olivia Dreibelbis, Alice Driver, Vuk Dragojevic, Franck Ebang Toung Mve, Fil Eden, Mukesha Eduige, Stephen Edmonds, Denise Edmonds, Selina Efthimiou, Nikos Efthimiou, Delshad Emami, Kitty Emery, Jacqueline Ernst, Ricardo Estrada, Tannia Esparza, Rachel Eschle, Howell Evans, Dick & Jane Ewing, Kathleen Fallon Pasakarnis, Roberto Faria, Monica Farah, Fran Fitzpatrick, Anne Fleming, Dawn Fludder, Zakk Flash, Valerie Frappier, Frank Fredericks, Gloria Funcheon, Kit Furukawa, Marika Galadza, Tania Garcia-Pina, Evelyne Gaudet, Michael Gaudet, Cyn Gaetani, Jane Ashley Gagné, Nicole Gaudet, Matthias Gelber, Amra Ghouse, Victoria Gilligan, Virginia Gilbert, Morgan Gingerich, Sue Goldstein, David Go, Rebekah Go, Efrat Gold, Sue Goldstein, Michelle Gram, Barbara Gray, Annie Griffiths, Sheila Guinther, Brennan Hardy, Easton Hanna, Amy Haertel, Bemen Habashi, Rebecca Hale, Gerry Harrington, Zen Harbison, Sandy Han, Sarah Hansen, Nathaniel Hayes, Myra Hegmann, Colin Henderson, Tony D. Higgins, James Hinton, Dian Hill, Jodi Hilton, Henry Homer, Emily Hollinger, Rephael Houston, Patrick Horton, Kim-Chi Hoang Lazier, Brian Horneck, Phillip Htike, Kirsty Hunsberger-Shortt, Kat Hudson, Bryce MK Hudson, Elisa L. Iannacone, Seref Isler, Christi Ivers, Youness Jamil, Goran Jagetic, Sanjay Joshi, Sandy Kamo, Maya Kamo, Tsugumi Kanno, George Kalaouzis, Ellis Katsof, Kelly Kamo McHugh, Kate Kamo McHugh, Robert Kalman, Noriko Kamo, Denise Kamo, Zachary Katsof, Arielle Kandel, Sean Kamo McHugh, Patrick Kane, Michelle Keast, Kathryn Kenealy, Heather Kendall, Shannon Keast, Dana Keller, Kathryn Keanie, Carolyn Keays, Lynne Kersner, Juliana Kerr, Layla Khamoushian, Ann Crawford Kirkland, Tamar Kieval Brill, Taichi Kitamura, Jessica Y. Kim, Barry Kluner,

Dahlia Klinger, Yemi Knight, Pavan Konanur, Mariya Koroleva, Indrani Kopal, Kaloyan Kolev, Mariska Kriebel, Christina Kraczkowski, Anya Kroupnik, Josh Kunder, Kim Kusz, Bridget Lane, Manoj Lekraj, Youjia Lee, Raquel Lee, Zachary Lee, Darryl P. Lewis, Jennifer Litwa, Natalie Litvak, Virginia Lingham, Maria Lipert , Maria Elena Lopez, Laura Lopera, June Lohman, Lucy Lu, Jennifer Lynde, Alex Mackay Thomson, Chip & Monica Markovich, Jody Mashek, Sarah Mark, Rose Mak, David Mason, Jeremy Martin, Paul Matzner, Kristen Mark, Charisse Maningas, Ann Mark, Narad Mani Nepal, Ruth Marimo, Cristina Martelo, Teny Matavoosi, Marta V. Martinez, Chad McClintock, Nancy McHugh, Hayley McIlwraith, Marisa Mcintyre, Madison McGrogan, Nancy McHugh, Paul N. McDaniel, Coletta McGrath, Michelle Miele, Layton Mikkalson, Jason Motlagh, Emily Moore, Julia Morgan, Rosie Morison, Tarek Mounib, Jackie Molloy, Alda Muhlbauer, Isabelle Muhlbauer, Gayatri Nairr, Amy Nave, Drew Nash, Cindy Nava, Zammy Navarro, Stacey Newman, Bee Nix, Louise Noguchi, Isabel Norwood, Matt Norwood, Tha Zin Nwe Htoo, Michael Okuley, Carrie Olsem, Oyu O'Leary, Jon Olbey, Erin Oogarah, Josephine Opar, Jennifer O'Reilly, Gemma Owusu, Sunder Palani, Bomi Park, Swati Patel, Ryan Park, Russell Pangborn, Bomi Park, Asha Patel, Rachel Peet, Jassiel Perez, Yin Peet, Kelley Peters, Daphne Perugini, Lauren Pesqueira, Shanelle Pearse, Patricia Piche, Abigail Piña Mandujano, Sylvia Pivko, Marc-André Plouffe, Nat Pooran, Beth Potter, Erick Portillo, Priscilla Powers, Andrea Portella , Felisa Ponce, Tom Proctor, Natalie Preddie-Zamojc, Christy Prada, Branden Prather, Christy Presler, Jimmy Prevost , Robert Pulkys, Ala Qahwash, Laura Quinton, Natalia Quinones, Glenda Rahn, Karla Rahn, Rachel Rakili, Gary & Mary Ann Recker, Wesley Lincoln Reibeling, Samira Rehman, Amanda Reid, Carlos Andrés Glynias Restrepo, Alicia Rixen, Analisse Ríos, Federico Rios, Valerie Rosen, Art Roffey, PhD, Ray Rodriguez, Jennifer Rodrigues, Amy Ross, Jenny Robb, Sylvia Robison, Hernán Rodriguez Montes, Lulu Runge, Federico Salas-Isnardi, Sophia Said , Mujtaba Sarwar, Seydi Sarr, Katie Sadie, Yukiko Satake, Jess Salomon, Sassan Sanei, Michael Saxe, Luisa Santos, Claudia Salinas, Adriana Santos, Mary & Arnold C. Schwartz, Natalie Schneider, Tamara Schnarr, Ron Scrogham, Scott C. Shafer, Tori Shafer, Palav Shah, Daniel Shapiro, Alex Shiew, Nic Shafer, Carolyn Shafer, Susan Shumaker, Carol Simon Levin, Duncan Sill, Tamsyn Sitler, Ayman Siraj, Michael Skehan, Cameron Slipp, Francesca Smith, Patricia Souhrada, Anna Sabrina Sopian, Valdir Solera Junior, Maranie R. Staab, Jessica Stutsman, The Steplock Family, Gail Stapleton, Kendra Strong, Catherine Stinson, Conan Stark, John Sugzdinis, Grace Sudden, Erik Syngle, Peter Tao, Yu Hang Tan, Samantha Tai, Jazmin Tapia, Vanessa Tamburro, Victor Tamashiro, Victoria Taylor, Lisa Takkinen, Job Taminiau, Lilian S. Yamamoto, Alan Teder, Guirlene Thomas-Durosier, Benjamin Thielemier, Lee Thao, Cristina Therriault, Jonathan Tichepco, BJ Tilos, Marko Tomas, Sarah Tonkin, Kostas Tsembelis, Carlos Urgilez, Christian Ugaz Valencia, Montserrat Vargas, Ashton Van Dam, Akins Van Horne, Rhoda Vanderhart, Ron VanMoerkerke, Henry Vanderspek , Slav Velkov, Angelica Cristina Vega, Beatrice Veschetti, Sabato Visconti, Arturo Victoriano, Leitha Walling, Tahmina Watson, Isabelle Wahlmann, Stephen Watson, Robert Welsh, Elka Weinstein, Laszlo Windhoffer, Andrew Williamson, Rachel Wilburn, Sarah Willett Recarte, Erika Wood, Crystal Kaakeeyáa Worl , AJ Wolske, Phanat Xanamane, Maya A. Yampolsky, Syed Yaqeen, Rodney Yamauchi, Caroline Yasuda, Anya Yershov, Sonia Yeow, Mary Yoo, Amanda Young, Michelle Yoon, Sahar Zaidi, Dima Zemsky, Kelly Zhu, Heidi Zorde, and Laura Zoeller.

# List of Participants

Abel, Helen, and Rediet (WV): 208
Abi (MS): 74
Adelina (GA): 181
Adriana (CA): 87
Alaa (OH): 231
Alex (SD): 120
Alhaji (PA): 284
Amal's Family (CT): 70
Amber-Dawn (NM): 228
Amelia (CA): 142
Analisse (CT): 82
Andy (MO): 166
Anna (FL): 276
Anya and Laszlo (MD): 277
Armando (CA): 207
Arthena (WV): 252
Asani (MI): 290
Batsheba (CA): 136
Belma (ID): 26
Ben (OR): 202
Bikes for Refugees (VA): 256
Billy Ireland Cartoon Library & Museum (OH): 259
Bomi (MO): 111
Brónagh (UT): 145
Carlos (MO): 101
Carlos (PA): 102
Cat (OH): 113
Célia (NV): 127
Chhuani and Lao (MI): 68
Chompoo (AK): 200
Chris (MO): 103
Chris and Yadira (LA): 133
Christian (NJ): 94
Christina (NJ): 275
Christine (MA): 256
Chuda (VT): 168

Cindy (NM): 31
Claudia (CA): 127
Clement (NY): 64
Collin and Sophie (KY): 272
Cristiana (NY): 234
Cyndi (LA): 252
Dam (SC): 17
David (OK): 71
Dhamarys (RI): 152
Diana (SC): 153
Diana (WY): 150
Dima (CA): 108
Dimple (NC): 119
Dom (OR): 276
E.J. (AK): 236
Edgar (TX): 95
Edi and Etrit (MI): 162
El Zócalo Immigrant Resource Center (AR): 253
Elke (GA): 123
Eman and Jess (NY): 149
Emilia (IA): 62
Erika (ND): 128
Ernie (AZ): 24
Federico (NC): 164
Felipe (NC): 56
Felipe (WA): 140
Fowzia (ND): 240
Fozia (TN): 132
Franck (NE): 242
Frederic (NV): 114
Fresh Start Farms (NH): 260
Gemma (IA): 286
Germaine (HI): 225
Goran (IN): 180
Guirlene (IN): 206
Heval (GA): 59

Hilde (NH): 212
Humberto (AR): 96
Ihab (VA): 224
Ihssan (LA): 73
Imad (OK): 230
Irina (ND): 63
Isabel (AL): 259
Isabel (MT): 103
Isabelle (NY): 80
Isaías (CO): 199
Ivy (TX): 288
Jacqueline (AR): 169
James (MO): 193
Jani (IL): 277
Javier (CA): 52
Jazmin (PA): 60
Jennifer (MT): 121
Jennifer (NM): 119
Jesus (AZ): 218
Jo (OR): 29
Joanne (OH): 16
Joel (UT): 211
Johanna (NJ): 95
John (WI): 248
John and Josie (TX): 171
Jonathan (HI): 66
Jonathan (NV): 129
Jorge (CO): 104
José Arnulfo (OH): 109
Joseph (CT): 124
Juan (AL): 251
Juana (FL): 281
Julia (NY): 198
Jum (VA): 29
Kakiko (AK): 118
Karla (KS): 88
Kayse (OR): 192
Kiril (AZ): 145
Kit (HI): 153
Kriz (TN): 126

Kwesi (IN): 231
Laura (DE): 46
Laura (MA): 83
Laura (TX): 219
Lee (MN): 232
Leezia (DC): 244
Lei Anne (NC): 289
Liyah (ID): 58
Lorenzo (AZ): 160
Luana and Carolina (FL): 63
Luckner (FL): 263
Luis (MS): 182
Luis (VA): 176
Luisa (FL): 263
Maggie (NM): 74
Mahvash (IN): 117
Making Movies (MO): 185
Manjit (HI): 33
Margaret (TX): 92
Maria (MD): 51
Mariya (CA): 213
Marta (RI): 179
Maya and Nazmi (AL): 163
Mayra (OK): 85
Melyssa (FL): 219
Michael (VA): 258
Michelle (CA): 220
Mike (OK): 55
Mimi (OR): 180
Ming Yuan (PA): 216
Mira (VT): 19
Mireya (FL): 150
Miriam (IA): 217
Mobina (DE): 178
Monica (AZ): 195
Monica (IL): 27
Monse (DE): 43
Montserrat (NY): 135
Moon (ME): 65

Mukesha (KY): 67
Narad (OH): 257
Nasir (IL): 183
Naty (KS): 159
Navid (HI): 255
Nikos (WI): 282
Nirmal and Sapna (SC): 235
Nithya (DC): 100
Noah (UT): 16
Nusrat (MD): 22
Olivia (PA): 125
Pascale (FL): 257
Patricia (WV): 90
Paty (KS): 258
Paul (IN): 28
Paw Say's Family (SD): 190
Phanat (LA): 222
Phil (TN): 18
Pom (IA): 72
Priscilla (NH): 177
Rais (WA): 265
Ralph (KS): 132
Ramon (CA): 156
Raquel (UT): 285
Raul (FL): 17
Ric (IL): 54
Riho (SD): 40
Rodain (AZ): 47
Rosie and Matt (WA): 284
Rossy (TX): 78
Ruqiya (ME): 112
Ruth (MI): 116
Ruth (NE): 270
Sabato (MA): 98
Sadami (WY): 287
Saleha (IL): 203
Sally (NJ): 21
Sarah (TX): 131
Serghei (IL): 274

Seydi (MI): 247
Shadi (VT): 279
Shuangyi (NM): 81
Simone (MD): 212
Sofia (KS): 220
Sohini (GA): 281
Sophia (AR): 196
Sue (CT): 253
Surekha (KY): 144
Suud (MN): 242
Taichi (WA): 283
Tamim (CA): 30
Tania (TX): 134
Tano (KS): 21
Tariq and Hina (AL): 226
Thibault (NY): 84
Thierry (CA): 289
Thomas (PA): 68
Thu Ha (SC): 167
Tirso (FL): 262
Valdir (HI): 146
Vic (CO): 15
Vicky and Pat (KY): 164
Violeta (CT): 177
Wilmot (MT): 48
Winnie (ID): 188
Wissam (NE): 44
Ximena (FL): 80
Yassin (TN): 147
Yasumin (ME): 41
Yauo (WI): 186
Yemi (AK): 214
Yesica (FL): 159
Yin (MA): 161
Yolfer (NJ): 147
Youness (VT): 183
Yuli (AR): 99
Zammy (NV): 113
Zoi and George (AK): 154

Cataloguing data is available from Library and
Archives Canada

ISBN 978-1-77327-221-4 (hbk.)

If you wish to support immigrants and immigration
reform in the United States, please visit
FindingAmerican.com for a list of advocacy groups.

Design by Naomi MacDougall
Photography by Colin Boyd Shafer

Editing by Michael Leyne
Copy editing and proofreading by Viktoria Cseh
Front Cover image: Rossy, from Mexico, stands
beside the border in Hidalgo, Texas.
Author photograph by Ebti Nabaj

Printed and bound in China by C&C Offset Printing Co.
Distributed internationally by Publishers Group West

Figure 1 Publishing Inc.
Vancouver BC Canada
www.figure1publishing.com

Figure 1 Publishing works in the traditional, unceded territory of the xʷməθkʷəy̓əm
(Musqueam), Sḵwx̱wú7mesh (Squamish), and səlilwətaɬ (Tsleil-Waututh) peoples.

**COLIN BOYD SHAFER** is a documentary photographer and a social
sciences educator. His recent, award-winning projects include
*INTERLOVE*, a photography series that highlights interfaith love stories,
and *Cosmopolis Toronto*, which features someone from every country
of the world who now calls Toronto home. Shafer is the Canadian son
of immigrants from the United States and England, and lives in his
hometown of Kitchener, Ontario, with his wife, Kate, daughter, Isabel,
and too many plants and cameras.

SOCIAL ACCOUNTS
@findingamerican
facebook.com/findingamerican

Acton, Massachusetts / Albuquerque, New Mexico / Aldan, Pennsylvania / Anchora
California / Atlanta, Georgia / Aurora, Colorado / Austin, Texas / Barre, Vermont / Battle
Air, Maryland / Bellevue, Nebraska / Bentonville, Arkansas / Billings, Montana / Birn
Vermont / Cambridge, Massachusetts / Cambridge, Maine / Carmel, Indiana / Cary
Carolina / Charlottesville, Virginia / Chicago, Illinois / Cincinnati, Ohio / Clarkston, Geor
Carolina / Columbus, Ohio / Corvallis, Oregon / Crozet, Virginia / Dallas, Texas / Delmar, D
New Hampshire / Durham, North Carolina / Elk Point, South Dakota / Englewood, Colora
Dakota / Flagstaff, Arizona / Fort Smith, Arkansas / Garden City, Kansas / Germantown, Oh
Virginia / Hartford, Connecticut / Helena, Montana / Hilliard, Ohio / Hollywood, Florida / I
York / Jackson, Mississippi / Kalamazoo, Michigan / Kansas City, Kansas / Kansas City, M
Pennsylvania / Las Vegas, Nevada / Lebanon, New Hampshire / Lexington, Kentucky
Kentucky / Lynchburg, Virginia / Maplewood, Minnesota / Martinsville, Indiana / Miami
Montana / Mobile, Alabama / Montgomery, Alabama / Moorhead, Minnesota / Morgan
nnessee / New Albany, Mississippi / New Haven, Connecticut / New Iberia, Louisiana / New
ouri / Norman, Oklahoma / North Bethesda, Maryland / North Ridgeville, Ohio / Nor
ma / Omaha, Nebraska / Orlando, Florida / Oxford, Mississippi / Palacios, Texas / P
rtland, Oregon / Powell, Tennessee / Providence, Rhode Island / Reno, Nevada / Ri
tonio, Texas / San Diego, California / San Francisco, California / Santa Fe, New
n Hill, Pennsylvania / Silver Spring, Maryland / Sioux Falls, South Dakota / S
Stillwater, Minnesota / Storm Lake, Iowa / Takoma Park, Maryland / Tay
City, New Jersey / Union Gap, Washington / Wailuku, Hawai'i / Walnut Cr
Wichita, Kansas / Wilmington, Delaware / Winchester, Virginia / Winc